Arizona Highways

Photography
Guide

How & Where to Make
Great Photographs

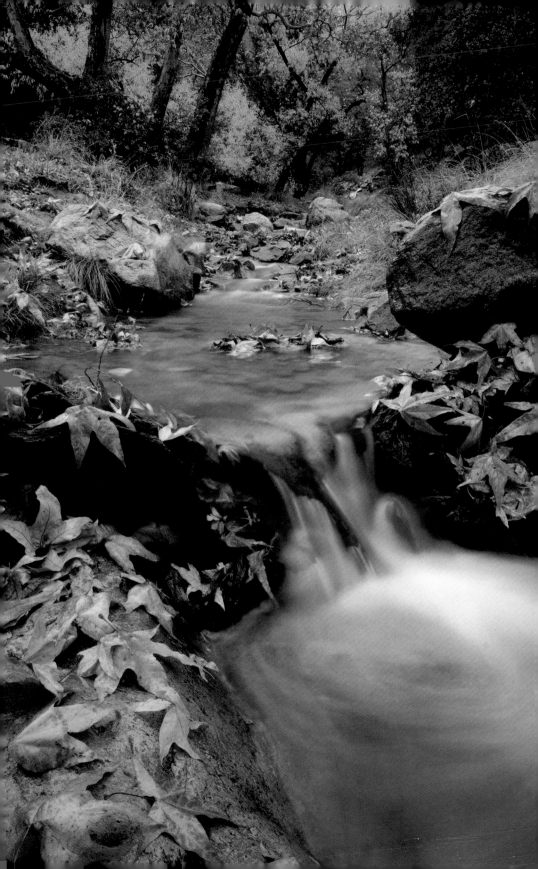

ARIZONA HIGHWAYS

Photography Guide

How & Where to Make
Great Photographs

Text and photographs
by *Arizona Highways*
editors and contributors

TEXT AND PHOTOGRAPHS: *Arizona Highways* Editors and Contributors

AUTHORS AND PHOTOGRAPHERS LISTED ALPHABETICALLY: John Annerino, Nick Berezenko, Lawrence W. Cheek, LeRoy DeJolie, Jack Dykinga, Peter Ensenberger, Kerrick James, Jeff Kida, Jack Kurtz, Gary Ladd, Larry Lindahl, Richard Maack, David Muench, Ruth Rudner, and Tom Vezo.

TEXT EDITOR: Lawrence W. Cheek

COPY EDITOR: Evelyn Howell

PHOTOGRAPHY EDITOR: Jeff Kida

CHARTS: Ronda Johnson

DESIGNER: Vicky Vaughn Design

ART DIRECTOR: Barbara Glynn Denney

Library of Congress Control Number: 2007394724
ISBN 978-1-932082-84-5

First printing, 2008. Printed in China .

Published by the Books Division of Arizona Highways® magazine, a monthly publication of the Arizona Department of Transportation, 2039 West Lewis Avenue, Phoenix, Arizona 85009. Telephone: (602) 712-2200. Web site: www.arizonahighways.com

PUBLISHER: Win Holden

EDITOR: Robert Stieve

MANAGING EDITOR: Bob Albano

ASSOCIATE EDITOR: Evelyn Howell

DIRECTOR OF PHOTOGRAPHY: Peter Ensenberger

PRODUCTION DIRECTOR: Michael Bianchi

PRODUCTION ASSISTANTS: Annette Phares, Diana Benzel-Rice, Ronda Johnson

Front Cover:
Fluffy clouds build over red buttes near the Navajo Nation's Lukachukai Mountains.
DAVID MUENCH.

Spine:
Havasu Falls in the Grand Canyon.
GARY LADD.

Page 2:
Autumn leaves decorate a stream in the Santa Rita Mountains south of Tucson.
DAVID MUENCH.

ARIZONA HIGHWAYS

Read Me First

THIS BOOK IS ABOUT insights and photographic experiences shared by a group of remarkable individuals, *Arizona Highways* magazine's contributing photographers. For more than 80 years we at the magazine have worked with amazing talent, the likes of Ansel Adams, Esther Henderson, Josef and David Muench, Pulitzer-prize-winner Jack Dykinga.

Within these pages we share with you lifetimes of hard work translated into knowledge, all presented in a user-friendly manner. We cover photographing the magnificent landscapes of Arizona, complemented by shooting the state's wildlife, architecture, people, and cultures. We delve into motivation, personal philosophies, and, what inspires some of the best working professionals in the photographic community today. You'll see that different people have passions for different things. Rarely does an individual excel at all types of photography, so explore this book vigorously, find what you love, and pursue it.

The book opens with a sizzling appetizer, a portfolio of diverse imagery designed to open up your senses to a multitude of possibilities.

From there, our guidebook is divided into three sections.

"The Basics" section deals with the very fundamentals of our craft. This includes digital cameras, related equipment, and software; how to formulate the best exposure; and how to use light to your best advantage. We naturally integrate vision and composition into the mix and speak to making your outings more interesting by choosing a variety of shots—long, medium, and close-up.

From there we discuss "Types" of photography and how to take breathtaking landscapes and appealing images of wildlife. Cultures are revealed through travel, people, and events. Our adventure chapter will captivate those who prefer an adrenaline rush to a caffeinated buzz.

The final section delivers some of the Grand Canyon State's most spectacular scenic locations. Complete with directions, ✳ we escort you from the mysterious Navajo Indian Reservation to the otherworldly Sonoran Desert. We guide you through the Red Rock Country of Sedona, where soaring coral sandstone forms are contrasted by softer, cooler piñon pines and juniper trees. Explore the Mogollon Rim, a geological backbone that vaults abruptly 2,000 feet from the searing desert floor to a forest fantasy. The unparalleled majesty of the Grand Canyon and the adjoining Colorado Plateau present photographic opportunities not found anywhere else.

Throughout the book, you'll find "Photo Tips" and references directing you to the appropriate pages that will help demystify technical speed bumps.

Take this photo guidebook with you as you travel and explore. Use it as inspiration or to generate project ideas. Imagine the camera as a vehicle that has the ability to transform your visual world. Most of all, enjoy!

—Jeff Kida, *Arizona Highways* Photography Editor

✳ *Throughout this book this symbol has been placed after the names of sites that contributors consider among the best for making photographs in Arizona. Directions for finding the spots are listed alphabetically by location name beginning on Page 328.*

Table of Contents

PETER ENSENBERGER

JACK DYKINGA

Places for Photography 200

GARY LADD

✣ *Throughout this book this symbol has been placed after the names of sites that contributors consider among the best for making photographs in Arizona. Directions for finding the spots are listed alphabetically by location.*

Portfolio

The following collection represents prime examples of how and where to make great photographs in the *Arizona Highways* style.

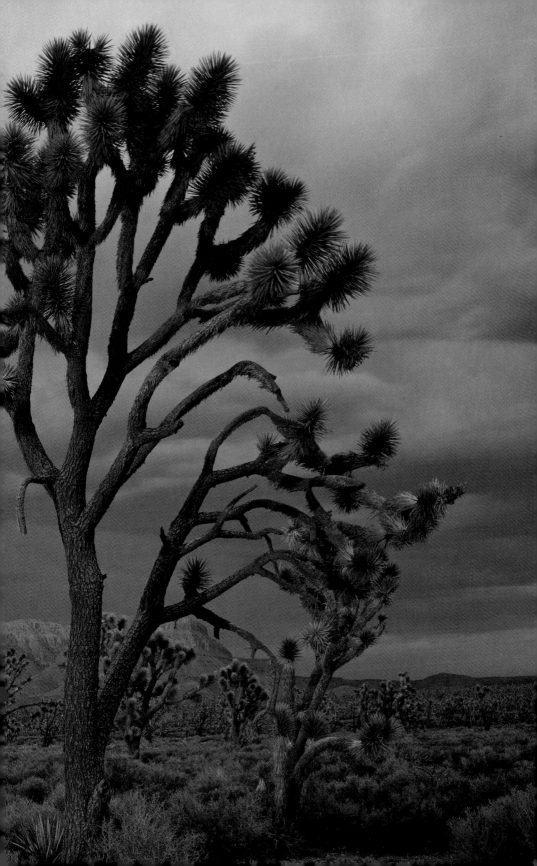

Portfolio

Photographing Arizona conjures up challenge and adventure, more than you'll find
in any other state. Sunlight sometimes paints the land in otherworldly colors and
sometimes bleaches it with brutal, white light. Exotic landscapes blend dominant
plants, flat land edged by mountains, and a great expanse of sky. Making photo-
graphs of landscapes, wildlife, people, and activities requires a mastery of basics
and a knowledge of the subjects. The opening gallery illustrate what is possible
in a wide range of subjects and settings.

Landscape (pages 118-131)
Preceding pages 8-9: Photographer Jack Dykinga scanned
weather conditions one summer waiting for the "monsoon"
storms to build and create spectacular atmospheric conditions.
This image was made in the Mohave Desert outside Kingman on
an Arca Swiss 4x5 field camera. He used a 180mm lens and Fuji
Velvia 50 film. JACK DYKINGA

Adventure (page 190-199)
Right: Descending through primordial mists, a climber moves
almost blindly through the minimal light in the Mazatzal
Mountains. Dicey weather conditions add to the inherent risks of
technical rock climbing. The shadowy nature of this scene really
attracts a reader's attention. JOHN ANNERINO

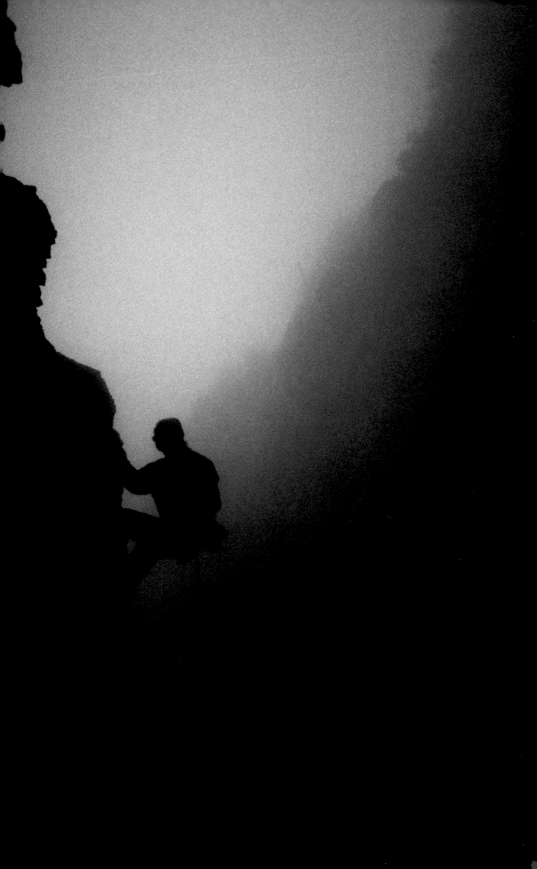

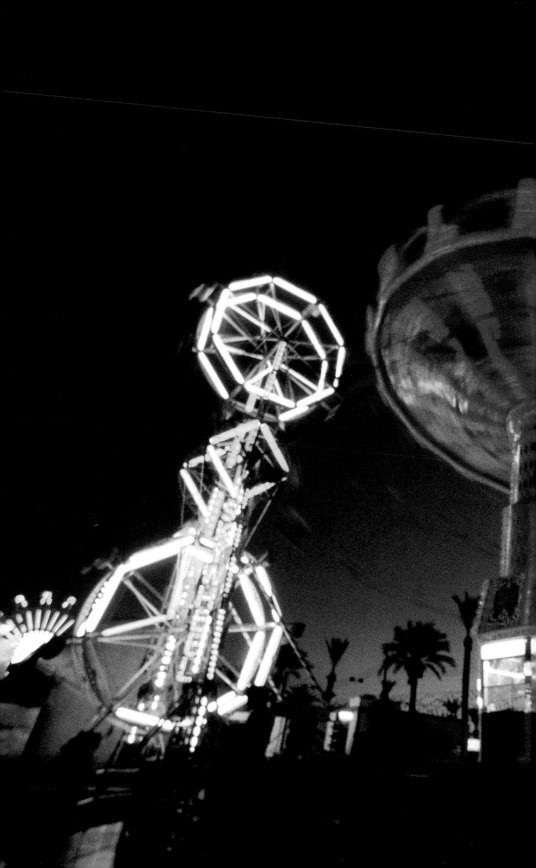

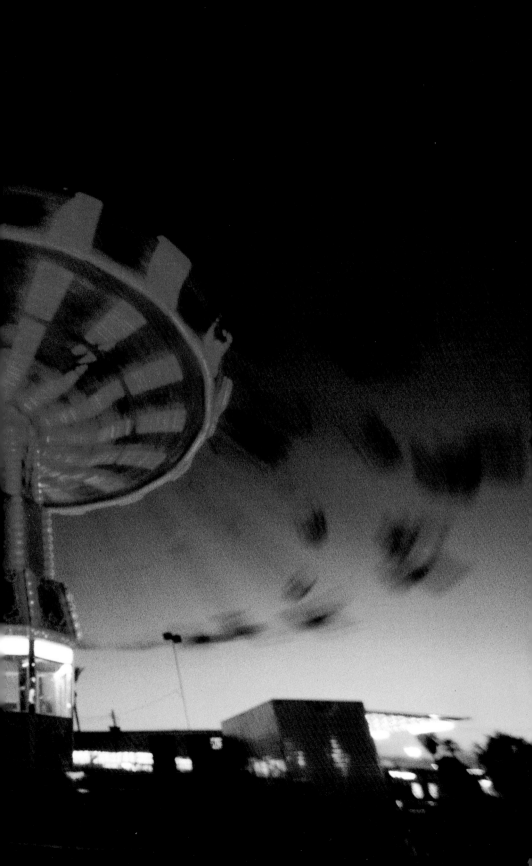

Portfolio

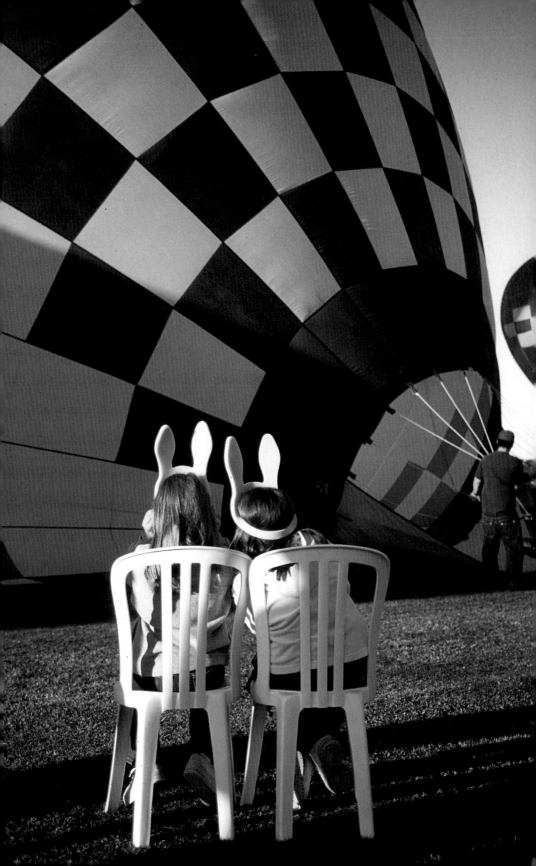

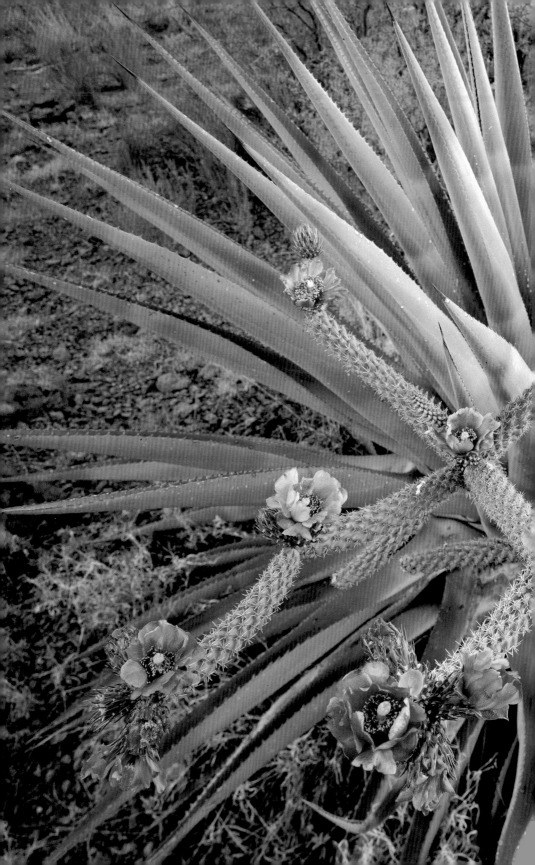

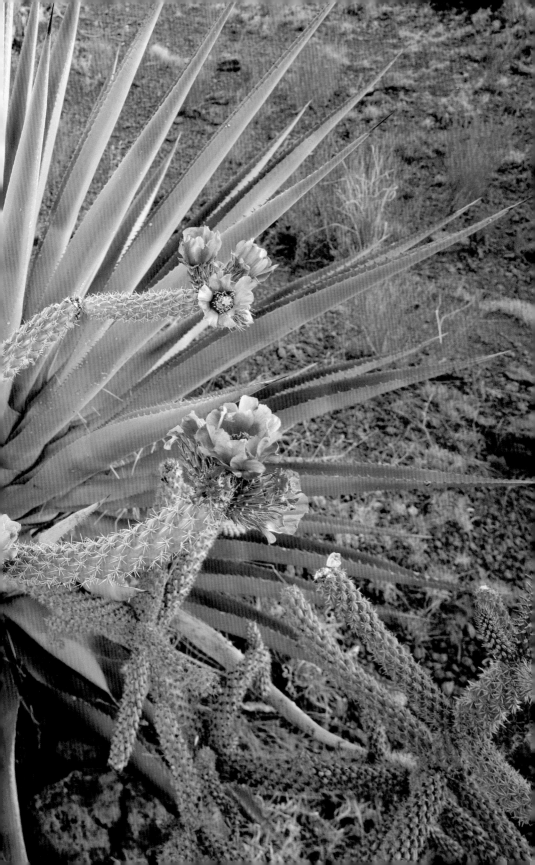

Portfolio

Preceding pages 16–17: Soft light and contrasting tones and textures create a study in pastels. While not a true close-up, this still life of a cane cholla and century plant is a reminder that not every image needs to have a horizon to make it successful.
DAVID MUENCH

Right: The photographer almost crashed his car when he saw this burst of sunlight through the trees on a foggy morning. Dramatic light and the monochromatic blue created a powerful scene and a tricky exposure. PETER ENSENBERGER

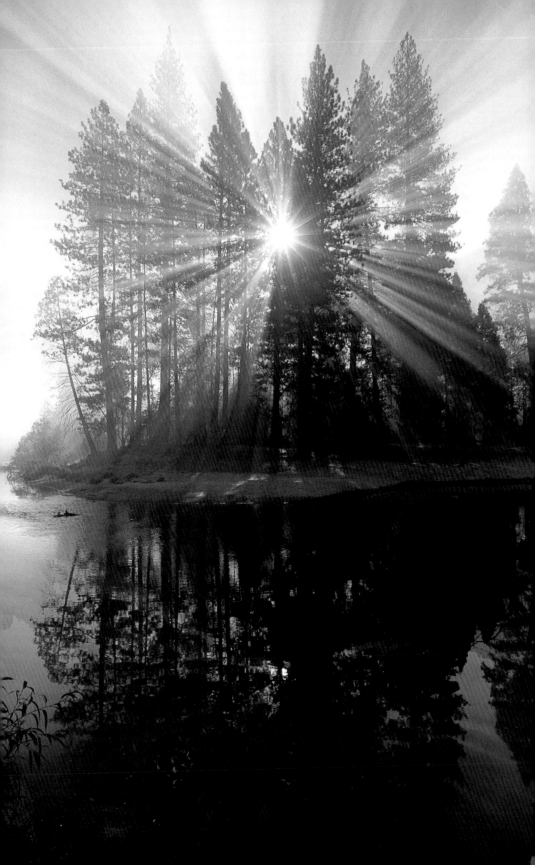

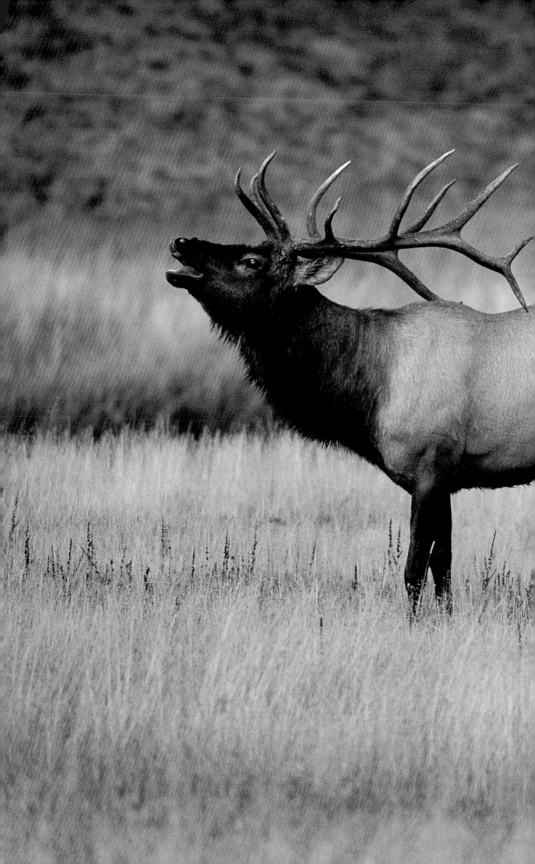

Portfolio

Wildlife (pages 132-145)
Preceding pages 20–21: As summer draws to a close, a male elk opens the lines of mating communication by bugling. Shooting from his car with a 600mm lens steadied with a bean bag, the photographer used Fuji Provia 100 film. TOM VEZO

Travel (pages 174-189)
Right: Teepees line a section of Historic Route 66 in northern Arizona. Getting low and using the hood of an older model blue car to reflect the sky and teepees created an added dimension to the already interesting scene. KERRICK JAMES

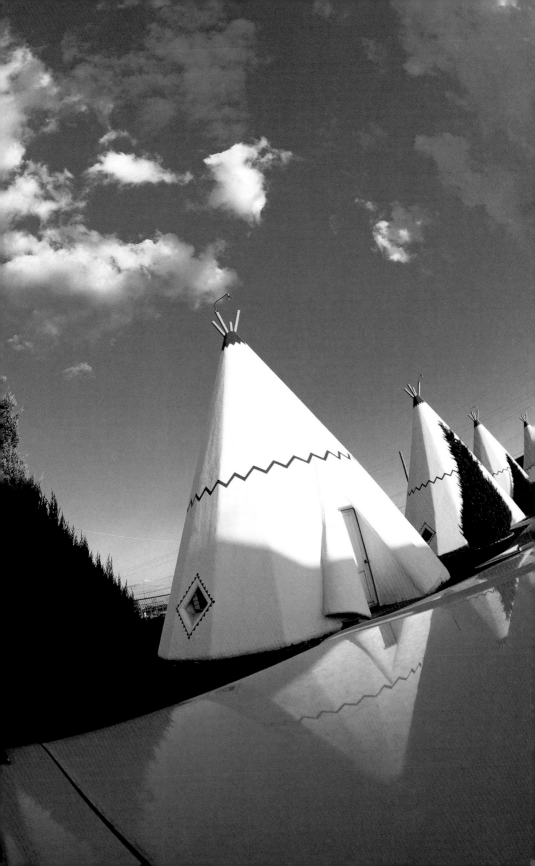

Portfolio

Preceding pages 24–25: While backpacking with a friend on the Tohono O'odham Indian Reservation, John Annerino had to be dragged out of his warm sleeping bag to make this spectacular sunrise image. Sometimes sacrificing a little sleep is a worthwhile investment. JOHN ANNERINO

Right: A brilliant rainbow arcs into Giants Thumb during a summer "monsoon" cloudburst in Sedona. Paying attention to changing weather conditions can provide wonderfully surprising results for a photographer. The leading and trailing edges of storms create atmospheric conditions that add dimension and texture to photographs. LARRY LINDAHL

The Basics

Digital
Photography

Using a narrow depth of field allows some
of these Mexican goldpoppies to be in
sharp focus and others to be somewhat
blurred. The image was made with a long
telephoto lens and a large aperture. (See
Page 78.) PETER ENSENBERGER

by Jack Kurtz

BACK IN THE DARK AGES of photography, say around 1995–96, digital equipment was considered "good enough" in some circles, even though it could not match film for producing quality images. Digital just wasn't "there" yet.

That was then, now digital photography has gone mainstream. Many pros, even the foot-draggers who wouldn't dream of giving up Velvia, haven't shot film in years.

In the United States and Europe, digital cameras outsell film by a wide margin. Sales by film manufacturers, notably Kodak and Ilford, have fallen. Photographers now argue about the merits of Lexar or SanDisk memory cards with the same passion they expressed for Kodak Ektachrome vs. Fuji Velvia. Photographers now talk about megapixels and CCDs instead of ISO and film type. Here are the advantages of digital:

Instant Corrections

After you make a photo you check it out on the liquid crystal display (LCD) on the back of the camera. Your subject's eyes are closed? No problem. Shoot again. Cropped off your mother-in-law's forehead? No excuses now. Shoot it again. Overexposed or underexposed the image? Check your LCD, make your corrections, and move on.

People are always portrayed best in soft light, whether the subject is posed or spontaneous. Either way, be aware of the background. Shown here is Jones Benally just before he competes in a World Championship Hoop Dance competition. Shot with a 200mm lens at f/2.8, the image was intended to have a blurred background.
JEFF KIDA

Digital photography allows you to become your own instructor. Using the LCD on the camera or your computer, you can see what you've done wrong and fix it. You can experiment freely, blending light sources and using a very slow shutter speed to create a mood, and not worry about wasting film. You're not paying for film, so go wild. If the photo is bad, simply delete it on the computer; no one, not even you, need to be reminded of the mistake. If it's interesting, but not quite there, archive the photo on your computer and come back to it in a few weeks to see what went wrong and what you did right.

Of course, you can use the instant feedback features and LCD to make sure your exposure is correct before making the picture. The LCD works for a quick check of the image, but a lot of variables—including viewing angle, ambient light, and brightness of the LCD—can affect how the image looks on screen.

However, don't use the LCD as the sole judge of exposure.

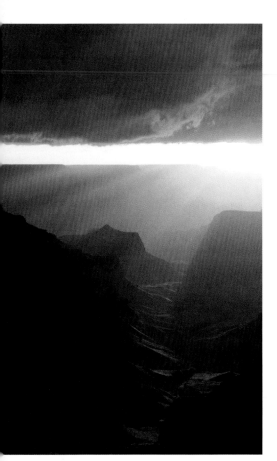

Digital cameras display what's called a histogram, a graphical representation of the exposure. A histogram usually looks like a graphic portrayal of a mountain range or mesa. The far left end of the histogram represents the shadow (or dark) areas of the photo, and the far right side represents the highlight (or brighter) areas.

A "good" histogram evenly spreads across the frame from left to right. The histogram from a dark or underexposed photo will be squeezed into the left side. Conversely, an overly bright or overexposed photo will be squeezed into the right side.

Remember to take the composition of your photo into account when you view a histogram.

A photo of a snowy scene in the mountains, with beautiful skies and puffy clouds, is going to have more highlights, and you can expect the histogram to be weighted heavily to the right. Conversely, a scene made up of mostly dark tones, perhaps an elk in the woods, is going have more shadow detail and the histogram will be weighted to the left.

The important thing is to make sure the histogram is not piled up against one side or the other. Always judge your exposures using the histogram (see chart on Page 36). Never judge them by just looking at your subject on the LCD.

A rapidly moving storm along the North Rim of the Grand Canyon created a myriad of lighting opportunities for Christine Keith. The original frame, above, included some clouds and sky. Later reviewing the image on her computer, Chris thought a stronger image could be made by cropping out the clear band of the sky, right.
CHRISTINE KEITH

Easy Photo Sharing

Back in the film days, you would drop off rolls at a local lab, wait from an hour to a day, look at the prints, have reprints made, and drop them in the mail. A week or more after the family reunion, if everything went well, your mom would be getting the family snaps. If things didn't go well, she'd get the prints just in time for next year's reunion. With digital, you can make the photo, pop the memory card into the computer (or connect the camera to a computer), and e-mail mom the photo, and it can all be done in a matter of minutes.

She'll have the photos in her e-mail inbox before she gets home. If mom lives in an analog world, you can make prints—really good ones—from your home printer in minutes, while she's waiting for dessert. And she'll still have the photos before she leaves for home.

You can create Web pages instantly and the whole World Wide Web can see the photos. Using either iPhoto (for the Mac) or Picasa (for PCs, a free down-

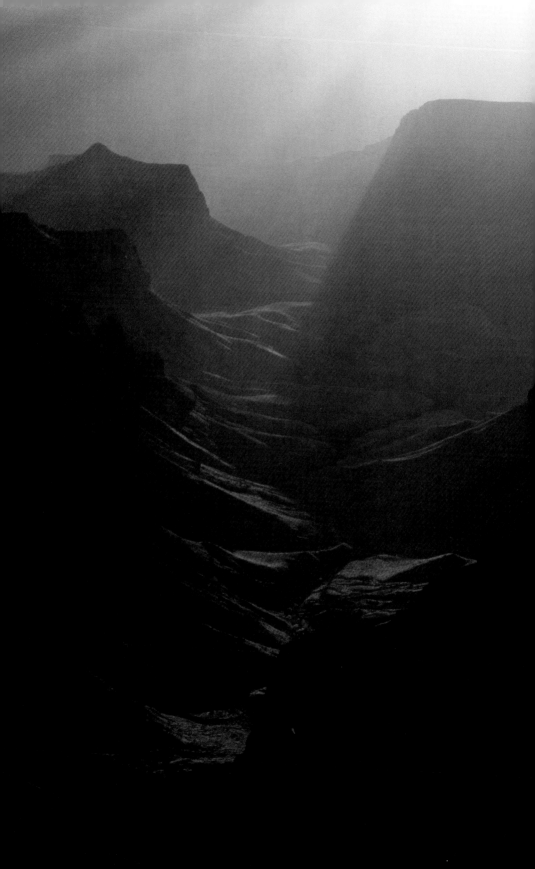

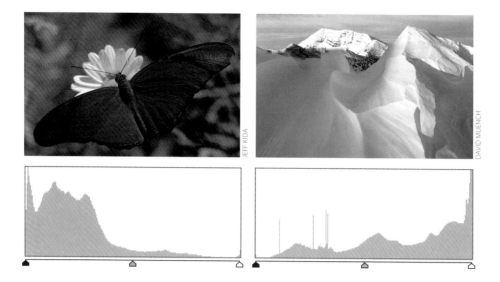

Histograms graphically display exposure data of a digital-photograph. The butterfly image displays mostly darker tones, therefore the graph is primarily weighted to the left. In the snow scene, displaying mostly highlights, the information shows on the right.

loadable program from Google) you can create and upload nearly instant photo galleries on the World Wide Web (a separate Internet account is required).

Color Balancing

The mystery of color balancing your photos becomes manageable and easy to understand.

Tungsten lights, such as home light bulbs, are very orange. Fluorescent lights have a greenish cast. The color of light at sunrise is different from that at midday, which is different from sunset's. Shade produces a different color cast than clouds.

With film, color correction required that you carry different types of film to use as conditions changed, or that you carry a stack of small filters and a color temperature meter.

Now, you set the digital camera's white balance (WB) on Auto and the camera will assess the light in the instant before the exposure and pick what it thinks is the best white balance. The camera's choice normally is close to being correct. The more experienced you become, the more control you can assert over the camera. And finally, you can always fix the color balance after you are done shooting by using computer software such as Photoshop Elements, iPhoto, or Picasa.

Instant ISO Adjustment

Back in film days, if your child's athletic event started at 3 P.M. in bright afternoon sun, you loaded the family camera with ISO 100 film. A storm rolled in, clouds blotted out the sun, and 100 speed film wasn't cutting it, so you changed to a roll of 400. Then the game went into overtime, and it got dark. Now the 400 wasn't fast enough, so you switched to 800 or 1,600 ISO film to keep shooting.

With digital, you can manually change the ISO sensitivity from photo to photo and just keep shooting. Or, with many cameras, you can let the Auto feature make the change.

A Camera for Every Need

The choices you face when shopping for a digital camera today can boggle the mind, but don't despair. We'll guide you in making a choice to suit your photo interests.

To begin, almost any of the high-end digital point-and-shoots, which today cost around $450, has less noise (digital grain) and generally makes better photos than did a $25,000 digital in 1997.

Broadly speaking, there are three types of consumer digital cameras.
• Mini digitals and point-and-shoots, such as the Canon Elph series, Olympus Stylus Series, or Nikon Coolpix cameras;
• "Bridge" cameras, such as the Canon PowerShot Pro 1 and "G" series or the Olympus 8080, which fill the gap between point-and-shoots and the third type;
• Single lens reflex, the well known SLR cameras and digital SLR (dSLR) cameras.

As more dSLR cameras have become available, prices for them have dropped, and bridge cameras have become less common. Many have been discontinued, others have been "dumbed down" because camera manufacturers are more interested in selling dSLRs and the accessories people inevitably buy to go with them than the all-in-one bridge cameras. This is a shame because many bridge cameras made ideal all-in-one packages for most people.

A Palette of Terms

We've already kicked around acronyms and terms that, if you're not into digital photography, might be confusing. When you start shopping for a camera, you're going to be hearing these terms, so this is probably good place to explain them.

Sensors: Your digital camera makes images using a sensor. This is usually a CCD (Charge Coupled Device) although some manufacturers, notably Canon, use CMOS (Complementary Metal–Oxide–Semiconductor) in some cameras. Unless you're a world-class nerd, the

White balance, usually known by its initials WB, is a control introduced by digital cameras. Different light sources—daylight, florescent, or tungsten—have different "color temperatures" for which the human eye compensates. More often than not, setting a camera to "A" or "AWB" will make the corrections necessary to reproduce colors as we see them.

Daylight

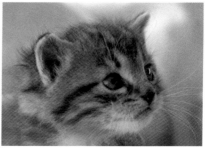
Florescent

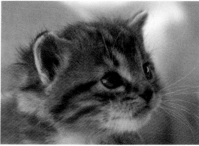
Tungsten

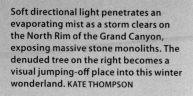

Soft directional light penetrates an evaporating mist as a storm clears on the North Rim of the Grand Canyon, exposing massive stone monoliths. The denuded tree on the right becomes a visual jumping-off place into this winter wonderland. KATE THOMPSON

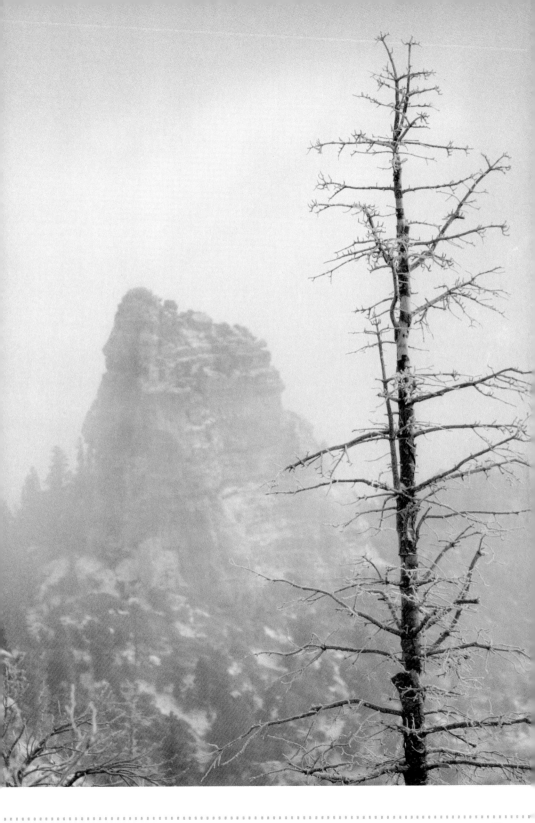

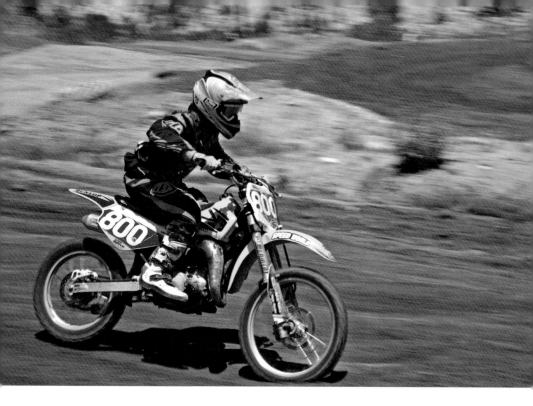

By using a slow-enough shutter speed and panning with the motocross rider's movement, the photographer was able to blur the background to heighten the sense of speed. Shot with a Canon 5D, 1/200 second at f/22. The ISO was 400. COLLEEN MINIUK-SPERRY

technical differences aren't important because both do essentially the same thing. An electrical current turns them on and they record a photo. However, each type of sensor has advantages over the other.

Pixel for pixel, CMOS sensors generate less noise (digital grain) than CCD sensors. CMOS is more energy efficient than CCDs, so battery life is better in CMOS cameras, and they run cooler than CCD sensors.

On the other hand, CCD sensors are a little sharper, so images made with CMOS sensors generally need to be sharpened a little more in the software on your computer. The sensor is hands down the most expensive part in a digital camera.

Point-and-shoot cameras, even the Canons, all use CCD sensors. Canon's CMOS sensors are used in all of their dSLRs.

Pixels: Then there are megapixels. Pixel is a contraction of PIcture ELement. A pixel is the smallest component of the photo. Mega means million. The PowerShot G7, a high-end Canon point-and-shoot, is 10 megapixels, or 10 million pixels; the EOS 5D is 12.8 megapixels, or almost a whopping 13 million pixels; and the Canon EOS 1Ds Mark III rates at 21.1 megapixels.

Most times, you will hear that more megapixels is better. That is not completely true.

Considering that price rises with pixel count, six megapixels are enough for all but the most critical printing. I have made great looking 13 x 19-inch display prints from six-megapixel files. I think six megapixels are the "sweet spot" for

most consumers. The files are big enough to make nice prints, but they are small enough to be easily archived.

Sensor size: The other thing you will hear when you're shopping has to do with sensor size, which refers to its physical size, not the number of pixels. There are generally three sizes of sensors used in consumer-oriented digital cameras (not including "medium format" digital cameras). Sensors are usually described as:
- 1/2.7", or the size of trimmed pinkie fingernail. Tiny (5.3 x 4.0mm in the 4x3 aspect ratio) and used only in the least expensive, smallest digital cameras.
- 1/1.8" or the size of a trimmed thumbnail. Still really small (7.2 x 5.3mm and in the 4x3 aspect ratio) and the size used in most consumer digital point-and-shoot cameras, whether they are medium-end or high-end.
- APS C, a term left over from the days of APS cameras (a discontinued film format). These are in digital SLR cameras and are 22 x 15mm and shoot in a 3x2 aspect ratio. These sensors are smaller than a piece of 35mm film but use the same aspect ratio.

Canon and Nikon make several dSLRs with "full frame" sensors that are the same size as 35mm film, 24 x 36mm.

And now we learn why more megapixels are not necessarily better. If you take two cameras, say from Canon, each producing 10-megapixel files but having different sensor sizes, the images from the larger sensor will look better. The smaller the number of pixels, the higher the level of noise, which is like digital grain and shows up as brightly colored speckles in the shadow areas of photos. Think of this as being like film formats. The old 110-sized negatives were tiny, and photos from these cameras were not very clear, compared to 35mm. Larger and clearer, 35mm negatives still don't match the breathtaking clarity of slides from 4x5 large-format cameras. That's 4 inches by 5 inches. A piece of 35mm film is 0.94 x 1.4 inches. So images from the point-and-shoots built with smaller sensors (the G7, and any other 1/1.8" sensor) are going to have a lot more noise than a 10-megapixel photo from any digital SLR.

Camera manufacturers are working hard to control the noise coming from the tiny-sensor cameras, but "grain" is unavoidable. Usually the camera makers control the noise by writing noise-removal codes into the camera's firmware and operating software, and the codes are pretty successful. But aggressive noise removal overly smoothes the picture and removes the detail. As a result, some high ISO photos from point-and-shoots look like watercolor paintings because there's so little detail left in them. It's a Faustian bargain.

Shown below are different sensor sizes relative to 35mm film. Larger sensors produce higher quality images. Depending on your photographic needs, sensor size might be an important consideration in choosing a camera.

A small-sensor point-and-shoot always will have more noise than a dSLR. This is something to consider if you are mostly doing nighttime or high ISO photography. At low ISOs, between 64 and 100, these cameras have generally amazing image quality, but most of the small point-and-shoots are suitable only for Web or small (4x6 or so) prints when used at ISOs above 200. Although some of the newer ones can eek out a nice image at ISO 400, that's the limit of

usability, even though the cameras can be set to ISO 1600 or even 3200. Digital SLRs, with their much larger sensor, can go up to ISO 3200 or higher.

LCD screen: Almost all digital cameras have an LCD screen. Some, mostly the entry level point-and-shoots, have only an LCD. You use the LCD for setting up the camera, reviewing and composing photos. When it comes to LCDs, bigger is always better. When you're handling the camera in the store, almost any LCD looks good, but take the camera outside in the Arizona sun and the LCD becomes a lot harder to see. When you are trying out cameras, see if the store will let you step outside to check the usability of the LCD in direct sunlight.

Recording modes: Almost all cameras record images in the JPEG (Joint Photographic Expert Group) format. The JPEG is a near-universal image format that compresses images, allowing you to get more photos on a memory card. Since files are compressed (smaller), they are also easier to work on with your computer and e-mail.

Besides JPEG, many digital cameras record images in what typically is called a RAW mode. RAW is not an acronym for anything. It simply means the image is stored in whatever proprietary format the camera manufacturer has designed. Because RAW files essentially are uncompressed and have all of the data the camera sensor recorded, they are much bigger than JPEGs (the camera throws away about one-third of the image data when it creates a JPEG).

More and more manufacturers are leaving the RAW option off their point-and-shoot cameras and reserving it for their dSLR cameras. RAW offers better image quality at the expense of storage and speed. JPEGs are easier to work with and take up less space on your memory card. JPEGs can be edited with any image-editing program you are likely to encounter, including iPhoto, which comes with every Mac, and Picasa, a free application for Windows from Google. RAW photos require special software, either from the camera manufacturer or from some third party, like Adobe's Photoshop Elements program.

Bells and Whistles

The first time you stand in front of the counter at the local camera store pondering your digital camera purchase is a little bit like going to a car dealer to buy a new car. No matter how much research you've done, how prepared you think you are, it's bewildering. What features do you need? What don't you need?

Image stabilization (IS): We've talked about megapixels, the sensor, and the LCD. They form the basis of the camera. Then there are the bells and whistles. Some of the bells and whistles are surprisingly useful. The most essential bell (or whistle) is Image Stabilization (sometimes called optical stabilization or vibration reduction), and it does exactly what its name implies: It reduces camera shake, helping you make sharper photos.

Image Stabilization was pioneered by Canon for large, professional-level lenses. Now it has trickled down to point-and-shoot cameras. Other companies have developed their own versions of Image Stabilization.

"Sweet light" extends beyond sunset. Architectural photographers have long since discovered that balancing man-made light with the transitional light of dawn and dusk—the sweet light—produces beautiful results. CHRISTINE KEITH

The way it works is nearly as amazing as its effectiveness. Sensors (not the same sensor that makes the photograph) in the camera can tell that the camera is shaking or vibrating and then sets about to shake or vibrate the sensor in the opposite directions. The net result is that the sensor is stabilized and the picture is sharp. It works like a gyroscope, which is used to stabilize high-tech gear in ships and airplanes.

I think IS is absolutely essential technology. It works really well on point-and-shoots but comes into its own in dSLR cameras.

When choosing to shoot JPEGs, use the largest file size and the highest quality available on your camera. Even though fewer images fit on a memory or storage card, the quality is more than worth the extra space needed to store them.

Some camera companies are cheating with their image stabilization. They program their point-and-shoot cameras to automatically raise the ISO until the shutter speed is above 1/60 second, considered the slowest speed at which a camera can be handheld without blurring the image. This technique is not true image stabilization and leads to lots of noise (digital grain) in the photo. Make sure your camera uses true image stabilization and avoid the cameras that simply raise the ISO.

Dust removal: Another refinement deals with dust, which long has been the bane of serious photographers. Back when we were printing by hand, it used to get on negatives, and no matter how strenuously we'd clean the negatives we would end up with spots we had to tone out after the prints dried. With digital SLRs, dust settles on the sensor and shows up as irregularly shaped black spots. It is more apparent with wide-angle lenses (because they have more depth of field) and more apparent at small apertures (again, the depth of field thing). It is a real issue for landscape photographers.

Olympus introduced a dust-removal system for the dSLR cameras when it came out with the E1, a professional-level dSLR. It worked pretty well, and it wasn't long before others started to copy it. Now Nikon, Canon, Sony, and Pentax offer dust removal for their dSLR cameras.

Some, like Olympus, work by actually shaking the photographic sensor when you start up the camera.

Others, like Nikon, use software to remove dust. The dust spots on the sensor are mapped by the camera and then when you open the image in the computer, the software automatically removes the dust. This has one huge drawback. You must use the Nikon software to acquire your photos. If your workflow is built around Photoshop, Lightroom, Aperture, or any other third-party software you won't be able to use Nikon's dust removal.

Still others, like Canon, use both. The sensor is cleaned on startup, and then the remaining dust is mapped for later removal. But again, like Nikon, you have to use the Canon software to take advantage of the dust mapping (the sensor cleaning works regardless of the software you use).

Dust is an issue if you use a dSLR because when you change lenses you expose the sensor to the elements, including dust flying around. Dust control is

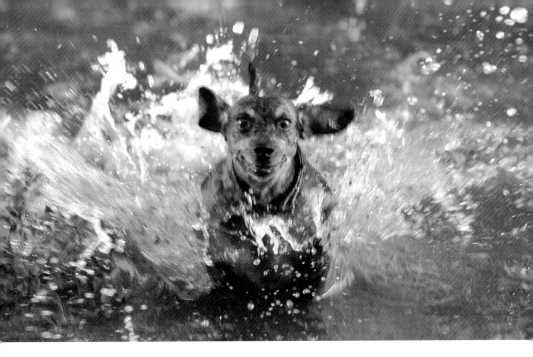

not an issue for point-and-shoot users because those cameras are sealed.

However, dust control isn't the only advantage point-and-shoots have over dSLR cameras.

Video: Almost all of the digital point-and-shoots also shoot video (none of the digital SLR cameras can shoot video). Some shoot pretty good video, some barely better than cell phone video. But none is a true replacement for a real video camera.

For one thing, the sound capture on digital still cameras is not very good. So, unless you're shooting silent movies, you are going to be disappointed. For another, many of the features on true video cameras (zooming while shooting) are not available on most digital cameras. And finally, many digital still cameras limit their video capture based on the camera's internal memory, ability to process the data, and the size and speed of memory cards.

Memory cards: There are a lot of memorycard formats in the marketplace. Most dSLRs use Compact Flash (CF). Most point-and-shoots and some dSLRs use Secure Digital (SD). SD is a newer format that is becoming very popular. SD cards are much smaller than CF, but in practical use there is no difference. The cards are not interchangeable, though. Olympus and Fuji have developed their own card format called xD, and Sony (and only Sony) has the Memory Stick.

The memory card a camera uses would be the last criterium I would use in deciding what camera to purchase. They are equally reliable. But if you have more than one camera, you probably want to make sure all of them use the same type of memory, otherwise keeping track of different cards could be difficult.

As amazing as the technology has become, many compact digitals suffer from "shutter lag", which is the delay that occurs when the built-in computer assesses proper exposure and focus. If your joy is shooting things that move, and you're looking to buy, think about a dSLR. This image was shot at 1/250 second at f/2.8.
JEFF KIDA

The larger digital cameras and the dSLRs handle much like their film counterparts. In the spirit of all that is old is new again, some cameras, like the Canon G7, have gone "retro" with buttons and dials intentionally mimicking film cameras of 20 years ago. But most of the small digital cameras rely on contextual "buttons" on their LCDs. You do pretty much everything except turn the camera on, make the picture, and replay the photos using controls on the LCD. This arrangement helps streamline the physical design of the camera, but it can be hard to make changes on the fly. This might be a generational thing. Younger photographers will find it easier to navigate the LCD screens than older users will.

Also, if you wear reading glasses, you may find it hard to use the LCD. It's not that the screens are too small; it's that your arms are too short to hold the camera far enough from your face to see and use the screen.

Doing research on the Internet or with a book is a great way to check out the specifications of a digital camera; but cameras can be highly personal, and all the research in the world is no substitute for actually trying it out. Experience the sensation of holding it and trying to navigate the controls. Before buying, place the models you are considering side by side to compare sizes. Try the LCD. Can you actually see it? Do the buttons and controls fall where you expect them to? How are the ergonomics of the camera? Is the shutter lag acceptable?

If you already have experience with one brand of camera, you may find that experience helpful and choose to stay with that brand. There certainly is a family resemblance to cameras. Canon point-and-shoots may differ considerably from their dSLRs, but there are still similarities within the family that will probably make it easier to move from their point-and-shoot to their dSLR. The same holds for Nikon and Olympus cameras.

The biggest advantage to the very small, inexpensive digital cameras is that they are tiny and cheap. Many fit into a shirt pocket. Most do not have an optical viewfinder. Instead, they use the LCD on the camera back for framing photos and setting up the camera. If you are not comfortable using the LCD, you will find it very hard to use.

Within their limits, the image quality of tiny cameras is quite good. Some examples of these tiny cameras are the Canon Elph series, the Olympus FE series, and the Nikon Coolpix S and L series. These are point-and-shoots in the truest sense of the term. They offer very limited manual control and have weak, built-in flashes.

Memory cards come in many configurations now with greater amounts of storage capacity. Carry at least two in the field because occasionally they can fail or become corrupted. Shown here is a memory card reader designed to read different types of cards.

Some, like those from Kodak, come with (or offer as an extra-cost option) docking stations that are permanently attached to the computer, via a USB port. Drop the camera onto the docking station and it automatically downloads images to the computer.

Some manufacturers are incorporating WiFi and Bluetooth, the same wireless networking protocols many computers have. With these cameras you don't even need a cable to transfer your photos to the computer. Just hit the send button, and they fly to their home on your hard drive.

Virtually all compact digital cameras are menu driven, so using the LCD becomes second nature. A bigger LCD screen will make a photographer's life in the field much easier.

Advanced point-and-shoot cameras, like the Canon G7, Nikon Coolpix P5000, and Olympus SP series, are quite a bit bigger, but most will still fit into a coat or cargo-pants pocket. They usually offer more manual control and some have a "hot shoe" so you can use a larger flash, most times the same flash you have for your digital SLR. They generally have better lenses and are capable of professional results under the right circumstances. They have enough features and quality that people who think they are serious about photography can buy them and grow into them as their skills improve; yet, they are easy enough to use for weekend snappers to make nice pictures without thinking about what they are doing.

The two biggest disadvantages to the point-and-shoot cameras are that they produce a lot of noise at high ISO because their sensors are so small, and they have almost intolerable "shutter lag."

Shutter lag is the time between the instant you press the shutter button and the camera actually makes the photo. With point-and-shoots the lag can be a second or more. This makes it all but unusable for wildlife and sports. Even for the point-and-shoots that have the extended zoom range, and all of the major manufacturers make point-and-shoots that zoom out to 350mm or 400mm (35mm equivalent). So the lens can do the job but shutter lag will prevent consistent success.

Digital Single Lens Reflex (dSLR) cameras are just like their film forebears. They are true system cameras with interchangeable lenses, a variety of flashes and accessory battery grips. They offer serious photographers the most flexibility and make the clearest photos of any of the digital cameras. Although they have come down dramatically in price in recent years, they are still the most expensive digital cameras. The image quality from the current 8 and 10-megapixel cameras rival what 35mm file does under all but the most critical processing and scanning can achieve. You can get a good entry-level dSLR with two lens kits (wide-angle, normal zoom, and telephoto zoom) from reputable manufacturers (Nikon, Olympus, Canon) for under $1,000. If you are serious about photography and want to grow into landscape, birds and wildlife, and more advanced family photos like youth sports, it is hard to equal these kits.

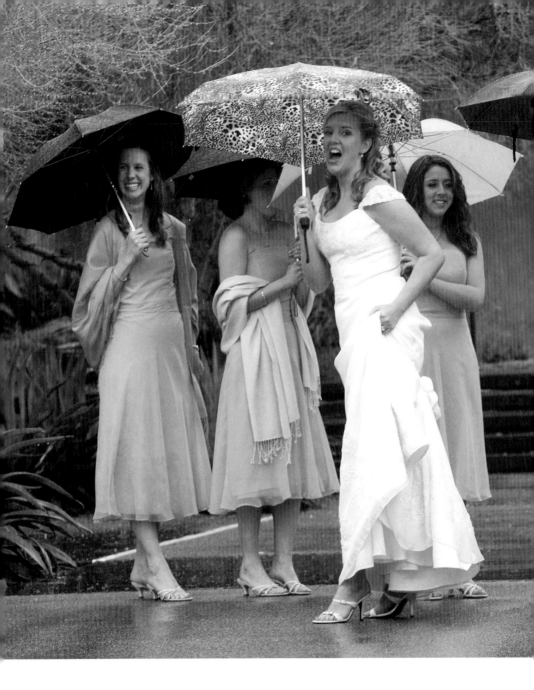

The Setup

The natural inclination is to rush out and make some photos when you get your new camera home. But don't. Take a deep breath, open the box, sit down, and read the manual. Digital isn't your grandpa's Box Brownie.

Most digital cameras, except for the least expensive and lowest resolution ones, offer a plethora of setup options. If you are using a digital point-and-

Searching for interesting weather photos on her day off, the photographer happened onto a wedding party with members attempting to make photographs during a rare Phoenix rain shower. Keeping her distance to allow privacy, she used a telephoto lens and perfect timing to capture a wonderful moment at the Desert Botanical Garden. CHRISTINE KEITH

shoot, you probably are limited to shooting JPEGs. Before you do anything else you will want to set the resolution and level of JPEG compression.

I think this is easy. Set it up for the highest resolution and lowest JPEG compression (largest size, fewest number of photos on the memory card). Most digital cameras offer multiple levels of resolution and JPEG compression. Usually three. So an 8-megapixel camera may offer image storage at 8, 6, and 4 mega-

pixels and compression at superfine, fine, and normal. You can get a lot more, as many 10 times more, photos on a card if you set the camera to the lower resolution and most compression. But it's a false economy and here's why.

You can always make a large, high-resolution photo smaller, but there is a limit on how much larger you can make a small, low-resolution photo. If you enlarge the photo too much, you start to see individual pixels instead of detail. This is called pixelization, and it's a bad thing. It is roughly analogous to taking an extra-small shirt and trying to fit on a NFL lineman. It stretches, rips, and falls apart. That's what will happen to your photos.

You may want to set the camera to the lowest resolution because you think you won't need the photo you're about to make; but if you forget to set it back to high resolution when you go to the Grand Canyon and see a bull elk pause at sunset near Mather Point, you'll have lost a rare moment.

JPEG compression differs from low resolution, but setting it too high can have the same effect. JPEG is considered "lossy" compression. This is not an acronym; it simply means that when the photo is compressed into a JPEG, some data is thrown away or lost. The more compression, the more lost data and the photo starts to lose detail. Furthermore, every time you open and save a JPEG you throw away some data. Throwing away all this data eventually takes a toll on your photos, and you see artifacting, the result of too much compression. Artifacting looks like pixelization, and its net effect is the same.

RAW vs. JPEG

If you are using a digital Single Lens Reflex camera, you have the option of shooting RAW files. RAW vs. JPEG is as much a hot button topic as Mac vs. Windows or Coke vs. Pepsi.

Proponents of RAW files will tell you they make the best quality images because they capture all of the data that passed through your camera's sensor, and that YOU, the photographer, retain control over the final look of your photos.

Proponents of JPEGs say that it's not worth the extra time it takes to process RAW files on the computer and the extra storage needed to handle the RAW files (which are two to five times bigger than JPEGs).

Both sides are right. To a point. If your exposures are dead on and your color balance spot on, you can get pretty much the same quality out of RAW files and JPEGs.

With RAW files it is relatively easy to recover "blown" or badly overexposed highlights. Incorrect color balance can be fixed with one click of the computer mouse.

With JPEGs, blown highlights are gone. They can be made darker, but they are gray with no detail. Color balance can be adjusted with a series of steps, but the result frequently ends up with undesirable color shifts in parts of the photo.

If you are using a point-and-shoot camera that doesn't have the flexibility of shooting RAW, your choice is made for you. If you are using a dSLR, you should at least experiment with shooting RAW to see if it's for you.

Photographing action and sporting events often involves using longer telephoto lenses and shooting at higher shutter speeds in order to "freeze" motion. Adam Myerson leads the pack through a corner at a criterium race held in Globe. The ISO was 100, the lens was a 285mm, and the shutter speed was 1/500 second. COLLEEN MINIUK-SPERRY

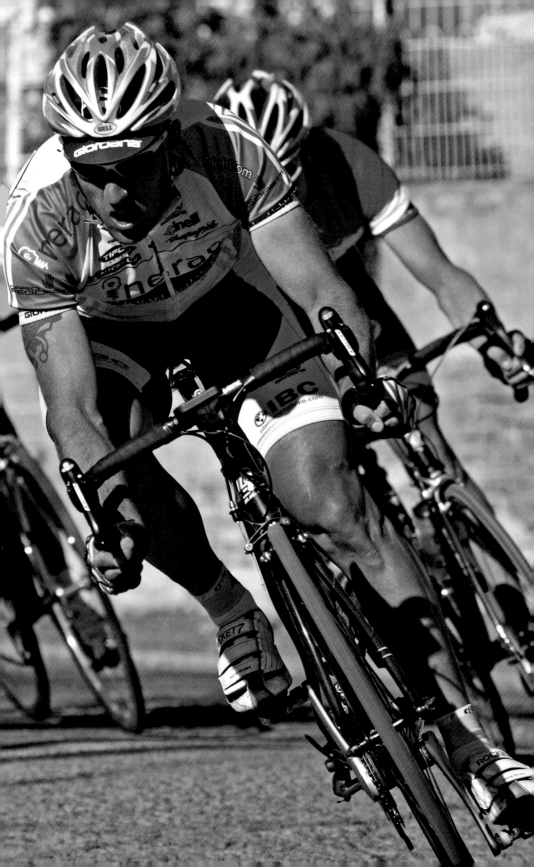

The ability to choose different resolutions in a digital camera menu is now commonplace. Whenever possible, choose the highest resolution available, it's better to have more information to start with. The photo, above left, was shot at the lowest resolution on a 6-megapixel camera. When enlarged, you can see artifacts and pixelization.

More on ISO

Remember that one of the advantages of digital photography is that you can set the ISO on the fly, depending on the light you are working in. Lower ISO settings (64, 80, 100) require the most light but have the best image quality. As a rule of thumb you should try to use the lowest ISO possible, especially with point-and-shoot cameras. Noise increases quickly at medium ISO (200 with a point-and-shoot) and image quality degrades with the increased noise, making high ISO photography with a point-and-shoot very frustrating. Frustration increases if you are printing your photos (or having them printed) for display and making large prints (8 x 10 and larger). If you are just making small prints or putting the photos on the Web, you can use the medium ISOs.

The situation is not so dire if you are using a dSLR. Because their sensors are larger, their pixels are larger, and they generate less noise. You can easily go up to ISO 800 with a dSLR. Some cameras, notably Canon's, (because of the CMOS sensors) have extraordinarily low noise, and you can get excellent results at ISO 1600 and usable results at 3200.

Contrast and Sharpening

Most digital cameras allow you to set how much contrast and sharpening is applied to the photo. Contrast is easy to understand; it is the difference between the lightest and darkest parts of the photo. Higher-contrast photos have brighter whites and darker blacks.

How much contrast you apply depends on how much processing you plan to do with photos in Photoshop or other editing software. If your workflow is to tweak and modify your photos in the computer, you should set a medium to lower amount of contrast. One of the problems with JPEGs is that once data is gone it is really gone. Set your contrast level too high in the camera and you run the very real risk of "clipping" the highlights, so what could be blue sky with puffy white clouds becomes a blue sky with clumps of white in it. Remember

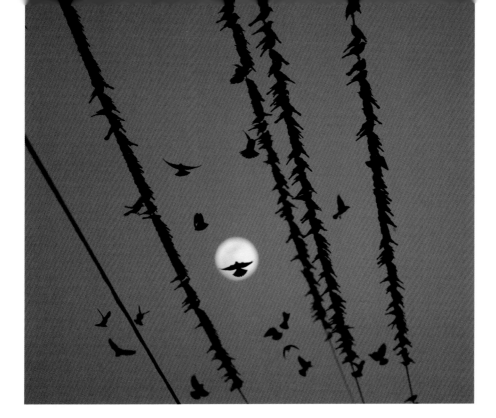

that it is almost impossible to recover lost highlights from a JPEG. If you are not going to tweak the photo after you shoot it, you can set the contrast up a notch or two to get a punchier photo.

The other variable is sharpening. You can either sharpen your photo in camera or afterwards in your editing software. Sharpening sounds cool—who doesn't like sharp photos? But it is a little bit of a misnomer. It does not take an out-of-focus picture and miraculously make it in focus. What sharpening really does is restore whatever sharpness is already there.

Because of the mechanics of sensor design, digital photos always look a little softer than they really are. Almost all digital photos can be improved with some sharpening. When software sharpens a photo, it looks for an edge and then bumps up the contrast along the edge. So it doesn't have much effect on a clear blue sky, but dramatic affect on something with a lot of texture, like a brick wall. Over-sharpening can wreck a picture. Sharpening halos makes edges look artificial and magnifies the noise. Sharpening can always be added to a photo, but once applied it cannot be undone. So don't go crazy.

You can set various levels of sharpening in camera, but the problem with in-camera sharpening is that it's an all or nothing proposition. It needs to be used carefully.

If you plan to tweak the photo with editing software after you make it, you should set minimal in-camera sharpening and work on the photo in your computer. If you are not going to tweak the photo in software, you can set sharpen-

After finishing an assignment covering bird-watchers close to Tucson, the photographer noticed a large number of Brewers blackbirds on nearby telephone wires. With a full moon rising, she positioned herself so the moon was framed between the wires. Timing her shots and using the LCD on the back of the camera, she kept shooting until she got what she wanted.
CHRISTINE KEITH

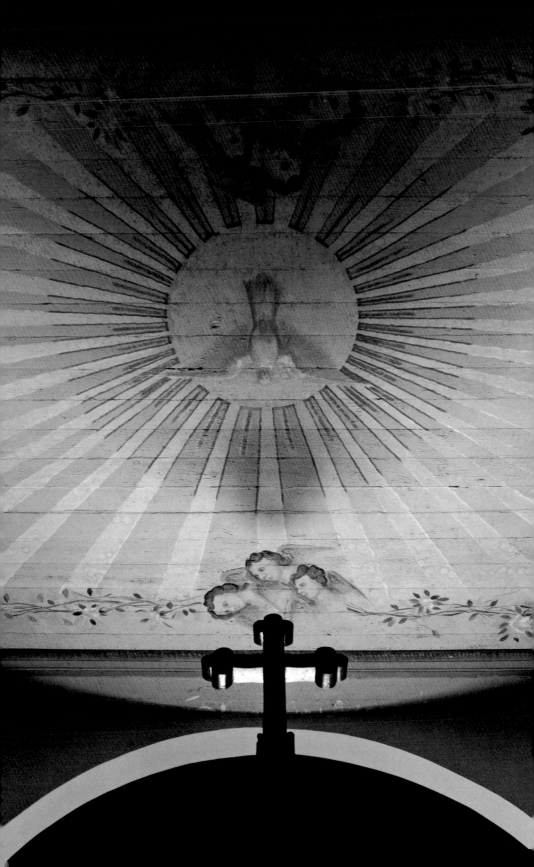

ing to +1. (Most cameras use numeric scales for sharpening and contrast from 3 or 2 to +2 or +3. It's not very exact, but it is simple.)

White Balance

The final thing to consider is the white balance. This is the color balance of the photo. Color temperature is measured in degrees Kelvin. "Normal" daylight is about 5500 degrees Kelvin, a candle flame is about 2000 Kelvin, an indoor tungsten bulb is 2800 Kelvin, fluorescent lights about 3800, cloudy skies about 6500, and so on.

All digital cameras have an automatic white-balance function. In addition, most digital cameras allow you to set the white balance manually. The color temperature is usually represented by a little icon—the sun for daylight, a light bulb for tungsten lights, a fluorescent tube for fluorescent lights, etc. It is a simple matter to select the icon that matches your light source.

If you want to have some fun, you can intentionally select the "wrong" one and see what it does to your photo. For example, set the white balance to cloudy when you are shooting in regular daylight. This will "warm" the picture considerably (make it more orange/yellow). The manufacturers have worked hard to improve the auto white balance of their cameras and for the most part you can leave the camera in AWB until you are comfortable experimenting.

Now What?

You're probably going to discover that you're shooting more pictures than ever with a digital camera. You're not going to keep all of the photos you make, but you will want to keep many of them. The easiest thing to do is simply dump them on your computer hard drive. Bad idea. You won't be able to find them two weeks after you dump them.

Archive is the fancy way of saying store and catalog. Thanks to free software, archiving photos and designing a digital workflow has never been easier.

Workflow can be broken down to two components: browsing and editing. Browsing is just that, it's looking at and sorting your photos in your software packages. Editing is actually working on the photo, making corrections to the image, cropping, etc. Consumers have never had it so good since both Mac and Windows users have free software available that both browses and edits and does more.

Most of the cameras come with their own software that you can get started with, and for occasional use the manufacturer software is okay. But moving a library from one software package to another can be tedious, and the camera-supplied software isn't really up to the task of cataloging your work. I suggest you pick your software package before you even start downloading photos.

Macintosh users have iPhoto, which comes free with every new Mac. With iPhoto you can sort and keyword your photos, edit them, build Web sites and online galleries (a separate Internet account is required), create custom greeting cards and books, and order prints. It works really well. It stores photos in a library and allows you to move them into albums. A photo can be stored in more than one album. The iPhoto software ties into the other Apple applications so

Indirect light washes over a fresco at the mission in Magdalena, Mexico. The homage defines both artwork and textures of the poured concrete substrate. Shot with a digital camera, the technology allows a photographer to make adjustments for color variations not always sensitive to the human eye.
JEFF KIDA

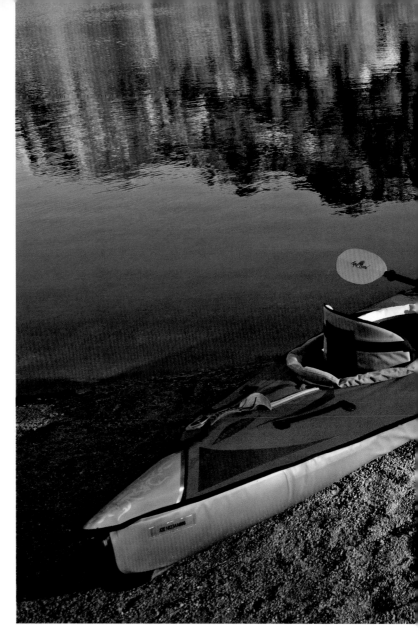

Granite Basin Lake is the perfect setting for this brilliant red kayak. The diagonal position of the vessel leads the viewer's eye into the wind-stirred reflection. Shot with a wide-angle lens at f/11, the focus is sharp throughout the entire image.
COLLEEN MINIUK-SPERRY

your iPhoto library is available when you are working in Pages (Apple's word processor/desktop publishing program), iWeb (their Web design program), and iMovie and Final Cut (Apple's video editing programs). This dramatically simplifies your workflow and allows you to work with your photos regardless of what program you're in.

Windows users have a certain level of parity with Picasa from Google (the Internet search giant). Picasa allows you to do many of the same things iPhoto does. Picasa does not share its library with other Windows programs the same

way iPhoto shares with other Apple applications, but it does most of the other things and is an excellent choice for Windows users.

Both iPhoto and Picasa have rudimentary photo-editing tools that allow you to adjust brightness, contrast, sharpness, and color balance, to remove red eye and crop. Both programs also offer limited support for converting RAW camera files to JPEG.

Either iPhoto or Picasa offers more than enough to keep aspiring photographers satisfied until they make the leap to high-end editing programs.

The next step up in photo-editing software is Adobe Photoshop Elements. Available for either Mac or Windows, Elements is the very little brother to Adobe Photoshop, the 800-pound gorilla of image-editing applications. It does most of the things Photoshop does, and it does them a little simpler (Photoshop offers better support for offset printing). Elements and Photoshop use the same RAW converter, Adobe Camera RAW, so you can easily acquire and edit your RAW files once you start shooting RAW. If you find yourself limited by iPhoto or Picasa, Photoshop Elements is a good choice.

There are three choices for really serious photographers: Adobe Photoshop, Adobe Photoshop Lightroom, and Apple's Aperture, which is Macintosh only.

Photoshop needs no introduction. It is the gold standard of image-editing software but it is very expensive and complicated. It costs more than all but the most expensive digital cameras and takes years to master.

The other two products, Lightroom and Aperture are relatively new and very intriguing.

They are more like iPhoto on steroids than Photoshop. Both have archive management features, offer a host of editing functions that are more powerful than either iPhoto or Picasa, and allow you to track and manage projects.

Both edit work in a breakthrough way. In the old days, before Lightroom and Aperture, you opened a photo, worked on it, saved your changes, and closed the photo. Once you saved and closed the photo, your changes were committed, there was no going back. With Lightroom and Aperture your photo isn't actually changed. You work on your photos from within the database and your changes are attached to the photo in the database. The photo is exported from the database with your changes but the original file is never touched. This represents a breakthrough in image editing. Lightroom and Aperture require a different workflow than Photoshop does, but if you're starting from scratch, either program is worth a look. Experienced Photoshop users may not like the new workflow, but it's great to have the options.

Lightroom runs on either Macs or Windows, but Aperture is Mac only. Aperture is a little more powerful than Lightroom, but it requires a more powerful computer. If you have a high-end Mac, Aperture is wonderful. If you are using a consumer Mac, like a low-end iMac or MacBook, Lightroom might be a better choice. If you're using Windows, your choice is made for you.

If you tell it to, your Mac will automatically download your memory card into iPhoto (or Lightroom or Aperture). It senses when either the card or a camera is attached and goes to work. Picasa offers similar functionality on a Windows computer.

If you want to download your photos manually, you can turn off the auto download feature.

Connect your memory card or camera to the computer using either

Digital capture is very similar to exposing transparency film. The "dynamic range" actually is quite limited. In this close-up, sunlight is illuminating the top of the flower, while the ground is shadowed. By metering for the sunlit portion, the photographer correctly exposes for the bloom, while the shaded tones are rendered an inky black beyond the ability of the sensor to register much detail. JEFF KIDA

a card reader (about $20 from any consumer electronics store) or a USB cable. I recommend using a card reader. They are faster and allow you, or someone else in the family, to keep using the camera while you're editing. If you have the camera tethered to the computer for editing, no one else can use it for making pictures. It's important to remember that card readers are powered by the computer, but cameras are not. You need to keep freshly charged batteries in the camera if you are editing off of it.

Launch iPhoto or Picasa and start the importing process. The end result is the same either way on a Mac or Windows. Once your images are imported into the programs' libraries you can eject the memory card from the computer.

Now you are ready to browse through your photos. Whether you use iPhoto, Picasa, or the software that came with your camera, your photos will be displayed in an array that looks like the familiar contact sheets of days gone by. After you've selected your photos (different applications have different ways of making selections—some use checkmarks, some use stars, and some use colored labels) you are ready to start working on the photos. You will probably want to adjust the exposure, the contrast, and the sharpness, and perhaps the color balance.

Making adjustments is where the new photo-editing processes used by iPhoto, Picasa, Lightroom, and Aperture really shine. Remember that just a couple of years ago, when you opened and worked on a JPEG you always ran the risk of doing more harm than good, and once you saved your changes you were committed. But Lightroom, Aperture, iPhoto, and Picasa are all nondestructive editors. They do not change or overwrite your original photo. They attach small text files with your changes to the photo. Those changes are applied to the photo when you export it to either another application or your desktop.

If your needs are basic, iPhoto or Picasa will do everything you need. If your needs are more advanced, Lightroom, or Aperture are both wonderful pieces of software.

Gear: Packing Camera Bags

by Jeff Kida

hoosing photo equipment is a very personal decision. Camera to camera, bag to bag, project to project, each of us will select and pack it differently. Shooting close-ups at the botanical garden might only require a single camera body, a 100mm macro lens and a light-weight tripod. Literally, a walk in the park. Attempting to capture rodeo action for me involves the use of two or three camera bodies outfitted with zoom lenses of different focal lengths, a 600mm telephoto lens, and a monopod. These are clearly very different tool kits based on intended results.

With each equipment acquisition, it's very important to familiarize yourself with the new item. Whether it's a camera, lens, or filter, study the manual, test it and examine the results before you go into the field for an important shoot. This way, when a big event arrives, you will be comfortable and relaxed knowing you have tried and tested everything thoroughly.

So much of digital photography is about keeping things organized. As you acquire more memory cards, think about using a wallet to keep things together. When using a wallet, it's a good idea to store empty cards face up and filled cards face down. That way, there's instant recognition of what's available.

My basic travel kit consists of:
• Two digital camera bodies, which are the same model. This way, I'm not searching for controls;
• Three lenses—a 17-35mm wide-angle zoom, a 60mm macro, an 80-200mm zoom;
• One flash, one cable release, and a polarizing filter (circular);
• Lens cleaning fluid, lens cloth, memory cards in a wallet, extra batteries, and a tripod.
• A small collapsible reflector and diffuser.

A more complete kit would add extension tubes for close-up work, a 300mm telephoto lens, and a second flash.

I like to be mobile and responsive when I'm on location. Traveling locally, I use a digital backpack, which holds the above-mentioned gear and has a compartment for a laptop behind the straps. Often, on arrival I unpack just what I need and work with individual cameras slung over each shoulder. When it's hot, I pack memory cards and batteries in a fanny pack that I wear facing forward for quick access. As the temperatures drop, I sometimes use a photo vest over a jacket and load up the pockets with needed supplies.

When I fly, I like to keep a basic photo kit with me in the

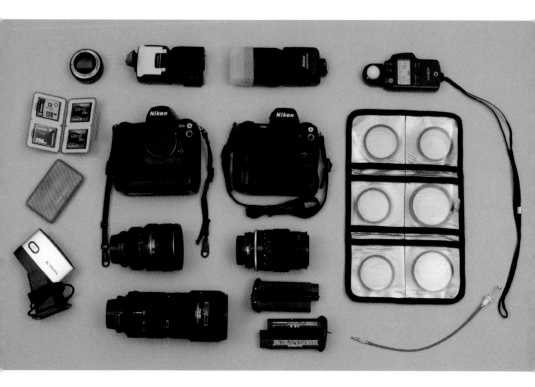

This shows a standard 35mm kit that fits inside a Lowe Pro Digital Backpack. The configuration shows both film and digital SLRs. Note how similar they appear and locations of controls.

cabin. When traveling with a lot of gear that has to be checked with baggage, I use Pelican cases that are made of hard, durable plastic and have "O" rings that protect the contents from moisture and dust. I also use these any time I'm working from watercraft.

Note: I keep my memory cards with me at all times. These contain the images for which I've worked hard—why let them go missing with checked luggage?

Tripods

As day turns to night, meandering into and beyond the last hours of magic light, shadows elongate and forms are defined progressively by deeper tones in the cooler spectrum. A softness pervades the scene laid out before you, but you still want sharp photos front to back. It's time to battle with the three-legged monster, the tripod. Cursed by many a novice and workshop participant, tripods are terribly underrated and a relatively inexpensive addition that will improve anyone's images, instantly.

Primarily used for stability, the tripod also helps greatly with composition. It forces you to slow down and become more a part of the photographic process. You can continue to use a lower ISO ensuring the best quality from your camera and given the added stability, image quality is further improved, allowing you to make more sizeable enlargements. Portraits, still lifes, architecture, wildlife, and macro work are great situations to use the maligned apparatus. Use a tripod; you'll be glad you did!

Very often tripods are sold as two separate components, the legs and the head. First, the legs.

Most photos are taken from eye level or below, so it's not necessary to buy an overly tall set of sticks. Try to find one that extends to your eye level without using the center column. Also, in terms of size and weight, know what size camera and/or lenses you will be mounting. When you use a tripod, do so without too much extension of the center column. This gives you a much more stable platform.

Most tripods today are made with aluminum or carbon fiber. Carbon fiber is lighter in weight but much more expensive. Know your needs and pocket-

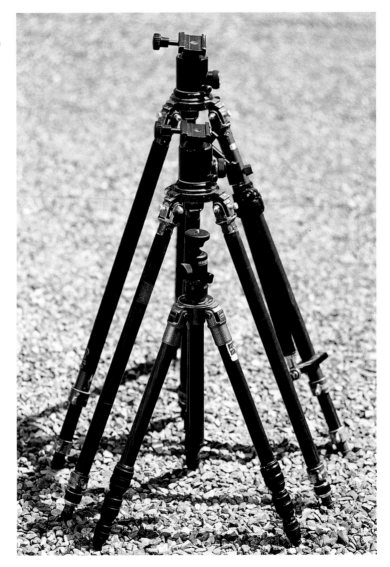

Tripods can be a photographer's best friend. Shown here are three sizes made of carbon fiber. When choosing one, you should consider weight, height, sturdiness, and the types of cameras or lenses to be mounted.
JACK DYKINGA

book. Two of the better manufacturers are Bogen and Gitzo.

I prefer legs that aren't restricted or attached to the center column. This will come in handy on uneven terrain.

A reversible center column that allows you to shoot close to the ground is a real plus.

Now the heads.

The head connects to both the legs and the camera or lens. The head is what allows you to angle, tilt, and pan with relative ease. There are essentially two types of heads that mount to the legs. A ball head and a pan-tilt head.

Pan-tilt heads usually have three separate knobs or controls, one for each axis. Those are forward and back, side to side and panning. These are precise and are very good for architecture and in a studio setting. They are very stable but a little slow to use at times.

Ball heads have a single control and are very simple and fast to use. They pack compactly and come in any number of sizes. Some of the popular manufacturers are Arca Swiss, Bogen, and FOBA.

Filters

There are several filters that should be considered to both solve problems and develop a personal shooting style. Polarizer, graduated neutral density filters, and color compensating (warming) filters. All filters modify the characteristics of light and as such should be considered just as much a tool as any camera or lens. If at all possible, it's great to standardize filter sizes.

Polarizer: This is the filter often described as "making the sky bluer." It also reduces reflections and glare in water or any other reflective surface. It improves saturation, especially on overcast days, but know that you can loose up to two f-stops when used at maximum.

There are two types of polarizing filters, linear and circular. With today's technology, the circular is what you want. It will allow the autofocus and automatic exposure meter to function properly on your camera.

With extremely wide-angle lenses, you should buy a "thin" filter, other-

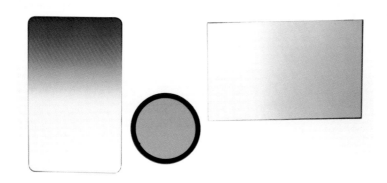

Polarizers and neutral density filters are very useful, especially in landscape work. All filters modify light characteristics and should be thought of as serious tools in a photographer's kit.

A polarizing filter can be an invaluable tool when dealing with reflections. The top image is shot with a polarizer and the lower image without one.

wise you might see vignetting in the corners of you photographs.

Polarizing filters are traditionally neutral to cool in terms of tonal value. If your shooting style favors a warmer feel, you can purchase a warm-balanced version, which saves you from stacking additional warming filters.

These filters are most effective when used 90 degrees off axis to the sun. Changing this angle substantially or using an extreme wide-angle lens can cause some very uneven tones in a pure blue sky. Just be careful.

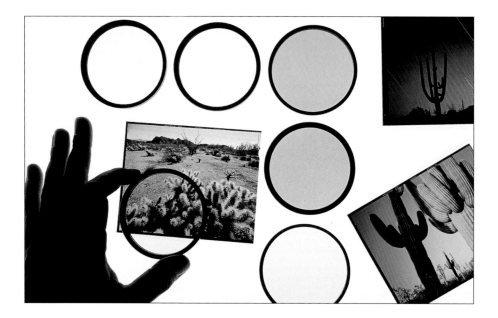

Graduated neutral density flilters: Graduated neutral density filters (GNDs) are usually rectangular, one end being clear and the other darkened or neutral density. These come in three different strengths of one, two or three f-stops with transitions being soft or hard-edged. The idea is to reduce the contrast range within a photograph, helping to hold tonal values from a very bright sky to a deeply shaded meadow. The filters fit into a bracket that allows the GND to slide up and down, then lock when the desired effect is achieved.

The filters are available in either plastic or optical glass. Cokin manufactures the less expensive version at a very affordable price point and are worth a trial. If you like the look, the costlier glass version will enhance image quality.

Warming filters: These filters have traditionally been used to adjust colors so they appear on film as the human eye perceives them. Since film doesn't "see" the same way we do, photographers have traditionally used color compensating filters (CC) to adjust tonal values in camera to their liking. With the arrival of digital capture and software like Photoshop, many photographers today are choosing to shoot without filters. They prefer to make adjustments first in camera and refine them later on the computer.

I've read reviews and arguments for both approaches. I think it's an individual call. For myself, I carry less weight, deal with fewer glass surfaces, and make color corrections after the fact. If you choose to use them, some excellent warming filter choices are: 81a, 81b, the 812 by Tiffen and the KR series by B+W. The 81s tend to be more yellow while the KRs and the 812 are more pink in tone.

Using these filters is a lot like cooking with spice: It gets down to personal taste.

Color correction filters are still used by photographers shooting transparency film. Since the human eye and film do not "see" colors in the same way, filters enable film to more closely reproduce the world as we know it.
JACK DYKINGA

Shooting early and late in the day allows film and digital sensors to reproduce detail in both shadows and highlighted areas such as this Kofa National Wildlife Refuge scene with chollas and ocotillos. JACK DYKINGA

Exposure

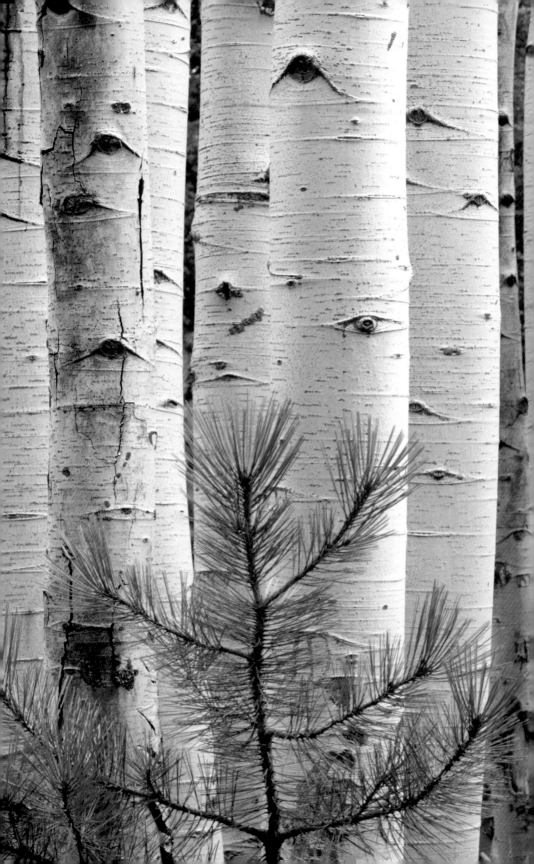

Matching Camera to Eye

by Lawrence W. Cheek

THE BASIC OBJECTIVE OF exposure is simple: to convince a camera to record a scene as your eyes see it. To make certain that a rare desert snowfall looks white, a well-tanned cowboy doesn't turn into a paleface, and a shady forest floor doesn't lose the texture and detail that energizes it.

This isn't always easy, because the excellent human eye can perceive detail in a much wider latitude—the difference between the brightest and darkest areas in a given scene—than either film or digital cameras can. The technical term for this is "dynamic range." Because we can see these details, we're disappointed when the photograph doesn't capture them.

Trying to catch up with the eye's capabilities, camera manufacturers have worked for decades to develop increasingly sophisticated light-metering and automatic-exposure systems. The good news is that their efforts are paying off—it's becoming easier all the time to make accurate exposures. But the artificial intelligence of a matrix metering system still can't parse every lighting situation nor replace a photographer's flesh-and-blood judgment based on knowledge and experience in the field.

Take care when photographing scenes that are composed of primarily light or dark tones. The trunks of aspen trees, far left, would be rendered into a medium gray tone if you just point and shoot. The high-contrast image of the cowboy presents a different problem for an in-camera light meter. It reads a mass of black shadows and wants to compensate and make those dark tones a medium gray, which in turn would render everything within the frame overexposed or too light.

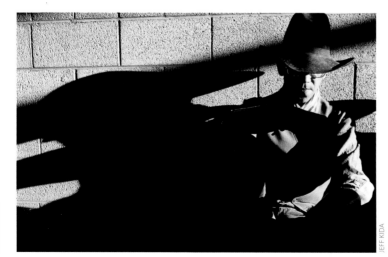

DAVID MUENCH

JEFF KIDA

ISO 200

This is the same poppy photographed digitally at different ISO's. Note from left to right the increase in "noise" from 200 to 1600. Films render the best color and finest grain at speeds slower than 400 ISO. Most digital sensors render the least amount of noise below 400 ISO.

In making good exposures, Arizona challenges us more than places of lesser extremes. The bright sunlight creates scenes of very high contrast—brilliant reflections from sand, rock, water or foliage juxtaposed with deep, dark shadows. This contrast can make photos either very dramatic or totally useless. For example, see the cowboy image on Page 69.

The basics

The first decision you have to make on exposure is the sensitivity of your digital capture or film. This is expressed in an ISO number such as 100 or 200. (Rather blandly, ISO stands for the International Standards Organization.) An ISO of 200 means the silicon diode array or film is twice as sensitive to light as an ISO of 100, and 400 is twice the sensitivity of 200. (See chart below.)

Changing the ISO affects the quality of the picture you make. For generations, film photographers bemoaned the grainy effect that plagued enlargements taken on high-speed film. At ISO 400, the sky on a big print looked like sandpaper. Digital capture extracts a similar penalty for speed: an increase in electronic "noise," which looks a lot like grain. In either kind of camera, detail suffers as the ISO numbers rise. (See flower above.)

ISO	25	50	100	200	400	800	1600	3200

Low sensitivity, longer exposure	*Sensitivity / reaction to light*	High sensitivity, quicker exposures
Less grain, low noise	*Grain / Noise*	More grain, more noise
More accurate	*Accurate color reproduction*	Less accurate
Larger prints possible	*Ability to enlarge / grain*	Large prints not always possible

THE BASICS

ISO 400 ISO 1600

For daylight pictures in which nothing is expected to move, leave the camera's ISO number as low as possible—100 is typical. This will ensure the best-quality photography your camera is capable of. Reserve the higher settings of 400, 800 and 1600 for situations involving low light or motion, such as a historic church interior or a rodeo.

Next, two mechanical variables control the exposure on any camera, whether digital or film: the size of the lens opening (aperture) and the length of time the shutter remains open (speed). A camera's exposure controls are set up so that each f-stop or aperture is exactly equal to a step of shutter speed. For example, try an exposure of f/8 at 1/125 second. If you were to open the aperture by one stop to f/5.6, the shutter would admit twice the light into the camera.

Increasing the speed to 1/250 would then admit half as much light as the slower speed, so:

f/8 at 1/125 = f/5.6 at 1/250. See chart below.

The different apertures and shutter speeds, however, also change two other qualities of the photograph you're making. The aperture affects depth of field, and if the subject is moving, the speed determines whether it will be blurred or sharp. We'll cover depth of field and motion later in this chapter.

Happily for the math-challenged, all three exposure variables—ISO, f-stops, and shutter speeds—proceed in same-sized increments. One f-stop, one ISO

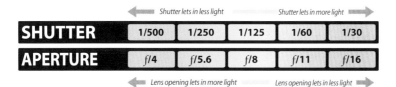

	Shutter lets in less light ←			→ Shutter lets in more light	
SHUTTER	1/500	1/250	1/125	1/60	1/30
APERTURE	f/4	f/5.6	f/8	f/11	f/16
	← Lens opening lets in more light			Lens opening lets in less light →	

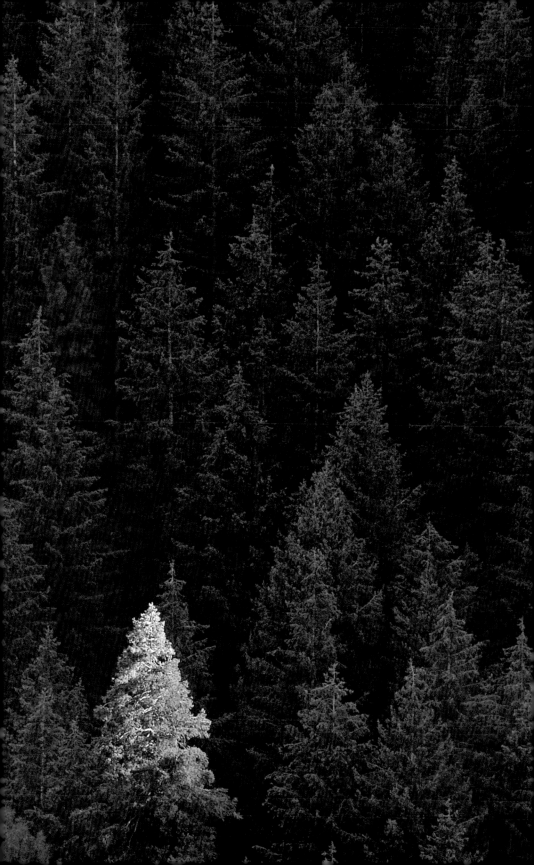

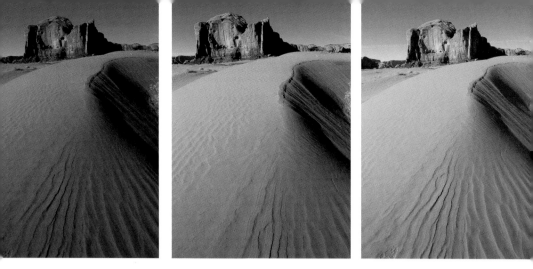

step, and one halving or doubling of shutter speed have the same basic effect on exposure. The chart on Page 71 illustrates that point.

There are dozens of shutter/aperture combinations that will give this same exposure.

Three variables can seem overwhelming to juggle for each picture, so choose the film or ISO according to the type of photography or light conditions. That's the foundation. Then deal with the issues of aperture and shutter speed. Which brings us to:

The amateur's predicament

Nearly all cameras today provide some form of automatic exposure control, often with a bewildering menu of optional settings. The amateur's choice is whether to take the path of least resistance and let the camera decide, or invest more effort and determine the exposure manually.

In general, the less contrast you see within the frame you've composed, the more likely the camera will give you the best possible exposure automatically. An intimate landscape in the soft natural lighting of an overcast sky is a perfect example. But if the frame includes bright sky, deep shadows, a highly reflective surface, or a dark object in which surface detail is important, such as a black cat, the camera can be fooled.

One way to deal with problem exposures is simply to bracket every shot, making the "correct" exposure plus a "bracket" of two others at 1/3 stop under and over. See example above. Many cameras will do this automatically if you select a bracketing program. In editing, then, you simply delete the unwanted exposures. Digital photography renders this virtually painless; you're not throwing away film you've paid for. The drawback is that you may not be learning how to evaluate exposure problems. You also may find that some of those problems were so unusual that the best solution lay somewhere outside your bracket, so use your LCD and histogram to review the images.

The best bet is to think through the exposure problem first, use your judg-

A series of photos from Monument Valley, above, shows typical exposure with bracketing of one-third-stop increments. You can do this manually or program a newer camera to do it automatically.

In automatic exposure mode, the single sunlit tree, far left, would have been overexposed when the program compensated for the predominantly dark background. Metering off the highlights and bracketing in small, one-third-stop increments allowed the photographer to select the best balance of highlight and shadow detail in the final edit. PETER ENSENBERGER

ment and experience to inform the camera's best hunch, and then bracket that exposure.

All modern SLR cameras, digital or film, have a remarkable built-in tool to help: a light metering system that provides at least three ways to evaluate a picture. Some compact zooms also have it. If you're like many amateur photographers, you'll never use or even suspect all the capabilities of your camera, but this one is among the first you should master.

In ancient times—30 years ago—a light meter surveyed all the light it "saw" through the lens, gave some extra weight to the center of the frame, and averaged it out. This was adequate for low-contrast scenes, but very likely to give a misleading reading of high-contrast scenes. A good camera today gives you a choice of at least three modes: matrix, center-weighted, and spot.

Matrix metering divides the frame into a number of segments, then uses an algorithm based on the manufacturer's experience with how people take pictures to arrive at an exposure. Center-weighted metering guesses that you've placed the subject at the center of photo, and gives the most consideration to that segment of the matrix. (If you're following the Rule of Thirds—described in "Composition," Page 102—you will fool it, repeatedly). Spot metering measures only the light in a circle at the very center of the frame, as little as 1 percent of the total area.

The grid pattern laid over the sunset photo suggests the different areas from which a matrix meter would take samples. The different spots are evaluated and an "appropriate" exposure is determined. If the upper section of a photo is much brighter than the lower, the matrix will assume the scene is a landscape and bias the exposure to accurately portray the lower portion.
JACK DYKINGA

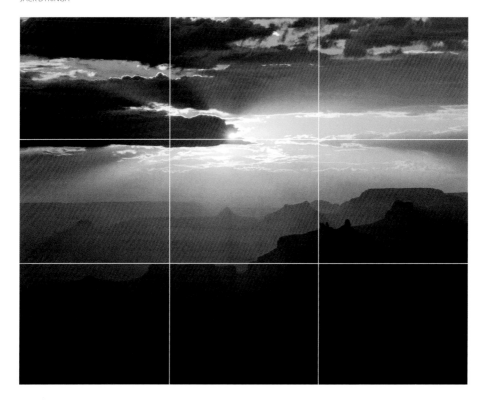

For low-contrast situations, the matrix usually will do a good job of judging the exposure. It may also perform well in some conventional high-contrast scenes. For example, if it sees a band of bright light at the top of the frame, it will think: "Aha! that's the sky," and make adjustments accordingly.

"Proper" exposures are often a matter of choice. Take a look at the photograph on Page 72, a single illuminated pine tree in a forest of shadowed brethren. If you set the camera on any of its automatic functions, the built-in light meter will see all the dark trees and want to make the shadows a medium tone, thereby making the lone pine greatly overexposed. Knowing the limitations of film, Peter Ensenberger saw this scene and made a conscious decision to expose for the sunlit tree only, giving up most of the detail in the remaining trees but renedering a very dramatic image.

There are number of situations where the built-in light meter simply won't be able to help you make proper exposures. These would include night scenes, fireworks and photographing star trails. Look at the spectacular image of star trails made at Monument Valley on Page 77. Kerrick James composed this image separating the Mittens in the foreground with star trails generated in this eight-hour exposure. Most in-camera meters will only give a light meter reading of up to 30 seconds, not nearly enough time to produce an image as dramatic as this. Images of this type require very dark skies on near moonless nights with minimum exposures of 20 minutes.

Watch your highlights!

A photograph's highlights are its brightest areas, created wherever the light-reflecting quality of a surface is higher than the average in a picture. Examples would be white helmets of snow on a saguaro, or the white streaks in a skunk's fur. Your exposure should avoid "blowing out" these highlights, overexposing them so that all their detail is lost. In digital editing on your computer, you can usually bring up hidden details in an underexposed area, but there are no details left in an overexposed highlight.

Digital cameras have some excellent tools to help you avoid blown-out highlights. The more accessible tool is the highlight alert on the LCD display, which literally blinks pixels on any overexposed highlights. Bracket the exposure until the blinking subsides, and you've got it. There are exceptions. Sometimes you may want a hot point of light, such as a reflection of direct sunlight on the fender of a car. This is called a spectral highlight, and it will usually be a very small element in the composition. Another exception might be of a pure, smooth, white surface which really has no detail to offer. Again, such an element will likely be small.

The other tool is the in-camera histogram (Page 36), which is a graph of the light values in the frame. Dark tones are displayed to the left, bright tones to the right. Learning to interpret the histogram in detail takes some practice, but you can get basic exposure advice from it very easily.

If the graph is fat on the far left, the photograph is likely to be underexposed. If it bulges or there's a substantial "plateau" on the right, it's overexposed. And

a sharp "spike" on the right indicates a blown-out highlight.

Although some guidebooks warn against using the camera's LCD screen to preview exposure—it can be difficult to view in bright light—it can actually become a valuable teaching tool once you become accustomed to how your screen displays photos. Many professionals use it to assess the light-to-shadow ratio and help them decide whether to use a flash to open up the dark areas.

All together, the camera's metering options (along with your experience in interpreting them), the highlight alert, the histogram, and the LCD screen form a wonderful arsenal of tools for figuring good exposure.

Dirty sand, faded snow

Some landscapes almost universally call for extra help from a thinking photographer. Snow scenes, sand dunes, and the highly reflective orange-red sand and sandstone formations of the Colorado Plateau are among them. Your camera is programmed to judge everything it sees as if it reflected an average of 18 percent of the light falling on it. Since these bright, relatively flat surfaces reflect much more than that value, the camera will consistently underexpose such photos. White sand and pristine snow will appear gray and dirty; the rippled red dunes of the Colorado Plateau will fade to a wan terra-cotta.

An old rule of thumb called for increasing the exposure by 1.5 to 2 stops on a sunlit snow scene. If your light meter read the exposure as f/8 at 1/125, you would set the camera at f/4 at 1/125 or f/8 at 1/30. That's not bad for guesswork. But you can use your camera's spot meter to take a reading from an 18 percent gray card (available at any photo store) or anything in the scene that looks to your eyes like an average level of reflectivity. If you're shooting digital, remember, a little underexposure is better than overexposure—you can correct it more effectively with your computer editing.

Most SLRs and many less expensive digital zoom cameras have a programmable feature called exposure compensation, which applies plus- or minus- changes to the camera's automatic exposure in 1/3 stop increments of 1/3 up to two stops. If you're doing a whole morning's shoot among the dunes, this is a useful tool.

Finally, learn the camera

The beauty of a modern camera is its incredible array of tools to help the creative photographer. The bane of a modern camera is this same incredible array of tools. It is complicated—no way around it. To be able to shift among the different metering programs, automatic bracketing, exposure compensation, and much, much more, you have to be able to find the controls and know what they do.

Today's cameras contain a world of help for the photographer of every level of expertise. You just have to know how to ask for it.

Stars turn into streaks of light behind Monument Valley's famous Mittens during this eight-hour exposure. When shooting fireworks and star trails, you can't depend on your light meter. For fireworks, set the ISO to 100, the aperture to f/8, and try exposing between 1/4 second to 10 seconds. With star trails, the larger the lens opening, the wider the streaks will be; and the longer the exposure time, the longer the trails.
KERRICK JAMES

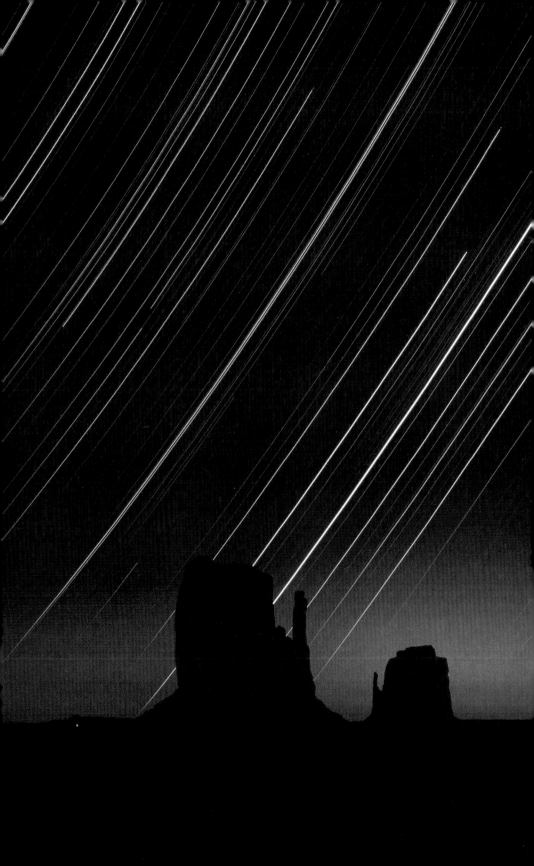

Depth of Field *by Lawrence W. Cheek*

Learning to use depth of field is one of the most important steps on the path from casual snapshooter to skilled amateur photographer. It's not difficult to understand or master, but you will have to insist that your highly automated camera gives some of its exposure control back to you. If it's a point-and-shoot, it may be reluctant to do so, but there still may be ways to trick it—for the photograph's benefit.

Depth of field directly relates to the size of the aperture, and it refers to the part of the composition that is in sharp focus. Simply remember this: the larger the aperture, the shallower the depth of field. Shutter speed and ISO do not affect depth of field.

Let's say you wanted to make a photo of a hiker standing on a ledge at the Grand Canyon. You have a 50mm lens on your camera at about 15 feet from your subject, who is framed vertically. Shot at f/4, only the hiker would be in focus, with the foreground and distant vistas sufficiently blurred. If you made the same photo at f/16, the image would be sharp from the hiker's feet to the most distant horizon.

Here's a second basic guideline to remember: The shorter the focal length of the lens, the more depth of field it will provide. If you're using an 18-70mm zoom, the 18mm setting will allow much more depth of field than the 70mm at the same aperture. This is one reason why landscape photos that encompass everything from foreground flowers to background mountains are usually shot with wide-angle lenses.

It is important to remember there are always choices when determining depth of field. Settings and circumstances often make this an easy judgement call. Notice the image of the young hoop dancer on Page 152. It was shot with a 300mm lens wide open at f/2.8. The spectators at this event were only 20 feet back and yet any and all detail are completely blurred to where the performer is beautifully isolated from other distracting details.

In the photo of the Vaqueras de Tucson on Page 155, a wide-angle lens and an aperture of f/16 were used to carry depth of field. The viewer is given more a sense of place in this situation which works to establish an overall feel for the event.

Distance away (in feet)	5'	10'	15'	20'	25'	30'	35'	40'
f/4								
f/8								
f/16								

Amount of image in focus in **FRONT** of the subject

Amount of image in focus **BEHIND** the subject

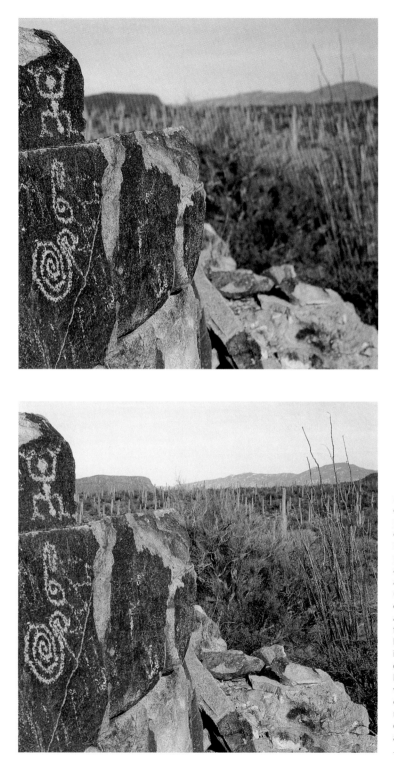

Mastering depth of field allows a photographer to control the final image. These two photos were shot at different apertures, the upper at f/8 (less depth of field) and the lower at f/22 (more depth). It's up to the individual to decide the final look of an image, which can be controlled with most compact cameras and all SLRs.
JERRY JACKA

A lone verbena, right, emerging from a coral sand dune is an immediate focal point. Soft directional light emphasizes different textures, and the great depth of field moves the viewer's eye easily from the flowers to the distant mountains. As spectacular as the photo is, from a metering perspective it's simple and straight forward.
JACK DYKINGA

Almost all SLRs offer a depth-of-field preview option that stops down the lens to the aperture you've chosen before you make the picture. This feature allows you to see exactly what the camera will record. However, if the aperture is small, the image will appear fairly dark, so it may be difficult to judge how much of the picture is in focus. This is where experience and familiarity with your camera and lenses come into play.

Sometimes your chosen depth of field will be a compromise. If you're shooting a landscape and a breeze is rustling the flowers in the foreground, you can increase your shutter speed to freeze the unwelcome action, which will mean opening up the aperture. Either the slower shutter speed or the wider aperture will mean some blurring, although the effects will be different. Experience is the only way to judge which evil will be the lesser.

If you're using one of the popular compact zoom digital cameras instead of an SLR, you still have quite a bit of control over depth of field. Setting the camera in aperture priority mode will let you choose your depth of field while the camera worries about the consequences of the shutter speed. To keep the consequences from being unpleasant—say, if the camera selects a ¼ second shutter speed, which is far too slow for you to hand-hold the camera without movement—you should be using a tripod. If you select shutter priority, the camera will choose the aperture for you.

If you're using a shallow depth of field, don't think you're trapped into placing the subject in the center of the frame, where the autofocus automatically locks in. You can center the subject, press the shutter button halfway to trigger the automatic focus, then recompose the picture while keeping the button half-depressed. This trick should ensure that the principal subject is in the sharpest focus no matter how the picture is composed.

Using a shallow depth of field isolates a red Indian paintbrush blossom against a cluttered background of purple lupines. The photographer "defocused" the background with a wide aperture, thus blurring the lupines into unobjectionable pools of purple.
PETER ENSENBERGER

Motion *by Peter Ensenberger*

I n the early days of photography, captured images were called "stills." Slow lenses, bulky view cameras, and heavy tripods dictated timed exposures on glass plate negatives lasting several seconds or even minutes, forcing photographers to admonish their portrait subjects to "hold still" for the duration. These limitations helped shape the photographic style of the

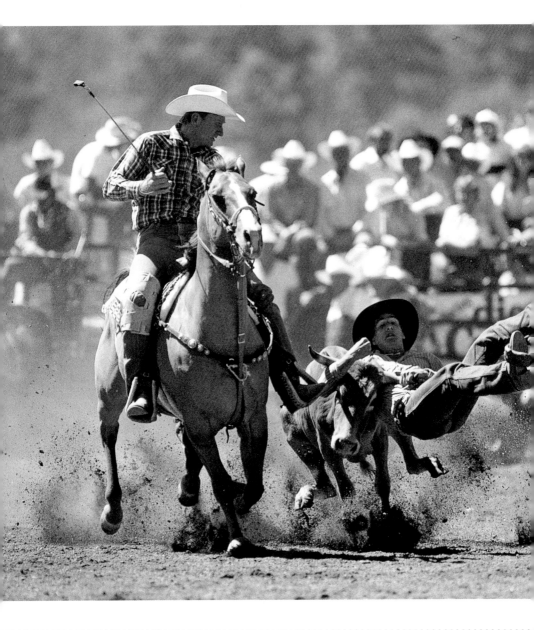

THE BASICS

times, and they made the early film record of our world look decidedly static.

George Eastman invented the roll-film camera in the 1880s, which was the breakthrough that gave creative photojournalists such as Henri Cartier-Bresson and W. Eugene Smith the mobility to embrace life's movement around them, often incorporating a blur of action to breathe animation into their images.

With modern single lens reflex cameras we have more flexibility for capturing action than ever before. The choice to freeze action at 1/8000 second or allow a moving subject to become an impressionistic blur at a quarter second is literally at our fingertips.

For those who like to challenge convention, here are some tips for panning and blurring using motion in your photographs, sometimes with whimsical results if you're willing to push the envelope.

Panning

A well-executed panning shot of a moving subject can yield a dynamic image that has an abstract, almost painterly quality. Panning pushes the bounds of conventional photographic methods, accelerating a still medium to the speed of life. Panning with speeding race cars, for example, blurs the background, capturing the illusion of velocity. While shutter speeds of 1/1000 second or faster will freeze cars speeding around a track, it will likewise freeze the background, making them appear as though they are parked on the track. A slow shutter speed works much better for telling the story of a race—whether it's cars, horses, or a desert bobcat in hot pursuit of a rabbit.

Using a slow shutter speed while panning the camera at a rate matching your subject's speed, you can maintain fairly sharp focus on the subject and blur the background with the camera's horizontal movement. Panning often works best in low light, with a slow ISO or with the use of a neutral density filter if shooting in bright light conditions.

Freezing sports action at the peak moment with a handheld camera requires fast shutter speeds. A minimum of 1/500 second will stop most motion when the action is coming toward the camera, but faster shutter speeds will avoid blur when the camera pans with side-to-side action. Sports photographers often work with shutter speeds of 1/1000 second or faster, utilizing fast lenses or high ISO settings to achieve proper exposure.
PETER ENSENBERGER

Matching shutter speed with the pace of a moving subject produces images with proper amounts of sharpness and blur. Panning with running baseball players at 1/15 second records the motion without losing the subject's identity.
PETER ENSENBERGER

Since some autofocus cameras don't react quickly to fast-moving subjects, you may have to switch off the autofocus feature. Set the exposure program for shutter priority or manual operation so you can select the appropriate shutter speed. The shutter speed you choose and the speed of your panning motion depend on the amount of available light and the speed of your subject, but generally a range from 1/4 to 1/30 second works best.

Scrutinize the background and determine where you want your subject to be when you make the exposure and manually prefocus on that spot. Pick up your subject in the viewfinder and pace your panning motion with its speed by pivoting at the waist as you track it to the desired spot. Don't stop the motion when you release the shutter. Continue to pan for the duration of the exposure. Effective panning requires practice, so make several exposures at various shutter speeds and compare your results until you develop a feel for it. Race cars obviously require a faster shutter speed, whereas slower shutter speeds work better for sprinting baseball players and Thoroughbreds breaking from the starting gate.

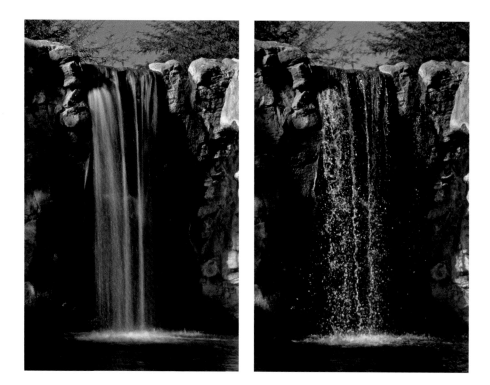

Blurring

By stabilizing the camera on a tripod and using slow shutter speeds, moving objects become impressionistic blurs in front of your lens, conveying action in a different way than panning does. Motion itself becomes the subject of blurred photographs. Blurring effects usually occur with shutter speeds of 1/30 second or slower, depending on how fast your subject is moving. Just as with panning, it helps to work in low light or use a neutral density filter.

You can create a pan-blur combination with a small on-camera flash. Either pan with the subject or hold the camera steady on a tripod while utilizing a slow shutter speed to record the movement, and trigger the flash to freeze the subject as it moves past the camera position. This works best in dimly lit situations with shutter speeds of 1/15 or slower and with the subject within 5 to 15 feet of the flash (see Page 86).

Take a meter reading of the scene with the shutter speed at 1/15 (slower if you want more blur) and set the appropriate aperture. You may try slightly underexposing the scene to emphasize the subject being illuminated by the flash. For a panning shot, begin your pan as the subject approaches and release the shutter, triggering the flash. Then continue the panning motion for the duration of the exposure. For a blurring shot, brace the camera or mount it on a tripod and release the shutter as the subject moves past. A slow shutter speed will create a blur of the subject's movement and the flash will freeze it in mid-motion as it passes by, creating a unique effect.

The waterfall image on the left was made at 1/4 second while the one on the right was made at 1/500 second. The smaller aperture opening used with the slower speed enhances depth of field but gives the water a milky appearance.
RICHARD MAACK

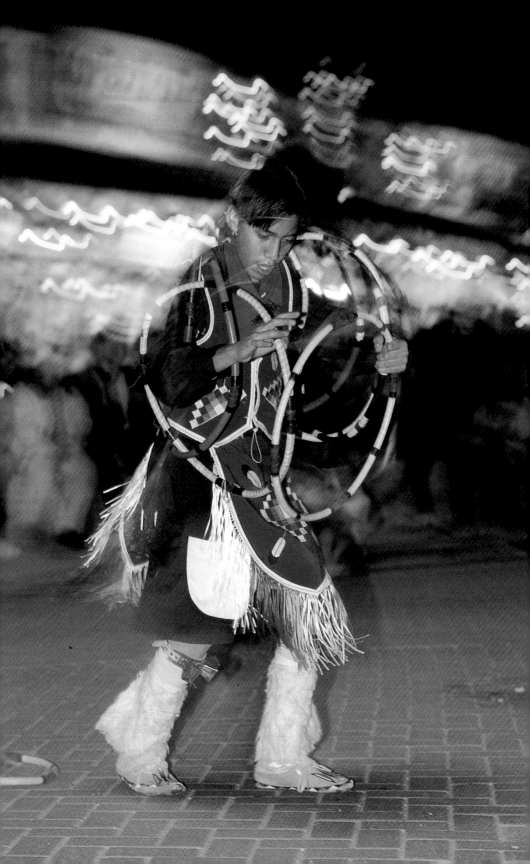

Flowing water

Flowing water, as with any moving subject, can bring the feeling of animation to a still photograph. Dismissing the blurred water technique as passé or unrealistic doesn't quite resonate. Most often, the blurred water effect results from the technical limitations of the lens, film, or digital imaging array. The photographer must give priority to aperture settings that achieve maximum depth of field. That usually dictates a slow shutter speed, especially when using a 4x5 view camera. But by artfully using the water's motion in the composition, the photographer can add an interesting and emotional element to the image. Why rule out the option if it can lead to something beautiful?

Whether it's the torrent of Lava Falls in the Grand Canyon, a gentle cascade along Oak Creek, or waves lapping at a sandy beach in Baja, the photographer has to make choices that determine the sensation of movement in the final photograph.

The first choice concerns technical considerations or limitations. Most landscape photographers working for *Arizona Highways* use an extremely slow, very fine-grained color transparency film, usually rated ISO 50 or 100. The slower the film, the longer the exposure required to ensure sharp focus from near to far. These photographers also may be working at dawn or dusk to take advantage of the warm but stingy light, so they're typically exposing moving water for several seconds. Inevitably, it registers as "milky" on the film.

The second choice you must make when photographing water is aesthetic and a matter of the feeling you want to evoke. Stepping up the ISO to 400 or higher may make it possible to "freeze" a river rapid, defining its sparkles and splashes precisely—though like the ghostly milk of long exposures, this look can only exist in a photograph and not in real life. Shutter speeds in the middle range—typically 1/30 to 1/4 second—are a compromise, suggesting movement without too much blurring of the water's form. The higher ISO, however, will render the photo grainier, degrading the quality of a big enlargement.

Not all flowing waters are alike. Waterfalls move water faster than river rapids, and tall waterfalls appear to move faster than short ones. The faster the water movement, the more blur will occur at a given shutter speed. Moving water is a complicated issue with many variables, so the best advice is to try a range of shutter/aperture combinations and use the one you like best.

There's no right or wrong in judging a photographer's response to these situations. The camera is capable of seeing the world in a broad range of time intervals. There's a compatible shutter speed to synchronize with most any moving subject, and what results is an ever-changing take on reality. Limitations of the medium, the subject, the photographer's vision, and personal taste all factor into the equation.

As with all photographic techniques, a lot of practice and experimentation with motion can lead your photography in interesting directions and help you to develop a photographic style that portrays the world as it really is—full of life, change, and motion.

In low-light situations you can use a strobe (flash) with a slower shutter speed so the ambient light becomes more prominent in the scene. This photo of the hoop dancer was shot at 1/2 second at 100 ISO. The image shows some movement, helping to convey action. JEFF KIDA

The form and texture of saguaros are accentuated by warm cross light from a setting sun coupled with the use of a telephoto lens from a long distance to compress the cacti against dark shadows. Juxtaposition of highlights and shadows plays up graphic qualities and emphasizes the saguaros as focal points.

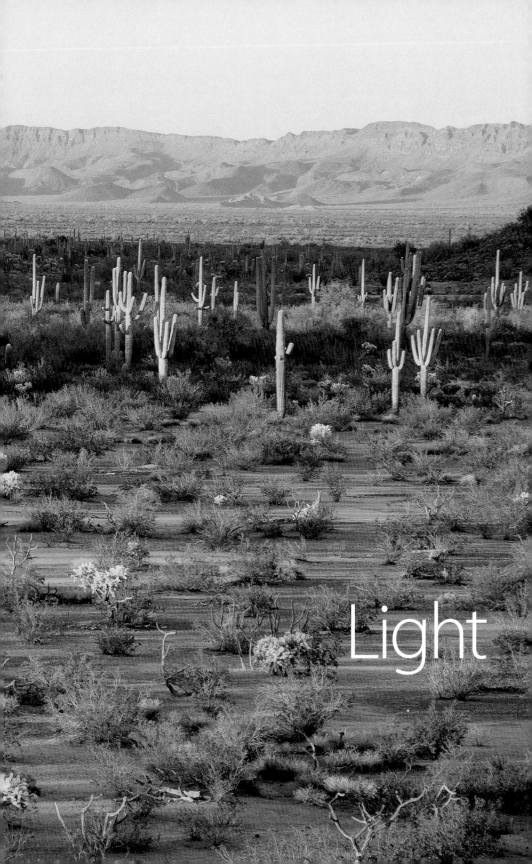

Light

Complementing the Subject

Text and Photographs by Peter Ensenberger

THE MAKING OF A GREAT PHOTOGRAPH requires many elements to click at precisely the same moment. Photographer and camera, subject and composition, weather and light, all work in concert. Luck can factor into the equation, but as the saying goes, "Luck favors the well-prepared."

Being well-prepared includes developing an awareness of the quality and direction of the prevailing light and how it interacts with your subject. Light awareness is a vital first step toward improving your photography.

In its most basic form, photography is the recording of light in a scene that is captured in the grains on film or pixels of a digital file. The way in which a photographer uses the light when creating an image can make a vast difference in the success or failure of a photograph.

One basic skill that sets photographers apart from snap shooters is the ability to analyze weather and lighting conditions, artfully incorporating them into pleasing compositions. Light and shadow become integral parts of a composition, often as important as the subject itself. But because not much can be done to control lighting in the "outdoor studio," photographers always strive to put themselves in prime light situations and then use that light to its best advantage in recording a scene. Snap shooters, on the other hand, tend to front-light their subjects or don't take time to consider the best use of the available light. The usual results are photographs with harsh, flat, or indifferent light.

In my role as an instructor for the *Arizona Highways* School of Photography or when leading *Arizona Highways* photo workshops in the field, I stress the importance of developing a keen awareness of light. Recognizing the quality of light around you should become second nature.

A good exercise to help develop your light awareness is to begin taking notice of the light in the images you see in magazines, books, and calendars. Study how professionals use light in their photographs. When touring an art exhibit, look closely at the quality of light that artists create in their paintings. Early 20th-century photographer Leonard Misonne said it succinctly: "Light glorifies everything. It transforms and ennobles the most commonplace and ordinary subjects. The object is nothing; light is everything."

When editing photographs for publication in *Arizona Highways*, I first look at the quality of light, how it complements the subject, and consider

Peeking through an opening in the clouds on an overcast day, the sun casts a sliver of theatrical light on sandstone cliffs edging Lake Powell. The strongly directional light spotlights the subject, accenting the structure and texture of the massive rock walls.

whether the photographer got the most out of the prevailing conditions. Sometimes the subject of a great photograph is nothing sublime in itself. Jerry Sieve's October 1987 cover photo for the magazine depicted a weedy irrigation ditch in the Gila River Valley of southeastern Arizona. But the beautiful early morning light made the water look delectably blue and turned the weeds into filaments of gold.

Of course, nature does not always present us with beautiful prime light. Clouds and weather can get in the way. Overcast, hazy, or foggy conditions will soften and diffuse the sunlight. But good photographers adapt. On a dull, overcast day, they turn to intimate landscapes or close-ups. When a storm moves in, they point their cameras skyward to take advantage of the dramatic play of light unfolding above the landscape.

Let's examine some common types of light and their effects.

Cross light

Working in the light that occurs at sunrise and sunset will have an immediate and positive impact on your images. And it costs nothing but a bit of sleep.

Photographers call it "prime" or "sweet" light. When the sun is low on the horizon, its light passes through more of the earth's atmosphere than at any other time of day, softening and diffusing the light and filtering it toward the warm or red end of the spectrum. It's usually the best of the day's light, adding richness and warmth to the colors of your subjects. In the air over Arizona, the dust particles suspended in the air boost the warm color even more than in the moist, green regions of the globe. Because daytime wind kicks up particles that commonly settle during the night, Arizona's late light is usually warmer than its early light.

The first light of sunrise, right, strikes an ocotillo and the tips of a saguaro's arms at right angles to the camera position, demonstrating the effects of cross light. Photographing in early and late light also can provide shadowy backgrounds for strongly lit subjects, yielding exposures that render richer color saturation.

Morning and evening also provide the strongest directional light, creating long shadows that can add drama to a scene and make subjects appear more three-dimensional. Low cross light raking over the landscape at right angles accentuates form and texture. With only a few minutes of prime light in which to work, photographers must move quickly to capture their subjects in optimal conditions.

Backlight

Always front lighting your subjects will cause you to miss good opportunities for the creative use of light. Light behind the subject can help to create more interesting visual and graphic effects (see Pages 124-125).

Backlighting produces strong separation between subject and background by creating a rim of light around the subject. Use this type to emphasize the shapes of subjects. Backlight also is best for capturing the translucent quality of flowers and foliage, such as colorful autumn leaves, and it can be used to silhouette a subject, producing images with strong graphic qualities.

When using backlight, watch out for sunlight striking the front of the lens. Use of a lens hood or the shadow from your hand will shield the front element of the lens from direct rays of the sun, preventing unwanted haze and lens flare.

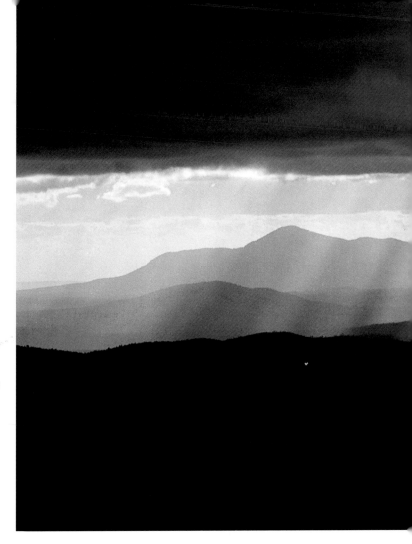

Few conditions provide more drama to a photograph than the play of light that occurs during the buildup and clearing of a storm front. Often, the leading and trailing edges of storms clash with sunlight, creating dramatic weather moments. Shafts of bright sunlight piercing through dark clouds make proper exposures tricky.

Backlighting may require exposure adjustments, the use of fill flash, or a small solar reflector to achieve the proper amount of shadow detail. If a silhouette effect is what you want, no shadow detail is necessary. But if shadow detail is important to the subject, increase exposure by one to two stops or use on-camera flash balanced with the ambient light to illuminate the shadows. In lieu of flash, a light reflector, such as a piece of white cardboard or a manufactured reflective disk, can provide a subtler, more natural quality of fill light on a shadowed subject. The disks may have a gold-colored reflector, which throws warmer light than a flash. Position the reflector to bounce diffused sunlight on the subject to open up shadows and reveal details.

Because backlight can play tricks with the camera's light meter or exposure settings, it's a good idea to bracket exposures to ensure properly exposed highlights and shadows. Two-stop bracketing is not too much for insurance on tricky scenes.

THE BASICS

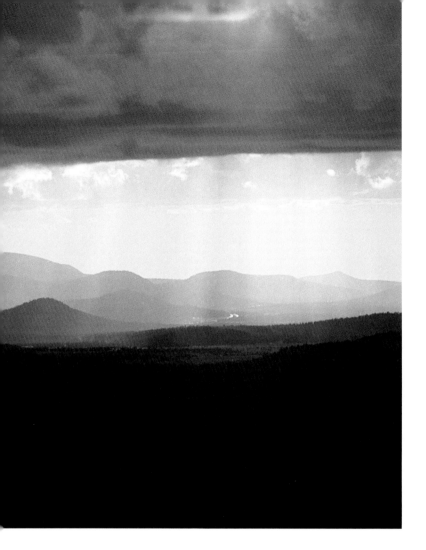

Soft light

On light overcast days, soft, diffused light spreads evenly over the landscape from different directions. With no strong highlights or shadows, it's difficult to build dramatic compositions in a grand landscape. These are good times to focus attention on smaller subjects or work with macro equipment and close-up techniques (see Pages 110-115). Several of the professional contributors to this book provide illustrations, and most issues of *Arizona Highways* will also contain examples. An overcast sky doesn't mean putting your camera away for the day; it simply changes where you'll point it.

Soft light is nondirectional, making it suitable for portraits or other situations where "contrasty" light is not aesthetically pleasing or complementary to the subject. Photographing in soft light often brings out rich tones and subtle hues and emboldens primary colors.

Beware of heavy overcast or dark clouds where minimal flat light will mute

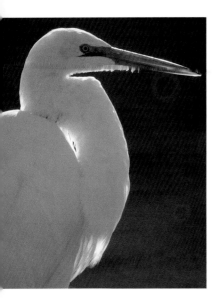

Backlight forms a "halo" around a subject, creating a distinct separation between the subject and the background. Using backlight in conjunction with a dark, shadowy background isolates the subject and plays up its graphic nature.

the colors and soften the details of your subject. If you have a strong foreground subject, you can experiment with fill flash to highlight it.

Storm light

The lighting condition that gets nature and outdoor photographers seriously excited is storm light. They will stalk a storm front for days, planning their approach. They relish the buildup and break of a storm and scoff at the hazards to bring back dramatic, awe-inspiring images (see Pages 324-325).

Arizona Highways occasionally publishes a cover featuring a storm, and the most dramatic in my memory was William Wantland's shot of a lightning strike over Tucson, which we published in August 1990. What made this such a great shot was the fact that the storm cloud was lit up by the setting sun and the electricity surging in its belly.

When the leading or trailing edge of a brooding storm clashes with the sun, the light display can be magical. Modern photographic equipment can tolerate brief exposure to rain, but be sure to pack a towel, a large plastic bag, and a collapsible umbrella in your photo bag in case you need protection from a determined downpour. Once the storm has arrived and weather is socked in, photography can be futile, with flat light and rainy or snowy conditions. Most photographers—though not all—pack up and stay warm and dry until the storm breaks and the trailing edge passes through. And we can't emphasize this enough: Seek safe shelter immediately when lightning storms approach. Arizona is serious lightning country.

Exposures can be tricky when bright shafts of sunlight pierce through dark storm clouds. Take meter readings and expose for the brightest parts of the scene, or simply underexpose the scene by two stops to get saturated color and moody black clouds. Again, bracketing ensures getting the best image and gives you options when editing.

Midday light

Unfortunately, photographers can't always be in the right place at the right time. Tight travel itineraries occasionally force them to work in less-than-optimal lighting conditions. Typically, the high overhead sun of midday is the worst light of the day. The cool, flat light is harsh on most subjects, washing out colors and robbing them of any three-dimensional effect.

It's challenging, if not impossible, to make good photographs under such bad conditions. In my photo workshops, we typically spend middays indoors, eating lunch, studying slide shows, or just napping. (We were up and on the bus before dawn, and we'll be working until the last glimmer of light.) A polarizer can drain off some of the reflections and enrich the colors of your subjects. Close to the winter solstice, the sun is low enough in the sky that surprisingly

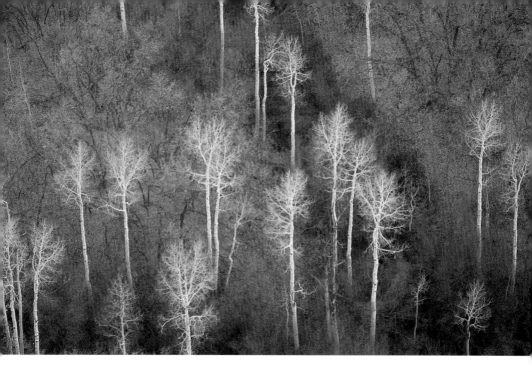

dramatic photos can occur any time of day. In Monument Valley one November day I was watching the sky fill up with bright, puffy cumulus clouds, when it rather belatedly occurred to me that I might want to make a few photographs. Since most of the color was in the sky and the light on the buttes still fairly dull, I turned the camera skyward. One of those images, made around 1 P.M., sold years later for $3,500—the most I ever earned from any single stock photo sale.

If no other options present themselves, look for the boldest shadows you can find and try to emphasize them in your composition. Shadows add drama. One big exception is in photographing people. Midday light is very unflattering for portraits, causing deep shadows around the eyes and under the nose and chin. Portraiture is best done in the soft, even light of full shade, or with the addition of fill light from a flash or reflector. Mottled light in the shade of one of Arizona's thin-leafed trees such as palo verde or mesquite can be interesting for portraiture, but you'll need to position your subject carefully to get it right. A dark splotch over an eye won't be good.

Photographers usually find their subjects, then watch and wait for the light to reach peak enhancement before making a photograph. But sometimes I like to shake up the process by using the light as my motivation. Often it is the quality of the light, not the subject, which entices me to make a photograph. When the light turns dramatic, I go in search of subjects to photograph just to take advantage of the existing light. I've found that good light can create a mood, elevate the subject, and even change the way I respond to the subject.

On your next photographic outing, try looking for good light first and a good subject second. It will open your eyes to photography's most useful, and least expensive, accessory.

Reflected and diffused, the light on these aspens is soft and non directional, producing a scene that lacks shadows and rich, saturated color. When shooting in soft light or overcast conditions, it's best to forsake grand landscapes and focus on details and intimate scenes, like the ghostly forms of leafless aspen trees in muted hues.

An imposing subject on the scale of the Grand Canyon poses photographic challenges. Choosing a scene with overlapping compositional elements of foreground, middle ground and background creates the effect of three-dimensional depth in a two-dimensional photograph.

Composition

Adding Artistic Dimensions

Text and Photographs by Peter Ensenberger

THE QUALITY OF LIGHT or the subject may catch the eye, but the artistry of composition must hold it.

Composing a photograph is essentially an editing process—deciding what to leave in and what to take out. Basic rules of good composition will help you achieve visual harmony or dynamic tension. They are intended as inspiration rather than as dogma, and they can be creatively broken to excellent effect—sometimes. At the outset, though, these basic elements of effective composition will help you design well-balanced images that are pleasing to the eye.

Strong focal point

It is usually best to have one main subject as the focal point because a photograph generally can tell only one story successfully. The main subject can be one object or several, and you may decide to include a secondary subject. But make sure nothing detracts from the focal point. Lacking a strong center of interest forces the viewer to search for something to observe, eyes seeking a resting place. Always give the main focal point sufficient prominence in the

Wide-angle lenses provide an interesting change in perspective from what the eye sees. Here, the photographer intentionally distorts the saguaro by moving in close with a 24mm lens, thus making an uncommon image of a common Arizona subject. But beware of unintentional distortions when using wide-angles. Tilting the camera too far will make normally vertical subjects appear to lean toward the center of the frame.

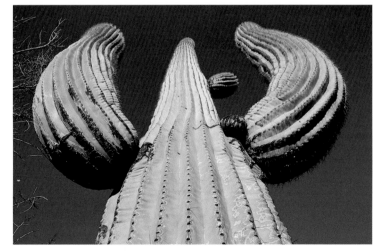

A reflection repeats the form and pattern of the sweeping curve of Rainbow Bridge, turning the arch into a circle framing a sandstone monolith. The image is a splendid example of a photographer taking advantage of bold compositional elements to make a strong, graphic image.

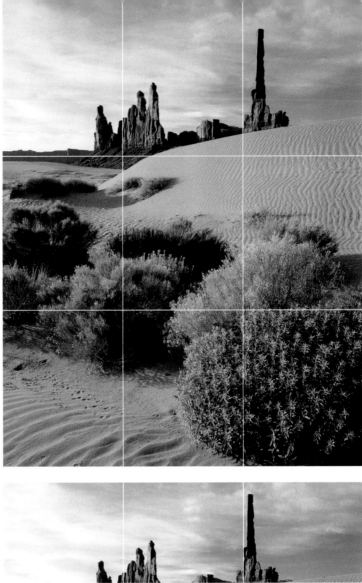

Traditional guidelines for balanced composition begin with the basic "Rule of Thirds." Both the vertical and horizontal compositions here divide the frame into three sections and place the main subject and other important elements (such as the horizon) along imaginary grid lines or at the points where grid lines intersect. This technique forces off-center placement of the subject, prevents the horizon from bisecting the scene, and leads to comfortable spatial relation-ships between compositional elements.

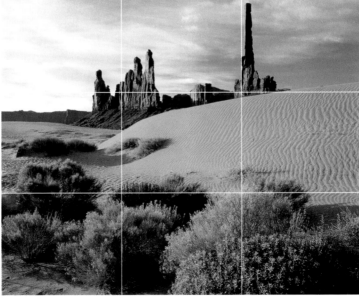

composition so that all other elements are subordinate. Even if the focal point is small, it can be given prominence by composing empty space around it.

Rule of Thirds

The exact center of any composition is an unsatisfying place for the viewer's eye to come to rest. With the main subject placed in the center, the viewer is less likely to explore the rest of the photograph because the mind doesn't sense any one instinctive direction in which to move. There's not enough implied "room" in any direction.

To promote eye movement in your photographs and avoid the static bull's-eye composition, use the Rule of Thirds guideline for off-center placement of the main subject (opposite page). This is the traditional way to create a well-balanced composition and has been used by artists for centuries. To apply the Rule of Thirds, imagine the scene in your viewfinder divided into thirds both horizontally and vertically, similar to a tic-tac-toe grid laid over the scene. (Some helpful digital cameras can overlay an optional grid on the viewfinder—consult your manual.) Place the main subject and other important elements of your composition along the grid lines or at the points where the grid lines intersect. Employing the Rule of Thirds not only helps avoid symmetrical composition, but it also will provide a pleasing proportion of space around the main subject to prevent distracting tension between the focal point and the edge of the frame.

A common compositional faux pas is positioning the horizon precisely in the middle of the frame, bisecting the scene. Remembering the Rule of Thirds, the horizon is best placed near one of the grid lines. This way, the photo emphasizes either a dramatic sky or an interesting foreground.

When photographing animals in the wild, making a pleasing composition is often secondary to just getting a shot off before the subject scampers away. Quietly working your way closer allows time to properly compose the scene. Find the angle and light direction that best displays the animal's features. Here, the deer is positioned at the point where two leading diagonal lines of the pond's edge intersect, directing the viewer's eye to the subject. A long telephoto lens is highly recommended for photographing wild animals sensitive to human presence (see Wildlife Chapter, Page 132).

Simplicity

The best way to present a clear message in a photograph is to keep the composition simple. The fewer elements you work with, the easier it is to design a pleasing image and orchestrate the viewer's eye movement. There are several ways to simplify a composition, but the primary technique is to move in closer to the main subject. Photojournalist Robert Capa, famous for his documentation of five 20th-century wars, said it best: "If your pictures aren't good enough, you're not close enough." (Tragically, Capa died following his own maxim when he tripped a land mine. That's worth remembering as you maneuver for a shot over a canyon rim.)

Whether you physically move the camera in or zoom optically, getting closer allows you to fill the frame with the subject, paring the composition down to its essential components. It removes visual distractions from the edges of the frame, eliminates superfluous elements, and defocuses the background. Although landscape photographers usually try to keep every element in sharp focus, that shallow depth of field sometimes is desirable. It helps to isolate the subject from a busy background by blurring objectionable clutter, and may even create soft pools of complementary color behind the subject.

Leading lines

Another compositional technique to create energy and movement in a photograph is the use of leading lines. Whether they are graceful curves or dynamic diagonals, all lines should lead the viewer's eye toward the focal point. In landscapes, leading lines might be sand ripples, a road or hiking trail, or even a dead branch on the ground.

But be careful. Leading lines can also work against you by directing the eye away from the subject or, if the line divides the photograph in two, leading it right out of the image.

Diagonal lines create visual energy in a photograph and lead the eye to the main subject. Including the prevailing lines of two fallen trees entering the frame from the lower right corner draws the viewer's eye up to the backlit aspen trees. But be careful when incorporating leading lines in compositions. If prevailing lines in a scene lead away from the subject, they will do more harm than good for a composition.

Horizontal or vertical?

Even the cheapest camera has more artistic potential than its owner exploits if it's never turned to the vertical position. Let the lines in the composition help you decide whether the scene should be shot horizontally or vertically. If it presents strong vertical lines, compose vertically to take full advantage of them.

With strong horizontal lines, a horizontal camera orientation makes good use of the long lines in your composition and helps avoid wasted space at the edges of the frame.

Other considerations

• Take notice of white or light areas in your composition. The viewer's eye will always go to the brightest part of a scene, so eliminate any bright spots that will pull attention away from the main subject.

• Look for repetition of shapes and textures. Patterns create rhythm and motion in a composition.

• Compose boldly using sweeping diagonal lines. Long, uninterrupted horizontal lines can be static and visually boring. Conversely, diagonal lines add

Landscape photographers often employ the "near-far" or "forced perspective" approach when composing for a scene with an interesting foreground and background (see Landscape Chapter, Page 118). Wide-angle lenses bring emphasis to foreground subjects, making them look larger than life, while minimizing distant objects. This balanced rock provides a forceful foreground for the repetition of similar rock formations in the background.

visual energy. Change camera angle to pivot prevailing lines so they don't run parallel to the top and bottom of the frame. If you're shooting a flat-roofed adobe house, for example, a straight-on shot will line up the parapet with the top of the frame. It will almost surely be more effective to move toward one of the house's corners, which will portray the roofline as a diagonal.

• Try using a wide-angle lens. Wide angles can provide a dramatic perspective change from what the eye sees, and they emphasize diagonal lines, which can be used as strong elements to create energy in a composition. Be aware, though, of unwelcome distortions. A wide-angle lens pointed up toward a cluster of saguaro cacti will make them all appear to lean toward the center of the frame. Intentional and extreme distortions, best created with an extreme wide-angle or fish-eye lens, can be intriguing.

• Think through the scene before you, from the ground right at your feet to the horizon and the sky beyond it. Composing with a foreground, middle ground and background with overlapping compositional elements creates the effect of three-dimensional depth in a two-dimensional photograph.

Using these basic compositional techniques can lead you to visual harmony. Of course there's the other side of the coin—how to successfully break the rules of composition to create dynamic tension or tell an unusual story. But it's important to know and practice the basics before deviating. After they have become second nature to you, begin to experiment. It's okay to break the rules, but do so knowingly. When you know and understand the basics of good composition, you are free to roam the spatial relationships within your viewfinder.

This photograph is all about lines, patterns, and textures, even though the truck is the focal point of the composition. The placid horizontal line of the road interrupts the repeating pattern of dynamic diagonals. Utilizing the Rule of Thirds, the photographer placed the road in the upper portion of the frame to keep it from bisecting the image and placed the truck left of center to avoid static, bull's-eye composition.

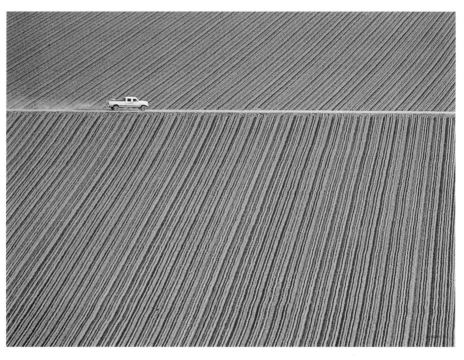

Close-up photography relies heavily on form and composition. Here, early light creates shadows, revealing patterns and textures on this organ pipe cactus shot at the Desert Botanical Garden in Phoenix.

Close-ups

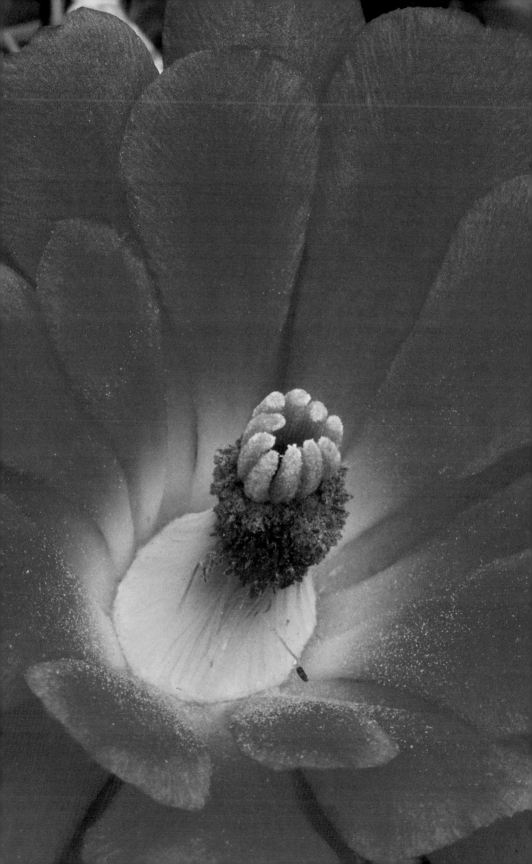

More expensive than extension tubes, but providing the added value of optics designed for close-up use, a macro lens from a quality manufacturer offers another good choice for producing close-up images. Again, the longer the focal length, the more comfortable the working distance from the subject.

Canon and Nikon both make very fine close-up lenses. Aftermarket manufacturers such as Sigma, Tokina, and Tamron offer serviceable choices. For best results, buy a dedicated macro lens. It will produce sharper photos than a 28 to 300 zoom lens with macro capability, because the optics of the macro lens are optimized for that one purpose.

Close-up photography on location is full of challenges, as any number of variables conspire to frustrate even the most dedicated photographer. The worst is wind. Even a slight breeze—no more than a breath of wind—may create enough movement in a delicate subject to seriously degrade the quality of the image.

The photograph of the Indian blanket flower here is a case in point. My assignment was to produce an image suitable for the cover of the *Arizona Highways* wildflower guide. I had a tight deadline, and although it was early in the season, I found one example in bloom at the Desert Botanical Garden ✾ in Phoenix. I set up my 4x5 view camera to photograph the silver dollar-sized flower larger than life-size and exposed 10 sheets of film. After processing, however,

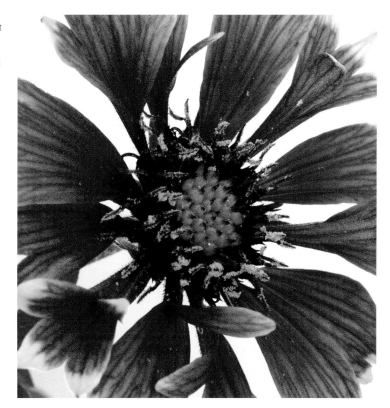

This Indian blanket flower was shot with a 4x5 view camera by Richard Maack in pre-dawn light at Phoenix's Desert Botanical Garden. Backlit from the eastern sky, the exposure was six seconds at f/32. Because of the length of exposure, a slight breeze caused flower movement in nine of 10 sheets of film.

THE BASICS

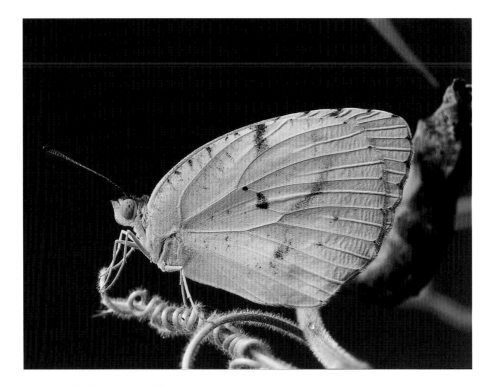

concentrate on those that produce high-quality images and give the biggest bang for your buck.

The bellows and focusing rail combination, along with a flat-field lens designed for macro use, provides the ultimate in macro-photography quality. However, such a setup can cost well over $1,000. An economical alternative is a meter-coupled set of three extension rings in various sizes (coupled together to make a tube, or used individually, or in pairs). This will probably cost less than $150. Extension tubes contain no glass, so unlike using close-up filters, there's no degrading of optical quality from additional glass.

Extension tubes work by moving the lens farther away from the image-capture surface or film plane, thus increasing the size of the image circle. If you think of the image circle as the base of a cone of light extending from the back of the lens, moving the lens away makes the cone bigger, enlarging the subject projected onto the capture medium.

Extension tubes can be used with almost any lens, but longer lenses in the telephoto range provide the flattest field of view and offer a more comfortable working distance from the subject than shorter focal length lenses. I've had good success—and many published photographs—using an old Nikkor 80-200 mm f/4 zoom coupled with an inexpensive set of extension tubes.

With extension tubes mounted on the camera, you'll no longer be able to focus the lens to infinity. You'll use them for close-up work, then remove them and mount the lens normally for other types of photography.

The photo of the orange butterfly was essentially made in the same plane of focus (parallel to the film plane or sensor) so that virtually everything is sharp. This is an important consideration when thinking about the final composition of a close-up. JIM HONCOOP

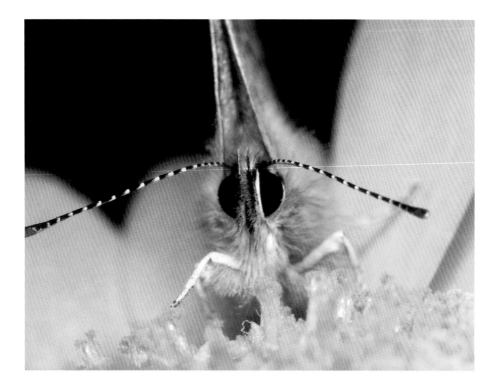

landscape, combining individual images from the macro-photographs at his feet to views of the towering mountains in the distance—and everything in between. Most of the close-up photographs were images of plant life. In showcasing the grand and not-so-grand together, Muench crafted a visual story in which the whole became greater than the sum of the parts. Accomplishing this feat by illuminating his narrative with images not normally covered while photographing a grand landscape, Muench helped bring a visceral sense of immediacy to what might otherwise have been a series of cool and iconic scenic photographs.

Few of us can match David Muench's technique or artistic vision, but we can go a long way by training ourselves to see nature as he does.

The way we use light in a photograph helps to establish mood and create an emotional response. When we manipulate that mood, we become artists. Likewise it is with patterns. Nature provides the architecture of a leaf or flower, but the point of view and the composition we create in the camera offers it to the world as a uniquely human work of art.

Equipment and technique

Viewing the world in photographic close-up requires a technical strategy to make it happen. There are a number of different equipment approaches possible for 35mm close-up photography—close-up filters, macro lenses, bellows and focusing rail, extension tubes, reversing rings, and tele-extenders. But we'll

Learning to See

Text and Photographs by Richard Maack

GARY LADD, A SUPERB LANDSCAPE PHOTOGRAPHER who wrote about the Grand Canyon and Colorado Plateau for this book, once said something that has stuck with me: "All photography is about patterns."

Those patterns are vividly apparent in Gary's grand landscapes of the Colorado Plateau, from the sweeping parallel lines of ancient sand dunes to the swirling dances of light and form in the walls of a slot canyon. But they also exist in the world of individual leaves, flowers, stems, dewdrops, and spider-Webs, where, with a modest investment of extra equipment and effort, a photographer can discover a whole world of new subjects, stories—and patterns.

Our brains seem to be wired to respond positively to visual repetition, just as we prefer music with a clear rhythmic pattern. Maybe there's a sense of security in discerning the underlying order of things, or simply reassurance in knowing that there is an order.

Whatever the case, patterns can add strength to a composition and provide the visual anchor necessary to help keep viewers interested in a subject. And botanicals, in particular, provide excellent images of repeating patterns. Close-ups are especially compelling because they offer an entry to a world usually not seen. The veins of a cottonwood leaf. The claw-like spines of a barrel cactus, guarding its delicate flowers. The bark of a ponderosa pine. These botanical patterns exist all around us, at all levels. We only need to look for them.

Photographic seeing

Abandoning a tendency to see the world within the limitations of human scale and looking for images in the very small, or the very large, broadens the subject matter available to us as photographers. This is especially true in photographs of botanical subjects.

Practice by viewing a scene in a linear fashion—from close-up, to near-foreground, to mid-ground, to distance. This provides a useful exercise in opening up new visual possibilities. Considering how these elements work together to form a whole reveals the pieces of the narrative puzzle.

A few years ago, I was lucky enough to be the photography editor for an *Arizona Highways'* book by David Muench titled *Vast & Intimate*. Muench's concept was to create a visual narrative spanning the totality of a particular

Shot with a 100mm macro lens, the composition of this image draws the eye immediately to the stigma and style of this claretcup hedgehog bloom. The natural deep red lines formed by the petals direct the viewer into the contrasting yellow and green hues.

I discovered that only one of the images was acceptably sharp. The magnification of the subject accentuated the effects of an almost imperceptible breeze, ruining nearly every photograph.

There are quite a few approaches for dealing with wind and subject movement in close-up photography—bracing the subject with attenuated arms attached to the tripod, building a windbreak, or even taking the subject indoors. Since I like to travel as lightly as possible in the field, none of those solutions works for me. I have, however, developed a strategy to maximize my possibilities for sharp close-ups outdoors.

When I'm photographing plants, I usually try to arrive about 30 minutes before sunrise. The soft pre-dawn glow creates open shadows and gentle contrast, generally producing nicely saturated photographs (this look may be approximated at other times of the day by using a diffuser between your subject and the sun). The primary benefit, however, is the stillness of the air before the sun begins to heat the air and convection stimulates morning breezes. (Winds will also calm down for a short time after the sun sets.) After the sun rises, I switch to longer views where a little movement is more tolerable.

Water in the form of dew or lingering raindrops on plants is usually a blessing rather than a curse. Leaves are glossier, colors more saturated. Bugs may challenge the photographer, but if they can be persuaded to alight in the right place (and stand still), they can add interest and drama to a composition.

The proper use of light and depth of field are critical to making a fine image, especially close-ups. The top image was shot at f/22 in bright sunlight. Notice the highlights on the flower petals and the distracting patterns in the background. The bottom photo is of the same flower in shadow with the lens opened to f/4. This reveals more detail in the bloom and softens the background clutter due to the shallow depth of field.

Depth of field

A critical consideration in close-up photography is depth of field. The area in focus in a macro photo of a flower with a wide-open lens may be only millimeters deep. Because of this very limited depth-of-field, where we choose to place our point of focus becomes a very important element. My rule: Keep the tips of the stamens or pistil of the flower sharp.

The stamen(s) or pistil function visually like the human eye in a portrait. As long as the eye closest to the camera in a head-and-shoulders portrait is sharp, everything else can be soft, to some degree, and viewers will forgive it. The same holds true of the pistil or stamens of a flower.

Close-up photography offers a wealth of easily accessible subject matter and the joys of an infinite variety of creative choices in their exploration. The fact that, unlike many other forms of photography, economical options are available for equipment, makes it even easier to enjoy. Just the process of making an image in close-up opens a wonderful world outside the tumult of everyday life. Looking into that world with a camera provides a vision beyond human limitations and a window to not only the subject, but our own creativity.

Types of Photography

Misty View: From the Grand Canyon's North Rim, the North Kaibab Trail overlooks an eerie cover of fog.

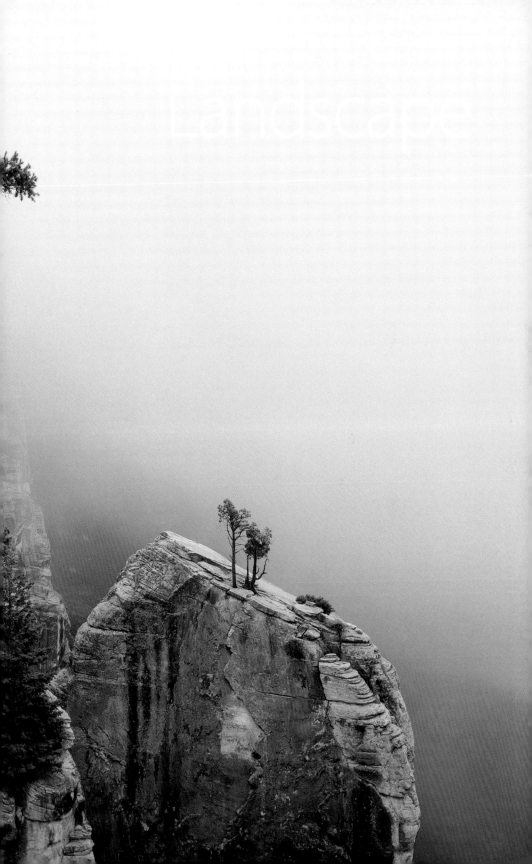

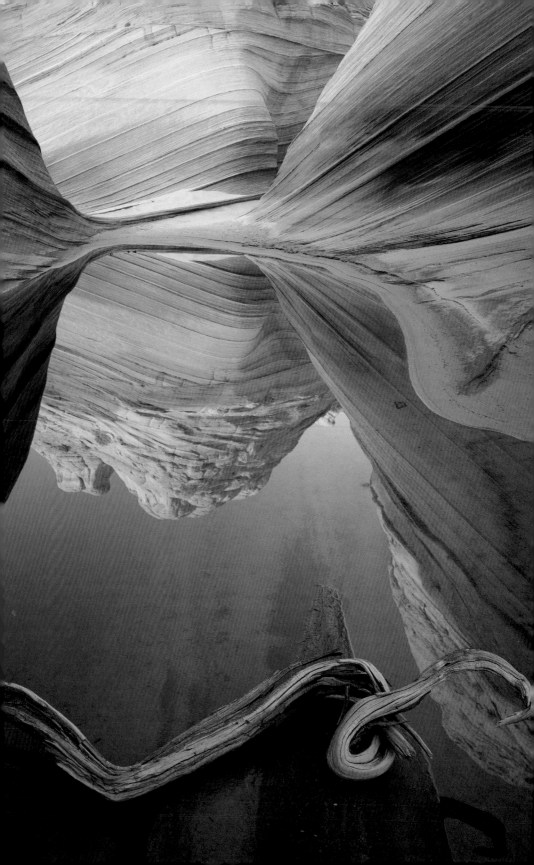

Understanding the Land

Text and Photographs by Jack Dykinga

W<small>E</small> PHOTOGRAPHERS ARE AN ARROGANT LOT. We speed across the land thinking we can capture its magic and do it all on our preconceived schedules.

I am no different. However, during my more than 30 years as a landscape photographer, the land has taught me to use my eyes to truly appreciate its message and then bend to its will.

One morning on the Colorado Plateau ✳, I awoke in the pre-dawn hour and jolted myself to life with strong coffee to begin my trek up a sandy wash. I was trying to beat the sun to a section of striated cliffs and salmon-colored petrified sand dunes. With any luck the effort would pay off and I'd record the crimson first light coloring the stone. Three miles later, it became painfully clear that the sun had won the race. The crimson phase came and went, and I lumbered in half an hour late. My friend, noted photographer Jeff Foott, would simply say: "You're late for work."

I repeated the same process the next day, this time managing to win the race. I discovered a bonus: pools of water amid the petrified dunes. Hurriedly I assembled my camera and tripod—just in time for the day's wind to spread the first ripples across the pool's surface, ruining the reflection I was trying to record. I muttered sailor's terms as I plodded back to my camp.

Several more trips netted similar results, near-misses all. Still, during my many visits, this spot on the Colorado Plateau became a favorite stop whenever I headed to northern Arizona. Every time I visited, the conditions were not quite the same and yet not quite right either. The wind was blowing, the sun didn't emerge from the clouds, or there was no water in the pools. Once, my entire camera, lens, and tripod took a very interesting dive (degree of difficulty: 1.7) after a dust devil turned my focusing cloth into a sail, sending the complete package 25 feet down a cliff face.

Then one time, driving home from Salt Lake City with a new camera, I decided I could detour to the trailhead and arrive by midnight. I would give the place one more shot. Four hours later, I was kicking sandy steps up the dunes, slogging toward my favorite spot. The hair on my neck fairly bristled as before me appeared a mirror-like surface on a pool, perfectly reflecting the banded sandstone as well as a curled root resting on the shoreline. Within minutes, my

Layers in Time: Like petrified dunes, the layered sandstone rims a pool in Paria Canyon ✳ in the Arizona Strip. The piece of driftwood in the foreground anchors this magical reflection.

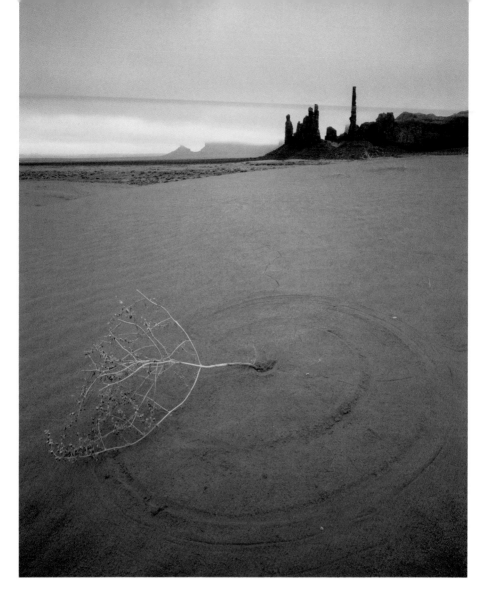

Clock of Sand:
A windblown
tumbleweed
scribes a clockwise
arc on the ground,
with Monument
Valley ✛ formations
in the background.

trembling hands pushed film in and out of the view camera as the sun painted the scene with lurid color. This image remains one of my favorites, and it taught me a fundamental lesson: You can't simply charge into the natural world and impose your schedule on it. It'll happen…when it happens.

The long road to this picture also taught me to get to know my subject. How arrogant I was to think I could simply drive up to a place and capture its essence without first spending time to understand and truly see the land.

Nowadays, I have a ritual upon arriving at a new location that involves walking around without a camera for as long as it takes to learn my way around. I scan the landscape for nuances in patterns, juxtapositions of colors, plants, and telling details like animal tracks and wind-sculpting. Though

All in the Hands:
Photographer
Jack Dykinga
illustrates his
framing
technique.
CHRIS RICHARDS/
ARIZONA DAILY
STAR

my children often ridicule me, I also pin a compass to my cap to gauge the sun's position at sunrise and sunset. I walk completely around favored compositions, trying to align a pleasing foreground and background, always with an eye to where the next sunrise or sunset will illuminate my hypothetical composition. I lie prone, trying to envision a low-angle image or climb a hill to envision grand overviews. All this time, I'm editing my growing mental list of potential images. The idea here is to compile favorite scenes in anticipation of the perfect light. I try to plan how to maximize the scene-setter overviews, the details, unique plants, anomalies, and interesting rock formations, as well the mix of colors before me. I call this "working the scene." Not only am I pre-visualizing the compositions, I'm also anticipating the ideal mix of images in a magazine layout. I try to tell the story of the place visually with photographs. If I'm successful, the reader will not only see what I saw, but hopefully feel what I felt when I captured the image.

By creating a rectangular window with my fingers, I visualize possible photographs. It helps me to isolate compositions from the surroundings. The sheer simplicity of this finger-framing makes for an intimate encounter with the landscape. Potential scenes are thus filed away in memory as visual notes for later action. I need to decide which scenes and which compositions will have the best chance of success in the brief moments of the prime evening or morning light. Even though I'm working with a time-consuming 4x5 view camera, I believe the same philosophy applies to photographing with a digital SLR that can record five frames per second: Think through the situation well in advance and commit to a single scene for that perfect moment when the light kisses and the muse whispers.

Cool and warm

Arizona's vast, empty vistas with sparse plant life allow the "sweet light" of early morning and late afternoon to sweep across the land without obstruction.

We are provided with a wonderful mix of cool blue-hued shadows and warm red-toned swaths of sunlight. That tonal juxtaposition has shaped many of my favorite images. The texture of the land is emphasized as horizontal illumination turns shadows into design elements.

We are also blessed with hot, dry, and clear desert air that sucks the mois-

Filtered Glare: On the San Carlos Apache Indian Reservation, a juniper tree's branches catch the sunlight and send out shadows.

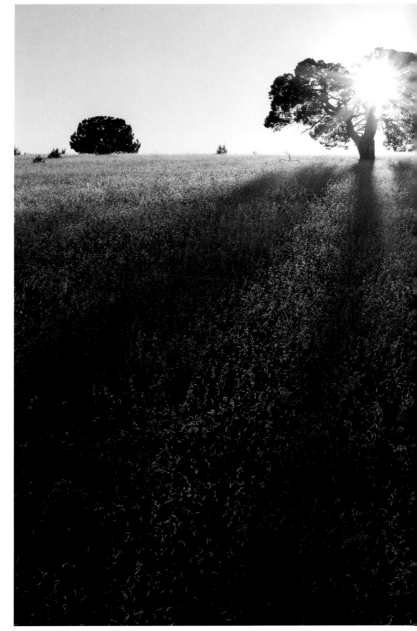

TYPES OF PHOTOGRAPHY

ture out of monsoon storms as they collide with the driest deserts to the west, leaving a clear path for the setting sun to illuminate those same clouds. The result is the classic blood-red Arizona sunset that can stop traffic or cause readers to write *Arizona Highways* claiming such colors cannot exist in nature! They simply can't believe the images haven't been altered.

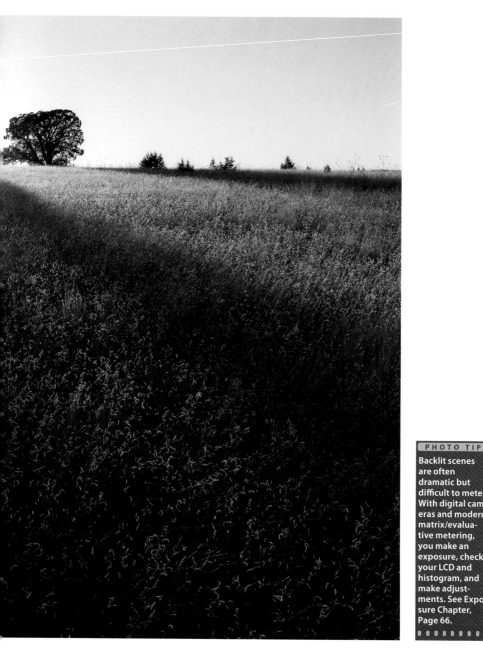

PHOTO TIP

Backlit scenes are often dramatic but difficult to meter. With digital cameras and modern matrix/evaluative metering, you make an exposure, check your LCD and histogram, and make adjustments. See Exposure Chapter, Page 66.

Desert Color:
Sand verbena and ajo lilies adorn the Mohawk Dunes ✤ in Yuma County. The use of the verbenas in the lower part of the frame and the high horizon are key elements to this image.

Ask any great landscape photographer what conditions yield the best images and you'll likely hear: "during or just after a storm." The land becomes exciting on a visceral level when the clouds swirl and the winds howl.

I remember sloshing down the North Kaibab Trail ✤ from the North Rim of the Grand Canyon during a light rain. It had rained all night and layers of fog engulfed the Canyon, but there were signs the storm was lifting. I coaxed my friend Linda Caravello to join me as the "official umbrella bearer." We hiked into the Canyon, descending the first few hundred feet in a virtual white-out. When the rain began to diminish and the spires started to poke through the fog, I dropped my pack, mounted the camera on the tripod, and began burning film, working under the flimsy protection of the umbrella. And working fast! All the earlier advice about being slow and methodical vanishes when the light and weather scream Right Now! The best you can hope for is that all those years of practice, of going slowly and carefully creating compositions has become imprinted in your brain.

On another occasion in Organ Pipe Cactus National Monument ✤, I could smell the ozone after a volley of lightning strikes. I was literally running, trying to line up the setting sun behind me with the onrushing monsoon storm in front. Between worrying about running around with a three–legged lightning rod in my hands and staying ahead of the storm, I had no time or inclination for a slow, deliberate set-up. I quickly composed an organ pipe cactus in front of me and framed it with a rainbow cutting through neon-orange sky. The wind

ripped at my rain parka and the cactus arms swayed, but amid the several 15-second exposures were some well-timed lightning strikes. It was one of those times that Nature chose to cooperate.

Photographers often experience the equivalent of writer's block when confronted with such strange and grand landscapes as Arizona's, offering visual opportunities in every direction. They can freeze up from visual over-load, not even knowing where to begin. I have found that concentrating on small details and mid-range compositions is a great way to "break the ice." By visually dissecting the landscape using long focus or telephoto lenses to carve out smaller, more intimate compositions, I become un-blocked. I also begin to see the compositional relationships of the design elements, which helps me to better understand the location. For example, I can use a wide-angle lens to emphasize the foreground details and still portray the grand landscape in the background.

Attitude and equipment

Modern cameras have evolved into complicated machines that react to fast-changing conditions with remarkable speed. They autofocus, auto-expose, and even make logical assumptions about the photographer's intentions. They can do just about everything but "see." Unlike photographing wildlife, people, and sporting events, landscape photography is a slow, contempla-tive process. You almost need to fight your camera to resist the urge to work faster. Where many photographers squeeze off a burst of exposures to edit later, landscape photography requires the editing to be done in the camera. You don't edit the light.

With my heavy, cumbersome large-format 4x5 view camera, going slow is never a problem—it's a way of life! Its basic technology has not evolved sig-nificantly since Matthew Brady lugged his ancient camera around Civil War battlefields in the 1860s. It's virtually "bolted" to the ground on a heavy tri-pod. It has 20 ways of focusing and adjusting the plane of focus or perspective. It requires a dark cloth draped over my head to enable a careful view of the glass focusing screen. The image is inverted, which actually helps me reduce the scene to a mix of design elements rather than a literal representation. That keeps me concentrating purely on the composition. Everything is slow, noth-ing is automatic—and that's not bad. I am content with one or two very high-quality images per day.

Under the focusing cloth, the outside world disappears. Alone with the inverted image before me, I am free to create a composition without distrac-tions. Before me, a ground-glass focusing screen becomes my blank canvas, which I can fill with the composition of my choosing. I can "see" how my eye travels through it, following highlights. The corners in the frame and the layers of design patterns become instantly apparent. I eliminate the extraneous sim-ply by moving the camera closer or backing away to crop out distractions. Each slight adjustment and re-framing of the subject gradually perfects the composi-tion. The real challenge is to carefully compose the image and still work fast enough to capture rapidly changing light!

Sprawling Twigs:
Against the sandstone in Vermillion Cliffs National Monument, right, manzanita branches sprawl like grafitti.

No matter the format in either digital or film, concentration and solitude help create the most memorable images. I escape under the focusing cloth, but any photographer can concentrate on composition simply by using the depth of field preview button, which displays the image essentially as shapes and design. Shielding the camera from intense light with a jacket allows better concentration on design elements on the glowing LCD screen or in the viewfinder.

The foundation for my landscape photography is deeply rooted in the idea of telling the story of the land through photography. I started out as a photojournalist, and I still see myself in that role. I want to express myself while presenting as much information as possible. My tool of choice is a 4x5 Arca Swiss F field camera. Its precision adjustments and inherent stability allow me to accurately record the landscape with amazing clarity. Combined with the sheer size of the film (each transparency covers 20 square inches) it can capture every detail and can record the staggering equivalent of 500 megapixels of information.

Looming Tall:
The white-barked trunks of quaking aspen trees in the Apache-Sitgreaves National Forests, below, frame a blooming New Mexico locust.

Because accurately recording the detail within the landscape defines my work, I prefer small lens openings to achieve an image with extreme sharpness from very near to infinity. A typical exposure would be f/45 with the shutter open for 10 seconds or longer. I use six of the finest Schneider lenses available, ranging from a very wide-angle 58mm to a 400mm telephoto (equivalent to 16mm and 180mm on a 35mm SLR). With wide-angle lenses, I can emphasize the foreground by increasing the relative size of objects close to the camera.

TYPES OF PHOTOGRAPHY

In contrast, my telephoto lenses can compress the foreground to the background, stacking one against the other, creating an image where both foreground and background objects appear closer to each other. This is particularly useful when I am trying to portray the immense scale of my subject. For example, a saguaro silhouetted against a huge monsoon storm, when photographed with a telephoto lens, emphasizes the immense size and power of the cloudscape.

Since film, digital, and the human eye all see color differently, I generally employ several filters both to correct color imbalance and polarize the light to minimize reflections. I like the warming-polarizing filter. It cuts the inherent blue/cyan cast while emphasizing rich greens in plant life and can dramatically darken the blue sky, making puffy clouds appear three-dimensional. Slight warming is a good idea to combat the gains in blue tones during long exposures or when photographing in shaded areas deep in canyons with indirect light. There are several warming filters in varying strengths to choose from with the earlier letters indicating lesser degrees of warming: 81A, 81B, 81C, and the 81EF. Another warming filter with a very slight effect is the Tiffen 812 filter (similar to the 81A, but possessing a different color balance using slight magenta warm tones). I usually carry both the Tiffen 812 and the B+W 81EF filter and use them according to how blue I think the light may be, with the 81EF being my choice in blue-hued deep canyon light.

Sophisticated digital cameras have white-balance controls that compensate for these different color temperatures, and every photographer will have to experiment to find out what works best. Whatever the equipment, though, my guiding philosophy would be to strive for an honest representation of the scene's colors. I also believe that it's always better to do it in the field during capture rather than trying to manipulate images in Photoshop. And on that topic, I don't add or subtract elements on the computer. It's a debatable choice, but my decision is one that defines me as a photographer.

I have learned that scrambling to find a piece of equipment in the midst of fast-changing light makes landscape photography needlessly difficult. So, I carefully organize my huge Lowepro Super-Trekker pack with every piece of equipment easily visible and accessible when I open my pack. Everything is at my fingertips.

The new lightweight carbon fiber tripods are truly wonderful. Mine is a Gitzo 1325 tripod that is matched to my camera's size and weight, the ideal combination of stability and weight. That's the crucial decision a field photographer must make. You need to balance the weight, stability, and security of a really strong platform against the fact that you'll need to lug it across the landscape.

A photographer's ethic

The very best thing about photography is not the planned and preconceived notions, but the unexpected surprises that happen along the way. Serendipity, combined with listening and loving the place, have conspired to produce my best images. I consider them gifts.

However, I believe that with these gifts comes a responsibility to not only accurately portray the places, but also to help insure their future existence. I

have watched supposedly timeless features of the landscape become degraded by overuse and commercial exploitation. I have seen places where photographers have "improved" a composition by physically cutting or digging up vegetation or have covered up man-made deterioration through the liberal use of Photoshop. I have seen trails worn into fragile slickrock sandstone and loud arguments between competing photography tours in slot canyons. I worry that my images will bring throngs of less sensitive visitors into fragile places. Elliot Porter photographed an unknown canyon in a book entitled *The Place No One Knew*. Nobody knew Glen Canyon, and now it's buried under Lake Powell ✤. I can only hope that the more people intimately love and respect the land, the better are the chances of preservation.

I came to landscape photography via a long journalistic path that drummed into my head the ethics of that profession. Above all, telling the truth and respecting the subject remain my mantras. You will have to make your own discoveries, chart your own path, and find your own vision. I hope you'll just remember this: A photographer will never go wrong by loving the subject and treating it honestly.

Clean Background: As he was scouting osprey nesting locations, wildlife photographer Tom Vezo noticed that the birds of prey often lighted on this snag. So he positioned himself to catch the action. Jutting upward, the barren branch provided a clean, simple sky background. The photo was made with a 600mm lens.

Wildlife

Practicing Patience

Text and Photographs by Tom Vezo

EARLY ONE SPRING MORNING, photographically trolling near the Santa Rita Mountains ✤ south of Tucson, I noticed in the distance the top of a saguaro, oddly alone, apparently the only one around for miles. Knowing that this would probably be a good nesting site for one of the several bird species

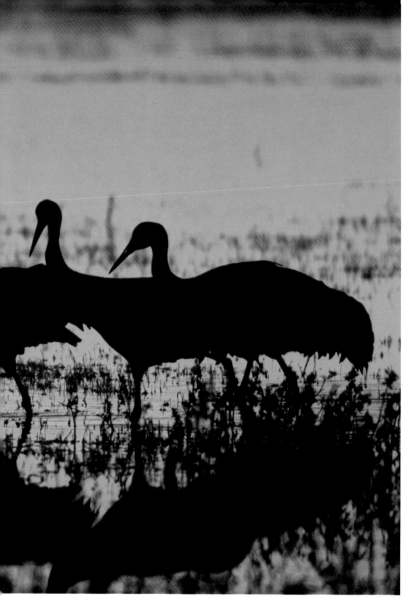

Colorful and Moody: This silhouette of sandhill cranes was made just before sunrise at New Mexico's Bosque del Apache National Wildlife Refuge. In early or late light, the water reflects the sky's warm color.

that like to homestead in saguaros, I parked my truck a quarter-mile away and hiked toward it. As I approached, I heard the familiar cackling of a Gila woodpecker. Then two American kestrels began flying around me, and I realized this same saguaro served as their home as well. I looked up, and there was a *third* neighbor, a gilded flicker, nesting near the top. And every one of the birds' nest holes were facing east, perfectly posed for a morning shoot.

Sometimes you get lucky, but this was over the top.

I desperately wanted to avoid scaring any of the residents, so I quickly set up my blind about 30 feet away and left the area. In two days, I figured, they would get used to the structure.

Ready to Shoot: Tom Vezo normally goes after wildlife with a Canon 1Ds Mark II digital camera with 600mm lens mounted on a Wimberley tripod head and an L.L. Rue umbrella-type blind that sets up in 30 seconds. The small blind conceals the photographer, chair, camera, and tripod.

Before sunrise on the third day, I hiked in with my camera and 600mm lens. The noisy woodpeckers detected my approach and alarmed the whole neighborhood, but after I settled into my blind they calmed down and began feeding their chicks. In a few moments I heard the kestrel call, and there he was, perched atop the saguaro with a headless lizard in his talons. I was literally vibrating with anticipation, shaking so severely that I blew the first four shots. But the kestrel stayed in that position for about two minutes, giving me plenty of time to regain my composure—and shoot dozens of frames, even experimenting with different compositions.

I returned to the saguaro condominium almost every day for the next couple of weeks, until all the chicks fledged. Some mornings the breakfast hour was so full of action in all three avian households that I could hardly decide which to shoot. I was working on a new book, *Birds of Prey in the American West,* and these photos made wonderful additions to it.

Luck? Absolutely, in stumbling onto that lone, overpopulated saguaro. But the three real keys to successful wildlife photography are putting in the time to find your subjects, getting to know their habits and habitats, and then patiently spending time photographing them. I'm still working on that four-shot loss of composure, hoping to prune it to two or three.

Equipment

First, let's talk gear. I use a 35mm Canon system for wildlife photography, and my primary lens is a Canon 600mm F/4 lens mounted on the tripod. This lens enables me to keep a good distance from my subjects without alarming them. It also allows me to capture my subjects larger in the frame, which makes for more dramatic photos. Alas, such lenses are breathtakingly expensive—currently about $7,500 to $9,000.

The minimum focal length I recommend for wildlife photography is a 400mm lens, with the fastest f-stop you can afford. (The smaller the number, the faster the lens. An f/4 is faster, and more expensive, than an f/5.6). A 1.4X or 2X teleconverter is always useful. These increase the effective magnification of the lens by 1.4 or 2 times its focal length, so a 600mm lens with a 1.4X converter attached becomes an 840mm lens. Teleconverters from the same manu-

facturer as your lens are best. My 1.4X Canon loses almost nothing in image quality. Aftermarket teleconverters are less expensive and may work well, but make sure you can return them if they don't meet your standards for sharpness and contrast.

Note that the use of the 2X converter will work best if your lenses have "image stabilization" (Canon's term) or "vibration reduction" (Nikon's). This is true of big telephotos from 400mm up, as well.

As of this writing, we still have the choice of shooting with film or digital capture. However, it won't be long before the use of film is a rarity. I have been shooting digital for a while now and find many positive aspects, especially for photographing wildlife. Digital cameras allow me to shoot quality images at ISO 200 to 400, while 35mm film with those speeds begins to show too much grain for my liking. These higher settings allow faster shutter speeds in low light and help tremendously with fast-moving subjects such as birds in flight. They offer more depth of field when I need it and provide more latitude in lighting and exposure. And you get to review your images immediately. There's nothing like shouting, "I nailed it!" seconds after you shoot a photo. (In wildlife photography this will generally scare your subject away, so shout internally).

One of the negative aspects of the digital life is the back-end work at the computer. I shoot in RAW mode, so it's extremely time-consuming to edit and process all the images I bring home. Shooting in RAW is a must for the professional as it captures the most information in the image file. Shooting in JPEG mode makes life a lot easier and is usually no problem for the amateur photographer.

With monster lenses like my 600mm F/4, a sturdy tripod is absolutely essential. A monopod just doesn't provide the necessary stability. I do hand-hold the much smaller and lighter 400mm F/5.6 for birds in flight, which allows me more flexibility than shooting from a tripod. I suggest you buy the best tripod you can that is lightweight but sturdy enough to support the weight of the camera and lens you are going to use. In general, the longer and heavier the lens and camera, the heavier the tripod you'll need. The tripod head is also an important item, and another in which buying cheap is false economy. I use a Foba Superball head or Wimberley head for fast and easy maneuvering of my long lens. Keep away from the heads with tri-mode handles. Even though they are less expensive (sometimes they come with the tripod) they are complicated and slow to use, and you will eventually buy a ball head or Wimberley anyway!

How to carry your gear? Many wildlife photographers find a photo vest, festooned with pockets for extra film or flash cards, lenses and teleconverters, sunscreen and bug spray, to be more useful than a backpack—it provides fast access to most of the things you need. Still, don't lug too much "stuff" into the field, as it can slow you down with too many decisions to make and limit your hiking range. Functionally, less is more.

Another indispensable item is a beanbag or window mount for resting your lens when shooting from your vehicle. Using your vehicle as a blind is very

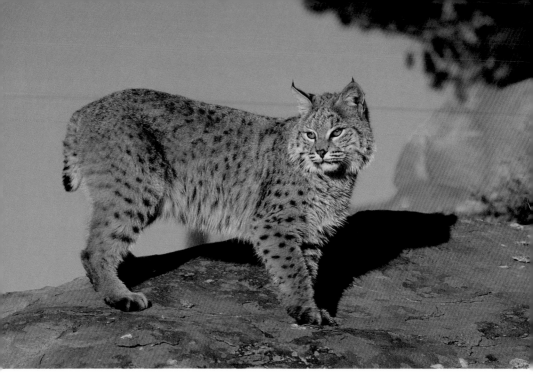

productive, as most animals are accustomed to cars and see them as no threat. I use a large bean bag, draping it over the open windowsill and placing my lens on it when I'm ready to shoot. This gives me a stable platform from which to photograph. I also use a panning plate when I shoot from my vehicle so I can pan left and right without resistance. It has an Arca Swiss-type mount that attaches to the quick-release plate on my lens. This allows me to get on my subject much faster and smoother.

Although I prefer shooting in natural light, sometimes I have to use flash. It's essential for night photography of owls and bats, and it's also useful to fill in the shadows that fall on creatures under bushes and trees. Besides the flash unit that fits my Canon system, I employ a couple of accessories to enhance my flash photography. I use a Wimberley flash arm that attaches to the lens quick-release plate to keep the flash 8 to 10 inches above the camera, which reduces or eliminates red-eye. I also use a flash extender, which employs a Fresnel lens (just like the ones in lighthouses) to magnify the light and extend its reach. This unit allows me to light up a subject 60 feet away, triple the normal reach of a flash.

Finding your subjects

Passion, patience, and persistence: these are the three qualities that you'll always find in successful wildlife photographers.

When I discover an area that has good potential for wildlife photography, I keep going back until I get the image I envision. It's this vision that keeps me motivated—that's the "passion" part of the equation.

The "patience" begins with scouting. When I first get to an area, I look at

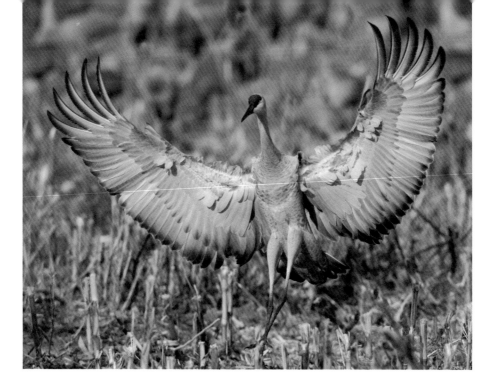

where the light is coming from. For most of my photography I like to keep the light behind me. Is it a morning or afternoon shoot, or both? What do the backgrounds look like? For me, backgrounds are as important as the subjects. If they're too confusing or bright, I usually won't shoot in that area.

Then I study the other creative potential in the vicinity. What color will my backgrounds be? If they're typically blurred green or tan, will that make my likely subjects pop out, or will it camouflage them? Once I start shooting, I begin to see other possibilities, and then I try to implement a plan to capture that potential.

An example from my own back yard, literally: I wanted to capture an image of the Cooper's hawk that often frequented my yard to prey on the smaller birds at my feeders. I knew the hawk would like a high perch from which to chart its hunting strategy. I put up a saguaro skeleton where the light would fall behind me in the afternoon and the bird would stand out against blue sky. The saguaro skeleton would give the feel of the desert and add color and texture to the image. I set up my blind in the afternoons and on the fourth day I got exactly what I wanted: a beautiful adult Cooper's hawk in the warm afternoon light.

When you've spent a couple of hours waiting for your subject and your patience is beginning to wear thin, stay another 15 minutes, and then another and another. Every investment of time gives you a better chance of getting what you want. My anticipation usually prevents me from getting bored, and I'm always watching other things going on at the location.

Patience, sprawling from hours into days and weeks, equals persistence. The key is to keep going back to a promising location because every day brings

Being Aware: With the wind and sun behind him, photographer Tom Vezo noticed sandhill cranes flying in very close to a road. Realizing that birds land with their wings into the wind he quickly relocated and captured this image. Being aware of your surroundings is key to good wildlife photography.

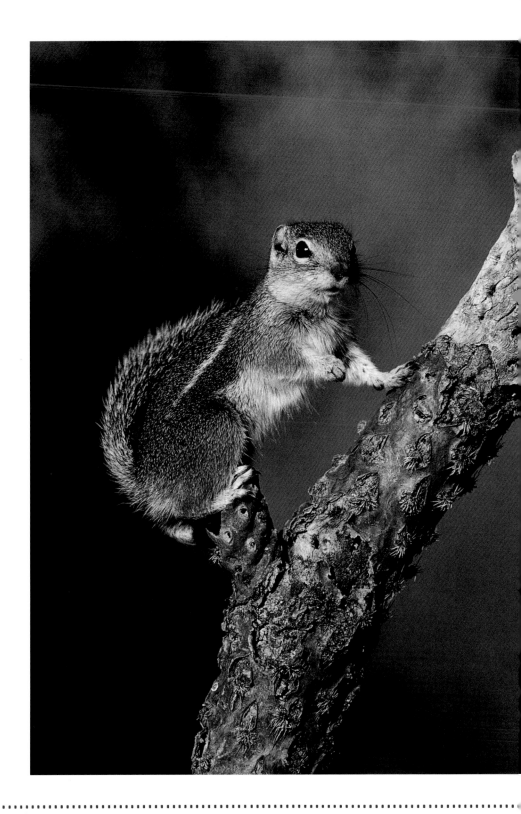

TYPES OF PHOTOGRAPHY

new possibilities. Animals' routines and interaction with each other is no more predictable than that of our own species. When I'm photographing my subjects, I try to capture every kind of event in their lives—feeding, courting, copulating, fighting, interacting with their young, chasing, fleeing, flying, and maybe even sleeping. Actions that tell stories about animals' lives are potentially more interesting than simple portraits in good light. However, I'm never averse to an expressive portrait, either—it can express character and provide an intimate look at the beauty of a wild creature that we seldom see so closely.

Leave Room: The photographer was careful not to frame this Harris' antelope squirrel too tightly, thus reinforcing the reality that it's in the wild with room to roam.

Finding subjects to photograph can be very easy or extremely difficult, depending on the species. The easiest venues are those where wildlife is accustomed to people: National parks, state parks, city parks, and zoos. These are good places to hone your skills in composition and exposure, as well as learning your equipment. Your own back yard is one of the best places to photograph wildlife. Put out some food and water, build a couple of perches near your source, and sit and wait with the light behind you. If you put bird food in your back yard, they will come. You may want to use a blind.

Driving the back roads of Arizona with your equipment on the seat next to you, again in the early morning or late afternoon, can be very productive, but your approach must be slow and easy. I typically drive about 10 miles an hour.

Another way to find your subjects is to seek out natural food sources that birds or mammals will come to, such as fruit-bearing plants and trees. Research is important. The Web is a great place to start your research or to plan your trip. You can learn dietary habits, when migration starts, when and where nesting takes place, times of sunrise and sunset, and more. Regional nature guidebooks such as Roseann and Jonathan Hanson's *Southern Arizona Nature Almanac* and the Peterson *Field Guide to Western Birds* are very helpful. It's important to know what you've photographed, because inevitably, someone will ask! With enough dedication and patience, you'll be able to consider yourself a photographer and a naturalist.

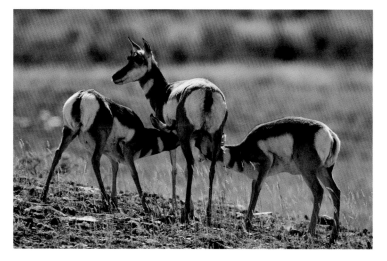

Patience Pays: Capturing animals in action tells a story. The photograher shot these pronghorns from his truck with a 600mm lens resting on a beanbag. He waited for hours for something to happen, and it finally did.

If you're visiting a park or wildlife preserve, call ahead to find out what's around and learn about any restrictions. Always abide by the rules of the parks and, if you see something of interest on private land, obtain permission from the owner before you enter.

Finding nesting birds or mammals is a good way to photograph wildlife. If you find an active nest or den, keep a reasonable distance—the presence of humans can cause parents to abandon it. The cold or the heat of the day can also cause eggs to freeze or heat up to the point of failure. Eggs and young are extremely vulnerable to temperature extremes, and it doesn't take long for them to perish. My rule of thumb: if I sit in my blind for 15 to 20 minutes and the bird or mammal doesn't return, I leave.

My bottom line: no photo is worth the life of any animal. If you cause nest failure or abandonment, your quest for photos is a failure.

Using a blind is often critical. If some animals detect your form or any movement, including your eyes, they will take a lot longer to return, or worse, not return at all—again, risking nest failure and photography failure. A lot of my work is done from an L.L. Rue blind, a tentlike contraption with a folding steel frame and camouflage fabric. It sets up in about 30 seconds. I sometimes build the blind about 50 or 60 feet from the den or nest and then leave. The next day, I move the blind a little closer so the bird or mammal gets used to the structure, and I leave again. On the third day, I am able to

'Captured' Bat: This bat is caught by a "photo trap" that simultaneously triggers three strobe lights and the camera. The device emits an infrared beam that, when broken by something like a bat, activates the strobe and camera setup.

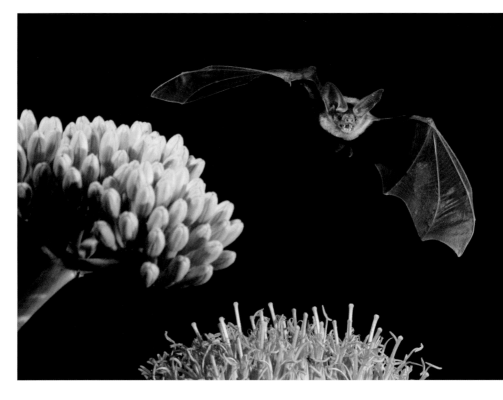

move in close enough to start shooting. However, you must enter the blind quickly and stay very quiet until the subjects return. This technique takes planning and patience, but it can win you some wonderful images.

Getting close and composing

When in the wild, moving in on your subjects on foot or in your vehicle takes practice as well as patience. Don't let excitement overwhelm you. Moving very slowly is the key. Make sure the light is behind you and walk or drive very slowly toward your subject, trying not to make eye contact—use your peripheral vision. If on foot, stop as soon as you see any indication of alarm from your subject and put down your tripod slowly and carefully. Stand there for a minute or two and make sure you do not make any quick movements with your hands until the animal accepts your presence and returns to its business. When the animal isn't looking, move up a bit more and repeat the pattern. In the meantime, take a couple of throwaway shots so the animal gets accustomed to the sound of your camera's shutter.

Composition is as critical in wildlife photography as in landscapes, but you may have little or no time to think about it. Learning to compose instinctively is essential. Most amateurs make the mistake of getting too close to the subject or cropping the image too tightly in editing. This works for some compositions, but for most, it doesn't. In a horizontal composition, if the animal is occupying the left side of the frame in your viewfinder, leave room on the right to give the sense that the animal has room to "move in the frame." If the subject is on the right, create some habitat on the left. Cropping a portrait too tightly gives the animal a confined look and, with the viewer's eye having nowhere to go, the image becomes static. The same rule applies to a vertical image—leave some room at the top and sides.

Some of my favorite photos come from the nesting birds I photograph in the holes of old trees; the bark itself adds character and depth to the photos. I love the craggy cliffs on which falcons, hawks, eagles, and vultures build their nests. The habitat is part of the animal's story. In Arizona, more often than not the habitats are richly textured and exotic, full of strange forms and sharp objects. I look for these elements because they add beauty and meaning to my images.

Birds and flight

Photographing birds in flight is challenging, and so much fun that it can be addictive. A great place to hone your skills is Bosque Del Apache National Wildlife Refuge in New Mexico's Rio Grande Valley and White Water Draw � in Sulphur Springs Valley near Willcox, Arizona. Thousands of sandhill cranes and snow geese winter in these two areas, and the shooting is fast and furious.

In both places I use a variety of lenses. If I want to capture flying birds up close and personal, I use my 600mm with and without the 1.4x teleconverter. I like to use my Wimberley tripod head because it gives me greater control and more precise movement. With the light behind me, I watch the flocks as they fly by, trying to pick out one or two birds long before they get to my parallel position. Then I lock my autofocus onto them. This gives me the opportunity

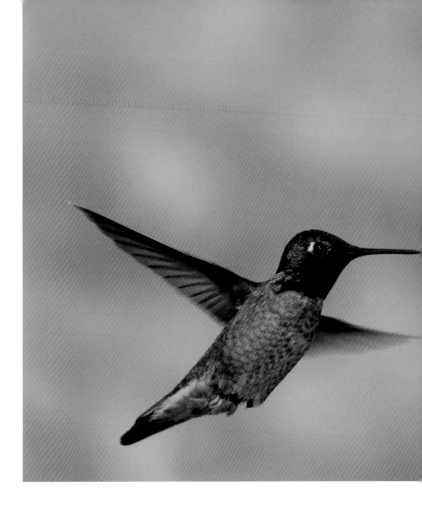

to position them for good composition before they get to the point where I'm ready to press the shutter. I track them in my viewfinder and as soon as I like what I see, I press and hold the shutter for bursts of three or four frames per second. This gives me multiple chances of getting their wings in the "up" position, which I like best. I can't react fast enough to get my preferred composition if I shoot only one frame at a time.

If I'm using film, I use Fuji Provia (ISO 100) pushed one stop to ISO 200. If I'm shooting digital, I set my ISO at 320 or 400. These settings allow me the fast shutter speeds I need to stop wing movement and make them appear sharp. Some photographers use ISOs over 400, but I think image quality starts to erode in that zone.

My method for proper exposure is evaluative metering in my Canon system and matrix metering when I was shooting Nikon equipment. They perform similarly. I dial in minus 1/3 to 2/3 of a stop on a white bird such as a snow goose and no compensation on a medium-tone bird such as a sandhill crane. See Exposure Chapter (Page 66). You will need to experiment with your own equipment to find the right settings. Ninety percent of my photos are correctly exposed, with slight

Place and wait:
The photographer placed a feeder close to this flower and waited for a hummingbird to visit. Shooting with a 600mm lens and an extension tube allowed the photographer to shoot from 15 feet away. The image was made at f/11, allowing both the flower and hummingbird to remain in focus.

variations in compensation for lighter or darker backgrounds and subjects.

I use other lenses to get four or more birds in my frame. The 100 to 400mm works well, allowing me to zoom in and out to capture as many birds as I choose. I usually hand-hold the camera when using this lens and prop my elbows against my torso for a more stable platform. I set the lens on Image Stabilization 2 and set my autofocus limiter switch to 6.5 meters to infinity, so it takes the lens less time to search for its subject. I do the equivalent with the 600mm lens, setting it to 16.2 meters to infinity for the same reason. I also use some wide-angle lenses. A great flock of birds taking off and filling the sky can make a spectacular photo.

Exploring Arizona's environments to photograph wildlife is an amazing hobby, a hunt with a camera that can take you to wonderful places and preserve spectacular memories through the images you capture. There is still so much we don't know about the lives of these wonderful animals, which is what keeps me going back to maybe document behavior that has never been seen before. But even if I don't get the shots I dream of, just being out there teaches me more and deepens my respect, appreciation, and sense of wonder.

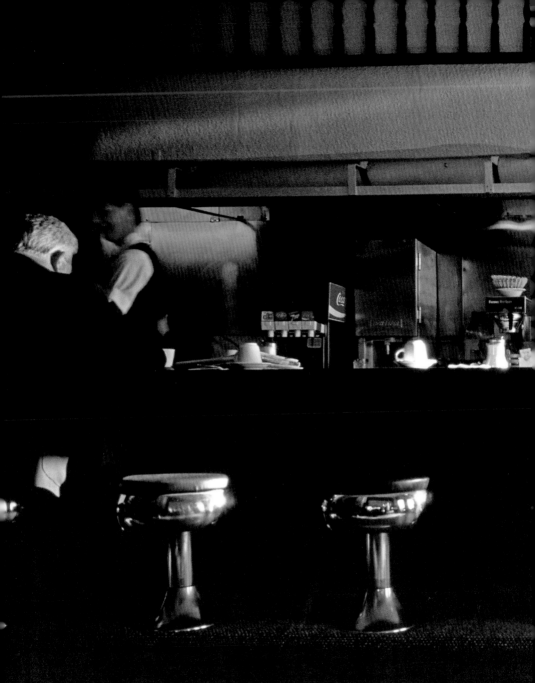

Gadsden Hotel Cowboy: Having worked all night lighting the lobby of the Gadsden Hotel, in Douglas, the photographer spied the chrome stools and made several images. He was still seated when a cowboy sat down, making an even stronger image.

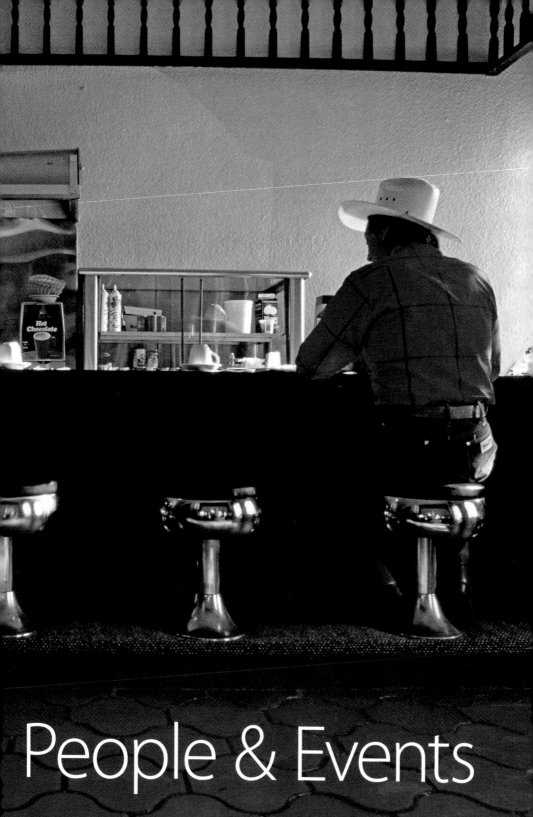

People & Events

Making Everyone Comfortable

Text and Photographs by Richard Maack

MY STRATEGY FOR PHOTOGRAPHING people and events comes straight from one of the legendary photojournalists of the 20th century, W. Eugene Smith. There's no reason to change it because it works—and digital photography is helping it to work even better.

I'm photographing the Little Buckaroos Rodeo in Holbrook, an annual event for cowkids from 3 to 12, and my game plan begins with operating around the edges. I start at the sign-up where some 50 kids are milling around an open courtyard with their parents. They're duded up in their best western outfits, fingering their lariats, looking apprehensive or (trying to look) cool. I drop to their level, duck-walking, shooting almost randomly. I know that most of my first 50 frames will be throwaways, but it doesn't matter. My aim is to melt into the hubbub, the background buzz, so they'll begin to ignore me.

I'm sure I look ridiculous, especially since it's just rained and I'm waddling in mud with the texture of brown yogurt. But it works: after a few minutes of watching an adult doing a duck imitation (with only the quack missing), they go back to doing what they do best: being kids. And I start getting the shots I care about, the ones where expressions, postures, and interactions form self-contained vignettes, pictures that tell stories.

As Smith observed, almost everyone, the photographer included, becomes at least a little self-conscious whenever a camera is injected into a social situation. So his modus operandi was to just start working, run at least two rolls of film through his camera, not really caring who he was shooting. He just wanted everyone to become comfortable with him moving about and hearing the sound of his shutter. This introductory work also helped Smith get acclimated to the pace of the activities and the personalities involved. And somewhere around the third roll of film, the good images would begin to appear.

My advantage as a 21st-century photographer is that I don't have to throw away 20 bucks worth of film while blending into the background. The "delete" button sweeps away my photographic detritus with no pain.

The approach pattern

When we're photographing a public event, there's generally no need to ask a subject's permission. But we often encounter people engaged in private activities

Soft light:
This portrait of D.R. Schrader illustrates the use of soft morning light and tight framing of a subject to focus attention on his eyes. The critical framing was accomplished by excluding the top and sides of his hat.

TYPES OF PHOTOGRAPHY

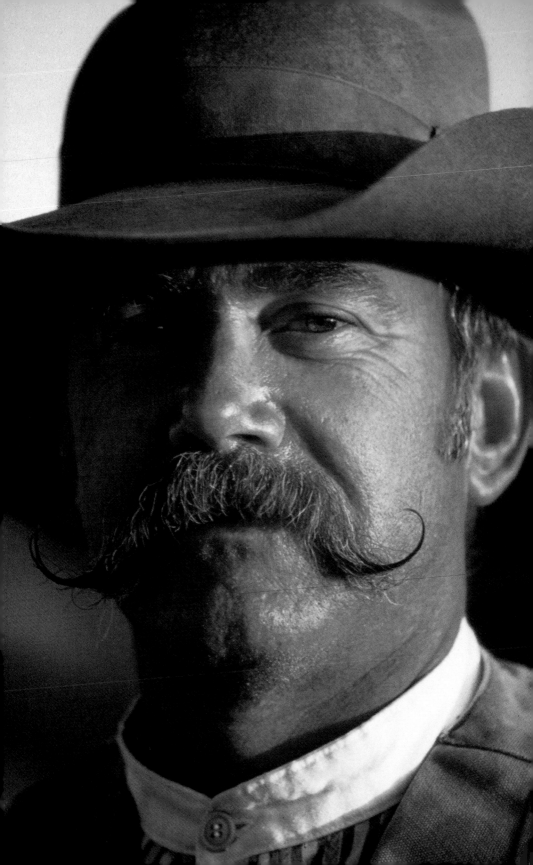

All natural:
There's no posing here. Participants in a "Little Buckaroos" rodeo in Holbrook forgot that a photographer was hanging around. But the photographer was ready when their expressions and body language were just right. Often, compelling images can be made away from the action of the main event.

that tell stories about culture, community, or interaction with the land—for example, a Tohono O'odham woman harvesting saguaro fruit, or kayakers about to launch an expedition on Lake Powell. If the photo is going to be close-up enough to show a recognizable face, we're obligated to ask permission. To shoot without it is theft, the taking of someone's privacy. But how to ask?

When approaching anyone, anywhere, sincerity is your first and best asset. You're intrigued enough by this person's appearance or activity to want to photograph it, so ask questions that show a genuine interest in the subject. ("I'm from Minnesota, and I never imagined a cactus fruit harvest. How do you do it?") Some successful photographers say they approach people with "childlike curiosity." This disarms their subjects' natural defenses. When the topic finally rolls around to photography, be honest about your intentions. Explain that you want to capture Arizona with some good photos, not the usual vacationer's snapshots. Offer to send a print, and make sure you follow through.

A second asset, ironically, is a minimum of equipment. Nothing will intimidate or embarrass the average cactus-fruit harvester faster than the sight of a charging photographer with two or three cameras draped over the neck and a bulging pack of paraphernalia. Survey the situation before your approach and leave extraneous equipment in the car—you can always fetch it later.

Third, use your imagination. If you sense that someone may be shy about having his or her face photographed, look for alternatives. Extremities in action can tell as powerful a story as a face. Navajo photographer Monty Roessel once produced a calendar for the Navajo Nation that featured wonderful photos of

people's hands: a soft and graceful woman's hand, lavished with turquoise jewelry; a pair of man's hands, sun-bronzed and sinewy.

Whatever my approach, I rarely ask people to pose. Very few subjects can "act natural" on command. I want to portray them responding to something other than me. So I ask if I can hang around or tag along, and just as I did when shooting the Little Buckaroos, I simply start working, with no intention—at first—of getting the defining shot. That will come later, after the subject has forgotten about me.

How to tell a story

Photography, at its best, always tells a story. Sometimes it's obvious, right out on the surface, and sometimes it's subtle, drafting the viewer's imagination to complete the story line. But it needs to be there.

Arizona Highways photography editor Jeff Kida once made a wonderfully evocative portrait of a monk at the Holy Trinity Monastery in southeastern Arizona. The elements in the photo were minimalist: the monk in his white habit, a blurred vertical column and a textured adobe wall in the background. Kida used a 180mm lens, which in his words "allowed the monk to be alone." The natural light, bouncing through a shaded open door, gave the portrait a slight blue cast, since color slide film tends to record shaded and reflected sunlight as slightly blue.

These simple elements were conscious decisions that all together sketched a complete life story. The apparent simplicity and solitude accurately portrayed the monastic life. Our subconscious minds interpret white and blue as colors of purity and peace. Had Kida chosen to make the photo in a cluttered study, or even outdoors among the lush cottonwoods and wildflowers on the monastery grounds, it would have lost that story line—and probably the portrait's emotional purity as well.

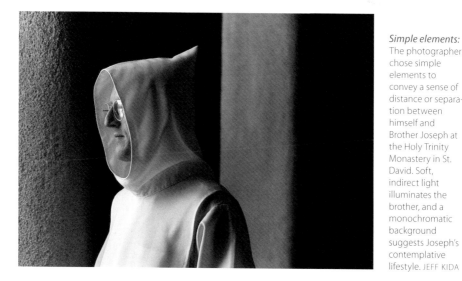

Simple elements: The photographer chose simple elements to convey a sense of distance or separation between himself and Brother Joseph at the Holy Trinity Monastery in St. David. Soft, indirect light illuminates the brother, and a monochromatic background suggests Joseph's contemplative lifestyle. JEFF KIDA

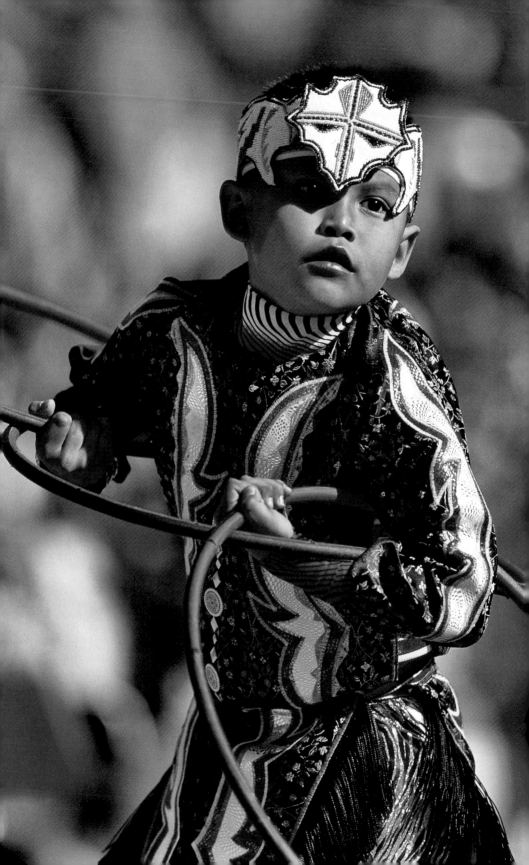

Viewers can also fill in a story with my photo of father and son at the Little Buckaroo rodeo. The dad gazes away heroically and coolly, while sheltering his little cowboy from the rain. The boy is trying his best to look cool, too, but he appears touchingly vulnerable. It's an interactive family drama, intimate and unashamedly sentimental. The yellow rain slicker adds a serendipitous splash of primary color, brightening the image and drawing the eye.

Sometimes it takes a series of photographs to tell a story, but I'm always looking for the single picture that's worth the proverbial thousand words. Those are the treasures of photography—the images that lodge in peoples' minds.

Establish, then close in

Imagine you're a photojournalist with an assignment to produce a photo essay of a parade. The procedure for documenting an event for your own vacation or family album is really no different. One of the first things you'll need is an "establishing shot," a photograph that lets the viewer know where the action is taking place and says something about the mood or atmosphere. It won't necessarily be the first scene you photograph, or the first thing that happens during the event. But it will establish the context for the essay.

For example, I once spent a weekend shooting a women's rappelling clinic at Camp Friendly Pines, just south of Prescott. My establishing shot was simply a couple of women walking to their cabins with their bags, a sign reading "No cars past this point" beside them. At Willcox's ✸ Rex Allen Days I photographed four women on prancing horses, all flashing pearlescent smiles and proudly carrying American flags. People's expressions, clothing, activities, buildings, signs, background scenery, weather—any or all of these can form a part of your establishing shot.

After this, concentrate on moving in. Experiment with different lenses. Look for small vignettes that tell an emotional story about human interactions. Search for graphic details in inanimate things to provide some compositional drama. Explore color by filling the frames with contrasting hues and saturated images. Go to photographs; don't wait for them to come to you.

I like to get close to my human subjects, either physically or in photographic composition. This helps to eliminate anything that might distract from the story. Often it means a tight crop. I'll crop at the shoulders, just above the waist, or just above the knees. I'm more than willing to crop limbs and hats if it will intensify the important elements in the image—the eyes, the face, the upper body. For example, look at the Sonoita Rodeo's Pee Wee Princess (Page 154), who I also photographed at Rex Allen Days. The top and edges of her cowboy hat brim aren't necessary, because the viewer's brain will unconsciously fill them in. Including enough room for them in the frame would have given the eye places to roam around the princess—which I didn't want.

While we're on the subject of cropping, do the best you can on-site and in-camera. It's good discipline, and it helps you to evaluate your subjects and their environments more critically.

If I'm shooting what photographers call an "environmental portrait," I look for a background that relates to the person's activity but doesn't distract. I want

Hoop dancer:
7-year-old Tyrese Jensen is performing only a few feet away from his audience. Fearing that too much depth of field would detract from the intricate detail of the dancer's costume, the photographer blurred the spectators by opening the aperture of his 300mm lens to f/2.8 (wide open).
JEFF KIDA

a balance between subject and environment, so that neither dominates the other. I don't want bright highlights in the background, and I don't want the person in the exact middle of the frame. If it sounds like there are a whole lot of things I don't want in my photograph, well, that's one of the prime secrets of composition: Eliminate the nonessentials. I decide what my subject is, then get rid of everything that doesn't drive the story I'm trying to tell.

Think like a camera

Take a camera with a normal lens, focus it at normal subject distances, center your subject in the viewfinder, repeat the process over and over, and you'll end up with some pretty boring photographs.

Although certain famous photographers are known for using normal or slightly wider-than-normal lenses on 35mm cameras—notably photojournalists Henri Cartier-Bresson and the aforementioned W. Eugene Smith—it takes an immensely talented photographer to make transcendent images with that limitation.

We lesser photographers can make our photographs more interesting by thinking like a camera—exploiting and celebrating the ways the camera lens "sees" the world, presenting a different and unusual visual perspective on a subject. At its best, this may expand or enhance our way of looking at reality.

Long focal-length lenses offer many advantages when making candid photographs or portraits. Although effective images can be made with almost any lens and camera combination, long focal-length lenses provide important benefits when photographing people in unguarded moments.

The photograph of the Sonoita Rodeo's Pee Wee Princess (shown at left) was made with one of my favorite focal-length combinations—an 80-200mm zoom, with the lens at its 200mm extreme—a strategy I routinely use for portraits. I could have used a shorter lens, but that would have put me close enough to the subject to violate the sense of personal space we all like to maintain and would have added a distracting element to our interaction. The 7 or 8 feet that the long lens provided maintained that space and helped lend a candid feel to the portrait.

Pee Wee Princess: Making photos of people during midday is often difficult because the light is harsh. Using backlight can remedy the situation, making faces evenly lit.

The second advantage of a longer lens for photographing people is the way it flattens perspective. Wide-angle lenses increase the angle of diagonals in perspective, and long focal length lenses compress those angles. What this means in a portrait made with a wide-angle lens is that everything close to the camera will appear bigger. What's closest to the camera (usually) in a portrait? The nose, which is not generally a flattering thing to emphasize. Long focal-length lenses push perspective to the opposite extreme, making a subject appear more two-dimensional—the nose smaller, prominent features subdued. It's almost always a more complimentary way to render a face.

Into the thick

Wide-angle lenses, however, have advantages when photographing people in groups. Very wide lenses, those with focal lengths shorter than 24mm, convey a vibrant sense of immediacy when photographing groups of people—particu-

larly when the photographer is in the thick of the action. The exaggerated angles of perspective add a dynamic sense of motion to even the most static subjects. Great depth of field and an emphatic near-far effect help to add muscle to the compositions.

One technique that doesn't require any particular lens is to photograph from a perspective other than normal standing eye height, 5 or 6 feet above ground level. This is obviously useful when photographing small children: Get down on your knees and you enter their world, which is a perspective that adults don't usually see. Or if you're photographing something like the women on horseback at Rex Allen Days, a camera close to the horseflesh and low to the ground can emphasize the power and nobility of the occasion. (Obviously, getting too low and too close can be hazardous to your health.)

Using the camera to the full range of its photographic possibilities can push the boundaries of human vision and perception. This means feeling free to experiment, and that means running a lot of film or pixels through your camera. There's no substitute for lots of shooting, followed by careful and critical editing later. Make your experience of photographing people and events an exercise of exploration—both of human culture and photographic technique. Giving yourself the greatest number of opportunities to succeed means getting better photographs.

Finding position: By placing himself in such a location that the light came from behind the riders, the photographer improved this midday situation. The beige-colored dirt of the rodeo grounds reflects light to help illuminate faces shielded by Western hats, and dust seems more pronounced with light coming from behind. (Smoke and fog also are rendered more dramatically with backlight.)

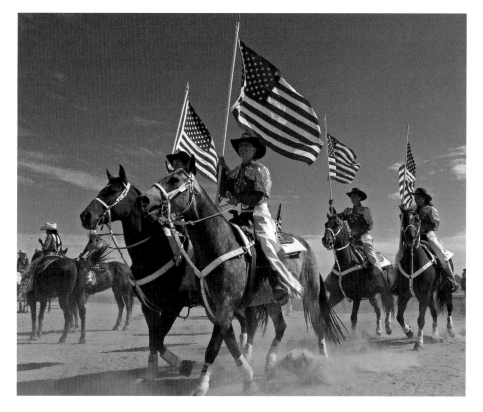

Shadows and highlights: Sunrise illuminates the dome of San Xavier Mission just outside of Tucson. Shadow and highlight work to define the half-moon shapes and intricate spires. The scene, shot on 35mm film with an 80-200 mm zoom lens is framed beautifully by an exterior arch.

Architecture

Recording Cultures

Text and Photographs by Richard Maack

IN THE SUMMER OF 1826, Frenchman Nicephore Niepce didn't have to look far to find a subject for the world's first photograph. His subject was architecture.

Using a camera obscura (essentially a light-tight box with a lens at one end and a piece of ground glass at the other, projecting a reversed and upside-down image), Niepce's exposure on a sheet of polished pewter coated with bitumen of Judea produced the first permanent photographic image on any medium.

Not Much Room: This image combines late afternoon light and a 19th-century gallows to focus attention on the historic Tombstone Courthouse. With so little room between the courtyard and the building, the photographer tested settings with as many as 20 Polaroid shots before making the final image with a 4x5 view camera. The scene's vertical lines stay true on the image because the camera is level, not pointed up or down.

Of course there's a very good reason to photograph a building when your exposure is 10 hours long—you need a subject that probably isn't going to move. Even though necessity helped dictate the theme for Niepce, this first photograph illustrates many of the traits that make architectural subjects so compelling, both for the viewer and photographer. Buildings are balanced, angular, and dominated by bold forms. Strong diagonal lines create a sense of motion. Vertical lines serve as a framing device, focusing our attention within the image while a bold trapezoidal roofline anchors the composition.

These simple graphic forms can be found in almost all subjects architectural. Although light and atmospheric conditions may add theatricality to a scene, it's often just basic shapes that power a composition. The photograph of the Cochise County Courthouse in Tombsone is an excellent example. Sunlight and shadow and a dramatic sky add interest, but it's the geometric shapes enclosed within the rectangle of the photograph that ultimately makes the composition work.

Another reason to photograph buildings is that they form a record of civilization and culture—how we relate to history, to the land, and to each other. In Arizona, this record takes dramatic and powerful forms. Fabled frontier towns such as Tombstone, Bisbee, Prescott, and Jerome ❋ proudly preserve their youthful ambitions in their architecture, from Tombstone's miniature Italianate Victorian City Hall to the magisterial Greek Revival courthouse in Prescott. Scores of ghost towns quietly decay, poignant testimonials to failed dreams. In the modern era, landmark 20th-century buildings such as Sedona's Chapel of the Holy Cross and Frank Lloyd Wright's Taliesin West in Scottsdale ❋ show how architects have tried to come to terms with the dramatic landscape of Arizona. All these buildings tell stories—about us.

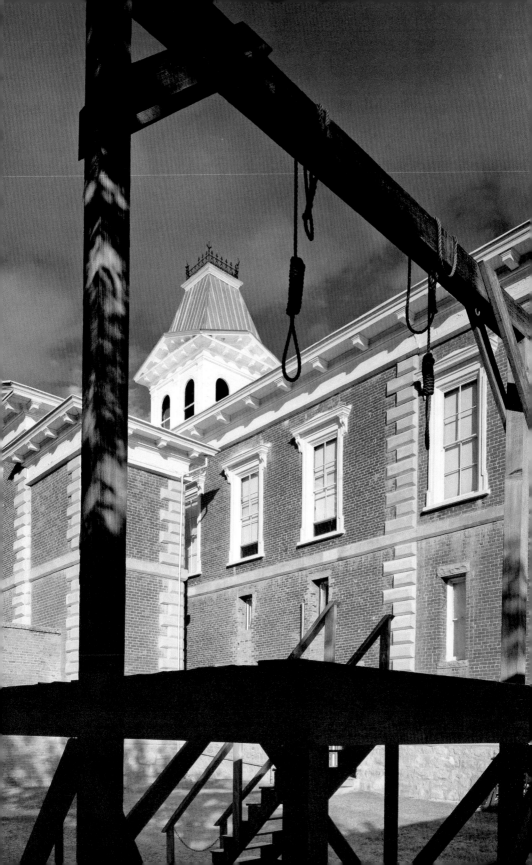

The man-made landscape

Before I actually started making a living with a camera, I concentrated on photographing landscapes. Although I considered myself a photographer, most of my income came from other areas of the industry—working in photo labs, selling equipment, and, for a time, serving as an artist's rep for a commercial studio. My landscape photography provided a creative outlet and on occasion a small check from a print sale.

My leap to full-time commercial photographer began when a photo lab laid me off. Reaching deep into nearly empty pockets, I took my remaining $250 and bought a couple of boxes of 4x5 Ektachrome. Using that film to photograph commercial buildings near my home in central Phoenix, I put together a small portfolio of images to market my services to architectural firms. With construction booming in Phoenix, many firms were anxious to document their projects. It didn't take long to launch a new career.

It was a gentle and almost linear transition from landscapes to building exteriors. Since I was already a "big-camera guy"—using 4x5 and 8x10 view cameras for landscape photography—I didn't need much new technical knowledge for architectural exteriors. Camera movements and compositional techniques remained much the same. The time I had spent learning about light and its qualities in the landscape served me well with architecture. Natural light will accentuate textures and depth, reveal form and character, and create vibrant patterns of sunlight and shadow in the same ways, whether it's striking a mountain or illuminating the man-made façade of a building.

Night and Day: Often, architectural photographers will work all night setting the camera position and lights. Once done, they wait for the first light of morning to illuminate key features in a scene. In this case it was the Tiffany stained glass at the top of the stairway of the Gadsden Hotel in Douglas ✤.

Getting technical

Most architectural photographs have several technical and stylistic traits in common: They're made with wide-angle lenses and maximum depth of field, with the camera mounted on a tripod. Horizons are level, and the vertical lines in the buildings do not converge.

Wide-angle lenses

Wide-angle lenses allow you to work close to your subject and are particularly important when photographing architectural interiors. These lenses also increase the angle of the lines of normal perspective as they recede from the image's vanishing point, adding dramatic motion to a photograph through the sweep of implied, or visible, diagonal lines.

Most published exterior photographs and almost all interior images are made with wide-angle lenses. With 35mm cameras, lenses in the 17 to 24 mm range most closely match this look.

Depth of field

Maximum depth of field should generally be your aim in architectural photography. All the details of the building should be in sharp focus, as well as the landscaping and nearby surroundings. Sometimes, however, you'll want to isolate a detail, such as a wrought-iron gate or gargoyle, with a telephoto lens and

A Building Detail:
The semi-circular design element was spotted inside the old Grand Theatre in Douglas, Arizona. The image was made with a 35mm film camera using available light and an 80-200mm zoom lens.

shallow depth of field. In such a case the blurred background can reduce clutter and clarify the prime subject.

Tripod and cable release

The most important tools you can have to ensure sharp focus during long exposures are a tripod and a cable release. I use them in the vast majority of the photographs I make. My personal rule is: "If it ain't movin', I'm on a tripod." The tripod also helps to keep the camera level and precisely align parallel lines in a composition.

I prefer three-way pan/tilt heads over ball heads on a tripod even though they add weight. The fact that you can level your camera either vertically or horizontally and lock down your setting before you move on to the next adjustment makes leveling a camera much easier with a three-way pan/tilt head.

Vertical and horizontal lines in square

Technically correct architectural photography generally requires a level horizon and vertical lines that don't converge. Vertical lines converge when your camera is pointed up or down, giving the impression that subjects are falling over backward or leaning to one side or another. Rendering vertical subjects with correct perspective is generally preferred, because that's the way human eyes see the world—balanced, square and with a level horizon.

I learned to be a photographer by reading Ansel Adams' *Basic Photo* series, and I still subscribe to Adams' opinion on the matter. He felt that obviously vertical subjects in a photograph should remain vertical unless you're adding a great deal of convergence for dramatic effect. He insisted that a small amount of convergence in a photograph only betrayed sloppy technique.

The key to making buildings stand up straight is leveling the camera back and keeping it parallel to the vertical lines in the building. When I'm photographing with a tripod and vertical lines or the horizon figure into the composition, I actually use a level to square the camera's back. This ensures that vertical lines

and subjects will remain vertical in your photograph and that the horizon (or implied horizon) will be absolutely horizontal. Levels can be purchased that fit into the flash shoe of your camera, or you can simply use a line level, which is inexpensive and readily available at your local hardware store. Since I tend to lose them, I keep a few extra and stash one in each of my camera bags.

Often you'll find that once you level the camera's back, you're slicing off the top of the building in your frame. There are four possible remedies. You can move the camera farther away from the subject, try a wider-angle lens, or move the camera higher (for example, shoot from a second-story balcony across the street from your subject). The expensive solution is a tilt/shift lens, which will lend an SLR some of the capability of a view camera in architectural and landscape photography.

The power of form

More than almost any other photographic style, architectural photography relies upon, and gains much of its visual authority from, the graphic depiction of geometric shapes within a rectangle. An attractive architectural subject may make an interesting image, but it's just as likely that an abstract composition of simple architectural form will provide the viewer with a satisfying visual joyride. It's surprising how something as simple as graphic shapes in a frame can move us, but it's those possibilities that help make architectural photography appealing, both for the viewer and the photographer.

The details speak: Often, a detailed section of a building can speak volumes about the entire makeup of a location. The photographer spotted these elements on the back porch of the Riordan Mansion in Flagstaff �֍.

Mission San Xavier del Bac ✛ This famous
Spanish mission may be the most inspiring
subject for architectural photography in
Arizona, and maybe the entire Southwest.

Rising from the floodplain of the Santa
Cruz River 9 miles south of Tucson, San Xavier
commands the landscape with more authority
than most modern skyscrapers. Visible from
more than a mile away as you approach on
Interstate 19, the great white building never fails
to astonish with its dramatic Spanish baroque
architecture and the sheer incongruousness
of its remote location on the Tohono O'odham
Indian Reservation. Still an active Catholic parish
church, San Xavier ministers to the spiritual
needs of the 24,000-member tribe, as well as
welcoming visitors from around the world.

San Xavier's caretakers are photographer-
friendly and welcome those interested in
capturing images of the mission. Donations for
the church's maintenance are appreciated.

Since San Xavier is an active church,
photographers must be respectful. Photos
should never be made during Mass, and
worshipers praying at any time should not be
disturbed. The work of the mission as a place
of worship takes priority. Church services,
however, occupy only a couple of hours of the
day, and even while they are in progress, there
are many other opportunities for photographs
outside on the mission grounds.

The front elevation of San Xavier faces
south, so it's illuminated by the rising or
setting sun most directly in the winter months.
Unfortunately, that's also the time when days
are shorter and visitors are likely to be milling
around at sunrise and sunset, when the light
is best. To further complicate photography,
the mission's school is in session on weekdays,
causing a bustle of activity in the area. During
the winter months, the best time to find the
front elevation of the mission without people
in view is Saturday mornings at dawn.

OPPOSITE: **San Xavier del Bac.** ABOVE: **San Xavier del Bac Baptistery.**

Dominated by a striking arched entryway,
the north (or back) side of the mission
receives light most directly at sunrise and
sunset during the summer months. However,
almost any time of year offers spectacular
opportunities for great light and dramatic
compositions. The two photographs shown
here demonstrate some of the possibilities:
the first photographed at sunset during the
summer months, and the second at dawn on a
very chilly morning in January.

The qualities of changing light on the
mission's exterior always presents great
prospects. Keeping your camera set up
through the first or last hour of sunlight
provides an almost kaleidoscopic spectacle of
incremental changes in color.

Photographing the interior presents
other challenges. Because of the low light
level inside, expect long exposures. A tripod
and cable release are essential for sharp
photographs. A low ISO setting or slow film

may require exposures of 30 seconds or longer with small apertures for maximum depth of field. The space is too large for flash, except for close-ups. The image of the mission's baptistery (Page 165), photographed with 4x5 Fujichrome Provia ISO 100 film at f/22, was made in the last fading light of the day with a four-minute exposure.

Since a 210-year-old fired adobe building requires regular maintenance, certain times may find the mission's finest views obscured by scaffolding. However, there is always something to photograph at San Xavier. If a cherished view is encrusted with construction equipment, consider the less obvious alternatives. You might come up with a rarity—a fresh and original image of one of Arizona's most photographed landmarks.

Taliesin West ✤ No other building in Arizona, nor in Frank Lloyd Wright's vast catalogue of work, insinuates itself into the landscape so beautifully and thoroughly as Taliesin West, which Wright designed as his winter retreat in 1938. The triangular terrace on the south is an echo of the McDowell Mountains in the backdrop. The strange, fin-like trusses elbowed over the drafting studio give the compound a defensive posture, like

the body armor of a horned lizard, and yet on a winter evening when pink streaks rake the sky overhead, the armor melts into the heavens. Wright was showing us how to build in the desert, deferring to the land even while creating architecture of breathtaking power and beauty.

The best photos of Taliesin West illustrate its quirky details, like the boulders strategically designed into the compound; or the architecture's kinship with the moods, shapes, and textures of its site. The Frank Lloyd Wright Foundation, which administers tours, doesn't allow visitors to wander at random, so the best photographic opportunities are on the three-hour "Behind the Scenes" tour. Tripods are officially "discouraged," but an ISO of 400 will allow many good interior shots (Wright was a master of daylighting). The complex faces southeast, so winter shots using a wide-angle lens on the south lawn or the desert beyond will give a sense of how the buildings embrace their environment. Taliesin West is at Cactus Road and Frank Lloyd Wright Boulevard in northeast Scottsdale.

Prescott ✤ This town served as Arizona Territory's capital from 1864 to 1867 and again from 1877 to 1889. The Victorian homes

LEFT: **Bashford House, Prescott.** BELOW: **Taliesin West, Living room.**

Bisbee at Twilight.

and commercial buildings from those days, particularly after 1880, look more like New England than Arizona—the remarkable efforts of pioneer settlers to create an oasis of civilization in what was then a rough and isolated frontier.

Start your photographic tour along Mt. Vernon Street, with its grand old Victorian mansions, and work your way back to Courthouse Square, the Yavapai County Courthouse, and infamous "Whiskey Row." A few blocks west of the downtown square on Gurley Street, the grounds of Sharlot Hall

Museum harbor a number of relocated historic structures, including the Victorian Bashford House and the first Governor's Mansion, a large log home built in 1864.

Tombstone ✺ It may be more famous for gunfire, but this most notorious of the Old West's historic towns offers a trove of well-preserved examples of 1880s architecture.

The best place to start is at the Tombstone Courthouse State Historic Park at the corner of Toughnut and Third Street. Acquired by the state in 1959, the 1882 Italian Renaissance

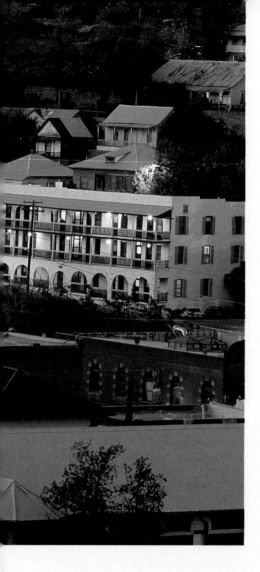

illuminate the front of the building. However, I think the image works well because of the theatrical quality of the light.

Tombstone is compact, and most of its historic buildings are within a few blocks of each other. Check out Tombstone City Hall, Schieffelin Hall, the Crystal Palace Saloon, Allen Street, the Rose Tree Inn, and the Bird Cage Saloon.

Bisbee ⊕ A copper, silver and gold mining town reborn as an artist colony and tourist attraction, Bisbee's winding streets, jewel-box Victorians clinging to steep hillsides and overflow of vivid characters offer a rich vein of color and possibility for photographers. Tucked into the Mule Mountains about 100 miles east of Tucson, the town's rambling streets of tightly packed, century-old buildings give it a funky charm and lots of visual interest. The population peaked in the 1800s, crashed and has built back up to about 6,000.

Tourism has largely replaced mining as the town's economic engine. The town now has a more polished look, complete with refurbished hotels, bed and breakfasts, coffee houses, bookstores, art galleries and antique shops. The town has preserved and refurbished some of the most striking Victorian architecture in the state, not to mention an elegant Art Deco courthouse, the supposedly haunted, indubitably historic Copper Queen Hotel and vintage three-story school house perched on such a steep slope that each floor has it's own entrance from the facing hillside. The narrow streets fronted with shops and intricately decorated building facades offer a wealth of possibilities for a strolling photographer. The massive hole formed by the Lavender Pit Mine offer other angles for the more industrially minded—as do the daily, underground mine tours.

Revival Cochise County Courthouse now functions as a museum and visitors center celebrating the culture and history of the town and the surrounding area.

The front of the courthouse faces northeast, so late spring through early fall presents the best prospects for good light on that elevation. However, dramatic light will make a subject look great at almost any time of year. The photograph shown here was taken in March, about an hour before sunset after a passing storm. Since the sun is in the southern sky during that season, I wasn't able to

Jerome ⊕ Dramatically situated on Cleopatra Hill along the northern slopes of the Black Hills, Jerome' saw prosperity in the early 1900s and produced many historic

buildings. Sweeping views of the Verde Valley and the red rocks of Sedona provide a spectacular backdrop for the old mining boom town. When the mines closed in 1953, Jerome lost most of its residents. However, beginning in the early 1970s, its great views, clean air, and cool 5,000-foot elevation began to draw people back. Today, a thriving mix of art and commerce fuels the town's renaissance. Historic homes and commercial structures line the hilly streets that wind through the mountain community, providing many photographic possibilities.

Clifton ✣ Near the New Mexico border in east-central Arizona, Clifton boomed in the 1890s, as copper mining fueled a cosmopolitan expansion. When the mines played out, much of the populace and most commercial establishments moved up the hill to the company town of Morenci. Today, the empty hulks of Clifton's formerly prosperous buildings line Chase Creek Street. Once the town's main thoroughfare, Chase Creek and its two-story brick structures offer a glimpse of Arizona around 1900. Ornate metalwork crowns many of the old buildings, providing hints of past glories and boom-time optimism.

PHOTO TIP

Using black and white infrared film to illustrate a ghost story (see photo at right) was a brilliant idea. The characteristics of that film make it sensitive to a wider spectrum of light, often producing glowing, surreal effects. See Exposure Chapter, Page 66

Ruby ✣ Located 18 miles northwest of Nogales and just a few miles north of the Arizona-Mexico border, Ruby began life as Montana Camp, a mining outpost below Montana Peak. When a vein of silver was discovered in the 1870s, mining began in earnest. In 1912, when the owner of the general store sent in an application for a U.S. Post Office, he wrote his wife's maiden name, Ruby, on the application for the town's name.

Ruby continued as an active mining camp until the early 1940s when the mines played out. Many haunting reminders of its glory years remain. Check out the old schoolhouse where the original blackboard and upright piano molder in the dusty light of glassless windows. Outside, a ramshackle playground slide creaks and sways in the wind, a poignant reminder of happier times.

There are quite a few other noted ghost towns in Arizona. A good source for their locations and state of preservation is the *Arizona Highways* book, *Arizona Ghost Towns and Mining Camps* by Philip Varney.

Vulture City ✣ One of the finest true ghost towns in the American West, Vulture City grew up around the mine discovered by Henry Wickenburg in 1863. Thirteen miles southwest of the city that now bears Wickenburg's name, Vulture City once boasted a population of almost 5,000. Its history is replete with violence and tragedy. Eighteen of Vulture City's former residents swung to eternity at the end of a hangman's noose dangling from the branches of the ancient ironwood tree that still thrives beside the ruin of Henry Wickenburg's old cabin. Many more died in assorted acts of lawlessness. A few of those souls are said to haunt the decaying buildings.

Many structures in various states of repair and disrepair lie scattered across the property. Large metal buildings housing the mine's massive machinery remain mostly intact, providing compelling photographic subjects both inside and out. The assay office, built of mineral-laden rock quarried onsite, contains a wealth of gold locked in its walls and period artifacts inside. Wickenburg's cabin is just yards away, with the deadly hanging tree framing a ghostly view of its crumbling walls.

Since many of Vulture City's buildings crown hilltops or ridgelines, fiery sunsets provide opportunities for glorious silhouette images.

The Vulture Mine and surrounding buildings are privately owned, but self-guided tours are available for a nominal fee. Cameras are welcome.

Vulture City Fireplace.

Indian Ruins When I wrote the book *A.D. 1250* for *Arizona Highways*, two of my passions—architecture and Southwestern history—merged perfectly. My research included visiting every major Indian ruin in the Southwest, and I photographed most of them, either for publication or my own later interest.

I learned quickly that the prime challenge of photographing ruins today is excluding all the enhancements of modern civilization—interpretive signs, helpful guardrails, protective canopies, and visitors in chartreuse shorts. None of these do our photos any good.

The best insurance against the hordes, of course, is to be the first to arrive in the morning. At sites such as Wupatki National Monument ✦, which is open to visitors from sunrise to sunset, all this requires is the willpower to roll out of a warm motel bed in Flagstaff at 5 A.M. and drive 40 miles before dawn. Since Wupatki's lonely Wukoki Ruin is among my most cherished architectural destinations in Arizona, I've done exactly that several times. It's worth the effort. Being onsite alone also makes it easier to maneuver the camera angle to banish the interpretive aids, since I don't also have to dodge other people. I do, however, need to keep my own shadow out of the composition.

The often-neglected opportunity in photographing ruins is the chance to interpret the relationship of an ancient people to the land. Note the word interpret—it's necessarily guesswork, because archaeology doesn't tell us how the Salado or Sinagua peoples actually felt about their environment. We superimpose our own experience and cultural values on what we see, and maybe we romanticize. Still, my favorite view of Wukoki portrays the six-room pueblo as frighteningly small, lonely, and vulnerable in a starkly arid landscape—a metaphor for what I imagine to have been the fragility of human life in Arizona 800 years ago.

The building materials of these

Wupatki National Monument. GEORGE H.H. HUEY

civilizations came directly out of their building sites—sandstone blocks, clay mortar, and adobe. I like images that demonstrate the material or spiritual connection of architecture and site, perhaps because they form a rebuke to the frequently disconnected architecture of our time. My favorite in this category is a shot of one of the 14th-century Salado alcove dwellings at Tonto National Monument ✦,

where outside light reflected off the hillside softly illuminates the mortar-washed façade of the pueblo. There's an almost perfect harmony between the craggy surfaces of the alcove and the like-colored but linear walls of the building, as if the architecture were merely offering a bit of respectful housekeeping to Nature.

The architecture of Arizona's earlier peoples not only provides a wealth of clues to understanding their cultures, but also may suggest ways that we could better relate to the land as we build today. When I give slide lectures on Arizona architecture, I always include Wukoki and Tonto, and when they appear on the screen, a palpable sense of appreciation ripples through the room. These buildings respect or maybe even fulfill their sites, a rare quality for the architecture of any time. —*Lawrence W. Cheek*

Thanks for the Memories: A vintage Corvette suns outside the Hackberry General Store on one of the remaining segments of Historic Route 66.

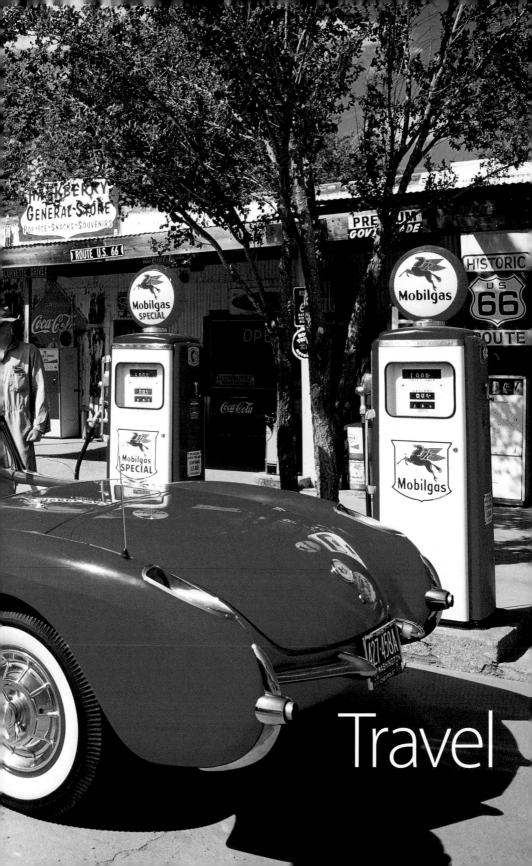

Travel

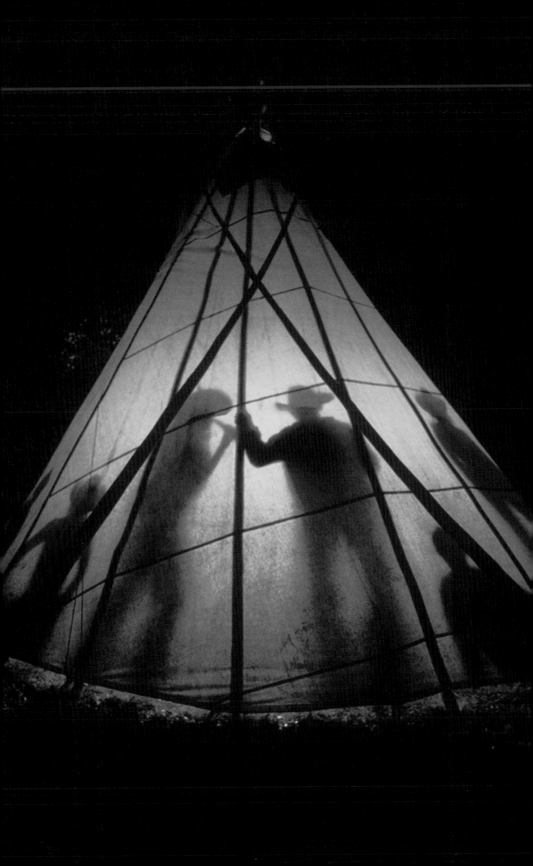

Rendering a Trip's Memories

Text and Photographs by Kerrick James

ARIZONA'S HIGHWAYS ARE AMONG my favorite subjects, because a road can form a visual narrative through a landscape. Pure landscape photographers generally hate to see any human intrusions on nature through their lenses, and will go to great lengths to banish roads from sight and mind. But I think of myself as a travel photographer, telling all kinds of stories about places. Our civilization's relationship with the land is a large part of the experience of travel. That's where the roads come in.

When an unusual spring storm dumped nearly a foot of heavy, glistening snow on the high Sonoran Desert just east of Phoenix, I headed out early to shoot the rare image of snow-capped saguaros. I found them, but I also turned my camera just in time to see three matched Jeeps chugging along a red dirt road flanked by snowbanks under a clearing blue sky. It was the relationship of all these elements—snow, saguaros, road, Jeeps—that told a story.

I know I've made some memorable travel photographs when the viewer's reaction is "I've got to go see that!" I've done my job well when readers feel inspired to plan their own journeys to drive that back road, explore that amazing canyon, or follow folklorico dancers. I've taken many a trip myself because of one stunning image that burned itself into my mind, and I simply had to see it in person.

Travel photography, to me, encompasses everything under the sun. I shoot all the variety that a location has to offer: city skylines and streetscapes, shopping and nightlife, food and restaurants, Americana and local kitsch, and ethnic festivals. Curiosity is my motivator, and I love to be surprised. These are two powerful, and I think essential, ingredients behind good travel photographs. Even after shooting for many years, I'm still continually surprised by how photography renders moments and places, and thus shapes our memories of them.

Residents and visitors to Arizona are very lucky to have an amazingly rich mix of cultures, iconic places, and landscapes within one state. I live and work here for just that reason, and I'm thrilled to be able to share some of my favorite places with you. To help in your research of locations and photo ops go to sites such as www.arizonahighways.com and www.travel.azcentral. com. *Arizona Highways'* online magazine has excellent resources under the "Discover Arizona" button. Here you can find dates and details of festivals

Teepee Party: This was an easy image to make, using a tripod and center-weighted metering. The photographer asked the people inside to hold their impromptu poses every now and then when it looked natural. The warmth of the firelight and the glowing silhouettes hold your eye within the teepee area.

Rodeo Action: By using a slower shutter speed and moving the camera with the action (panning), you can achieve the blurred-background look shown in this Payson rodeo photo.

and events from guided dragonfly walks at Boyce Thompson Arboretum ✖ to Willcox's ✖ annual Peach Mania Festival. Hot-air balloon ascensions, cowboy poetry slams, vintage car rallies, quick-draw gunfights—all such things provide great photographic opportunities that tell stories about the experience of travel in Arizona.

You never know what those opportunities will lead. One recent August I was on the Navajo reservation in northeastern Arizona shooting for a new book on the state's back roads. My online research had clued me into the annual Native American Arts and Crafts auction at the historic Hubbell Trading Post on the Navajo reservation, which promised to combine elements of native arts and culture and a wide variety of people to watch and photograph. I showed up, shot the event in natural light under a spacious tent, and made some fine images of native people and their art. While shooting, I fell in love with a striking Two

TYPES OF PHOTOGRAPHY

Grey Hills Navajo rug and made my first-ever bid, which turned out to be the only one. After collecting my prize, and my wits, I puzzled what to do with my very pricey new "prop." I have since photographed the rug, spread out on sandstone, all over the reservation.

Like legions of others who've been lured in by *Arizona Highways*, I started photographing because of a deep love of this landscape, especially the raw and elemental forms revealed throughout the state. Combine those grand forms with epic weather, as is on display every monsoon season, and you have potential for magical images. My favorite example occurred on an August trip to Monument Valley ✳.

One late afternoon I was shooting the deep ocher iron sands near the Yebechei Group, or Totem Poles, in the tribal park outback. An enormous arching cloud front rumbled in from the southwest, blotting out the sun, and soon

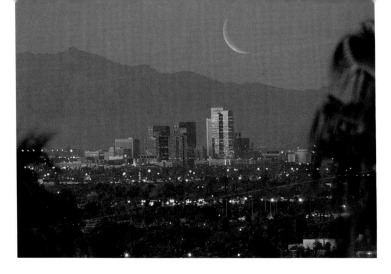

severe howling winds and dust erased the spires as well. I drove as quickly as I could back to the visitor center, parking where the old campground site offers a perfectly balanced vista of the Mittens and Merrick Butte. By the time I got there the rain was blowing sideways, in sheets worthy of a hurricane. Lightning was sparking within 100 yards, and the thunder was immediate and deafening. I cowered in my pickup for 20 minutes, stewing over how my lovely day had gone to hell so quickly, when I realized that this thunderstorm cell was moving in a line across the Mittens, toward Hovenweep in Utah.

When you see veils of rain falling before you in late afternoon, the low sun behind your shoulder can gift you with rainbows, and soon it did. A perfect double rainbow arched over the Mittens, and a warm light bathed the entire sky and landscape. I had difficulty believing what I was seeing as I shot fiendishly, ripping rolls of film through my cameras. I learned that day that you need a very wide lens, roughly 15mm, to encompass the field of a double rainbow. Fortunately, I had one in the bottom of my bag, rarely used, but suddenly invaluable. I also used my polarizing filter to intensify the rainbow's color, while keeping it within the realm of believability.

I shot at least 10 rolls of film before the storm stole away toward the Four Corners. One image became the cover of the 1995 *Arizona Highways* calendar, and others have appeared in print many times. For me it was the storm of a lifetime, and now you know why I never shy away from storms. Storm light can be the most beautiful light you'll ever see.

No human figures appeared in those Monument Valley images for obvious reasons, but I generally look for people to include in a landscape photograph. In the right positions, they can work graphically to activate an otherwise static scene. The old rule was to put people in to provide scale, which is valuable, but you must pay careful attention to how they are standing, walking, or moving. The wrong pose, an awkward gesture or position, is very distracting.

I once shot a Grand Canyon river guide playing his Indian flute in Blacktail Canyon. His figure provided not only an interesting silhouette and scale, but also a sense of the moment in which he filled the air with music. It told a story,

rather than merely documenting a place. On another day in the Grand Canyon I photographed a pair of river guides looking over the Colorado River at Nankoweap. I had shot this view without people for several minutes, but didn't feel finished with it. When the two stood on the edge of the trail, and one pointed out a detail, I was thrilled. The gesture was natural and unscripted. It felt genuine, and that was the key.

Travel stories need a new or unusual point of view, sometimes literally, to attract readers. Your vacation photos are no different—a visual jolt of adrenaline will hook the viewer. I love to shoot the landscape from above in a man-made conveyance—a hot air balloon over the Sonoran desert, a helicopter buzzing Monument Valley, or a scarlet red biplane soaring over Sedona. Consider when the prime light will illuminate your subject, and schedule your aerial adventure accordingly. When shooting from above, keep airplane parts out of the composition.

Back on earth, some of my favorite Arizona roads are U.S. Route 163 from Kayenta to Monument Valley, old U.S. Route 66 between Seligman and Kingman �, and the Apache Trail � (State Route 88) from Tortilla Flat to Roosevelt Lake. Think of roads as a visual narrative thread into and through a landscape, and don't be afraid to shoot them while you're moving, as long as someone else is driving! I have actually set up a tripod to shoot a highway through my sunroof, slowing the shutter speed to 1/15 or 1/30 second. If the road is smooth, the center of the frame remains fairly tight and sharp, with radiating lines of blur from that point of focus. The viewer's eye will cling to that one-point perspective, which is very important with so much radial blur streaming by.

I also look for unusual or historic vehicles on the roads, like vintage Corvettes on Route 66; for theatrical backdrops like the sandstone monoliths of Monument Valley; or even for mirages. I shoot mirages with a 600mm lens to compress the perspective and intensify the mirage in the frame. It should shimmer like water vapor, but feel ephemeral. A digital SLR's 200mm or 300mm zoom, coupled with a 1.4X teleconverter, will give much the same effect.

Of course highways lead to discoveries, some that you may expect but many that you don't. I love to find and shoot examples of kitsch, or Americana. Arizona seems to have embraced kitsch as a native art form, and large-scale examples abound. To mine that visual vein, drive old Route 66 from just west of Ash Fork to Kingman. I'll never forget the delight I felt in first sighting the famous Snowcap Drive-In in Seligman. It's awash in 1950s kitsch and proud of it.

Farther west on this mainly two-lane road is Hackberry, where the general store serves as a Route 66 shrine. Inside this decidedly rambling structure stands a boyish Elvis cut-out dressed in a gold suit and wielding a blue neon guitar, and that's only the beginning of the adventure inside. Continue beyond Kingman to Oatman, and you'll find donkeys (the four-legged variety) roaming the winding main street, poking their long noses into the antique stores. On the outskirts of Wickenburg I found a shop that had a lineup of carved wooden Indians and one lonely cowboy. Their stoic faces made an amusing and memorable image that has been published numerous times, and that still pleases me.

Hispanic Style:
This adobe home was shot in early morning when the west-facing façade was in full shadow. Made with a 20mm lens, the soft, even light muted the intense colors of the house.

Skyline, then details

When I travel on assignment I first think about creating an overview, an image that sets the scene and suggests the character of the place. Some photographers call this the "establishing shot." When shooting towns or cities I look for a defining symbol that when combined with a clean view of the skyline or geographical backdrop will instantly tell the viewer where it is. For Phoenix, I have roamed the cactus-punctuated peaks around the Valley of the Sun for striking saguaros or palm trees to juxtapose with the downtown skyline, always at sunrise, sunset, or dusk. There are spectacular views from the end of San Juan Road in South Mountain Park ✳, and from the trails lacing up Camelback Mountain and Piestewa Peak. These scenics usually call for a long lens (200 to 600mm), so pack your tripod.

It's quite a different challenge to create a strong overview of a small mining town such as Bisbee, which fingers through several narrow, winding canyons. To find my classic view, I took to the narrow roads above the downtown district, and was lucky enough to stumble onto a wonderful display of Mexican gold poppies. They provided a contrasting foreground to the rust-red mountainsides and Italianate Victorian architecture of the proud copper town.

After the overviews, I hone in on the details that flesh out the portrait of a place. In the near-ghost town of Cochise ✳ in southeastern Arizona, the lonely country store sports a faded mural of a prospector pulling an unwilling burro. A telling and poetic detail if ever there was, and perfect for this locale. Always I look for surprises—images that no one, including me, expects. I appreciate juxtapositions of disparate elements, like the '50s cars next to the concrete teepees

at the famous Wigwam Motel in Holbrook. And finally, there are the close, tight details that draw the eye in. A cowboy's calloused hands or his mud-caked boot may tell his story as well as or even better than his portrait.

You can effectively isolate the viewer's eye on one element by shooting with a large aperture for a shallow depth of field. Don't always shoot with the same aperture or shutter speed combination. These should be chosen to suit the image you are making.

When shooting an event or a performance, such as the folklorico dancers at Tumacacori or bronco busters at the Payson Rodeo, try to capture the grace, energy, or emotion of the moment by concentrating on evocative gestures, expressions, or poses. Sometimes you will want to freeze this timely moment by using a very fast shutter speed, 1/1000 second or even higher. At other times, a speed as slow as 1/15 will blur the action, or the background if you are panning with the moving subject, and

convey the energy of the participants. Here you may have to stop your lens all the way down to f/16 or f/22, or even add a polarizer, to be able to shoot at 1/15 or slower in bright daylight. By using these techniques you are interpreting the moment and drawing the viewer in with you. These are some of the hardest images for a photographer to create, but are among the most rewarding.

Always be receptive to, and ready for, surprises. When I went to Organ Pipe Cactus National Monument ✳ to shoot the spring wildflower display, I was so intent on trying to compose the saguaros, chollas, and outbursts of poppies that I very nearly stepped on the only Gila monster I have ever seen in the wild. He was clearly not happy at how close I suddenly came to him, but he allowed me to shoot several frames before waddling off into the brush. I was there to shoot landscapes, which I do with a medium format camera on a tripod, but I habitually hike with a 35mm body and a medium range zoom lens looped over a shoulder. You never know when being able to shoot quickly can make all the difference in capturing a rare and beautiful shot, or having to tell another "one that got away . . ." story.

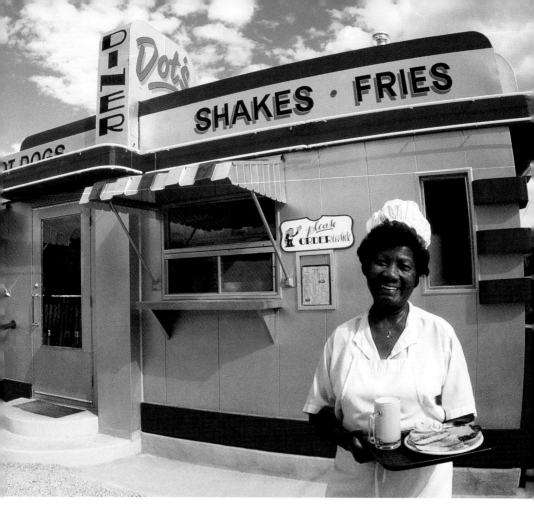

In taking travel pictures, as in most forms of photography, I recommend shooting as many variations as possible, and then analyzing what worked best, and why. Editing images, well after the shoot is over, is an important and often neglected part of the creative process. I try to view the images in progression, to see how I saw the scene, and what I missed, as well as what I did right. When an image really works well, think about why it does, and what you did to make that happen. Absorbing the lessons will make you more visually aware.

Living spaces

Arizona has some decidedly unique and photogenic accommodations for travelers, one of which is Bisbee's Shady Dell Trailer Park. Here you can stay in, and photograph, vintage trailers from the mid-20th century, complete with period furnishings, utensils, and pink flamingos. I love to include as many interior details as possible. You will find extreme wide-angle lenses of 14 to 21mm most useful for the compact interiors of a trailer, and a tripod will allow long exposures for maximum depth of field. A piece of fresh pie from Dot's Diner,

Dot's Diner: Dot has retired now, but her diner still serves up simple and satisfying diner fare, including dreamy pies and milk shakes. The photographer loved the diner itself, but felt it needed a human touch to come alive. Dot obliged with a cheeseburger, a shake, and a smile.

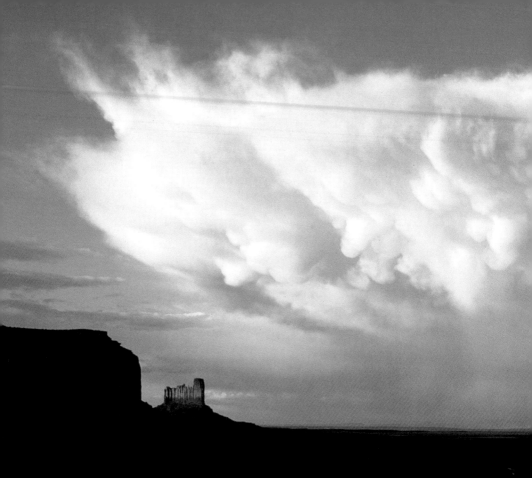

Rainbow: The only way to capture the breadth of a double rainbow is with a lens 15mm or wider (for 35mm film format). I very often also use a polarizer to intensify the colors of the rainbow, but the 15mm lens with which I shot this rainbow is so wide that it will see the filter, a major distraction! Here the colors were intense enough to carry the image, naturally.

right next door, can make an interior appear more welcoming. Which kind and color is a matter of taste. I thought the cherry pie went perfectly with the 1947 Airstream!

Another favorite spot for travelers to roost on the road is the Wigwam Motel in Holbrook ✳. Every time I drive through en route to the Colorado Plateau, I take the West Hopi Drive exit off Interstate 40 to check out how the teepees look today. Light is everything to a photographer, and it's no less critical when photographing kitsch. Sometimes you'll find striking clouds to include in your composition of the teepees, while on other days the twilight glow reflected on the spacious hoods and trunks of the '50s cars parked around is more inviting. A diagonal tailfin here or there can create a visual tweak that enhances a corner of the image, perhaps leading the viewer's eye into the picture.

On the southern fringe of downtown Tucson is the Barrio Historico ✳, where 19th-century adobe row houses have survived more than a century of sun-baked and monsoon-raked summers. Many are brightly painted, in honor of Mexican custom, and by framing the earthy textured walls with cactus and using the sweet light of early morning or late afternoon, these streetscapes will

TYPES OF PHOTOGRAPHY

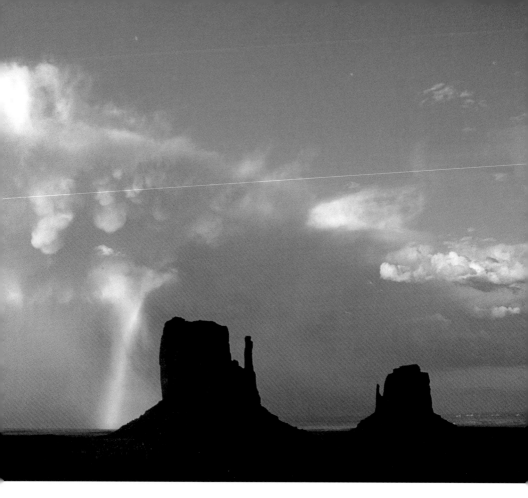

become lively and evocative color studies. As always, shoot tightly so that you hone in on the critical visual elements before you, choosing what to include and what to leave out. Less can be so much more.

It's legal to photograph a private home from a public street or sidewalk, but sometimes a homeowner will ask what you are doing or who you are shooting for. I politely explain what I'm doing and compliment the house, detailing the reasons why it's so photogenic. This usually satisfies the owner, and I can finish my shot. Once in a while someone becomes irate. If that happens, I fold up and walk away.

Let's shoot lunch!

Dining is an essential (and enjoyable) part of the cultural experience of travel, so why not document it with photographs? I like restaurants with color and panache to match their cuisine, even if it's just a restored diner. The Welcome Diner in Phoenix, 924 E. Roosevelt Street, is tiny, with barstool seating for maybe eight, but the colors and ambiance are a treat. I let the evenly shaded available light work for me, soft and slightly cool in color, and shot the counter

with a wide-angle lens high over my head, using slowish shutter speeds of 1/15 to 1/30th. The 17mm lens has surprising depth of field at F/8.

Sometimes I visit a restaurant and am blown away by the visuals of the space, but have little interest in showing the food. I may ask the manager if I can shoot a few images, but often that's unnecessary. If you're using available light and don't need to move tables or direct people, taking a few wide overview shots often goes unnoticed in the hubbub. Using a handheld wide lens at longer shutter speeds is very successful, especially when you can brace yourself against a wall or railing. Digital capture works especially well in mixed light or lighting that is not daylight balanced, since with many digital cameras you can choose your color settings to compensate for the variations.

One of my favorite restaurants in Phoenix to shoot (and to dine in) is Asi Es La Vida, 3602 N. 24th St. Even if I weren't wild about the food, which I am, I would come for the Day of the Dead decor of late October and early November. Lively and oh-so-colorful, these exuberant backdrops make for a visually busy space to shoot a plate of shrimp, as I did for *Sunset* Magazine. I shot verticals, close in to the food, and wider expansive shots to showcase the vivid wall paintings that energize the intimate space. I used a mixture of flash and ambient light through an open door to light the tabletop and the wall. It's a hot and active space for a food shot, but I like to think it looked as good as it tasted.

People and portraits

I prefer to shoot people in their natural environments, where they are at ease and their surroundings help to tell the story. I once shot a 15-year-old Navajo girl named Valerie Singer in Page for an *Arizona Highways* feature. She had lovely, strong facial planes, and I first thought of a tight head shot. But a warm wash of late afternoon light tempted me to include more of her figure, wrapped in a blanket, and her native soil softly went out of focus in the background. I'm glad I did, as her relationship to the land was as pleasing to me as her direct and open gaze into my lens.

I shot cowboy poet, humorist, and veterinarian Baxter Black for the cover of an inflight magazine, and here I wanted an environmental portrait out where a cowboy has time to write mental poetry and apparently develop a sharp and sardonic wit. I chose to shoot Baxter at twilight on open range southeast of Tucson, lit by firelight and one large reflector, "thinking stuff up," as he would put it. Now, no cowboy would actually be caught so close to a big fire like this, but he was game, and held still for some 1/4 second exposures as the sparks rose and the stars blinked in. Neither of us got burned, and everyone liked the final image.

Stories in silhouettes

I like the raw symbolic power of a clean silhouette, and am always on the lookout for clean and graphic backdrops for them. Silhouettes are easy to expose for: Just meter the illuminated background or sky. But pay attention to exact positions of people and their gestures. Don't be afraid to direct the subjects as you like.

Just a Gnaw: A bystander feeds one of Oatman's freely wandering burros.

I once shot a lone cowboy on a trail just off the road at South Mountain Park in Phoenix on his horse, framed between two perfect saguaros with the sunset afterglow to offset the distinctive shapes. Another time I shot the classic view of the Colorado River at Nankoweap, with hikers silhouetted high above the river, just below the prehistoric Puebloan granaries. With a medium-long lens to compress their jet-black figures against the ocher cliffs and the river below, the shot had a sense of both scale and moment.

My last silhouette example is an unconventional one. For an *Arizona Highways* story I shot a 50-mile horseback loop ride from Patagonia, and at night we stayed in tents. One night the cowboys set up a large teepee and built a fire inside. Their shadows were strongly silhouetted against the translucent skin of the teepee, resulting in a warm yellow look and comforting aura. It did the two things a good travel photo always should: It told a story and conveyed the feeling of what it was like to be there.

PHOTO TIP

When you're close to your subject, a wide-angle lens creates an intimate and interesting perspective. It also can emphasize and possibly distort that which is closest to the lens, depending on the focal length.

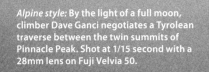

Alpine style: By the light of a full moon, climber Dave Ganci negotiates a Tyrolean traverse between the twin summits of Pinnacle Peak. Shot at 1/15 second with a 28mm lens on Fuji Velvia 50.

Adventure

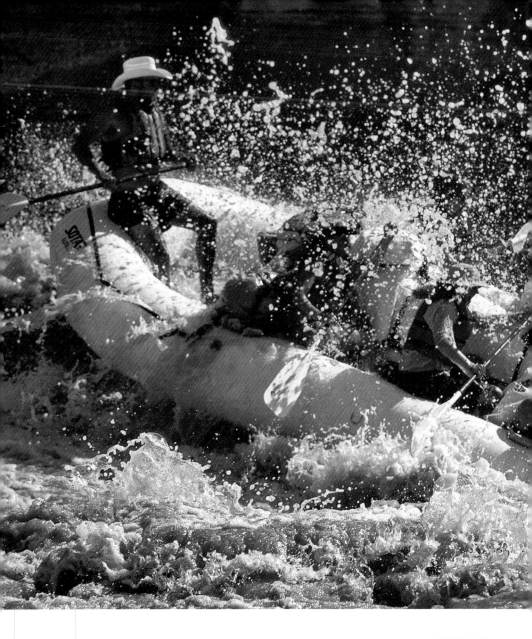

Documenting the Quest

Text and Photographs by John Annerino

ADVENTURE: *To many, the very word conjures up danger, excitement, fear, triumph . . . distant lands, exotic people, climbing to the summit of the world.* I wrote those lines in the preface to my first photography book, *High Risk Photography: The Adventure Behind the Image.* Fifteen years have passed and my definition

TYPES OF PHOTOGRAPHY

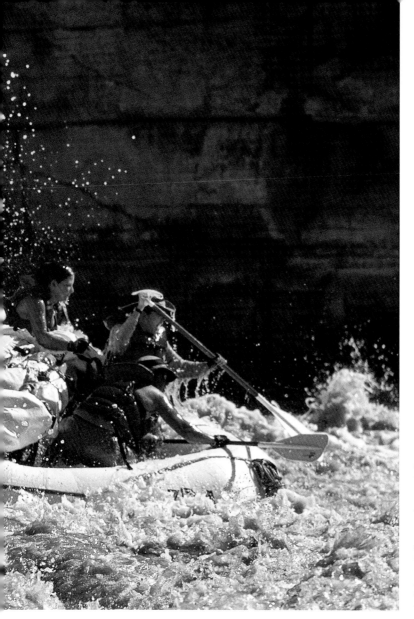

White Water Rafting: Paddle captain Jeff Pomeroy, far left, eyes his line through Upset Rapids at River Mile 150 on the Colorado River in Grand Canyon National Park. Shot at 1/500 second with a 180mm lens.

hasn't changed in substance. But I now use four words when I talk about adventure photography: quest, exploration, adventure, and discovery.

Those words are rooted in the exploits of iron-willed men whose life-and-death dramas played out on the world stage in the 20th century. Robert E. Peary and Matthew Henson reached the North Pole in 1909 after a grueling 37-day dog sled journey from Ellesmere Island. Roald Amundsen raced to the South Pole in 57 days in 1911. No adventure captivated the world more than New Zealander Edmund Hillary and Sherpa Tenzing Norgay's 1953 ascent of 29,035-foot Mount Everest. Shooting under the harshest conditions on earth,

each of these extraordinary adventures was captured on film.

Closer to home, one-armed Civil War veteran Major John Wesley Powell and his men braved deep, rugged chasms and frothing whitewater rapids that rivaled the grandeur of Mt. Everest when their leaky wooden boats navigated the Grand Canyon of the Colorado in 1869. But it wasn't until Powell's second Canyon expedition in 1871–72 that the adventure of surveying the "last explored, least inhabited region" of the contiguous United States was documented by expedition photographers E.O. Beaman and Jack Hillers with large-format wet-plate cameras. Beaman's and Hillers' explorations and photography laid the groundwork for Pennsylvania-born Ellsworth and Emery Kolb who, in 1901, began a lifetime of exploring and photographing hidden corners of the Grand Canyon not seen by Powell's photographers. But it was Hillers' skills as an explorer, combined with his uncanny ability to photograph remote landscapes and make evocative portraits of the Colorado Plateau's native people, that interpreted a world few Americans had seen. Hillers' work left me with a lasting impression.

Bagging a Peak:
A climber reaches the summit of Four Peaks at sunset, as a spectacular winter storm breaks over the Mazatzal Mountains east of Phoenix. The photo was made with a 28mm lens and Kodachrome 64 film.

As did that of Norwegian explorer Carl Lumholtz, who possessed those same skills. Departing from Bisbee in 1890, Lumholtz traversed Mexico's rival to the Grand Canyon, the Barranca del Cobre, and spent five years photographing the traditions and ceremonies of the people who dwelled throughout the storied Sierra Madre. In 1909 Lumholtz turned his attention to the Pimería Alta (Upper Pima Land) of Southern Arizona, photographing his year-long journey among the Tohono O'odham and their cruel and marvelous landscape with a Kodak 5x7 and two Folding Pocket cameras. In 1889, biogeographer C. Hart Merriam traversed the Painted Desert from the 12,643-foot summit of the San Francisco Peaks to the bottom of the Grand Canyon to visualize, sketch, and define his seminal *Life Zones of North America*.

Touched by the spirit of such explorers, I cut my teeth as a photographer in Arizona's hypnotic sweep of canyons, mountains, and deserts before expanding my horizons throughout the American West and Mexico. During my decade-long tenure teaching outdoor education, I carried a single 35mm Nikon SLR to photograph my students on adventures that took us to the summit of the San Francisco Peaks in the dead of winter to the depths of the Grand Canyon in spring; from the searing bajadas of the Eagletail Mountains to the redoubt of the Apaches in the Chiricahua Mountains. Since I was already weighted with a cumbersome backpack or rock climbing gear, carrying a single camera gave me the freedom to photograph my students and the landscapes we explored.

Inspired by the work of Gordon Parks, Peter Beard, and William Allard, who wielded their pens as deftly as their cameras, I forsook teaching to pursue my passion for photography and writing full-time: first as a freelancer shooting self-assigned picture stories, then as a contract photographer for the Liaison International photo agency.

How I work

Wherever I went, whatever the assignment, I followed basic tenets that continue to define my life's work of documenting endangered peoples, environments, cultures, and traditions.

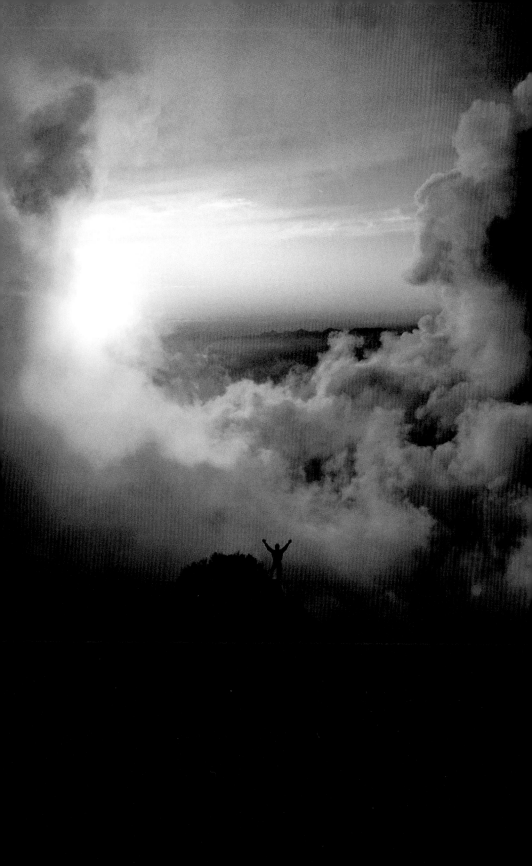

- **Portraits and People:** Get to know people face-to-face. Earn their trust by sharing something about yourself before asking them to expose their emotions to the unflinching eye of your camera.
- **Cultures, Traditions, and Informed Consent:** Make sure your subjects have a clear understanding of how your photographs will be used before asking for their consent. Be sensitive to their cultural traditions.
- **Remote Exposures:** Photograph places and people seldom seen.
- **Action and Adventure:** Get as close to the action as possible.

Long before I became a professional photographer, my quest had always been to explore and photograph the natural world that lay far beyond the realm of scenic vistas and the people who still inhabited it. My vision was shaped by these journeys and touched by the indigenous people I met. That has not changed. When I started sketching the itinerary for my second photography book, *Canyons of the Southwest*, my goal was to take viewers into the region's awesome canyons and barrancas with me. That was easier said than done. To photograph Baja California's highest mountain, 10,154-foot Picacho del Diablo, and the labyrinth of granite canyons that radiated from its summit, I needed to climb a daunting mountain 2 miles high. After two arduous forays, I finally reached the eagle's perch atop Picacho del Diablo, where my partner and I bivouacked for the night so I could photograph the "backbone of Baja" in the luminous light of sunset and sunrise. My quest had not been to photograph the adventure, which was almost incidental, but to take viewers into a remote landscape seldom seen. That formative experience became a guiding principle I followed throughout much of *Canyons of the Southwest* and subsequent books and assignments.

It nearly always paid off. While photographing a climbing feature for *Arizona Highways*, "Summit Classics" (February 1987), I was confronted by dismal gray clouds as my partner and I sat at the Four Peaks trailhead and debated whether to push on. I could photograph the summit from below and call it a day, but that wasn't enough. So we shouldered our packs and climbed through the mist and clouds until we reached the craggy 7,645-foot summit of Four Peaks. With little notice, the heavy gray clouds parted. I took a picture of my partner silhouetted by extraordinary winter light as the sun plummeted. We were forced to rappel through the fog in the dark, but the photograph made the cover of the magazine. The Kewevkapaya Yavapai called the peak *Wikejasa*, "Chopped-up Mountains." It was sacred, and I was blessed by that light.

Scenic vistas are often the starting point for my photography. Case in point: the Little Colorado River Gorge.

I'd never seen pictures taken from its interior. I sat on the rim of Salt Trail Canyon and traced the route of Third Mesa Hopi who'd once made sacred salt pilgrimages through the lower half of the gorge to the Grand Canyon. I sat on the opposite rim of Comanche Point and traced the 1909 route of the Kolb brothers into the mouth of the gorge. That wouldn't do, either. I wanted to explore the length of the Little Colorado River Gorge in hopes of bringing back

pictures I'd never seen. At the time, no one I was aware of had traversed the 57-mile-long gorge on foot from Cameron to the confluence with the Colorado River. If I succeeded, I still would have to trek another 19 miles and climb a vertical mile out of the Grand Canyon to reach Lipan Point on the South Rim.

Flash floods have claimed the lives of seasoned canyoneers, so timing was everything. The one safe bet was the blistering month of June, but 100-degree heat challenges anyone trying to reach Blue Springs, the first perennial water source, 35 miles below. Shouldering 3½ gallons of water, I pared my food down to rations, and my photographic gear down to a single 35mm Nikon, 28mm lens and polarizer, and a small Gitzo tripod. Five days later, I reached the South Rim, weary, weather-beaten, but elated that I'd returned with my coveted "remote exposures."

I used to ask myself a question: Is photographing the adventure the goal, or is the adventure a means of going deeper into the land to photograph a remote vista? I started out shooting the former until it evolved into the latter. But I began by photographing what I knew. I used that principle when I rowed the Colorado River through the Grand Canyon to shoot a photo essay titled "Enduring Magic of the Colorado River."

My goal was to shoot the river journey only during the magic light of dawn, twilight, sunrise, sunset, and refracted canyon light in between. I kept my cameras stowed most other times and focused on the adventure of rowing against hot, upstream winds and navigating the Canyon's booming whitewater rapids.

It was high noon on day 12 as our six oar boats neared the end of our trip at Diamond Creek. The midday summer light was terrible, and my cameras were securely stowed in a rocket box. We floated around a bend. And just then a magnificent desert bighorn ram stepped into the frame of the picture I would have taken, had a camera been in hand. The passengers crooned, "oooh!" My photo essay was sold around the world. But I still kick myself for missing that picture.

Before I photograph an area, I research to see what, if anything, has been shot so I have a grasp of what I'm getting into. Other times I'll scout the destination myself. Still, I'm often surprised by what I discover when I look through the viewfinder.

I received a call one day from a picture editor at *Travel & Leisure*. They were doing a cover story on the Grand Canyon. Did I have any good ideas for a cover? I suggested something "edgier" than the common rim view—someone peering over the very edge, and not at any of the familiar vistas that have been photographed endlessly. They assigned me the cover. Two veteran climbers agreed to join me on a cross-country trek to the remote, rugged 7,646-foot summit of Shiva Temple where we'd bivouac two nights so I'd have two sunrises and two sunsets to get the picture. I set up and photographed various versions of the cover photo I'd been assigned. Then I started exploring the southern edge of Shiva Temple until I discovered a view that captured the immense, three-dimensional scale of the Canyon, highlighted by the tiny figure of a man peering into it. The former made the cover, but

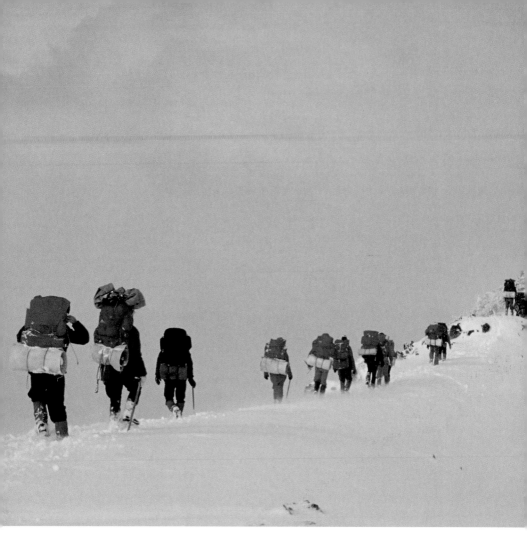

this image remains one of my favorite Grand Canyon pictures.

Arizona offers adventure destinations and remote lands for every taste and level of ability. But start out by shooting what you know best, whether you're a hiker, canyoneer, climber, or river runner.

Rivers

Arizona's canyon, mountain, and desert destinations are covered elsewhere in this book, and all offer endless avenues for adventure photography. But consider one other possibility: rivers.

The most renowned and spectacular, of course, is the 277- mile Grand Canyon of the Colorado, which offers stomach-churning big drops, 100 named rapids, and mesmerizing flatwater river scenes. From shore, you can photograph scenics at sunrise and sunset, side canyon hikes, scenery, and waterfalls. From your boat, you can photograph your guide in action and other rafts

drifting on placid currents through refracted canyon light.

Whitewater is one of the biggest lures for photographers, but that takes the most planning. To successfully photograph the river's Class 9 and 10 big drops like Hance, Horn, Granite, Hermit, Crystal, and Lava, make arrangements with your guide to tie off above the rapid so you can get in position along shore. The width of the river channel varies, so you need to carry a variety of fixed focal length lenses, or a zoom, with a range from 85mm to 180mm. Meter the light by panning down the length of the rapid. Then start focusing as the first boat slips down the tongue into the rapid, fill the frame, and follow the action. Shoot at your discretion. Then pan back up the rapid to shoot the next boat.

The river running season is late spring through early fall. Summer monsoons offers dramatic lighting and conditions. Guided trips ranging from one to 18 days are available from commercial outfitters using large inflatable rafts or wooden dories. Paddling the Grand Canyon on your own, however, requires plenty of whitewater expertise and a 10-year wait for a permit.

Hazards include: sun and heat exposure, slippery footing on boats, shoreline, and side hikes. Special gear needed: freezer-strength zip-locking bags to store film, lenses and cameras; canned air for cleaning sand out of cameras and lenses; extra batteries and film; and an ammo box and rocket box to stow your cameras, (normally available upon request from your outfitter).

The 52-mile upper Salt River northeast of Phoenix is a favorite during late winter and early spring when snowmelt from the White Mountains guarantees an exciting ride through a rugged desert canyon, with many of its sights accessible only from the river. Commercial outfitters offer one-day to five-day trips. If you paddle your own raft or kayak, you'll need permits from the White Mountain Apache tribe and/or Tonto National Forest, depending on your itinerary.

Canoeing the lower Colorado River through Havasu National Wildlife Refuge around Topock ✳ and the Imperial National Wildlife Refuge ✳ north of Yuma also offer wonderful opportunities to photograph the river, landscape, and waterfowl. Both are administered by the U.S. Fish and Wildlife Service, which regulates boating and camping.

Places for Photography

Storm Twin: Left over from an afternoon storm, a double rainbow arcs over the Grand Canyon as seen from Mather Point on the South Rim.

Grand Canyon

Overcoming Difficulties

Text and Photographs by Gary Ladd

MAY 1970, LEE'S FERRY ✳, ARIZONA. I pulled my hat down tight, stepped over the gunwale of a dory, and took a seat. The little wooden boat, designed for whitewater and colorfully painted, soon departed from the old gravel launch ramp, wet oars flashing in the sunlight.

Minutes earlier, under an ancient willow tree at river's edge, Martin Litton, trip leader and the owner of the Grand Canyon dory flotilla, described to us what we could expect of the next 19 days: roaring rapids, tranquil side canyons, hot afternoons, freezing cold water, sandstorms, and beauty beyond description. He also explained how experiences such as these were nearly lost when the Canyon came within a whisker of drowning beneath the deep water of a pair of reservoirs a few years before.

It was on that trip that the Grand Canyon ✳ became the catalyst that drew together the threads of my then and future life—hiking, backpacking, exploring, photographing, geologizing, and river-running—into a single tapestry. I was overwhelmed by what I saw on that river trip—the beauty, the grandeur, the adventure, the sheer size and complexity of the Canyon, and the experience it afforded. Photographing the Grand Canyon and the Colorado River, for better or worse, has dominated my life ever since.

Several circumstances gang up on photographers intent on bagging the Grand Canyon. Difficulty of access tops the list. Utter, absolute, rugged wilderness—the very attributes that make the Grand Canyon so appealing—also render its revelation by camera a great trial by terrain. Anybody who's serious about extensive photographic explorations of the Canyon must consider how he or she will physically get into it and effectively convey its trackless wilderness and unspoiled loveliness.

Glorious Plunge: On the Havasupai Indian Reservation in the depths of the Grand Canyon, Mooney Falls plummets into a blue pool amid travertine draperies.

And now the rest: The serious photographer's efforts will be judged against that of an army of other photographers, so ordinarily solid photographs are, to be blunt, inadequate. The frequent clear days of the desert Southwest present serious contrast problems. In the inner canyon (especially along the river), heat and blowing sand can easily disable cameras if not their operators. The weight of cameras, lenses, tripod, and film added to the weight of hiking and backpacking gear can literally bring a photographer to his knees. Finally, to protect those wilderness attributes that attract all of us

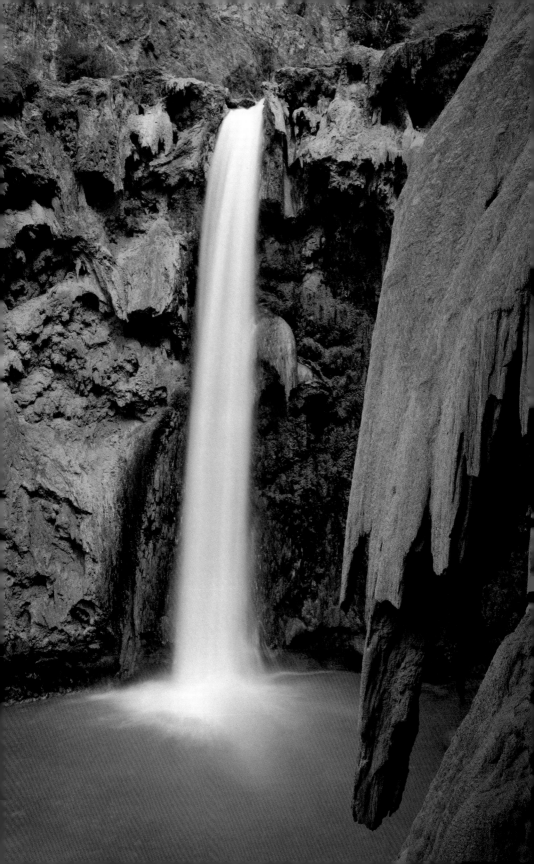

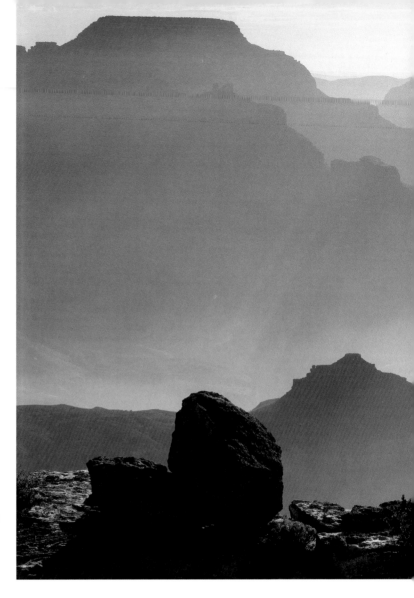

Smoky Blue Shrouds: Viewed from Mather Point, the knob atop Vishnu Temple rises above the hazy smoke from a forest fire.

to the Canyon, the National Park Service backpacking permit system sometimes means you can't go where you want to.

In an effort to find and record fresh images in Grand Canyon, I've tried to penetrate deep into the Canyon labyrinths. I've built and rowed my own wooden dory down the Colorado River; I've followed obscure routes into and through the Canyon pioneered by Harvey Butchart, George Steck, and Robert Benson; I've pushed on foot into places where no one that I knew of ever went before; and at times I've hiked to rim lands far from the roads. I've studied maps to locate new potential and I've returned repeatedly to fruitful locations where I suspect more potential lies untapped.

As American West photographer William Henry Jackson said, a successful

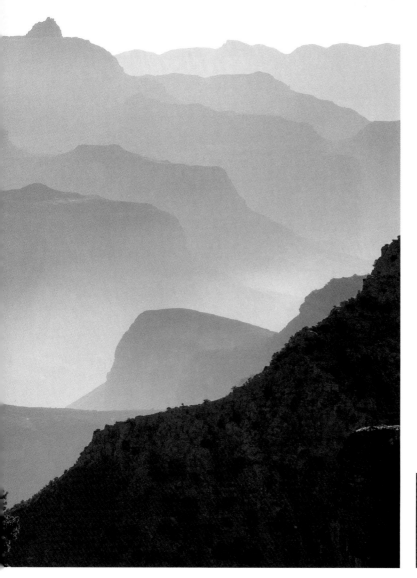

picture requires "labor, patience, and moral stamina." This is nowhere more true than inside the Grand Canyon. These are basic attitudes that cannot be activated by pressing buttons on high-dollar cameras.

During the 1970s, '80s, and '90s I made dozens of backpacking trips into the Grand Canyon. I carried my 4x5 camera on nearly every trip, adding 15 or more pounds to a pack that was already loaded with 40 to 60 pounds of gear, food, and water. In a series of trips I backpacked all the north side of the river from Lee's Ferry (mile 0) to Lava Falls (mile 179), missing only 8 river miles along the way. The real distance was probably more than 500 miles, few of which included a trace of trail. I also covered about half that distance on the south side of the river.

I would be thrilled to tell you that my various efforts produced a wealth of great photography from remote locations. It did not. It produced some. The problem, I think, is that high caliber photography takes time, and difficult trips into challenging locations are time- and effort-intensive themselves. Often little energy remains for photography. Great images under demanding circumstances arrive only in a trickle. As a result, no one has yet photographically mastered the Grand Canyon.

There is, however, one satisfying exception to my dismay with my own Grand Canyon photography: It's the collection of images made during boat trips down the Colorado River. It's along the river, where access is physically relatively easy, that I'm able to concentrate on finding fresh images. But even river access is difficult in its own way: Commercial trips are expensive and fairly inflexible, while self-guided trip permits are extremely difficult to obtain and (in my experience) often time-inefficient. Nevertheless, the river corridor remains a fountainhead of photographic possibilities.

On river trips there never seems to be enough time to run rapids, hike, eat, sleep, or just lean against a boulder and listen to the music of the water. So, while others study geology, I search for photographs. While they hike up well-known and frequently-photographed side canyons, I explore along the water's edge looking for interesting compositions and favorable illumination. While my companions relax with a cold drink, I'm out snooping among the boulders or climbing to benches for a better view. Or, at least, I'm feeling guilty about my slothful ways.

Have I sometimes missed strong images? Of course. I get worn out, I get lazy, I get fooled. Some of the lost opportunities still make me sick with regret. So…let's change the subject.

I've suggested that serious photographers penetrate deeper into the Canyon and work hard when they do. But what are the specifics? As always, I try to discern what is really in front of me—not what I think is there, not what it represents, not even what it really is, but what it really looks like through the peculiar window of the camera.

This is surprisingly difficult. I must forget that the Elves Chasm gneiss in the foreground is the oldest rock in the Canyon. If the rock outcrop is not appealing by way of color, form, or texture, then photographically it fails. My knowledge of the Canyon may help me find the image, but it should not be allowed to influence what I "see" in the finished image. Also, the three-dimensional world is recorded on a two-dimensional medium, thus skewing reality; so I can't allow my three-dimensional "thereness" experience to prejudice what I see on the ground glass or in the viewfinder. (I sometimes wonder if the inclusion of a forceful foreground in landscape scenes is effective simply because it acts as a substitute for the photograph's lost third dimension.)

Let's briefly consider three types of Grand Canyon locations: the Rim, the inner canyon, and the Colorado River corridor. In all cases, pleasing graphic lines must be pursued, flattering illumination is as important as the subject that it illuminates, and drama (by way of strong foreground elements, engaging subjects, rich colors, or interesting compositions) must always be in your sights.

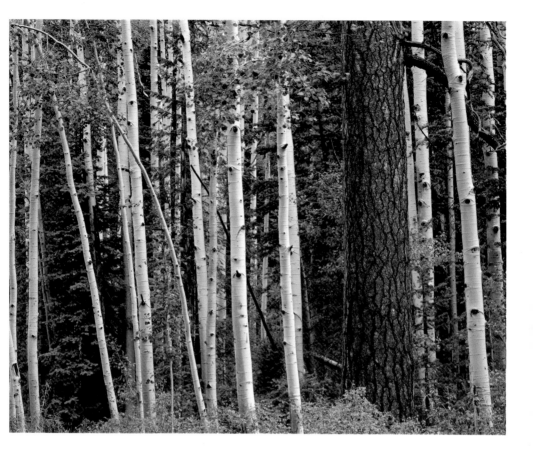

Along the Rim

Take heart and be joyful! One U. S. Geological Survey estimate pegs the total length of the Grand Canyon Rim at more than 2,700 miles! I would guess that fewer than 100 of these miles have been more than superficially investigated by photographers, leaving much potential untouched. Combined with the natural kaleidoscope of changing weather and lighting conditions, many fine photographs remain to be made without the need to take a single step into the craggy world below the Rim.

Dramatic or interesting clouds help immensely. The summer monsoon season is often the most productive time of year for clouds. It's then that afternoons bring billowing cloud structures, rain showers, theatrical light, and dramatic rainbows. The summer and early fall are, of course, the only times of year when North Rim roads are reliably free of snow and open. Keep checking for foreground "gold" such as jutting rimrock points, handsome tree silhouettes, blooming cacti and agave plants. Don't forget to include people in some scenes. I'm drawn to telephoto views with human figures projected against a rugged canyon backdrop. This combination lends a sense of scale and a touch of humanity to the Grand Canyon.

Stately Assembly: On the North Rim, a grove of slender aspens surrounds a rugged ponderosa pine. Rains from earlier in the day turned the ponderosa bark from tan to rich red.

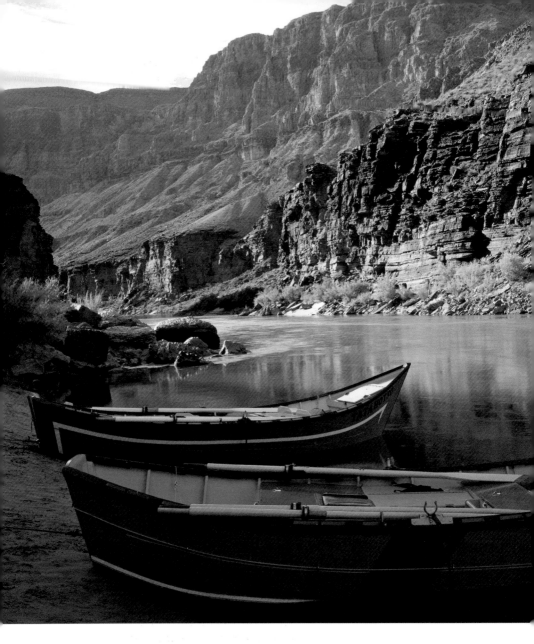

River Rest: Wooden dories rest along the Colorado River near River Mile 137. Making sure that no movement was apparent in the bobbing dories, the photographer had to keep his shutter speed relatively high.

The Inner Canyon

The trails and trail-less backcountry between rim and river offer access to a world wildly different from that of the Rim and the river. This canyon world, however, is more difficult to photograph than the others. It has neither the intimacy of the river corridor nor the drama of the high overlooks.

One section of inner Grand Canyon, however, offers an almost unlimited and unexploited potential. It's the Esplanade, the broad platform developed on the surface of the Supai sandstones in central and western Grand Canyon. The

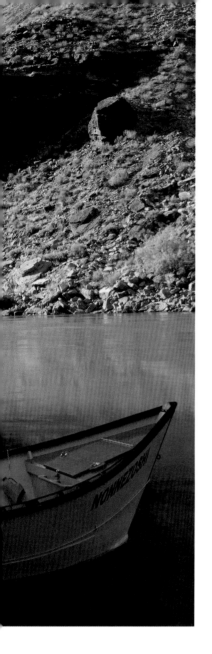

Esplanade's wildly eroded sandstone terrain offers a great mix of knobs, hollows, water pockets, and slickrock platforms, all stained orange and red. But difficulty of access is still a demoralizing obstacle. There are a few trails and routes in the Thunder River and Kanab Canyon area. And the Toroweap Overlook road allows some access to the Esplanade. But most of this enchanting part of Grand Canyon is far, far away, forever available only to the most determined and physically fit photographers.

Along the river

As nowhere else in Grand Canyon, the river ambiance is rousing. To stand on the shore of the Colorado, to watch it, to feel it, to hear it, and to inhale its fragrance is to find yourself in communion with the very forces that shape much of our Earth's surface. It is this dynamic physical setting—the sculptured boulders and cliffs, the air's vibration at the edge of a rapid, the heat and the silence of the nearby side canyons—that can dominate our experiences at the bottom of the Canyon, and our efforts to photograph it.

Unlike most of the Colorado River's canyons, the Grand Canyon is not playful. It is not whimsical, cute, or appealingly pretty. The river corridor here is profound. It seems that the gods of raging waters and steadfast rock have made their home here. Standing at the edge of Horn Creek Rapid or Granite Falls Rapid, it's impossible to feel otherwise.

To effectively photograph the Grand Canyon takes patience (hours, days, and years), it takes work (physical and mental to find and execute stronger images), and it takes persistence (to continue working when others have surrendered). And then, I think, effective Grand Canyon photography requires a sensitivity to the tiniest trifles in a colossal landscape. It is there, in its intricacies, that the true grandeur of the Canyon is revealed.

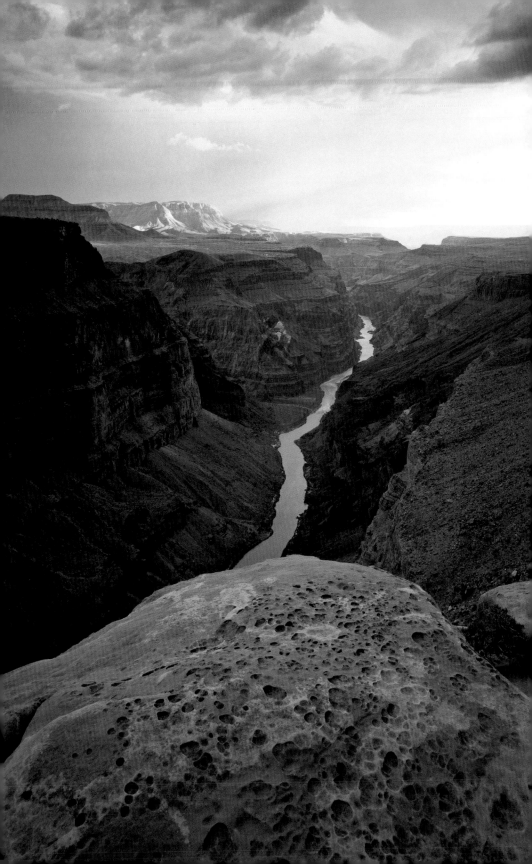

The Colorado River ✴ Photographically, the river corridor is the richest area of the Grand Canyon. The horizontal sweep of the river juxtaposed against the vertical cliff profiles, the rapids, the shoreline intricacies, the sculptured boulders, all form fertile photographic subjects. Some river boats, beautiful in their own right, offer still other possibilities. On Page 210, my dory *Tatahotso* and a companion rest at camp a mile below Deer Creek Falls. Thin clouds sprinkle a gentle light into the shade, allowing the details of the two boats to rise to prominence, even in subdued light.

Grandview Point ✴ I've experienced some fine sunsets at South Rim's Grandview Point, but I fumbled one when I gave up the wait too early. Years later, the mistake still stings. Grandview Point offers one unique advantage—a trail that drops into the Canyon directly from the overlook. While waiting for better light I sometimes hike down a bit and return to the Rim for sunset. The Grandview Trail also leads down a short distance to several informal view locations, an important plus when the Rim becomes crowded at sundown. In this scene the sun has already set. But fiery clouds in the western sky (out of the picture to the left) radiate crimson light into the Canyon, illuminating the west-facing cliffs and slopes. Contrast, always a problem when looking towards the setting or rising sun, was tamed by looking away from the sun. I usually prefer other locations for sunrise images.

Cape Royal ✴ North Rim's Cape Royal offers a great range of possibilities. I made this image near the picnic area where the blooming

LEFT: **From Toroweap Overlook.** BELOW: **From Grandview Point.**

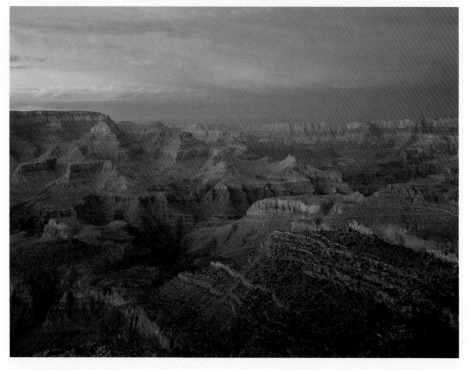

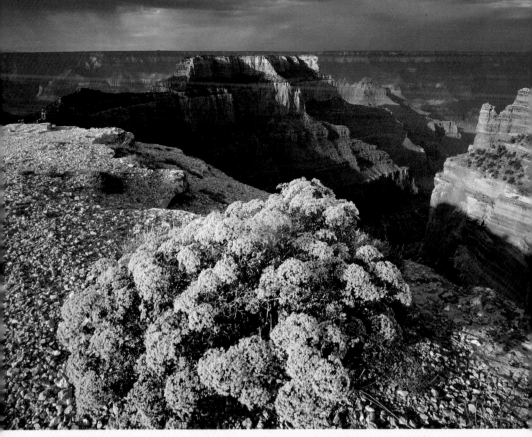

From Cape Royal.

buckwheat provided a fine foreground subject. Out on the point of the cape, the views are stupendous in almost every direction. Accordingly, countless photographs have been made there, most of them looking southeast, southwest (toward nearby Wotan's Throne) and west in both morning and evening light. Views eastward are tougher—the sun angle is difficult at both sunrise and sunset, and the Canyon terrain to the east is not as complex. There's one view to the east, however, that offers great promise, though I've yet to make or yet to see a really fine image. That's the Angels Window viewpoint, passed on the trail to the tip of Cape Royal. Too many photographers (myself included) are drawn out to land's end where the obvious opportunities await. Some future sunrise, somebody will make a glorious image of Angels Window. We shouldn't automatically gravitate to the easy or obvious.

Marble Canyon ✲ An element of danger is often present in landscape photography. In the Grand Canyon this means cliffs and edges. I personally enjoy transactions with exposure; I love climbing peaks and temples and picking my way across (some) steep talus slopes. Up to a point. I have my limits, and they have become easier to attain with each passing year. But being comfortable in the face of a little peril is one of my photography tools. On a route into Marble Canyon that long-time Grand Canyon explorer Harvey Butchart classified as "sporting," the ledge is barely a boot's width across. A good photo of such a place will express its inherent danger without putting anyone—either photographer or subject—at unreasonable risk.

Desert View ✲ The view from near the South Rim's Desert View Watchtower can be dynamite at sunset. The west-facing Palisades

of the Desert stretch northward from just east of Desert View, providing the feature with a clear line of illumination from the west. During one of my visits a group of kids had descended to a prominence below the rim. The group became my foreground with the drama of the cliffs looming large beyond and above them. In the summer months, the sun sets straight down the length of the Canyon as seen from Desert View. This geometry allows great possibilities for summer sunset images, especially when broken clouds swarm over the Canyon. Sunrise shots at Desert View are usually less interesting. Winter introduces problematic shadows from the South Rim into the Canyon, so look for snow or clouds to supply interest.

South Kaibab Trail ✺ One of the great sites for Grand Canyon photography is just a little over a mile down the South Kaibab Trail, just beyond Ooh Aah Point and just before Cedar Ridge. From the Rim I can easily hike to it in 45 minutes. Here's the appeal: For a distance of about 300 feet, the trail traverses the crest of a narrow ridge. The world falls away on both sides. O'Neill Butte thrusts up in the mid-distance and there are staggering views in almost every direction. Also, the Kaibab Trail itself along this stretch is surprisingly photogenic. I don't mind that it's well-traveled—human figures add interest and scale to a vast and awesome landscape. Sunrise is almost always usable here, especially in the summer months, and when clouds are properly formed and positioned, post-sunrise and late afternoon also work.

Point Imperial ✺ This is the highest point on the North Rim at 8,800 feet. Apart from stormy weather, sunrise and early morning offer the best time to photograph here. Most times the camera points southeast towards Mount Hayden and the maze of side canyons beyond. Because there's little room at the main overlook, I usually try to arrive early to claim a decent spot, an important point if you're working with a tripod. I've also tried many times to photograph southeastward along the Rim by following the Ken Patrick Trail. But from these displaced vantage points, Mount Hayden is no longer projected against a backdrop of rugged canyons and ridges. In my sunrise images I'll often retard the sky's brightness with a one- or two-stop graduated neutral density filter. Views to the north and northeast up Marble Canyon and on to the Paria Plateau are also appealing in early morning light. Bring a long lens for this view and consider using a polarizing filter—the angle is just right for summer morning photography.

Mather Point ✺ This is one of my favorite Rim locations because the topography gives Mather Point some great geometry. O'Neill Butte, northeast of the overlook, rises from a ridge where both morning and evening light can play on it. Also, the eastern horizon features the silhouettes of both Vishnu Temple and Wotans Throne. And during the summer monsoon season afternoon rainbows will arc over the Canyon with Vishnu Temple and Wotans Throne in the background. The location of the overlook, the location of the temples, the location of summertime's afternoon sun, the frequent afternoon occurrence of monsoon rains, and the 42-degree offset of rainbows from the antisolar point unite to create a photogenic geometry. Use a polarizing filter to enrich the rainbow colors. And bring a raincoat.

Havasu Canyon ✺ The turquoise waterfalls tumbling through red rock chasms will knock your socks off, although they require a hike of about 10 miles each way. Or you can travel most of the distance by horse or helicopter. I've concentrated on Havasu Falls and Mooney Falls (shown on Page 205), the largest of the four major waterfalls. As you might guess, I almost always try to find compositions that

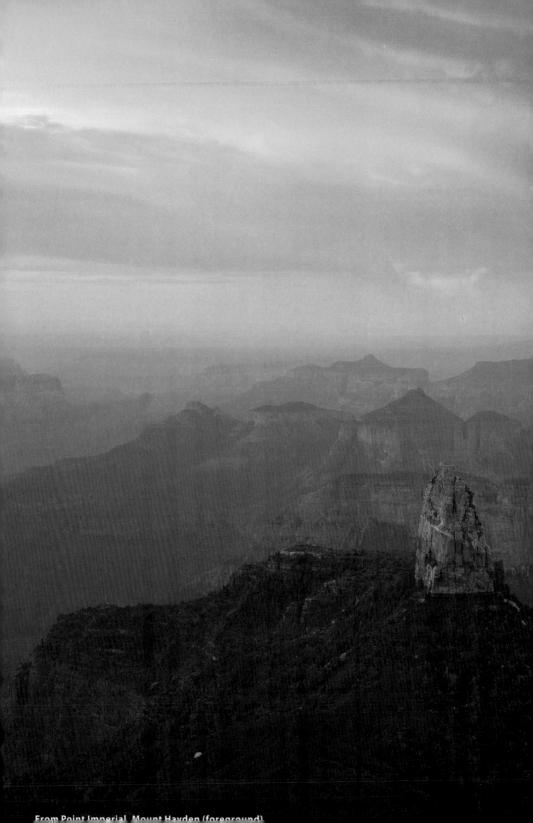

From Point Imperial, Mount Hayden (foreground)

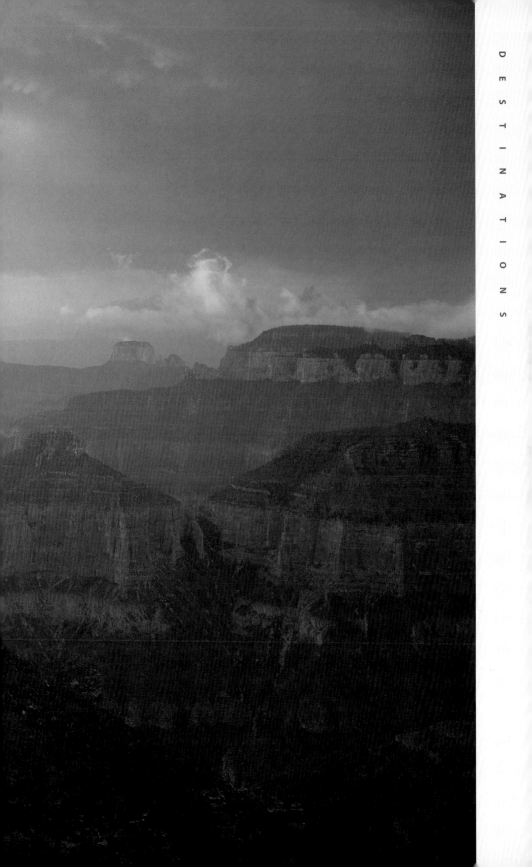

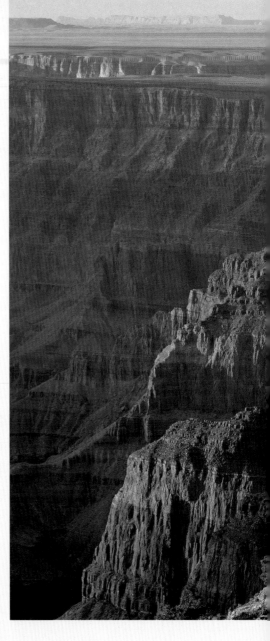

include foreground elements—a small cascade in the foreground, travertine draperies, or the trunks of cottonwood trees. I also prefer to photograph in morning and evening shade, or under light overcast to reduce the contrast. All trips begin at Hualapai Hilltop at the end of a 56-mile paved road, Hualapai Route 18, that begins 6 miles east of Peach Springs. There's a campground close to Havasu Falls and a lodge in the village of Supai. Be sure to secure reservations for the lodge or the campground.

Toroweap Overlook ✿ This remote overlook (shown on Page 212) is one of the most rewarding Grand Canyon viewpoints. Several miles of the Colorado River, 3,000

Climber, Grand Canyon.

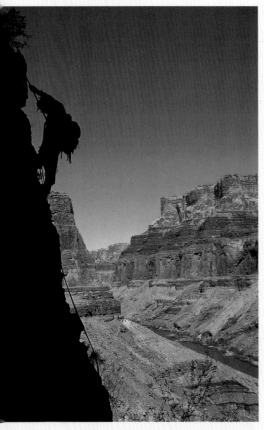

feet below, are visible more or less beneath your toes. Holiday visits to Toroweap should be avoided and weekend days are often busy in the spring and fall. I like winter days when few visitors are about and summer afternoons when monsoon clouds gather over the Canyon. Don't make this trip a day's

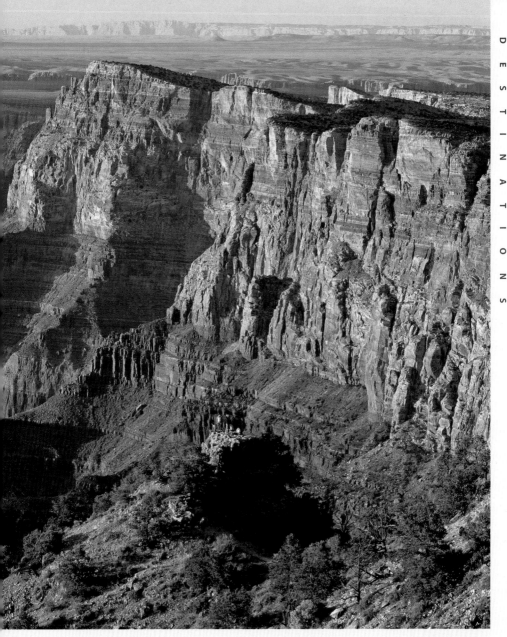

From Desert View.

outing—you'll want to spend the night in the nearby campground to catch both morning and evening light. Both are rich with opportunity, especially when clouds are about. Toroweap can be reached by either of two dirt and gravel roads. The shorter route—61 miles—begins 7 miles west of Fredonia via Forest Service Road 389. This road is usually in good repair, but it's subject to flash floods and washboarding, and near its end it crawls over gentle waves of orange slickrock. Passenger cars can sometimes make this trip, but off-road vehicles are a better choice. Good tires are a must, including a full-sized spare.

Rugged Mosaic: A November view of Dominguez Butte near the shore of Padre Bay shows the fractured rock uncovered by Lake Powell's receding waters.

Colorado Plateau

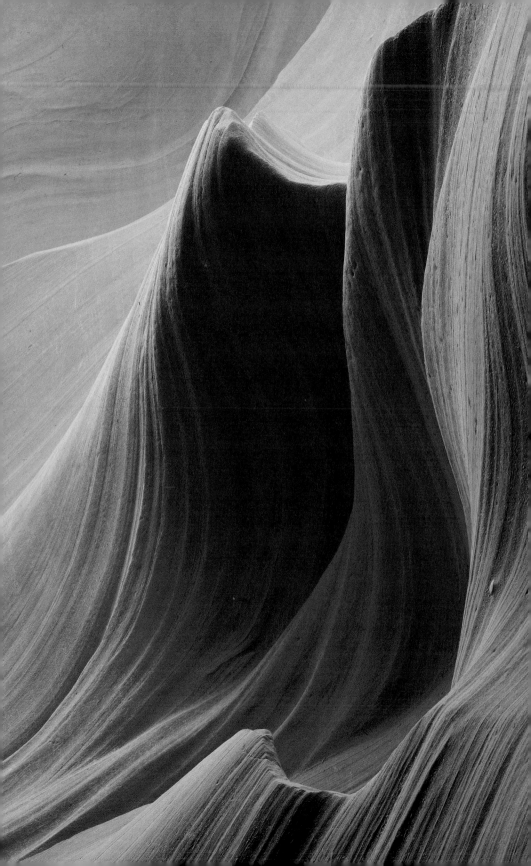

Avoiding the Seduction

Text and Photographs by Gary Ladd

WATCH OUT! YOU'VE JUST ENTERED what is arguably the most photogenic landscape on earth—the Colorado Plateau. I advise caution because the obvious wonders of the plateau can easily seduce photographers into chasing only the vast and grand images, while overlooking enchanting details. It's easy to get blinded by the glare of pure spectacle.

The Colorado Plateau is an elevated island of flat-lying rock layers surrounded by an ocean of heaving, broken mountains—the Rockies to the north and east, Basin and Range Province to the west and south. It sprawls across the Four Corners region with its center located along the eastern Arizona-Utah border near Monument Valley. In this chapter I'll focus specifically on the area that surrounds Page and Lake Powell. I live in Page, a small town created in the late 1950s to support the construction of Glen Canyon Dam and the vast lake upstream from it. For me, its great attraction is being completely surrounded by geology of endless fascination to a photographer.

Let's visit the starring locations of Antelope Canyon Navajo Tribal Park, Vermilion Cliffs National Monument, and Glen Canyon National Recreation Area (including Lake Powell and Horseshoe Bend). All have one physical element in common: Navajo sandstone, the soft, reddish rock that has given us slot canyons, towering escarpments, balanced rocks, domes, spires, and arches.

Antelope Canyon Navajo Tribal Park ✸

This canyon has become the standard of comparison for all slot canyons. Sections are improbably narrow and twisting with overhanging, convoluted walls. It's insanely photogenic. The entrances to both Lower and Upper Antelope Canyon are located just a few miles east of Page on State Route 98.

Light filtering down into the labyrinthine canyon, reflecting from wall to wall, is beyond description. At different times of the day in changing sections of canyon, the rock glows with a luminous fire that seems to burn within.

I prefer to work in Antelope Canyon on clear days when shafts of sunlight dive unimpeded into the canyon depths. Cloudy days smother the light and extinguish the "internal radiance" effect. I avoid windy days because the wind kicks sand and dust into the canyon, wreaking havoc on equipment and film. Although light levels in the narrow canyon are subdued, I never use a flash

Sinuous Sandstone: Sunlit Antelope Canyon shows curving ridges of flood-sculpted sandstone.

because I want to maintain the drama of warm natural light reflected from walls unseen, and I always use a tripod and small apertures to gain the maximum depth of field.

In general, the summer months are best for photography in slot canyons. Midday is often preferable, too. Both allow more sun into the tight canyons. But the winter months are not without their charms.

Unfortunately, Upper Antelope Canyon has become so crowded with visitors in the summer months that serious photography is nearly impossible. Visitors are everywhere, tripods are accidentally kicked, and patience wears thin. Lower Antelope Canyon requires the negotiation of a series of steel stairways and ladders. The steep metal stairways bolted to the walls discourage many visitors, making more room for tripods and hard-working photographers.

Almost everyone brackets their exposures in Antelope Canyon because its atmosphere is so unusual that "standard" exposure may not be best. Digital camera users can gain a feel for the best exposures as they work. Here's what works for me:

I have confidence in the matrix or segmented-type metering systems, common on both digital and modern film SLRs, and I often agree with the exposures calculated by the matrix system. But I sometimes like the effect of slight underexposure, about 2/3 of a stop under the matrix system's recommendation. I sometimes use a center-weighted exposure system and simply aim for the most important part of the scene, which (usually) deserves the highest consideration in exposure calculations.

Slot canyons are carved by flash floods, so it's important to keep an eye on the sky. This is critical during the July-September monsoon season: Check the forecast! I once drove out to a slot canyon east of Page with friends. The day was cloudy and a little drizzly, but after stalling for a while, in we went. Our logic was simple: It had been sprinkling for several hours without effect, and we had been planning this trip for several weeks. It took less than an hour to squirm through the narrows, no problem. Where the canyon widened again we scrambled up a side ravine that took us to the road. We hiked it back to our vehicles and the slot canyon, which—holy cow!—was now beginning to flood. Don't be this foolish!

Vermilion Cliffs National Monument ❀

For decades Paria Canyon has been known for its stunning patterns of desert varnish, lush green cottonwood trees, and soaring orange cliffs. Buckskin Gulch, a 13-mile-long tributary of Paria Canyon, is another magnificent slot canyon. I've never spent enough time in the Paria Canyon system, and I always seem to be vaguely planning a trip there sometime soon. This park is southwest of Page and most of its most scenic areas are accessible from the White House Trailhead and the House Rock Valley Road along the park's western boundary. Four-wheel-drive vehicles are sometimes needed for the House Rock Valley Road; they're required for the top of the plateau roads.

Even more astonishing than Paria Canyon is the plateau itself, where color, wonderful structural forms in the sandstone, and richly textured, sinuous

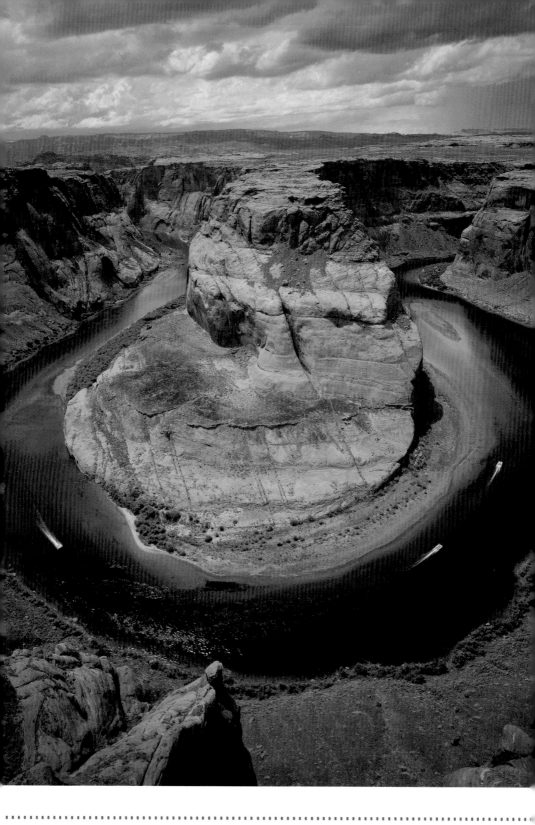

Stone Mirror: In the Vermilion Cliffs National Monument, still water on ridged sandstone glassily reflects blue sky and more sandstone.

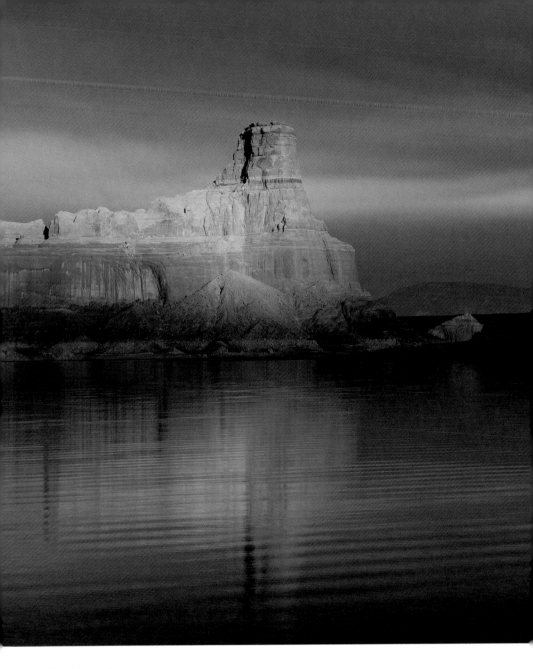

A Day's Farewell:
Last light on a
November
evening finds
Gunsight Butte
reflected in Lake
Powell.

surfaces abound. The Coyote Buttes area is one of the most fantastic areas of
Paria Plateau, where wind, rather than water, has engineered most of the sculpt-
ing of the landscape.

Bewilderingly irresistible—that's the phrase to use in describing the psyche-
delic cross-bedding patterns in the Navajo sandstone of the Coyote Buttes area.
The patterns formed when thousands of thin sheets of sand accumulated on the
leeward faces of sand dunes 190 million years ago. Changing wind directions

interlaced the bedding patterns and as the sand accumulation deepened, mineral-bearing waters circulated between the grains, cementing them together and often painting them with bands of color. Uplift of the Colorado Plateau and the subsequent erosion has exposed the internal architecture.

I often try to frame a "bundle" of compelling cross-bedding patterns in my foreground and include a pleasing skyline in the background. Usually a wide-angle lens is required to fully develop the sweeping foreground lines. However, there are also occasions when I need to gain another angle by going to a higher but more distant position. That calls for a mild telephoto. In any case, Coyote Buttes and similar areas are so loaded with strong patterns that the difficulty is not in finding them, but rather how to create a composition around just one.

Because much of this landscape is stark (without relief from high cliffs and trees), summer is a difficult time to photograph. It can be very hot, too. Late fall, winter, and early spring are often better.

Some of my strongest images from Coyote Buttes have used the synergy of patterns of rock interacting with patterns of plants. Pay attention to the narrow-leafed yuccas, junipers, and manzanitas. They offer effective counterpoints to the naked stone.

Yet another note of caution: Despite an almost flawless record elsewhere, I've fallen hard twice in Vermilion Cliffs, once breaking a thumb, the other time dislocating an elbow. Scan the topography for strong compositions, but keep an eye on the terrain at your feet, too.

Lake Powell and Glen Canyon National Recreation Area ✵

For reasons that are hard (for me) to appreciate, the lake and its surrounding landscape have failed to gain the attention they deserve from photographers.

Yes, I understand the criticism that Lake Powell, an artificial creation, flooded a natural canyon of incredible beauty. I know that the lake itself will die a slow death as it fills with silt. And I know that the interference of Glen Canyon Dam has distorted the natural rhythms of the Colorado River below in the Grand Canyon. Despite the realities, I find the lake and its unique sandstone setting utterly enchanting. Sapphire sky, pink stone, turquoise water—three brilliant spectacles of color intersect here.

Lake Powell, even when full to the brim, covers only 13 percent of Glen Canyon National Recreation Area, leaving whole kingdoms of sandstone monuments and towers forever beyond the reach of the water. And many of its side canyons, beyond the reach of the lake's fingers, are rich in photographic opportunities. Rainbow Bridge Canyon, for instance, is exceedingly photogenic. Forget the bridge; concentrate on that gorgeous canyon upstream from it.

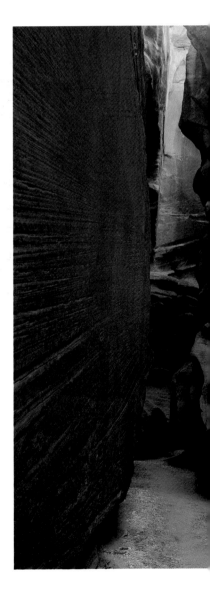

As usual, in photographing Lake Powell itself, I often attempt to find an attractive foreground such as a blooming evening primrose, a fractured bedrock outcrop, or a shoreline of colorful cobbles. Any one of these, when coupled with the lake in the background, plus an interesting skyline or attractive sky, can produce a successful image. If I can't locate an interesting foreground subject, I will at least try to include an island in the near distance or, if the lake is calm enough, utilize the lake's reflections.

Most of my lake trips are via speedboat, generally in the months of October to March. Lake Powell is 186 miles from end to end, and it can take a long time to explore, even by fast boat. A houseboat is nice in winter because the hours of darkness are too long for camping. July, August, and early September can offer spectacular monsoon downpours and wonderful waterfalls, but the lake is too crowded, chaotic, noisy, and hot for me.

Thirty-two years ago, in the fall of 1976, I rowed my dory for 150 miles from Hite to Wahweap. I was alone for 19 days, investigating for the first

time the lake, its side canyons, and its labyrinthine shoreline.

One evening I rowed into Davis Gulch on the Escalante River arm of the lake and camped upstream of LaGorce Arch. This was the canyon from which Everett Ruess, a lone 21-year-old artist and writer, disappeared in 1934. His fate is still debated around desert campfires. I believe that it was on this visit that I started calling out into the alcoves and amphitheaters, "Everett, I know you're out there. Everett!"

That night, lying in my sleeping bag in Davis Gulch, it was easy to appreciate Ruess's intoxication with the Navajo sandstone country. It's one of Earth's great places.

Rocky Confines: Hemmed in by solid rock, sunlight seeps into Buckskin Gulch on a late April afternoon.

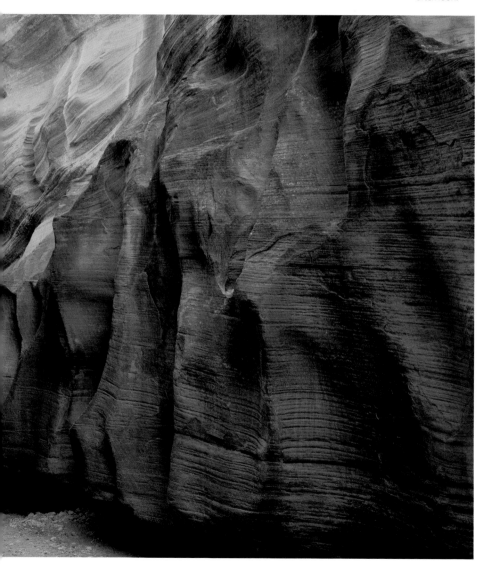

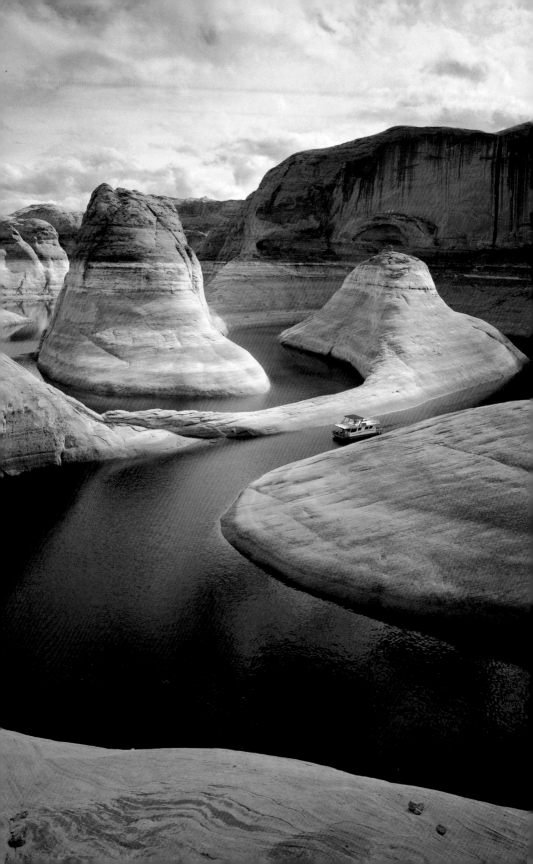

Here are 10 Colorado Plateau destinations that offer thrilling photographic opportunities for amateur and professional alike. Not all are well known, and not all are easy to get to—but the journeys can be as rewarding as the objectives.

Lake Powell, from the air ✱ Photographs of the Lake Powell region from the air are almost always more stunning than aerials of the Grand Canyon. The latter is extremely complex and flight restrictions (wisely) don't allow flights low enough for photographers to zero in on singular areas of interest. Telephoto lenses can be used, but then loss of contrast becomes an issue with the large volume of air between canyon and camera. At Lake Powell, the red rock, blue lake, and intricate, serrated shorelines offer large-scale objects, patterns, and lines. Photo overflights of Lake Powell can

be arranged at the Page airport. Remember to lock your camera's focus at infinity, use fast shutter speeds (1/500 or faster) and avoid midday tours when the light is miserably dull. I favor the hour starting about 30 minutes after sunrise (when the air is most likely to be stable), and the last 90 minutes before sunset. Broken clouds will extend these hours.

> **PHOTO TIP**
> Using leading lines when composing a photo draws viewers into the finished frame. They create interest and flow. See Composition Chapter, Page 98.

Reflection Canyon ✱ I often try to utilize nature's strong graphic lines—curving lines, parallel lines, diverging lines, symmetries, and broken symmetries—to suggest compositions. In Reflection Canyon, (shown at left) exceptionally low lake levels revealed the looping course of the creek that carved the canyon. I climbed up 140 feet to the lake's high water mark (as high as I could go) to reach an overview of the meandering canyon. This was my fourth attempt in four months to

LEFT: **Lake Powell's Reflection Canyon.** BELOW **Vermilion Cliffs National Monument.**

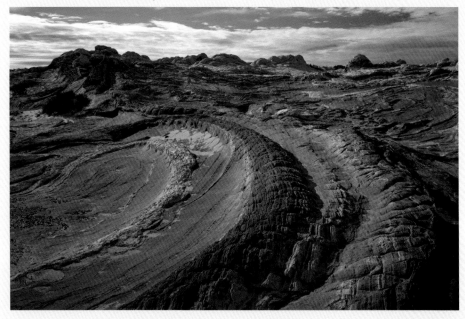

make this image in flattering light. I found the houseboat necessary because the unfamiliar slickrock terrain offers little hint of scale, a factor needed to appreciate the size of the canyon. This gorge is 36 lake miles east of Wahweap Marina.

Dominguez Butte ✦ There's no more important factor in landscape photography than forceful foregrounds. This image was made at the edge of Lake Powell's Padre Bay where wave action (when the lake was higher) stripped away the sandy soil to reveal fractured bedrock (shown on Page 220). Although our eyes cannot take in all of this scene simultaneously, a wide lens (in this case a 24mm lens in 35mm format) can gather into one glance a horizontal view outward to the butte and a near-vertical view downwards to the details of the foreground fracture patterns. It's an effective combination of near and far, small and large. Whenever I spot an appealing landscape feature such as Dominguez Butte, I immediately begin a search for a complimentary foreground. Then, when possible, I wait for good light. Dominguez Butte is 13 lake miles east of Wahweap Marina.

Gunsight Butte ✦ Occasionally the making of a satisfying image takes little more than patience. I made this one on the last evening of a photo workshop when heavy clouds blanketed the sky (Page 228). Several of us set up our equipment and hoped for a miracle. An hour later, for less than one minute, sunlight poured through a crack in the clouds and we were granted our reward. Gunsight Butte is 11 lake miles east of Wahweap Marina.

Iceberg Canyon ✦ Usually I advise avoiding images that confuse the viewer. But sometimes momentary confusion can be transformed into revelation, as in

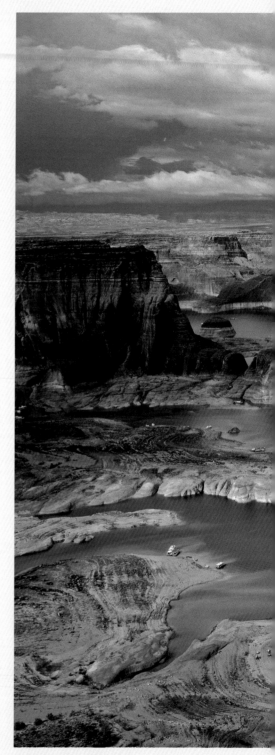

Padre Bay on Lake Powell.

PLACES FOR PHOTOGRAPHY

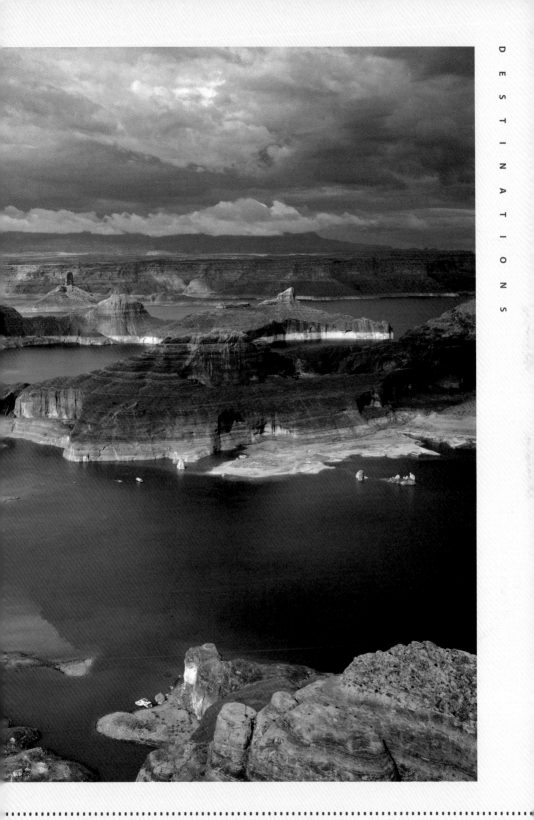

Colorado Plateau

Iceberg Canyon.

this abstraction of a Lake Powell tributary (Above). The subject is simple enough, but the angle of view and the scale are at first difficult to discern. It takes a moment to appreciate that we are looking down at a set of small pools and their reflections. I love these kinds of delayed-gratification abstractions because they slap us with the unexpected. Photographers come upon these images by serendipity; the trick is to recognize and develop them. Iceberg Canyon lies 15 lake miles south of Halls Crossing Marina.

Alstrom Point ⊕ When the light is good, the view from Alstrom Point can turn theatrical. I've stood at the edge of the mesa on a calm afternoon watching spotlights of sun sweep across the "stage" and eavesdropped on campers 1,000 feet below talking about their adventures on the lake— and I've have been flat-out stunned by the sublimity of the scene and its atmosphere. I prefer sunset over sunrise and I try to avoid windy days. Clouds play an extremely important role. They add interest to the sky, regulate the distribution and color of the light, add depth to the scene and improve the clarity of the photo by blocking direct sunlight from the mass of air between the distant topography and the camera. The price of admission, however, includes a four-wheel-drive, high-clearance vehicle and the possibility (on rainy days) of getting mired in bottomless grey mud.

Buckskin Gulch ❋ Yes, subject matter is important but illumination is equally so if the image is to escape the rut of the mundane. Here's a canyon corridor where one wall is flat and the other iis convoluted. (Jointing has produced the flat wall; swirling flood waters have sculpted the opposing wall.) The dichotomy of form is startling, and the illumination makes it more so. This image (Page 231) was made in late afternoon while the sculpted wall received warm light reflected from sunlit cliffs above and behind the camera, and the sheer wall was illuminated mostly by the faint but direct light of a clear, blue sky. Buckskin Gulch is generally regarded as the world's best slot hike, 13 miles in a canyon as little as 10 or 15 feet wide. Sections of it can be reached by way of the Houserock Valley Road, Wire Pass Trailhead, Paria Canyon, or the Middle Trail. This section is near the foot of the Middle Trail.

Horseshoe Bend ❋ "Knee-weakening" is what I call the view of the meandering Colorado River, 1,100 feet below the plateau (shown on Page 225). Effectively capturing the feeling requires a 24mm or wider lens in 35mm format. I prefer to photograph here when clouds congregate at about 3 P.M. in the summer months. At that hour the scene is slightly backlit, and shade has not yet draped into the far side of the canyon. Backlit photography is close to impossible in winter because the sun has abandoned the far side. Sunrise can work well if the sky is clear to the east. After the brief drama of sunrise, however, the illumination rapidly dissolves into hopelessness with black shadow drowning the interior of the canyon. Take U.S. Route 89 to 2 miles south of Page. Just south of Milepost 545, turn west on the gravel road and drive to the parking area. It's a half-mile hike to the overlook. Careful! There are no safety railings and you'll want to use great caution at the edge.

Coyote Buttes ❋ The Coyote Buttes area of Vermilion Cliffs National Monument has become such a popular photographic destination that it's difficult to extract fresh images. Here's an attempt to see anew by concentrating on details (pages 222–223). The image was made at the edge of the pool at the frequently-photographed Wave. Every photographer worth his salt must search out new compositions to avoid the mere duplication of his own earlier or another photographer's successful photographs. Hiking into Coyote Buttes requires a permit from the Bureau of Land Management, Vermilion Cliffs National Monument, which limits the number of daily visitors. Visit the BLM's Web site for current information. I use the Wire Pass Trailhead to get to the site.

Antelope Canyon ❋ Few locations offer as many images per square foot as Antelope Canyon (shown on Page 222) . The light and composition possibilities change with every hour and every season. I prefer Lower Antelope where I sense more potential and the steel stairways and ladders discourage at least some visitors. Upper Antelope can get so crowded, especially in the spring-summer-fall period, that earnest photography becomes impossible. Ironically, the ladders themselves, so angular and out of place in the convoluted canyon, are themselves interesting subjects. Tips: Remember that Lower Antelope is far more tortuous than Upper Antelope, making it easier to bang your equipment into overhanging walls. On windy days be very wary of sand wafting down into the canyon into your gear. Be alert to the danger of flash flooding. Bracket your exposures to make sure you've captured the best. Be patient, even when other photographers find your precise tripod location irresistible. Antelope Canyon is 3 miles west of Page off State Route 98; admission fee and guide service required.

Navajoland

Open Country: **Fluffy clouds scud over red buttes near the Navajo Nation's Lukachukai Mountains.**
DAVID MUENCH

Existing in Harmony

Many of the world's most famous photographers, professional and amateur, have found themselves drawn again and again to Navajoland, from Ansel Adams and Edward Curtis to U.S. Sen. Barry Goldwater. Here, two accomplished contemporary photographers, Navajo LeRoy DeJolie and California-born David Muench, describe their approaches—which are much alike in seeking, above all, to respect and document the spirit of the land.

by Lawrence W. Cheek

Aʟ1ᴠ*After a dozen years of work and friendship* with David Muench, I would have said, recklessly, that I knew as much about his photography as anyone could know; that I could recognize any of his photos anywhere; that nothing he did could surprise me.

And then, as great artists always do, he surprised me.

The shot is set in one of his lifelong haunts, Monument Valley, but its subject isn't the familiar rippled red sand or a spiny butte silhouetted in towering sky. It's a Navajo hogan (shown on Page 242), roughly plastered in ruddy clay, with the family laundry drying outside in the early morning sun. Behind it tower the spiky spires of the Yeibechei group. On one level it's an ironic picture: the mundane and messy litter of civilization sharing the frame with one of the most majestic landscapes on earth. But I know David intends a deeper message in it: the Navajo people's spiritual bond with their land. Somehow, the hogan and even the homely laundry belong—a point that David quietly emphasizes with the all-embracing light and the exact alignment of the hogan with the twin spires behind it.

David has felt drawn to the Navajo reservation since childhood, when he traveled there in the tow of his parents, Josef and Joyce Rockwood Muench. They photographed and wrote about the landscape's otherworldly beauty, and he relentlessly follows those tracks today.

"When I look at ruins like White House in Canyon de Chelly or Crack-in-Rock at Wupatki, I'm stunned by their perfect simplicity," he once told me. "That's not a patronizing judgment; it's a profound compliment. These buildings exist in perfect harmony with their environment. They give no offense. They appear to grow out of the land, as if their architects had somehow tapped into the consciousness of nature."

David's favorite destinations on the reservation are the internationally famous Monument Valley and the Lukachukai and Chuska mountains ✳, which few visitors ever explore.

Gilded Heights: Near Shiprock, New Mexico, tall aspens show their autumn colors as they rise along slopes of the Lukachukais framing the valley below.
DAVID MUENCH

Navajo Homestead: Taking advantage of late afternoon light, the photographer placed a sunlit hogan against a deeply shadowed hillside, making it immediately stand out. The use of a long telephoto lens compresses the scene while giving the sense of observing from a distance and not being disruptive.
DAVID MUENCH

Glowing Sky: The moon rises as the sky catches color from the sun setting beyond the Lukachukai Mountains.
DAVID MUENCH

Images of Monument Valley's buttes and spires are practically seared into our retinas—the obvious pictures, so David tends to look beneath and beyond them. Beneath, at the architecture of rippled sand and dune: Many of his best photos blatantly defy the compositional Rule of Thirds. For instance, in his shot "Dune Ripples", a foreground of red sand fills five-sixths of the frame. They command attention not only because the wind-whipped patterns of the sand are so striking, but also because the composition is unusual. They insist we look, and look intently, at something we never considered before.

"I'm always drawn to dunes," he says. "I could do a whole book on dunes alone." He has found that there are as many surface patterns in dunes as there are rhythms in music. The ripples can seem urgent or merely busy, confused or tranquil, jagged or flowing. The angle of the slope and the way the sunlight strikes it add more complexities. A low, strong sun can create miniature shadows under the breakers that give the whole composition a crisp, precise character. A higher sun filtered through thin cirrus clouds can make any dunescape seem soft and lazy.

And beyond the big monoliths: He's just as likely to trash the Rule of Thirds by filling the frame with sky, shrinking the monoliths to pipsqueak serrations on the horizon by using an extreme wide-angle lens. "Then you can't tell what they are—and that heightens the mystery around them," he explains.

The Lukachukai and Chuska ranges arc along the modern Arizona-New Mexico state line north and east of Canyon de Chelly. At sunset, the red dust suspended in the Navajo air floods the Chuskas with crimson and scarlet light so intense it hardly seems possible in nature. And that's what David is always

seeking: Nature extended to her outer limits, an ephemeral moment that will never exist again.

"I was working in the Lukachukais one evening," he recalls. "I had had a great afternoon shooting, and all of a sudden the full moon rose over the mountains. I had forgotten it was coming, and I thought, 'Oh my God, something more!' In a few minutes there was this wonderful transition, the amber sun dying and handing over the landscape to the care of a brittle white moon—a changing of the guard."

David works the reservation from a foundation of respect. He hires a Navajo guide to escort him if he's going off public roads, respects people's privacy, and tries never to disturb anything for the sake of a photograph. "I don't even like to turn rocks around," he says. "I don't want to add or subtract or embellish anything. I only want to record it honestly. This is not my personal ego trip."

Amateur photographers should learn to look at the possibilities as he does. "I try to find shapes in the foreground that intrigue me, things that connect the ground with the sky. I'll try anything to get your eye to move from near to far. It can start with the simplest things—dead wood is often beautiful in design. Or rocks, or the plant life that's so sparse out here. And then I try to place myself there in the time where I can work the most delicate or dramatic moods, early morning and late evenings, and return a few times."

PHOTO TIP

To maintain detail in both the foreground and the moon, shoot several days before the full moon.

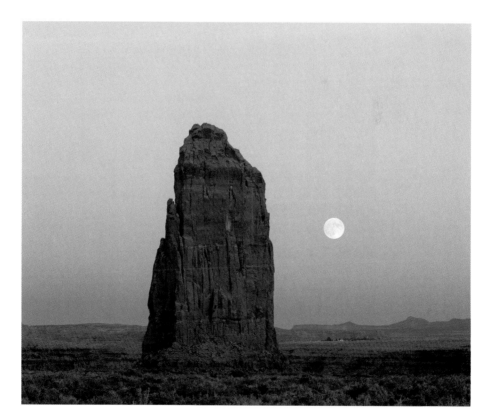

Seeing a Cathedral

by LeRoy DeJolie

Everywhere you look in Navajoland, nature presents itself in artistic ways. Beautiful and powerful patterns, lines, textures, shapes, and forms appear in both the intimate and grand landscapes. This is my lifelong home and my heritage as a Navajo; I'm a part of this and it is a part of me.

A modern map or atlas will depict the Navajo Indian Reservation as 27,000 square miles of high desert, mountain, and canyon sprawling across parts of the modern American states of Arizona, Utah, and New Mexico. I see my homeland instead as a vast cathedral anchored by four sacred mountains: Mount Blanca in the east, Mount Taylor in the south, San Francisco Peaks in the west, and Mount Hesperus in the north. My passion in life is to express what this is all about and to do my part in conserving and protecting the land. Our traditions and language are in danger of leaving us, but the land is our root.

I was born in Navajoland, but I went to schools in Phoenix and Los Angeles. All the time I was away in the cities, my heart remained anchored to the red rock canyons, mesas, and sage-covered rangeland of the Kaibito Plateau just south of Navajo Mountain. My memories sustained me: the sweet incense of cedar crackling in the fire, the aroma of brewing coffee in the morning, the dirt-floor hogan. I could never forget how, even on the coldest days, a bright, warm shaft of sunlight from the cobalt skies penetrated the hogan's smoke hole above, striking the inner gallery near the door, which faced east as Navajo culture dictates. The light illuminated everything, making it seem as though the interlocking cedar logs, which made up our traditional eight-sided structure, literally glowed with warmth.

My comprehension of the subjects I photograph today is informed by those sights, sounds, smells, and feelings. There's an energy that comes from deep inside, and it all began with those early years.

I started learning photography from my father, who was a photographer in the Korean War. I developed a special appreciation for large-format equipment, which I still use today for landscape photography. I use a Wista DX II wooden-body 4x5 field camera and a 1952 Deardorff 8x10. My reason for using these cameras goes beyond just producing fabulous images. They exercise my passion to savor each moment on film. Since it takes a great deal more time and effort to set up a heavy, slow, and cumbersome view camera, you are forced to select the

Stony Light: Staring across Hunt's Mesa gives a distant view of Monument Valley's staggering formations. Use of strong foregrounds in landscape work gives a sense of where to visually start your journey. LEROY DEJOLIE

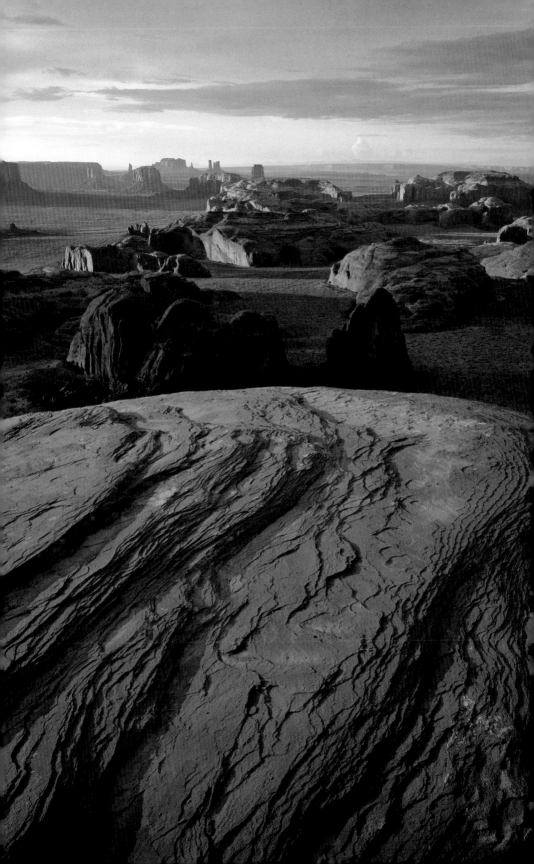

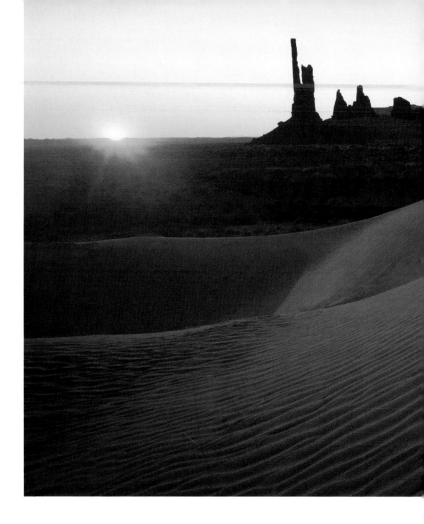

subject, analyze the lighting situation, and compose the image very carefully. You naturally become a more thoughtful photographer and pay greater attention to the details. I use a 35mm SLR for photographing people.

Lately, I've gotten into black and white. A lot of photographers in the past started out in black and white and moved into color; I did just the opposite. I love the sepia tones, and I like the fact that I can photograph any time of the day, including when the color photographers have to take a siesta.

My advice for photographing Navajoland is pretty simple. First, you just have to be outdoors a great deal to get to know the land and develop an eye to "see photographically." You have to be able to interpret changing lighting conditions—they are very changeable and very dramatic here—and be able to predict and wait for the right light. But it's not always about patience. Clouds, storms, and interesting light can appear and vanish quickly. You have to be ready to seize the moment.

I think there's a strong argument for keeping your equipment simple. I've found when conducting my photography workshops throughout Navajoland

that trying to carry more than is comfortable actually discourages you from making the images you want. I use a wide-angle lens for landscapes 90 percent of the time—somewhere in the realm of a 24mm equivalent. A long lens of 100mm or more is ideal for details and close-ups of faces. I think a wide range of filters is unnecessary; I just pack a polarizer and a warming filter. To minimize the risk of breakdowns, a backup camera body is very helpful. Sand and dust can be a real problem here. My rule is to clean the pack and equipment every evening. And I always recommend to my workshop participants that they carry a notebook, write down the details of every image they make, and review the notes in the evening. This is how we learn.

I know that a lot of visitors to the reservation are uncertain how to approach Navajo people. This is simple, too: All you have to do is ask. The great majority of Navajos are open, they like to talk, they love to joke, they want to share.

And this point circles back to what I'm trying to do in my work. I want to share my homeland through my photography. It's the best way I know to express who I am and, in doing that, help to preserve our heritage.

"The Navajo people have a custom that has endured," explains Ray Russell, manager of the Navajo Parks & Recreation Department. "Whenever visitors come, they are always treated as honored guests. They are offered shelter, warmth, and nourishment so they can continue along with their journey."

Visitors to the vast Navajo Nation, a land larger than West Virginia and blessed with much of North America's most amazing geology, will indeed find the Navajo people outgoing and hospitable—provided they are shown the courtesy and respect they deserve. Some tips for travel and photography:

• Kayenta, Chinle, and Window Rock are the most convenient towns for visitors; each offers several motels and restaurants. A few enterprising Navajos have opened "hogan & breakfast" accommodations. Two good Websites for trip planning are www.discovernavajo.com and www.explorenavajo.com.

• Visitors may drive on all signed routes, but may not drive off-road or on unsigned dirt roads unless with a Navajo guide. Some unpaved roads will challenge even four-wheel-drive vehicles, especially when wet. Ask nearby residents for advice and take discouraging words seriously.

• Rock climbing and mountain climbing are not permitted. Hiking and camping are allowed only by permit; contact the Navajo Parks & Recreation Department in Window Rock, (928) 871-6647. Officials suggest applying three to four weeks ahead of time.

• Possession of alcoholic beverages is prohibited. Firearms are prohibited except for hunting, which requires a permit from the Navajo Fish & Wildlife Department, (928) 871-6451.

• Photographers planning to use photos or video for any commercial application must apply for a permit from the Navajo Nation Film Office, (928) 871-7351. Stated fees vary and can be large. Amateur photographers should respect privacy and tribal culture, and ask permission before photographing any event or individual. If you're photographing a person, offer a gratuity.

Monument Valley Navajo Tribal Park ✳
Even the approach to this world-famous site offers astounding photographic opportunities: Driving southwest toward the park from Mexican Hat, Utah, on U.S. Route 163, the towering buttes and spires rising out of the plateau practically beg for roadside photography. As usual, early morning and late afternoon are the best times.

Early risers may drive into the park even before sunrise and shoot from the Visitor Center bluff, where there is a spectacular panorama of the Left Mitten, Right Mitten, and Merrick Butte—three "monuments" rising nearly 1,000 feet. Many famous photographs, including one by Ansel Adams, have been captured right here.

For a more intimate view of the valley, the 17-mile self-guided drive through the park is open from 6 A.M. to 8 P.M., May through September, and 8 A.M. to 5 P.M., October through April. The dirt road is occasionally challenging for passenger cars. There are enough photographic opportunities along the way to consume a full day—on the rare days when bald sky and harsh light don't wash out midday—including Elephant Butte, Three Sisters, John Ford's Point, Camel Butte, the Hub, Totem Pole and Yeibechei, Sand Springs, Artist's Point, North Window, and the Thumb.

You can also purchase guided tours from Navajo tour operators, who will take you down into the valley for a narrated Jeep cruise through the formations. The standard tours may not allow enough time for serious photography,

Monument Valley's Teardrop Arch.
DAVID MUENCH

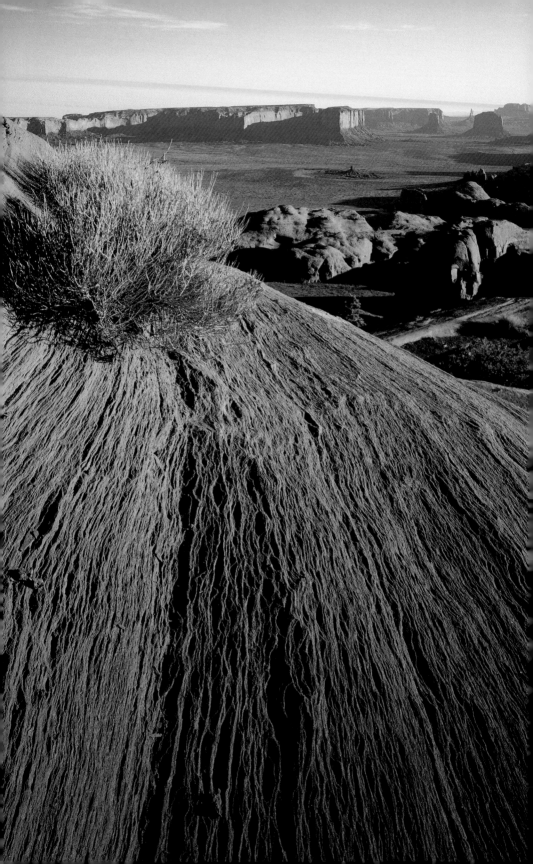

but you can arrange custom, one-on-one photographic tours with individual guides. Some are willing to start before dawn. Inquire at the visitor center or at nearby Goulding's Lodge. Many attractions such as Ear of the Wind, an arch with an opening shaped startlingly like a human ear, can be visited only with a guide.

Monument Valley is usually most photogenic for the first two hours and last two hours of light. Generally, avoid axial lighting, where the sun is directly behind you; and look for opportunities with sidelighting, where the sun is at your shoulder. If bright, direct sun is striking the sand or monuments, it will typically fool the camera into underexposure. As in Red Rock Country, experiment with opening up one to two stops.

Mystery Valley and Hunt's Mesa ✳

These little-known destinations lie just south of Monument Valley Navajo Tribal Park and are only accessible with a Navajo guide. But both are well worth the effort to make special arrangements to see and photograph.

In place of Monument Valley's angular fists and fingers thrusting into the sky, Mystery Valley features swirling, softly rounded sandstone wind sculptures, cascading and colliding and overlapping like a geologic soufflé that's been whipped into shape for a colossal oven. There are also dramatic arches and small prehistoric pueblo ruins.

Hunt's Mesa rises about 700 feet above Monument Valley and offers astounding views of its formations, often framed by exotically sculpted rocks or the ghostly remnants of piñon trees. SpiderWeb Arch, a formation with multiple openings, is a difficult but very rewarding destination. You can reach parts of the mesa by Jeep, but others require a strenuous hike. Best photographers' bet: Hire a guide for an overnight campout so you can be on site for sunset and sunrise.

Hunt's Mesa. LEROY DEJOLIE

Canyon de Chelly National Monument

✳ Tributaries of the Little Colorado have cut several beautiful canyons into the flat highlands of the Defiance Plateau. The most famous are Canyon del Muerto and Canyon de Chelly.

The name "Chelly" is a Spanish attempt to pronounce the Navajo word *Tsegi*, which means, "rock canyon". The accepted modern pronunciation for "de Chelly" is "d'shay." Canyon del Muerto, "Canyon of the Dead," was named when an 1882 Smithsonian expedition uncovered prehistoric Indian burials.

Visitors are allowed to travel inside these canyons only when accompanied by a park ranger or a Navajo guide. The one exception is the self-guided White House Ruin Trail.

There are some 400 prehistoric Pueblo ruins in the canyon, along with many prehistoric Puebloan and historic Navajo petroglyph sites. The Fremont cottonwood trees provide brilliant splashes of fall color, good for photographing both from the rims and inside the canyon. The color peaks in the third week of October.

The most spectacular geologic feature is Spider Rock, a slim sandstone spire that rises 800 feet from the canyon floor at the junction of Canyon de Chelly and Monument Canyon. It has served in many television commercials. Spider Rock can be photographed from South Rim Drive. Another excellent site is Tsegi Overlook, also on the South Rim.

The best opportunities for rim photography come on light overcast days. Or scout a location and shoot in the ambient light that comes just after sunset. Exposures then may be as long as 30 or 60 seconds. For best results, use a warming filter or a digital camera's "cloudy" color correction mode. Clean air is another essential for images from the rim. Polar air arriving behind troughs of low pressure is best. Ridges of high pressure often bring clear air at first, but during summertime the haze will usually thicken during the day. A polarizing filter can help cut through haze while lending the sky a deeper hue of blue.

The greenery in the canyons also takes on a richer color with a polarizer.

As in Monument Valley, Navajo guides will tailor trips in the canyons to individual photographic desires. Trips are available on foot, horseback, and four-wheel-drive vehicles. Inquire at the National Monument visitor center. Navajo families still farm the canyon floor in summer, so respect their property and do not cross fences in any season.

Lukachukai and Chuska Mountains ✤

Indian Route 13 crosses the highest range (9,835 feet) on the Navajo Indian Reservation, offering access to lovely aspen forests around Lukachukai Pass. On the downslope into New Mexico, haunting views emerge of the legend-rich peak of Shiprock 20 miles to the northeast. The road is now paved but not maintained in winter. A surprisingly good (and relatively easy) photo opportunity is the imposing range itself from Indian Route 12, which skirts the mountains' west side. Be there at sunset.

Navajo National Monument ✤ The best-

preserved and most extravagant pueblo ruins in what we now call Arizona reside in canyon wall alcoves in this national monument west of Kayenta. Rim trails are open to self-guided hiking, but rangers must lead hikers to Betatakin (5-mile round-trip) and Keet Seel (17 miles). Both pueblos were built between A.D. 1250 and 1286, then deserted by 1300. Keet Seel remains in such remarkable condition that from the canyon floor just below, it looks as though it had been abandoned just last month.

There are more photographic opportunities here than the conventional postcard views suggest. On one recent trip to Betatakin, LeRoy DeJolie "found a tree with an exquisite set of pine needles hanging down with the weight of the branches. I carefully and dramatically placed them in the composition and photographed the overhanging branches with Betatakin serving as the backdrop."

Coal Mine Canyon ✤ Coal Mine Canyon,

southeast of Tuba City, is a series of horseshoe-shaped amphitheaters carved by the erosional force of frost-wedging and the dissolving power of rainwater. The strata of coal, sandstone, mudstone, and limestone have become a wonderful maze of bizarre shapes including slot canyons, fins, and spires called "hoodoos."

Dawn, dusk, or an overcast day are most favorable for photography. The entire canyon can be photographed by walking around the rim; it's so photogenic that it's hard to make a bad image as long as the light is favorable. Use a telephoto lens, selecting small highlights of color as your main subject. Descending into the "canyon" is not recommended because it can be difficult to get out—and for the photographer, it's not necessary in any event. Coal Mine Canyon is 20 miles west of Tuba City on U.S. Route 264.

Hubbell Trading Post ✤ No photographic

adventure in Navajoland is complete without stepping back in time through this historic homestead, which includes the trading post, Hubbell home, and visitor center 1 mile west of Ganado.

This historic trading post was purchased by John Lorenzo Hubbell in 1878, and the Hubbell family operated the post until selling it to the National Park Service in 1967. The store is still active, its shelves filled with staples. It also serves as a showcase gallery for Navajo arts, featuring rugs, baskets, and silver jewelry.

The National Park Service allows interior photography without flash. Since the available light is dim, a tripod will be helpful, but watch out: The old wooden floors not only creak audibly but also move with people's footsteps. Click the shutter when nobody is walking nearby. Outside, photo opportunities include horse corrals, the Hubbell residence constructed between 1897 and 1910, a guest hogan dating from the 1940s, a barn, and several other historic buildings.

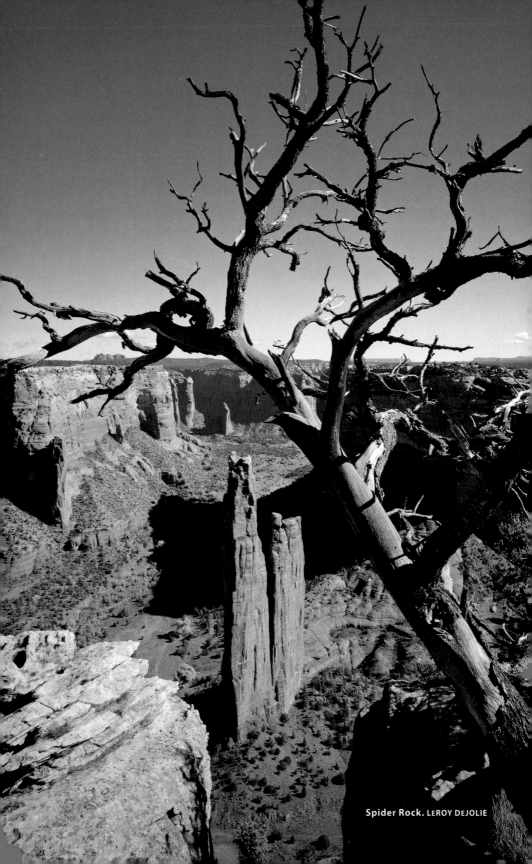

Spider Rock. LEROY DEJOLIE

Brins Mesa: After returning several times to this ephemeral pool, the photographer found magic when sunlight streaked through storm clouds to produce a glow on distant Wilson Mountain.

Red Rock
Country

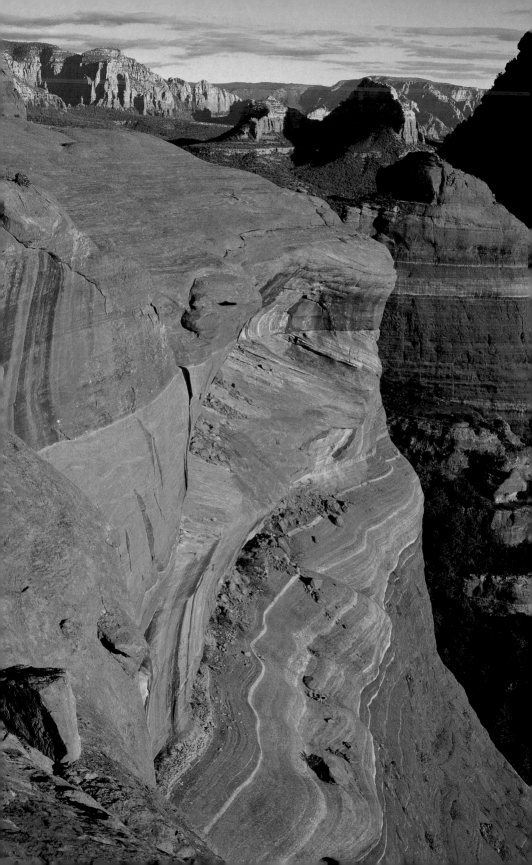

Unleashing Creativity

Text and Photographs by Larry Lindahl

EXPLORING THE SENSUAL AND MAJESTIC Sedona landscape awakens your creativity. From verdant creek beds to panoramic red rock vistas, unbelievable sunsets to vibrant wildflowers, roadside viewpoints to invigorating hiking trails—this is a place that inspires photography.

Capturing good photos of Red Rock Country isn't difficult, but truly engaging and dramatic pictures take some care and thought. An amateur photographer needn't merely copy what's already been done by professionals for the postcards and calendars of Sedona. When you see something that inspires you, make it a fresh experience. Start by asking yourself: What intrigues me about this scene? Slow down, study it, and then experiment with ways to simplify and exaggerate that feeling that stopped you in the first place. The red rock region is perfect for discovering and expanding your unique creative vision.

I recommend a few preparations. First, buy a Red Rock Pass ✳—daily, weekly or annual to match your needs. This allows you to park along roads in Coconino National Forest and at most trailheads. The U.S. Forest Service Red Rock Ranger District Website provides information. Some very popular destinations such as Red Rock Crossing have separate parking fees.

Next, get a detailed map of Sedona's roads, trails, and attractions. With dozens of scenic viewpoints and more than 100 hiking trails in the area, this is essential. Different maps provide different levels of information; choose the one that best serves your sense of adventure. Stores selling books or outdoor gear usually offer the best selection.

Now, where to go? West of Sedona, Dry Creek Basin ✳ offers trails to Devil's Bridge, Vultee Arch, and numerous canyons including photogenic Boynton Canyon. Trails up Doe Mesa or Bear Mountain provide panoramic views. Farther out, you'll find rock art and the prehistoric Palatki and Honanki pueblos.

To the northeast, State Route 89A rambles alongside Oak Creek, offering 14 miles of lush canyon scenery. Slide Rock State Park showcases a segment of creek flowing sinuously over bare sandstone beneath variegated red columns and spires. West Fork, a tributary of Oak Creek, draws hikers to serene reflections and vivid fall color in a deep, dramatically sculpted canyon. And several trails, A.B. Young being the steepest, climb out of Oak Creek Canyon to vistas high above. (Portfolio pages 34, 35)

Red Rock Ripple: High in Red Rock Country outside Sedona, Boynton Canyon boasts curving layers of striped sandstone.

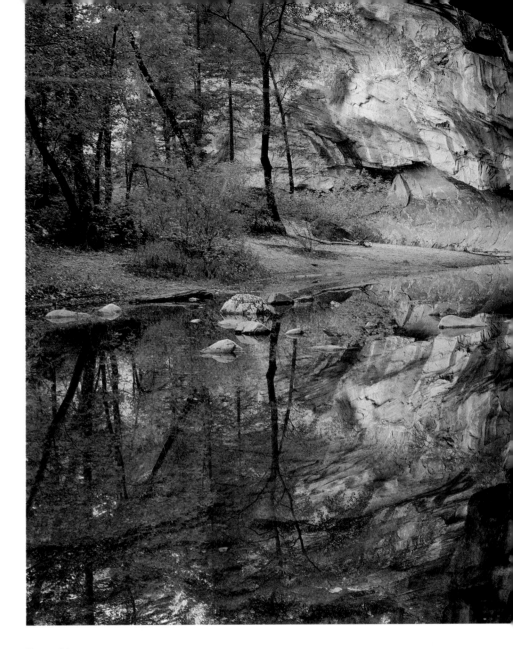

Streamside Serenity: An early October reflection touches a pool of the West Fork of Oak Creek. Working in subdued light is often a key to successful reflection photographs.

East of town, rough and rocky Schnebly Hill Road (high-clearance vehicles recommended) lets you drive among the red rocks for easy photos from the side of the road. Worthy scenes include Mitten Ridge with Teapot and Giant's Thumb, Camel's Head beside Snoopy Rock, and Munds Mountain.

South of town, the open valley bisected by State Route 179 gives you a chance to photograph the Chapel of the Holy Cross wedged below Twin Buttes. From there you get a fine view of the paired spires of the Nuns. The valley is contained by Gibraltar, Munds and Lee mountains on the east, the Transept on the west,

and stately Courthouse Butte and Bell Rock anchoring the southern end.

Southwest of town, scenic Upper Red Rock Loop Road twists and turns down to Red Rock Crossing. This short drive offers turnouts to take in the views as Cathedral Rock grandly rises before you. Red Rock Crossing offers the signature photo of Sedona—Oak Creek gently tripping beneath Cathedral Rock.

Shooting the rocks

Living in Sedona since the early 1990s, I have seen a lot of changes. Visitors increasingly lament how roads and houses encroach on the hillsides and ridgelines. Landscape photographers moan and grumble, then go to work using the rolling hills and bushy junipers to hide the architecture. It generally works.

Serious photographers usually wait until the golden hour, just before sunset, to unpack their cameras. In the canyons around Sedona, this may not always be the best bet. Boynton Canyon, Oak Creek Canyon, and West Fork sink into shadow by early afternoon. Avoid shooting canyon scenics that include large dark areas and severe sunlight. Human eyes have the exposure latitude to adjust to both extremes in one view, but cameras generally don't. Take advantage of overhead lighting without large shadows, or wait for a light overcast.

Most mesas and mountain cliffs, of course, catch every last ray of sunlight. To capture the sandstone formations ablaze in color, turn your back to the sun and aim your camera east. Cathedral Rock, Courthouse Butte, and the Nuns all stand tall enough to turn fiery orange in the last few moments before sunset. Shadows from the Transept, the tall ridge to the west, overtake Bell Rock by late afternoon.

Observing each season in Sedona, along with weather patterns and foliage changes, reveals a constantly changing landscape. Landmark rock formations catch the light differently as the seasons change. A perfect example is Coffee

Pot Rock. If you want the orange glow of sunset, plan on photographing it in the winter. After winter solstice, in late December, the rising and setting sun steadily moves northward. From early spring to late autumn, the shadow of Capitol Butte, or Thunder Mountain, falls on Coffee Pot at sunset.

Photos along Oak Creek require thoughtful preparation as well. Canopies of greenery above the cascading waters provide refreshing summer scenes. But this is no secret, so expect to see families picnicking, people fishing, or romantic couples sunbathing around every corner. To photograph Oak Creek without crowds, come in early spring or late summer when cold water discourages swimmers. If possible, plan your shoot on a weekday, early in the morning. Yes, the creek will be locked deep in shadow at that hour, but another way of looking at "shadow" is "consistent indirect light."

Hiking with a camera on a red rocks trail makes for a gratifying experience. When I go out to photograph, I relate to the land deeply and hike more thoughtfully. Whether it's a butterfly landing on a wildflower in West Fork or a cloud curling behind Cathedral Rock's spires at sunset, photographic moments here are bountiful—and unique among Arizona's scenic landscapes.

When you load your daypack bring the basics: plenty of water, extra food and clothing, a small first aid kit, and maybe a raincoat. Wear a hat, sunscreen, and sunglasses. And don't trust a cell phone to call for help if you get lost: Carry a map, compass, and flashlight.

I carry 35 to 40 pounds in my daypack. This includes the above-mentioned personal gear along with a Pentax 6x7 medium-format camera, tripod, and accessories. I usually pack three lenses: 55mm, 90mm, and 165mm. For scenes where I need more coverage I take a 45mm wide-angle. And until I scout a

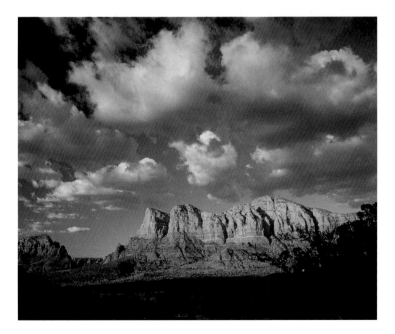

Sedona Reds: Twin Buttes (on left), Gibraltar Rock, and Lee Mountain glow with sunlight passing through afternoon cloud formations in the Sedona area.

specific composition, the 300mm telephoto lens stays in the truck. Using a medium-format 300mm lens requires a suspended five-pound bag of rice to dampen shutter vibration.

In my accessory bag, I carry a Lee filter holder, one- and two-stop graduated neutral density filters, and an 81A warming filter. The bag also contains polarizing filters, a spare cable release, extra batteries, an extra film spool, a lens cleaning brush, and a small chamois for drying the lens in wet weather.

To me, wildflowers, butterflies, and lizards are more interesting when they fill the frame. For these images I carry a 35mm Nikon FE2 and a 105mm macro lens. When the wildflowers bloom, I shoot landscapes in medium format and individual flowers with the Nikon and macro lens.

Bright sunlight bouncing off sandstone has fooled many a light meter. As with snow, the highly reflective rock will usually cause your camera to underexpose in automatic modes. Switch to manual and meter on a neutral-gray surface such as an evergreen tree or blue sky to the north. Compare this reading to the scene with the bright sandstone, and you may find quite a difference—typically 1 to 2 stops. Slightly overexposing bright sandstone may capture the tonal values more as your eyes see them.

In spring, watch carefully as moving clouds shade portions of the landscape. Look for precisely the right moment as the shifting highlights and shadows isolate one rock formation from the others. These transient moments produce dramatic and unusual photos.

From July through September, billowing monsoon clouds provide theatrical excitement, different from any other setting in Arizona. Dark skies frame glowing red rocks, and after the storm's pounding thunder and lightning, a brilliant rainbow may emerge.

By mid-October, the red rock canyons begin turning brilliant fall colors. The autumn show starts in the higher elevations toward Flagstaff and progresses downslope into Sedona. As the weeks pass into November, cottonwoods turn yellow, sycamores become burnt orange, and the bigtooth maples break into a variety of warm-shaded hues. Colorful cottonwoods and sycamores are easily photographed from the Midgley Bridge turnout just north of uptown Sedona. Walk the short trail beneath the bridge to the overlook, and below you will find a mixture of fall color intertwined with sparkling Oak Creek.

Bell Rock, the craggy dome 5 miles south of midtown on State Route 179, is another easy photo stop. It is also very popular, as it's one of Sedona's reputed "vortexes." To photograph it without clusters of people climbing its flanks you will need luck or unusual conditions. For me, it took a hot afternoon in the middle of summer—with record-setting high temperatures.

Moon and stars

Photographing a full moon rising from behind sunset-tinted red rocks takes planning. Sedona's tall cliffs delay the appearance of the moon by several minutes from the official moonrise charts. Schedule your photo of the moon rising at sunset one or two days before full moon. Moonrise occurs about 45 minutes later each consecutive day.

Golden Canopy: Autumn colors tinge a bigtooth maple in Oak Creek Canyon. Soft light is the key to making successful detail images.

Moonlight photos of the red rocks create dreamlike landscapes with stars sparkling above. Prepare for your nocturnal photo outing sometime during the two or three days surrounding full moon. Set your digital camera for ISO 400 or use 400 film, a normal lens (50mm equivalent), the widest aperture possible, a cable release, and tripod. Keep the moon at your back to light the subject—don't place it in the frame. Expose for no more than 15 seconds (any longer and stars will streak), and bracket.

Photographing wildflowers

The best show of color bursts forth from March to May after a wet November and December. The blooms of claret cup cactus and Indian paintbrush often appear first, followed by prickly pear, beavertail, and strawberry hedgehog cactus. On sunny inclines you will find Mexican poppies, black-footed daisies, fleabane, verbena, globemallow, penstemon, larkspur, evening primrose, and owls clover. Golden columbine and lupine, along with yellow and red monkey flower, show up in moist places such as West Fork and Oak Creek.

Boynton Pass and areas around Courthouse Butte and Bell Rock become carpets of purple when owls clover has a good year. You may find Brins Mesa covered in petite yellow flowers. Tiny cream cups sometimes bloom in abundance, but their miniature size makes them difficult to capture in landscape photos. Close-ups create a dramatic result. Find a cluster of flowers and compose your photo from low to the ground, about the same height as the flowers.

Photographing fall colors

The best color is found in side canyons and shady, moist areas. Oak Creek Canyon displays yellow cottonwoods and burnt-orange sycamores, but few red

Picked Out in Blue: Along the West Fork of Oak Creek, bracken fern emerges from a bed of blue lupine.

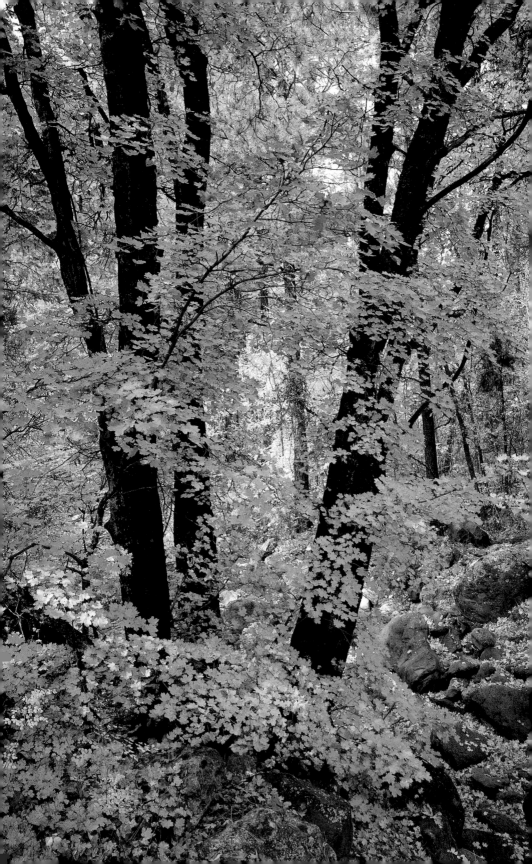

leaves. Boynton Canyon and Secret Canyon host scattered maples turning various colors in fall

The West Fork of Oak Creek is also well known for its autumn color, with its three mile trail along a gently flowing stream. In peak season, October through November, arrive early to find parking. A great spot for a reflection photo occurs just before the trail first begins to cross the creek and about 50 feet upstream. Take State Route 89A north from Sedona for 10.5 miles, and turn left (west) at the curve. The parking fee is not covered by the Red Rock Pass.

Cave Springs also offers strong fall color options in an easily accessible grove of colorful bigtooth maple and sycamore stands adjacent to State Route 89A. From Sedona, drive 11.4 miles up Oak Creek Canyon. Turn left (west) onto the road leading into the Cave Springs campground. Use the small, dirt parking area just off State 89A. Walk south across the entrance road to a dry creek bed about 200 yards away.

When the colors change in fall, a walk along Oak Creek on Allen's Bend Trail offers spectacular scenes and reflections. This is a particularly good spot where the trail follows the creek a short distance from its banks. After a half-mile the easy trail reaches a scenic place to turn around where tall cottonwoods interject rich yellows against the orange sandstone. The combination with a deep blue sky is stunning. Drive north from the "Y" up State Route 89A for 2.3 miles and turn right into Grasshopper Point Recreation Area. Parking fee required.

PHOTO TIP
A slow shutter speed creates the look of "milky" water and thus suggests motion. Using a tripod allows for a small aperture creating great depth of field. See Exposure Chapter, Page 66.

Snow on the Red Rocks

Fresh snow transforms the red rocks. Snowfall usually arrives late in this area, February, March, or even into April. Early morning photography is the most productive because the snow melts rapidly under the sun. Cathedral Rock seldom wears snow because of its lower elevation.

Bell Rock is one of the easiest of Sedona's distinctive sandstone landmarks to photograph on a snow day. Munds and Lee mountains, along with Courthouse Butte, make good backdrops. Ice forms in shaded areas, so watch where you step. From Sedona, drive about 6 miles south on State Route 179 and use roadside parking on the left or continue to Bell Rock Pathway parking area, also on the left.

Man-made Sedona

Sedona photography isn't all about nature. Picturesque arches and alleyways fill the authentic-looking Spanish Colonial plaza of Tlaquepaque. Carved wooden doors and wrought iron fixtures adorn the shops and restaurants among babbling fountains and grand old sycamore trees. Back in 1971, the developer actually designed the plazas and buildings around the already-mature trees rather than cut them down. The place feels romantic any time of year, but for one special evening in early December, Tlaquepaque is truly enchanting. The Lighting of the Luminarias festival launches the holiday season with a flourish of glowing candles in paper sacks lining rooftops, staircases, and pathways. Plan to arrive just before dusk when the balance of ambient light and candlelight is ideal for photos.

The Chapel of the Holy Cross, located just east of State Route 179 and 3 miles south of Tlaquepaque, inspires photographers with its artistic integration of architecture and nature. Designed and built in the mid-1950s, the austere but stirring chapel features a concrete cross soaring 90 feet high out of a cleavage in the red rocks—a symbolic anchor in eternity. A small pavilion grants an ideal view of the Nuns, a formation of stoic spires. Admission is free, but the gate closes at 5 P.M., well before sunset in summer. Evening photographs of the chapel from below, even after sunset, can be stunningly dramatic.

Photographing Sedona is red rocks and canyons could be a life's work. The beauty and intrigue are enticing, and the changing weather guarantees eternal variety.

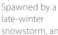

Icy Flow: Spawned by a late-winter snowstorm, an ephemeral waterfall delicately slips over the slick-rock outside Sedona.

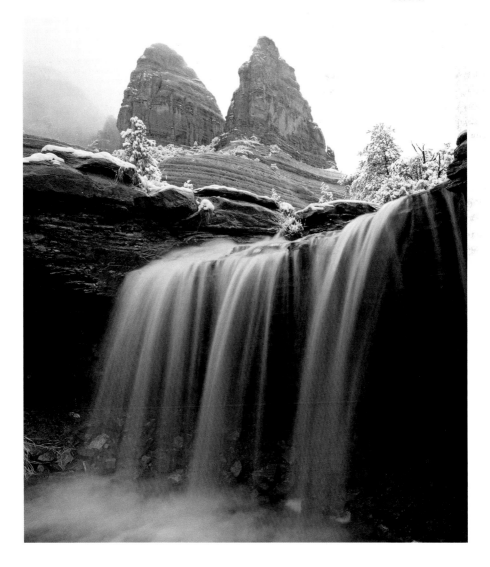

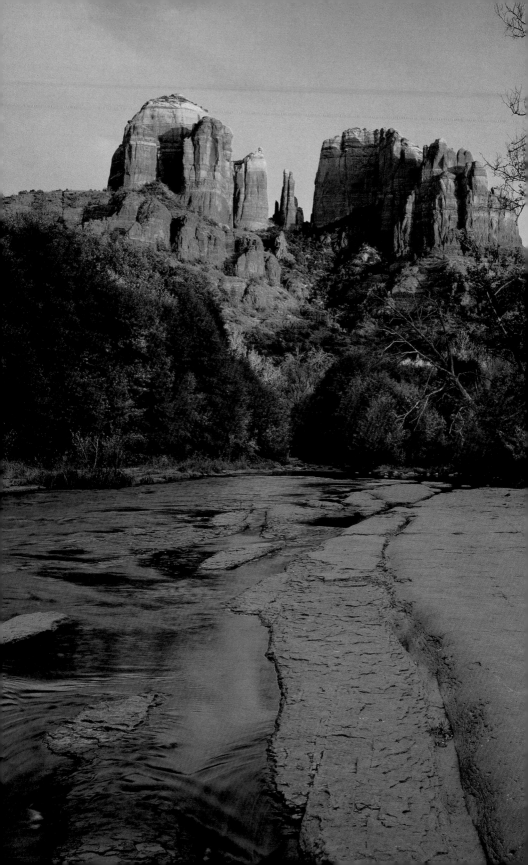

DESTINATIONS where to make great photographs

Red Rock Crossing ✳ Cathedral Rock rises above Oak Creek's clear water rippling over red sandstone into placid pools. Here is the classic photo of Sedona and a wonderful opportunity to explore your creativity. During warm months, this location is very popular, so visit in early spring or late summer to avoid crowds. Then look for reflection pools a few hundred feet downstream from the parking area, and the quaint, crescent-shaped falls about a half-mile upstream in a wooded area. Plan to finish your day at Red Rock Crossing with breathtaking photography from the "golden hour" through sunset.

The signage isn't entirely clear, so these driving directions will help: Drive west from Sedona on State Route 89A to the stoplight near the high school, and turn left (south) onto Upper Red Rock Loop Road. At the bottom of the hill (1.8 miles), turn left onto Chavez Ranch Road, cross over the small bridge, immediately turn right, and after about a half-mile turn left into Crescent Moon Picnic Area. Entrance fee is $7 per vehicle (not covered by Red Rock Pass). Open 8 A.M. to 8 P.M. (winter 8 A.M. to dusk). Alternative access to the park is about 4.6 miles from the Village of Oak Creek, near the end of Verde Valley School Road, with a dirt parking lot on the left.

V-Bar-V petroglyphs ✳ Hundreds of ancient symbols cover red sandstone panels at the largest petroglyph site in the Verde Valley. A short walk leads to the site near Beaver Creek, where many photogenic glyphs represent riparian birds and animals. All day is good for photographs. High noon makes interesting reflected light bouncing off the ground just moments before the sun actually comes over the west-facing panel and hits it directly. A polarizer will not help much. Open Friday through Monday, 9:30 A.M. to 3:30 P.M. Red Rock Pass required.

LEFT: **Cathedral Rock.** BELOW: **V-Bar-V Petroglyph Site.**

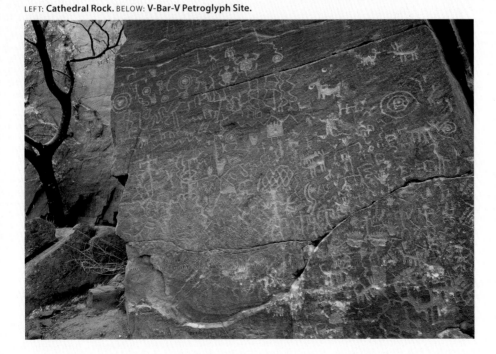

Palatki and Honanki �֎ The Sinagua, pueblo-dwelling farmers, populated Sedona, the Verde Valley, and the Flagstaff area from about A.D. 650 to 1400. These ancient ancestors of the Hopi grew corn and other crops in open fields, built stone dwellings, and left behind hundreds of mysterious pictographs and petroglyphs.

A half-mile hike takes visitors to Palatki, a picturesque two-story masonry dwelling under a huge cliff wall. Guided tours on an adjacent trail lead to the Red Cliff alcoves where visitors may photograph a wide variety of rock art. Location is about 15 miles northwest of Sedona (part of the way is on dirt roads). Open seven days a week, 9:30 A.M. to 3:30 P.M. (gate closes at 3 P.M.) The ruin lies in shadow early and late in the day, but the midday sun actually highlights the texture of the stone walls. Red Rock Pass required, no additional fees, reservation required for the rock art tour. (928) 282-3854.

Honanki lies a few miles away. A wooded trail leads to a viewing area of this large prehistoric pueblo tucked into an alcove below Loy Butte. The Sinagua, and later the Yavapai, painted pictographs above the ruins. Visitors are not allowed inside the dwelling. From Palatki, drive a short distance and turn right onto Forest Service Road 525, then continue about 5 miles on the very rough road (high clearance recommended). Open 9 A.M. to 4 P.M. The dwelling is in the alcove's shadow all summer, so all day is good for photography. In winter the low sun lights up the stone masonry. Red Rock Pass required.

The Forest Service-administered site is 2.8 miles east of the junction of Interstate 17 and State Route 179 on Forest Service Road 618.

Palatki Ruin.

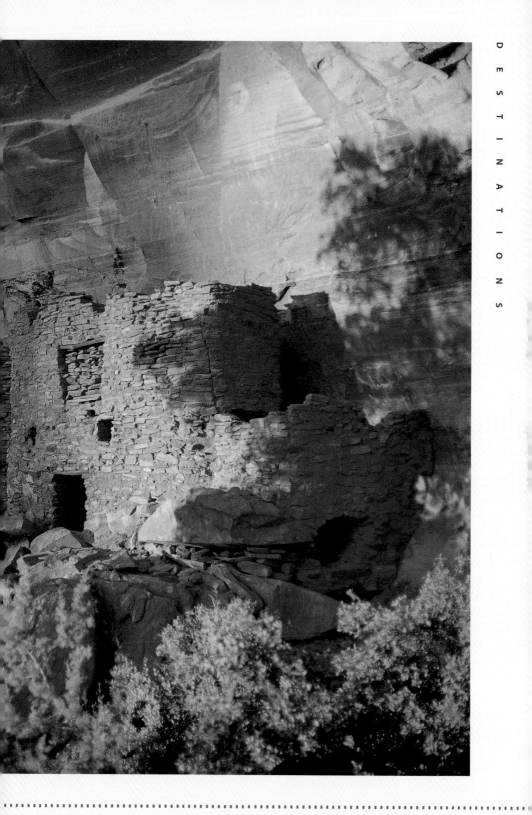

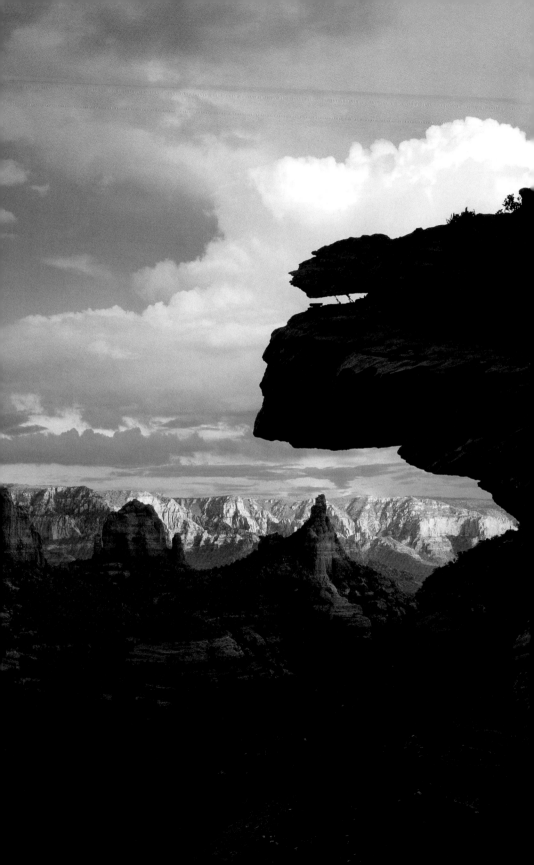

Tuzigoot and Montezuma Castle National Monuments ⊕ Built into a limestone cliff wall, Montezuma Castle, a five-story Sinagua dwelling, is picture perfect. The best photo opportunities are a few hours before and after midday. Large sycamores offer shade along the paved trail adjacent to Beaver Creek, and photographers have been known to shoot the cliff dwelling through the crook of an accommodating tree. Open seven days a week, 8 A.M. to 6 P.M. (winter: 8 A.M. to 5 P.M.).

Nearby, the Sinagua occupied Tuzigoot's 110 ridgetop rooms overlooking the Verde River from A.D. 1000 to 1400. A paved interpretive trail leads into the dwelling for several photographic opportunities, including the log-beamed interior and scenes from the lookout deck on top. Open seven days a week, 8 A.M. to 6 P.M. (winter: 8 A.M. to 5 P.M.).

Mitten Ridge and Soldiers Pass ⊕
A vast panorama of red rocks can easily be photographed from the Midgley Bridge turnout. Mitten Ridge to the east includes the distinctive Giant's Thumb with Munds Mountain in the background. Soldiers Pass, a valley of Arizona cypress and piñon trees, offers engaging views of surrounding cliffs and buttes.

LEFT: **Soldiers Pass.** BELOW: **Oak Creek.**

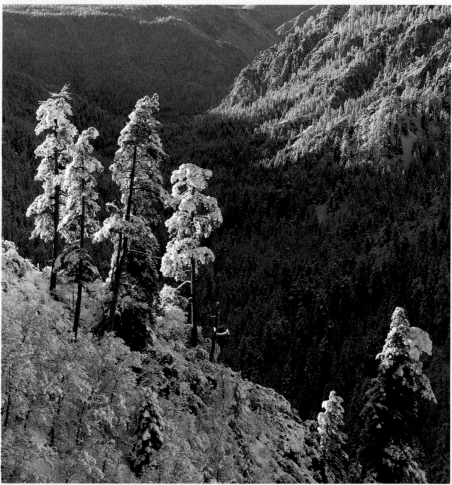

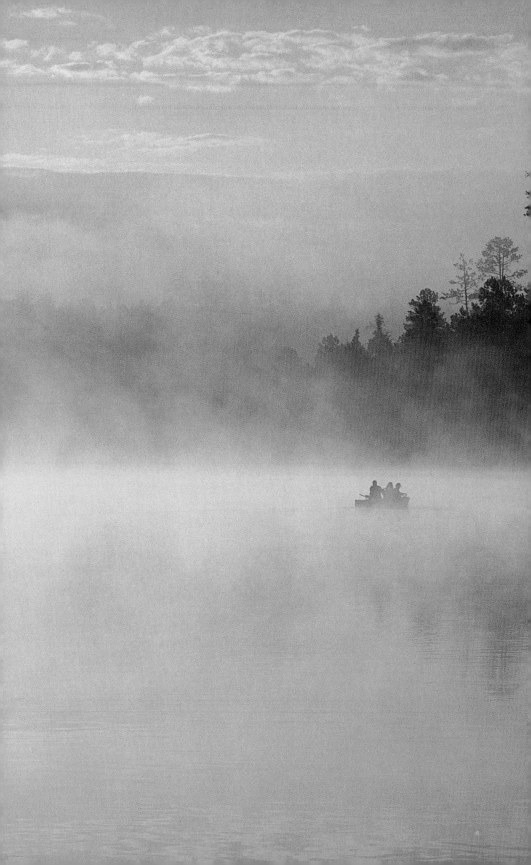

Mountain Country

Morning Mist: Two anglers try their luck in the morning mists at Woods Canyon Lake on the Mogollon Rim.

A World of Greens

Text and Photographs by Nick Berezenko

I N A STATE KNOWN for its desert vistas, central Arizona's Mogollon Rim country is as startling as a splash of cold water on a summer day. Here, in place of the upraised arms of saguaros and spiky halos of cholla cactus spines in hues of burnt umber and raw sienna, you're brought back to a world of soft and variegated greens—the vibrant freshness of grassy meadows, the emerald sheen of moss along a babbling brook, the viridian glow of ponderosa pines soughing in the wind.

In a state that's also renowned for its variety (that, quite frankly, has it all), the Rim Country is the part of Arizona that's probably most like the place you're from. Whether it be the stream-laced hills of Missouri or the manicured suburbs of Cleveland, most of us are used to a world of water, trees, and green.

And that's what makes photographing the Rim Country both an opportunity and a challenge. The advantage is that you're trying to capture the essence of a world that's at least composed of pieces you're already familiar with. Ironically, the challenge is the same. How do you take a picture of an environment most viewers are used to—and yet make it both insightful and unique?

The last 20 years since I plunked down for my own little share of the Rim Country in the form of a round-log cabin in the small town of Pine, I have been working at resolving this conundrum. And I have loved every moment doing it.

For at the same time that its elements are familiar, the Mogollon Rim is also awe-inspiring. To my mind it's Arizona's second most impressive landform, ranking right after the Grand Canyon.

The Rim is variously termed "a mountain canted on one side," an "escarpment," a "range," and a "mesa." It's actually the southern edge of the geological uplift known as the Colorado Plateau, which spans four states. In Arizona that edge curves in a craggy, 200-mile-long scimitar swath from the Grand Wash Cliffs in the northwest corner of the state, through the Red Rock Country of Sedona, and then east to segue into the Mogollon Mountains of New Mexico.

In many places the edge is an abrupt cliff, looking as if a piece of the world had simply been sliced away. Whether you're standing on top of it or viewing it from below, nowhere is this façade more impressive than the 42-mile stretch from Pine-Strawberry on State Route 87 to Al Fulton Point near Forest Lakes

Hidden Depths: A deep pool reflects the cliff walls in West Clear Creek. Notice how the backlight defines the rocky walls.

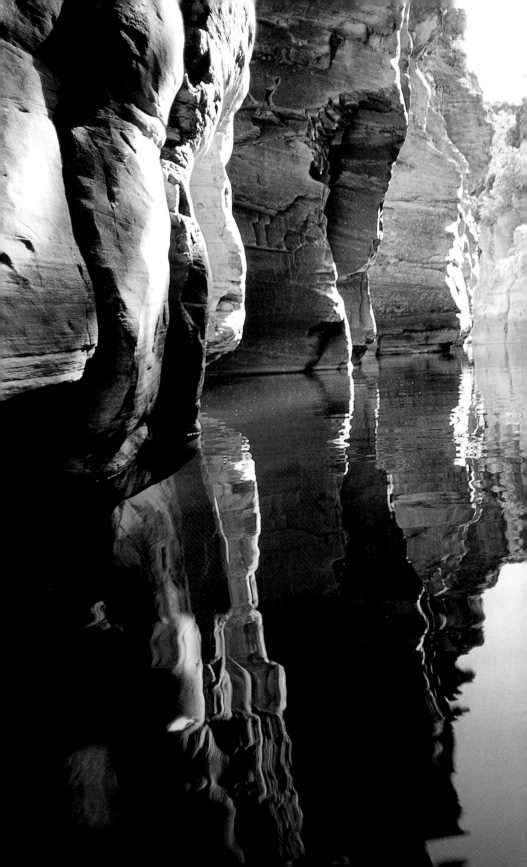

on State Route 260. In this section the wrinkled wall of stone, uplifted to an elevation of nearly 8,000 feet above sea level, looms as much as 2,000 feet over the broad expanse of the Tonto Basin. It is this region that is generally referred to as the Rim Country.

From early settler days on, its scope of grandeur and magnificence has elicited gasps of awe and wonder. Martha Summerhayes, a plucky young Army wife during the period of the Apache Wars in Arizona, rode with the first U.S. Army wagon train to travel along the Mogollon Rim. In her delightful memoir *Vanished Arizona*, she noted that when they reached the promontory now known as High-View Point, "The scenery was wild and grand; in fact, beyond all that I had ever dreamed of; more than that, it seemed so untrod, so fresh, somehow, and I do not suppose that even now, in the day of railroads and tourists, many people have had the view...."

And Zane Grey, who penned many of his popular Western novels of the early 1900s while looking out on the Tonto Basin from a cabin not 20 miles from where mine sits today, was stirred to wax poetically: "Westward along the Rim vast capes jutted out, differing in shape and length, all ragged sharp, fringed, reaching darkly for the gold and purple glory of the sunset. Shafts and rays of light streamed down from the rifts in the clouds, blazing upon the rock faces of the wall. Eastward the Rim zigzagged endlessly into pale cold purple. Southward a vast green hollow ran like a river to the sea, to empty it seemed, into space."

Thankfully, that feeling of space and solitude still pervades the Rim Country. Atop the Rim, myriad streams flow north in syncopated parallel formation, incising deep, narrow clefts that make travel across the plateau still formidable. The heartland below the Rim, though accessed by major highways, remains sparsely populated. Payson, the largest town in the region, counts fewer than 9,000 inhabitants.

So for 20 years I have Jeeped, hiked, and canyoneered this solitary fastness, exploring every nook and cranny. I have sat dreamlike at its many promontories, gazing at the deep green ocean of the Tonto rippling on for miles, seeing it dissolve into the haze of blue-layered mountain ranges. In dappled shade, I have tramped its lush interior forests, sweet-smelling glades of pine, spruce, fir, oak, fern, and wildflowers. Watched—and been watched by—the luminous eyes of elk, deer, wild turkey, bobcat, bear, coyote, mountain lion. Seen the morning fog lift off and swirl around shafts of golden sun rays on its seven mountain lakes and reservoirs. Swam through the deepest turquoise pools of some of the most incredibly beautiful slot canyons in the world.

And, of course, I've had to figure out how to photograph all this and convey its beauty, grandeur, and emotional power.

Photographically, the Rim Country presents its own peculiar spectrum of challenges. To begin with, the light is difficult. Landscape shooters know that the best time for scenics is early morning or late afternoon, when the light is soft and warm. This is fine for open deserts. But in the mountainous, fractured Rim Country, sunrise in the shadowed valleys can be as late as 8 A.M., by which time the light is just too harsh and contrasty. Down in the depths of steep, narrow

Stark Edge: Sunrise touches High-View Point on the Mogollon Rim. The diagonal lines and the use of foreground, middle ground, and background give this composition depth.

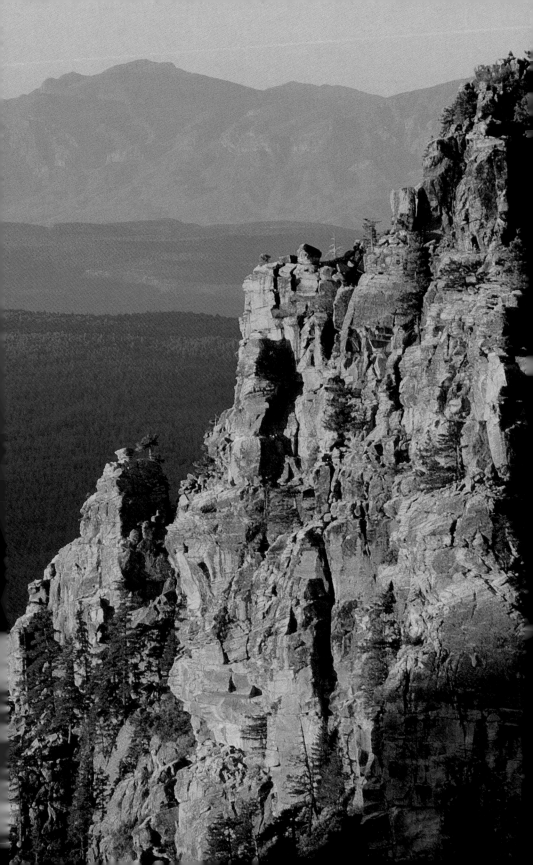

Hanging Garden: Spring water tumbles over the dripping greenery of fern and moss along West Clear Creek. See Flowing water, Page 87.

Maternal Concern: Near the Mogollon Rim's popular Woods Canyon Lake, an elk cow pauses with her calf.

canyons first light can arrive even later—and be even more unflattering. Here you must seek out tighter compositions utilizing shade or reflected light, or wait for a thin overcast of clouds to produce what I call "softbox" light—a softly glowing, pearly luminescence ideal for shooting down in canyons.

Fortunately, the Rim edge itself is oriented east and west, allowing early and late shooting. Just as at the Grand Canyon, you can shoot north or south when the sweet light rakes sideways across your composition, warmly bathing the highlighted side of features and producing lambent blue shadows on the dark side. This gives the appearance of depth and a pleasing texture to your image.

But the Rim presents another problem. For all its many miles of "shore-line," there are actually few viewpoints along the Rim edge that are tenable for shooting. Drive the 45-mile-long Rim Road (Forest Service Road 300) that hugs the edge closely and you'll notice how tall stands of ponderosa, spruce, and fir obscure your view for most of the way. In the clearings you do encounter, bays and capes jut out at weird angles, blocking out favorable south-facing composi-tions. Only a few points—you can count them on the fingers of one hand—afford a photographic opportunity, and these have become the "classic" views.

When you've found the perfect view, don't make one of the two common mistakes that many amateur photographers are prone to. Either they just start snapping away, trying to get it all in one frame. Or, just the opposite, they freeze up, not knowing where to begin.

True, when the light is glorious, you must work fast in order to seize the

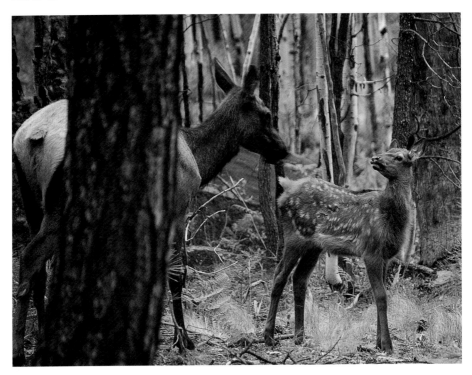

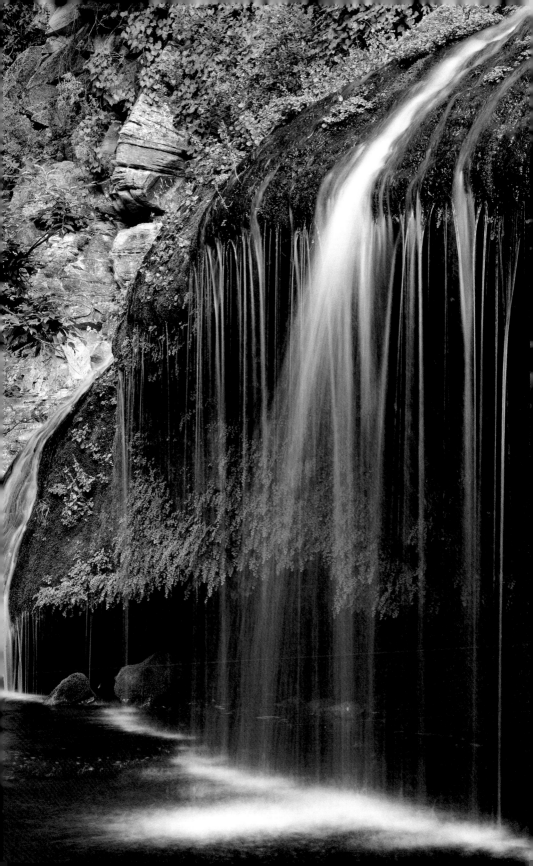

moment. But never, ever take a shot when you haven't felt what you're seeing. Take a deep breath, relax, and ask yourself: What is it that stirs me about this scene? And then look around for the best ways of showing it. You might decide to concentrate on a small detail. Or to show depth and scale, you might find you need to include a foreground element for contrast. Walk around a bit, crouch down, get close to a rock. See how each angle shows a different point of view— and conveys a different feeling. And then simply choose the one you like best.

Tucked Away: Enjoying the refreshing moisture from West Clear Creek, crimson monkeyflowers and maidenhair ferns grow near a jumble of rocks.

You'll be surprised how easily the best compositions come to you. In the end, it's all about: "You must love what you shoot—and shoot only what you love."

In my years of photographing the Rim Country, I have had the joy of ferreting out what I believe are the best places for making these discoveries. In the examples that follow I share what I've learned in the hope that you too will be inspired to interpret the magnificent Rim Country—and experience it along with me.

PHOTO TIP

The soft light of overcast days is perfect for recording details and close-ups. It reveals colors and patterns in a simple, straight-forward manner without having to compete with shadows. See Light Chapter, Page 88.

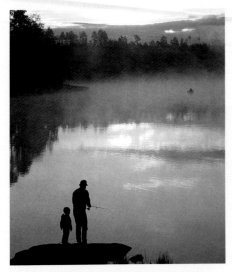

Father and Son Fish at Woods Canyon Lake.

Woods Canyon Lake ✳ The easiest-to-access of the seven Rim lakes, Woods Canyon Lake provides prime opportunities for scenic, fishing, boating, and wildlife shots (Herds of elk wander nonchalantly through the campgrounds).

One August I drove up in the early morning dark to arrive at the lake well before sunrise. Thanks to an overnight shower, a cloud of heavy fog had clamped down on the lake. As the first rays of sun hit, the fog began to lift, suffused by magical, golden light. The effect was serenely beautiful and I felt wrapped up in its enchantment. Coolly and calmly I began firing off shot after shot on my 35mm Nikon. Sometimes I shot directly into the sun and fog, with the fog acting as a diffusing filter to soften what otherwise would have been heavily backlit boats on the lake. I also photographed fishermen nearby on shore, the sun to my side, which caught highlights and details on the subjects. My favorite was the shot that captured the action of the angler's rod at the moment of making a strike.

Al Fulton Point ✳ During monsoon season I arrived at Al Fulton Point just as an afternoon shower let loose a torrential drumming of rain. I sat out the two-hour squall in my truck, and as soon as it let up, I hurriedly set up my 4x5 camera on the point. Some people assume that using a large-format camera, with its cumbersome bellows, upside-down image, and darkcloth hood for focusing, is a slow, meditative process. It can be, but sometimes the 4x5 is just as much about "seizing the moment" as a digital camera. Then you must work as quickly as possible, making all the various focus, rise-and-fall, and swing-and-tilt adjustments. As drops still dripped from the ponderosas, I was ready to squeeze off a couple of shots.

To me the shot exemplifies the cool and green of the Rim Country much more than does a gaudy sunset. I included the dripping trees not only for the feeling, but also for scale to contrast with the depth of the foggy basin below. Sometimes telling images are not so much about how places look, but how they smell and feel.

This is the easiest to reach of all Mogollon Rim points.

Tonto Falls ✳ You might think this pristine waterfall is set somewhere in the wilderness, but Tonto Falls is actually right beside a paved road. I decided to frame my portrait with close-up alder leaves. The waterfall runs year-around, but it is most beautiful from late spring to early fall, when the vegetation around it is the greenest. It took some work getting the swings on the 4x5 right, and I had to use a small f/stop (f/32) to bring both leaves and falls into focus. The small f/stop required a long exposure, which blurred the water—an effect that frankly I like.

Al Fulton Point.

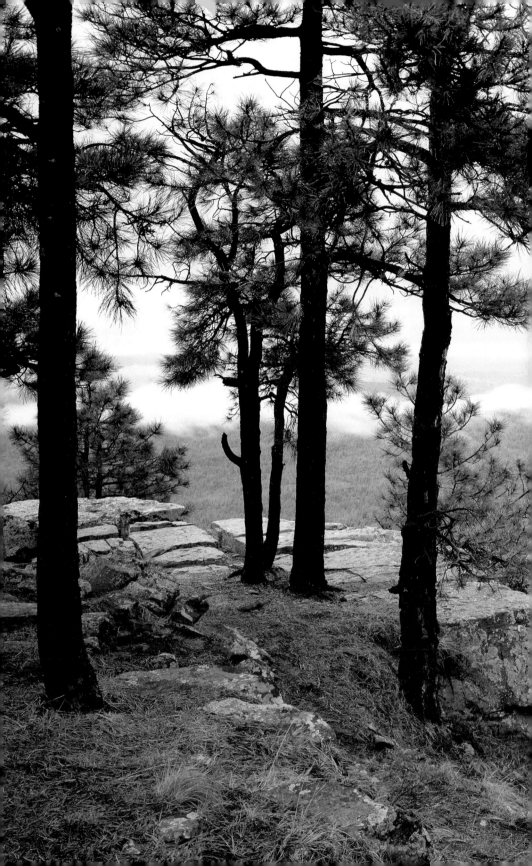

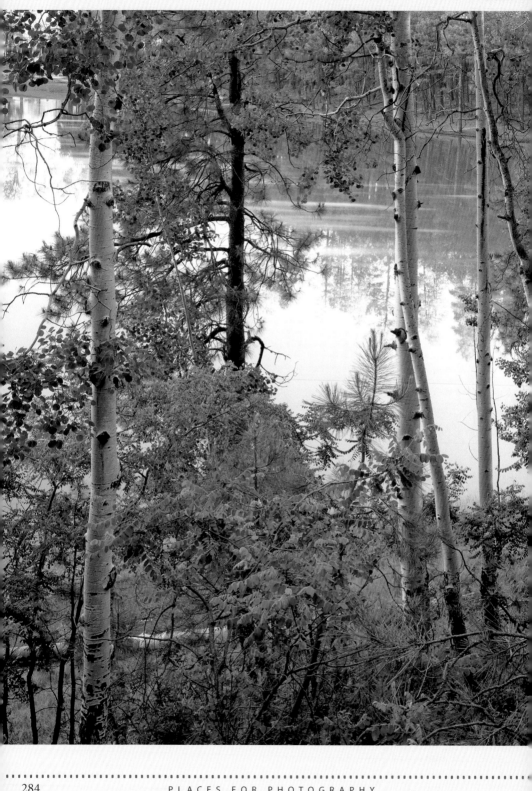

PLACES FOR PHOTOGRAPHY

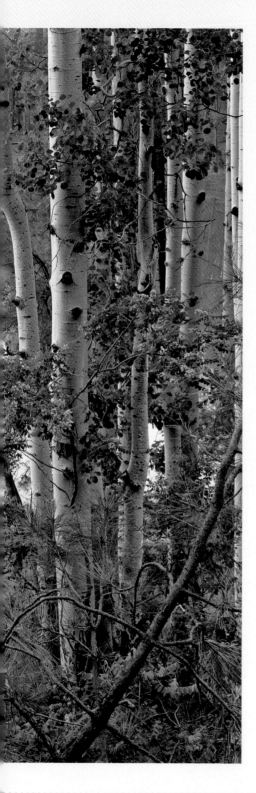

I shot on a day when a thin overcast produced "softbox" light, the soft, pearly light that's ideal for shooting inside canyons.

Potato Lake ✳ This tiny gem, one of only two natural lakes on the Rim, compensates in charm what it lacks in size. Set in an aspen-fringed bowl, the lake induces most people to take their pictures when the aspens are turning in the fall. Those images can be glorious, but I elected to shoot in the spring, when the purple blooms of New Mexico locust mingle with the white-barked aspen trees. Rather than shooting from the open side of the lake, I climbed the steep hill behind it in the pre-dawn hours to catch an image of early morning serenity.

By shooting down on the lake, I avoided having to include an overexposed sky and made the composition tighter, concentrating on what's really important—the aspen and locust trees. The tilts of the 4x5 camera allowed the aspen trunks to appear upright and parallel, instead of the converging parallels you would get with a conventional camera.

Jones Crossing ✳ Sometimes a part can tell more than a whole.

I was on assignment to illustrate a story on East Clear Creek and wanted a shot that would convey the feel of the primeval forest the creek runs through. After weeks of scouting, I finally found the perfect stand of ponderosas bedecked with old-man's-beard lichen near Jones Crossing. But the light wasn't right. I could see that strong, directional light confused the lichen and branches into a welter of lights and darks. So I went home and waited. It was a month before the skies clouded up and I could hustle out to shoot in softbox light.

Rather than trying to include the creek and trees in a general scenic, I used a medium telephoto to zoom in on the part that told

Potato Lake.

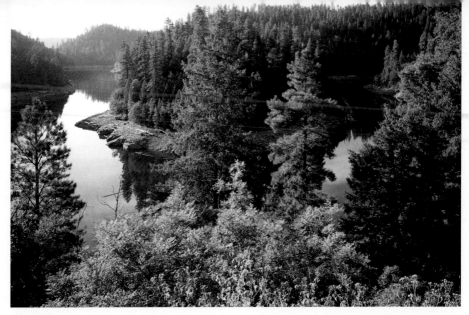

Blue Ridge Reservoir.

the story—the old-man's-beard. This isolated element carried more impact than a cluttered forest shot could have.

Blue Ridge Reservoir ❋ Sometimes you need the big picture to tell the whole story.

Blue Ridge Reservoir is a strange and wondrous lake. Because its waters drown the deep, twisting canyon of East Clear Creek, it constantly twists with serpentine folds and bends. To show this I chose a vantage point on the road above the lake and was able to include most of a major oxbow by using a wide-angle lens. My aim was simple: to communicate the riverine character of the lake. And to show it as a beautiful place. I had to arrive early in the morning when the sun began illuminating both arms, but was still not too harsh or contrasty.

Promontory Butte ❋ The editors of *Arizona Highways* wanted a new front cover for their *Mogollon Rim Guide*. They had precise specifications in mind—a shot showing a lot of cliff and a person on the edge for scale. In my four-wheel-drive vehicle I scouted the vast expanse of Promontory Butte, and after several days of bushwhacking the Rim edge, found the perfect point. A week later, with model Lori Shewey of Payson and photo director Pete Ensenberger in tow, we drove out to the point.

We waited for late afternoon to shoot. Though the picture doesn't show it, a fierce wind was blowing. This made it quite an adventure for Lori to stand perfectly still on the precarious edge, but it also kicked up a lot of dust in the air towards sunset, giving the picture a warm, serene glow. It was a vivid reminder that a lot of the best photographs come from inclement or stormy conditions that may at first seem discouraging.

West Clear Creek ❋ Truly one of Arizona's wonders, 40-mile West Clear Creek drops off the Rim near Clints Well and proceeds westward to Camp Verde. In its journey it goes through many transformations—from gurgling mountain brook, through hanging gardens of maidenhair fern, and through many, many "boxes," as canyoneers call the canyons—narrow slots with steep walls impossible to climb around and pools so deep they must be rafted or swum.

East Clear Creek.

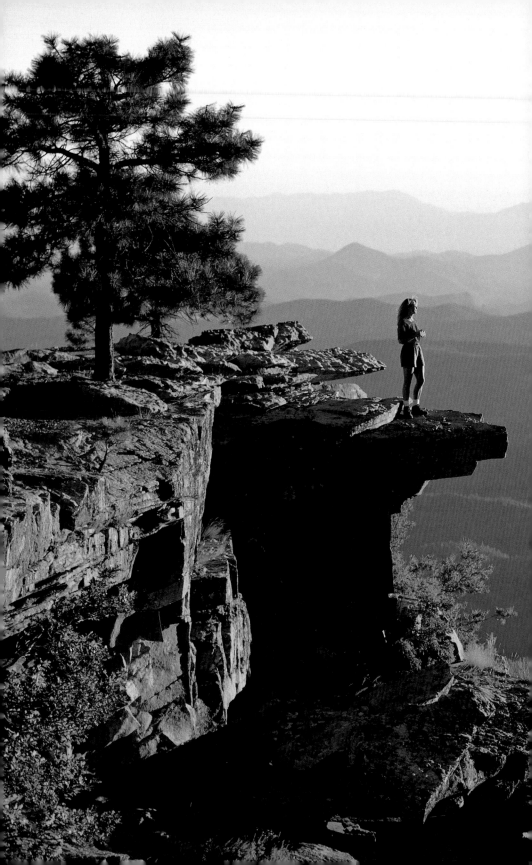

Promontory Point.

I spent three glorious albeit arduous years photographing this sublime but dangerous paradise. (Hikers have died negotiating its pools.) Since I needed to carry 30 pounds of camera equipment on top of a full pack for a week's trip, my canyoneering buddies and I came up with a system of keeping blown-up small boats on our packs (we looked like turtles!) when rock-hopping through dry sections and for floating on whenever we came to a pool.

This shot was taken while floating in 100-yard-long Mother-of-All-Pools in the White Boxes. I used a hand-held 35mm Olympus camera with no filtration. There is no way of negotiating these pools without swimming or rafting them, so you need waterproof drybags to pack your gear in. On the beaches

between the "boxes," you can unpack your gear and find many interesting subjects to photograph. Several faint, extremely rugged tracks access points above the boxes of the creek. The steep descents are dangerous, unmarked bushwhacks. To get a glimpse of the more accessible upper portion of the creek—and hike an actual trail down to the creek—you'll still require a high-clearance four-wheel-drive vehicle.

Fossil Springs ✹ Another sublime spectacle of the Rim Country, Fossil Springs is easier to reach but still requires a 4-mile hike down in. Here, bountiful springs pour out at a million gallons an hour, producing pools of aquamarine clarity.

To get this shot I used a 35mm Olympus

West Clear Creek.

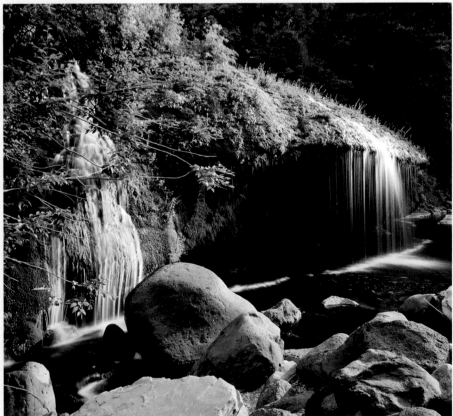

camera inside a watertight Ewa-Marine flexible PVC housing. Since I wanted the shot half underwater and half on top to show the setting, I had to submerge just the right distance at the precise moment that the swimmer made his dive. Bok Lundgren of Phoenix, whom I encountered at the springs, obligingly made several dives for me. But in only one did I have the luck of having the native dace fish fleeing in a school in front of him. Good photography demands patience and persistence, even when you're wet and out of breath.

Tonto National Monument ✳ The Salado culture occupied the Tonto Basin 700 years ago, building a thriving civilization along Tonto Creek and the Salt River. Around 1350 A.D.—

pressed by increasing warfare and devastation from an as yet unidentified source—remnants of the Salado fortified themselves in remote mountain cliff-dwellings. Tonto National Monument, high above present-day Roosevelt Lake, is the best preserved .

Many excellent pictures have been taken from inside the two sets of ruins, but I chose to concentrate on the glorious poppies blooming on the sheer slope below the upper ruins. It made me think that while the Salados' lives were fraught with danger, come each spring their hearts must have rejoiced—as mine did—at the beauty of Nature's bounty.

The lesson: seek out the not-so-obvious shot. Sometimes it may tell a deeper or more personal story.

Fossil Creek.

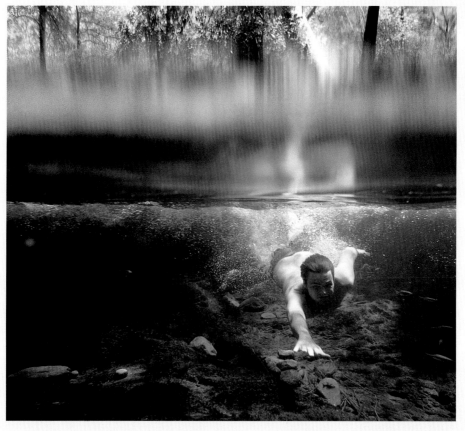

Sonoran Desert

Stark Contrast: Saguaro cacti
line up against the sunset sky.

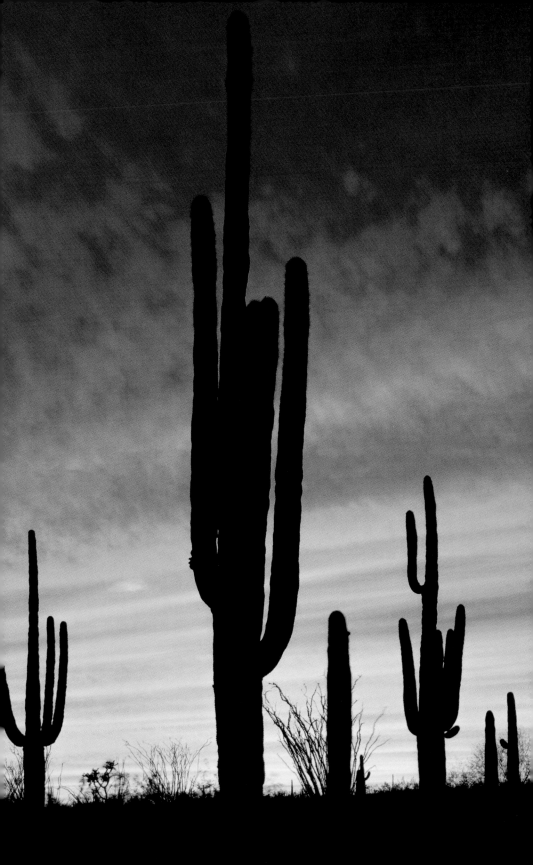

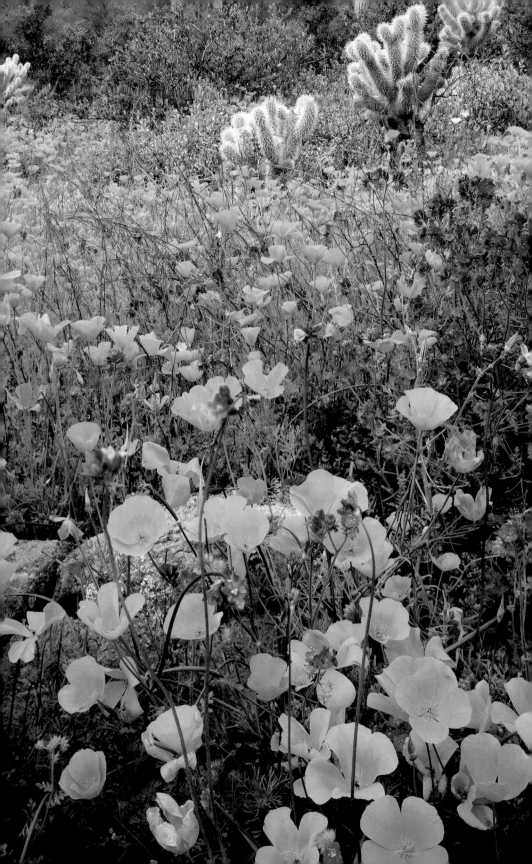

Dealing with "Too Much . . . "

Text and Photographs by Jack Dykinga

IN "ROCKY MOUNTAIN HIGH," John Denver sang about "coming home to a place he'd never been before." So it was with me when I arrived in the Sonoran Desert in 1972. My first impression was of a parched landscape with a million shades of brown. But this child of the Midwest had never seen so much sky, nor expected the special combination of vast deserts, sky-island mountains, and deep canyons cradling emerald treasures. They won my heart and permanently transformed me into a desert rat.

Photographers have always been drawn to Arizona's brilliant sunsets and comical cacti that appear to have been transplanted from another planet. Now it's where I live. The sparse rainfall and monumental geology of the Sonoran Desert provides photographers with neatly spaced, grandly scaled scenery, where each plant, each stone, and each mountain range stands alone in stoic dignity.

When I hike across a seemingly empty landscape in the pre-dawn hours, fighting off a deep morning chill that I know will soon turn into searing heat, I smile at the silhouettes around me. When I'm in the company of saguaros, I know I'm home.

Hot light, harsh contrast

First-time photographers in Arizona's Sonoran Desert (and the adjacent Mohave Desert, too) are typically shocked and disappointed by their images. There's just too much light and too much contrast between sunlit objects and shadow. The human eye can accommodate this wide range, but cameras can't—not even digital. When photographing the grand vistas, the solution is to work in the beginning and end of the day. The light is not only richer and warmer in color, but also softer and more horizontal. This avoids the deep midday shadows while providing amber-toned color to the desert's vastness.

Clouds are Nature's way of controlling contrast. With the diffused light under a cloud canopy, shadows disappear and the range between highlight and shadow is minimized. It is very important under these conditions to avoid including the ultra-bright sky in compositions because it will subdue the dominant element. It's times like these when I deliberately crop out the sky.

Wildflower Frenzy: Mexican gold poppies and scalloped phacelia flourish around a teddy bear cholla cactus. Soft light and Velvia film intensify floral colors.

Of course you can't count on clouds in the Sonoran Desert. So I bring my own cloud to facilitate soft light while photographing. The simple use of a diffusion disk or flex-fill (a spring loaded metal ring surrounding translucent white nylon) simulates a cloud softening and dispersing the light. I use it frequently while making detailed close-ups to both diffuse the light and to block the light breezes.

Photographing directly into the rising or setting sun can provide amazing

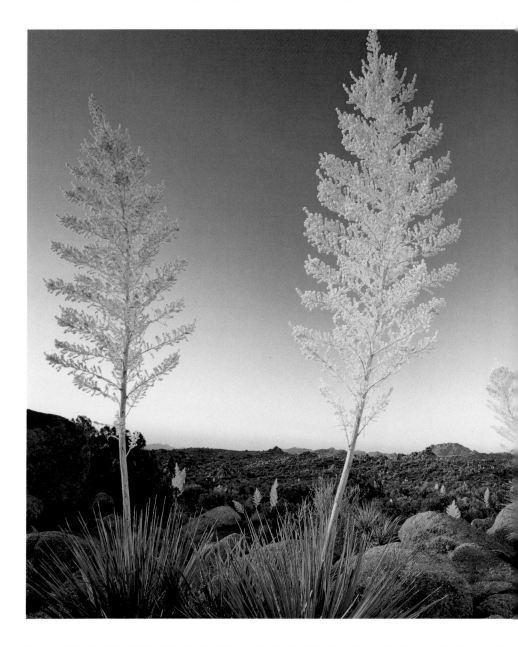

images. There are two problems: lens flare (optical aberrations often seen as multi-colored hexagons) and the extreme variance in light intensity between the sun on the horizon and the backlit foreground. You can minimize flare by shooting when there's just a glint of sunlight. Taking filters off the front element when shooting into the sun also reduces flare.

The extreme variance in desert light between full sun and darker partially shadowed areas can be minimized or eliminated by using a graduated density filter. These are filters with a neutral-grey tone ranging from very dark to clear glass in a smooth transition. I can effectively reduce the horizon-line brightness of the sun while leaving the foreground exposed properly. Graduated density filters ("grad" filters) come in varying strengths, but generally a filter that cuts the exposure by two f-stops will work best in the most common conditions. Most useful are the square filters with adapters that allow the glass to slide up or down. Another use for the "grad" filter is in photographing reflections in streams or lakes, balancing the darker reflected image with the brighter surrounding landscape.

Spiky Color: Bear grass blooms among granite boulders near western Arizona's Joshua Forest Scenic Road, which cuts through a transition area embracing elements of both the Sonoran and Mohave deserts.

Saguaros and sunsets

The endless parade of giant saguaro cacti silhouetted in blazing sunsets has become a photographic cliché, undeniably. Yet, to capture these dramatic moments effectively demands more skill and patience than one would imagine. I see too many images that "almost" work, but the overlapping silhouettes in the saguaro forest merely confuse the eye. The secret is in finding the ideal location, sometimes down to the inch. A technique I use is to place the camera as low as possible, using a tripod with legs that can be splayed out nearly parallel to the ground. Often I am lying flat on my belly. The camera is tilted up against the sky to keep the horizon line very low in the frame, while

PHOTO TIP

Contrasting colors create excitement. In this case, the yellow of the flowering bear grass immediately jumps out of a cobalt blue sky.

providing a clearer view of the arms and trunks of the cacti. This will produce "clean" images that are instantly recognizable, convey dramatic impact, and communicate without ambiguity.

Correctly exposing a blazing sunset is easier than one might imagine. With a spot meter that reads one degree of the scene (or a telephoto lens on a SLR with the meter program set to "spot"), I meter the light 15 to 20 degrees off the brightest point. This usually will give the correct exposure. Another method that works well is to meter the horizon's brightest area and then open the lens one full f-stop.

In the world of sunsets, however, the incorrect exposure is sometimes the better exposure. By bracketing exposures slightly (1/3 to 1/2 stop) above and below the light meter's recommendation, you can create very evocative images. Besides conveying an interesting mood, bracketing also ensures a successful shoot. Even digital photographers, who can see the results before leaving a location, should bracket to ensure the future option of "stitching" two slightly varied exposures together as a way to record both shadow details and highlights. It's good insurance that costs nothing.

I find that the subjects dictate my choice of lenses. For example, while in the openness of the Sonoran Desert, my choice will be skewed toward wide-angle lenses. I love to compose scenic images where the delicate detail in the foreground leads the eye into the background. Because there's space surrounding the plants and rock formations, each feature is isolated and can become a design element.

With careful observation, one can watch as the light just begins to illuminate the foreground cactus, along with the mountains in the background. Lighter areas in photographs lure the eyes. They become magnets drawing attention to and emphasizing portions of the composition. By creating a photograph where the light has yet to strike the ground surrounding the illuminated cactus, the cotton-top cactus is emphasized, becoming a lovely spiny circle in my foreground composition. It's the subject in a sea of darker desert sands, both a design and a unique character in the natural world.

Betting on the blooms

When the rains come, everything changes. Herds of photographers converge on prime Sonoran Desert real estate. Beginning in early March, the wildflowers begin to bloom, starting in the lowest and warmest regions of the Sonoran Desert near Yuma. Carpets of color appear first in places like the Eagletail and Kofa mountains, working their way east to Organ Pipe Cactus National Monument and the Superstition Mountains by mid-March. Considerable distance often lies between great outbursts of blooms. You may, for instance, find the "bloom of the century" on a flank of a remote mountain range surrounded by utterly parched earth. These are desert flowers that react quickly to isolated cloudbursts pouring inches of rain on a pinpoint. Though finding these micro-habitats can be difficult, there's just no shortcut. "Expert" predictions of desert blooms are usually wrong. Many scouting trips are required to find future photographs in fields of emerging plants and

Leafy Orange Wands: Just beyond the Cabeza Prieta National Wildlife Refuge's western edge, ocotillo leaves glow orange at dawn below the Tinajas Altas Mountains.

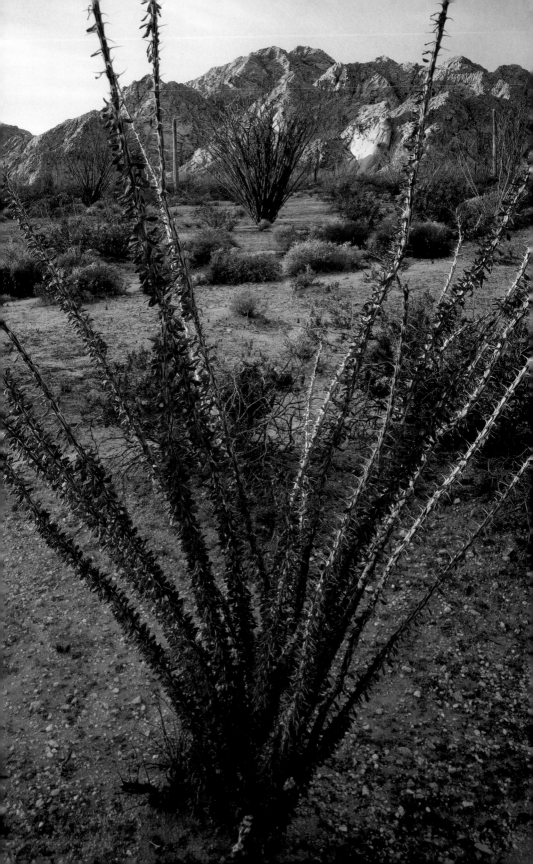

moisture-laden soil. Monitor weather reports and begin your search in February. The harder you work, the luckier you'll be. With years of familiarity, certain patterns emerge.

One of the showiest flowers occurring in the Sonoran Desert is the Mexican or California poppy. They can carpet a mountain bajada, or slope, when El Niño rains provide the ideal combination of moisture and warm winters. However, they're not the easiest thing to photograph. They only open in full sunlight and will begin to close if the wind ruffles their petals. Photographers have to deal with very fragile subjects that constantly sway with the slightest

Sprightly Survivors: In Picacho Peak State Park, Mexican poppies peep out from a fallen saguaro cactus.

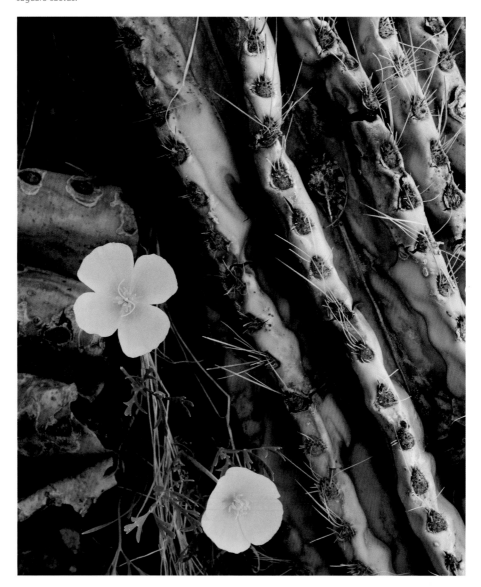

breeze, illuminated with harsh, contrasty light. Photographers shooting digital can speed up the ISO in-camera and dial back the contrast in editing to solve these problems. Film photographers can shift to lower contrast films such as Fuji Astia, or higher speed films such as Fuji Provia, Velvia 100, or Kodak Ektachrome VS. The best solution is to wait for that decisive moment when the wind stops or a passing cloud diffuses the light. When they occur simultaneously, it's as good as it gets!

Vast hillside gardens make wonderful images. However, with a little more time spent searching the landscape, I am able to pull out details that provide interesting juxtapositions. (Photo of poppies, Page 300). I love to contrast the harshness of stone against the fragile, delicate nature of the flower. Juxtapositions can contrast textures, colors, shapes, life, and death, and anomalies in patterns. Occasionally a single image can capture multiple contrasts, as in the photo on the facing page—life blooming in the presence of death.

Whenever I can pack many elements that are interesting and evocative into an image, the photograph has a better chance of succeeding. Both are ways to draw the eye into the composition and create impact.

Flowers such as lupine, owls clover, brittlebush, ocotillo, verbena, and even trees such as paloverde and ironwood all burst forth with color after a wet winter. Likewise cacti of all sizes, with showy blossoms forming crowns designed to draw in pollinators and photographers. Saguaro (in May), hedgehog (April), cholla (April), prickly pear (April), barrel (August), and claret cup (April-June) all produce fantastic blooms. (Saguaro bloom, Page 307).

Saguaros bloom during the night to attract bat pollinators, but each flower lasts just one night. To ensure success, I scout the locations before the blooms begin in search of the perfect saguaro composition. I watch for the flower buds appearing in early May. Once I find the perfect situation, I return every day at dawn when the flowers are fully open, until I can photograph the greatest number of flowers in full bloom. The flowers on one saguaro don't all bloom at once; the cactus staggers the blossoms over a period of time to increase the odds of pollination. The hunt can be a time-consuming process, but well worth the investment.

When you see interesting compositions in the textures or shapes of saguaro cactus trunks, experiment with close-ups of this distinctive adaptation to the desert. These images speak of both the harshness and beauty of the land. Saguaros with drooping limbs are a magnet for me. Their contorted shapes (a result of severe winter freezes) frame the landscape beyond and become dramatic elements for an image with impact. When I see a composition that looks promising, I try to envision it with the very best light of morning or evening, then return at the appropriate hour. I never simply drive up to a subject and come away with a publishable image on first encounter. Great images are the product of hard work and long hours of scouting.

Sand verbena and birdcage evening primrose also respond to mild winters with gentle rains. In sandy sections of western Arizona, they send pollinating moths into delirium with a fragrance that can stop them in mid-flight. That pervasive perfume, combined with the excitement of finding huge swaths of

color on the undulating dunes near the Mohawk Mountains, has led to many sleepless nights in desert campsites. I have a wonderful job—recording things so beautiful they disrupt my sleep!

I approached the possibilities of the Mohawk Dunes ✸ from two angles. One potential image was the close-up of the designs in contrasting colors of the flowers themselves. The other was the entire scene, from the foreground to the sunset-lit mountains in the background. This image also incorporated the ajo lilies. Together, these images provide a sense of place.

When I trek through the desert, I seek telling details that are both interesting designs and supply important information. I begin with wider images and keep getting closer until I fill the frame. When I teach photography workshops, I tell students to keep tightening the composition until all extraneous elements are gone.

The desert rat's pack

Cameras don't like grit and sand. Packing equipment for a prolonged desert visit means packing lens and camera cleaning kits comprising canned air, micropore lens cloths, and lens cleaning solution. A supply of zip-lock bags offers an extra barrier against the relentless rasp of sand. When there's a sandstorm raging, keep your cameras bagged and out of harm's way. Once during a photo workshop I was leading, a sandstorm blasted down the beaches of the lower Colorado River. One of the students was busily recording the chaos. His auto-focus lens totally froze.

Desert photography means desert hiking. The camera backpack I bear is what's needed to do my job. It's always too heavy and the trail is always too long. Yet, there's no better way to schlep bulky, heavy gear into the field. I use a pack with a very good suspension system that distributes the weight between my shoulders and my hips. It fits snugly and doesn't "pull" me backwards. Of course my paramount consideration is the well-being of the equipment. Ample padding and strong zippers that seal out dust and grit are important considerations that will both protect equipment and afford easy access. Little accessories like gardener's knee pads make close-up work more comfortable. After years of ice hockey and two knee surgeries, I probably ought to be following my own advice!

Hazards for photographers are much the same as they are for other wilderness hikers. Venomous snakes like to be out and about during those same hours when the sweetest desert light also attracts photographers. Often they're most visible and active during the months when spring wildflowers are at their peak. The solution is to stay alert and pay attention to where you step. Friends of mine swear by the protection of Kevlar gaiters, but in my opinion, rattlesnake danger is greatly exaggerated by legend and "war stories." Every snake I've ever seen in the desert has given me notice of its presence and has basically ignored me, once I ignored it.

Cacti actually seem more aggressive. They can and will stick to the unwary. Usually this entails stepping on cholla buds. The bud sticks to the boot's sole and with the force of the next full stride, the bud is rammed into the other leg's

calf. This is usually associated with a lot of pain and cursing. And now what? You can't pick it off with your hand unless you want to pin your hand to your leg. The classic "desert rat" solution is a comb. By slipping its teeth behind the cholla's spines, the bud can be flicked harmlessly off the leg.

My Mexican photographer friend Patricio Robles Gil describes many desert plants as "wait-a-bits." These are plants such as the catclaw acacia that have directional toothy spines that grab onto clothing—or flesh. They fairly scream: "wait-a-bit!" You disregard this command at your own peril. Better to stop and gently dislodge the spines. For this reason, when hiking in dense chaparral, many desert rats prefer heavy denim jeans. Hiking boots are my first line of defense against uneven rocky terrain and sharp plants. I wear heavy leather boots that support my delicate frame and the heavy pack.

When I'm camping deep in remote regions of the Sonoran Desert, I often walk about with a cup of coffee just to see the land being transformed at dawn. No camera, no company, simply alone with my thoughts. This connection to the land, nurtured in solitude, is the source of my creativity.

Frequently I see things that cause me pain and concern: carelessly trampled vegetation, dunes furrowed with off-road tire tracks, new subdivisions where there was once pristine desert minding its own business. People are loving the Sonoran Desert to death. Fortunately, national parks and monuments, national wildlife refuges, the Bureau of Land Management, and Arizona State Parks are preserving remarkable swaths of this desert. But we photographers can also protect it—by treading lightly and respectfully, and by spreading the inspirational joy and profound beauty of the untouched land to others through our photographs. It deserves our care and our best work.

Like No Place Else: Sonoran Desert icons, saguaro cacti march across a swath of desert. Saguaros framing saguaros add interest and dimension.

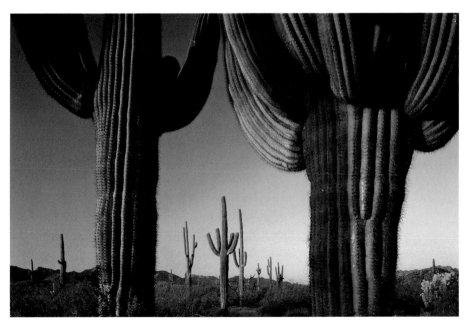

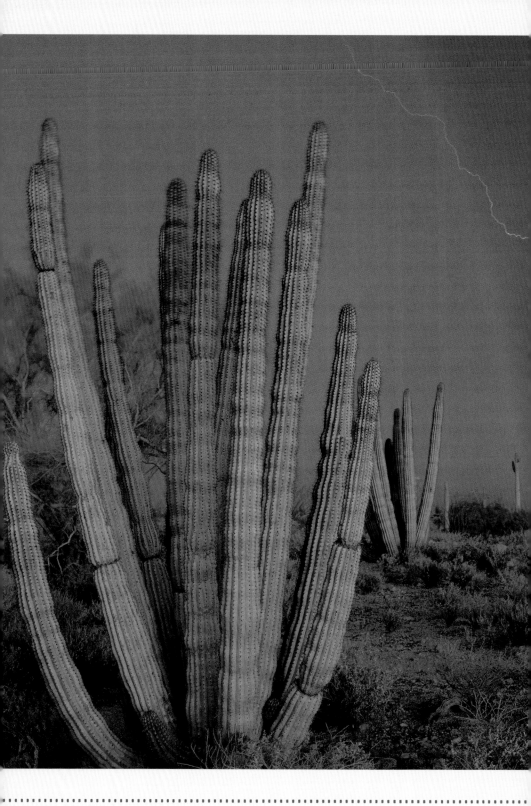

DESTINATIONS where to make great photographs

Sonoran Desert National Monument

✳ Nestled between Gila Bend and Casa Grande, this 775-square-mile preserve offers the greatest concentration of saguaro cacti in the world. Going south off Interstate 8 on the Vekol Road exit offers two distinct destinations. Ancient, battered, and weather-beaten saguaros bristle beside the road, and then to the east is the Table Mountain area and to the west lie the Sand Tank Mountains. The lava-strewn western flanks of Table Mountain can make for interesting foregrounds, while the sheer density of saguaros provide the attraction in the Sand Tanks. Roads throughout the monument are mostly bladed gravel whose conditions vary after summer monsoons. High clearance and/or four-wheel drive is advised. Campsites are unimproved and scattered. March and April can be good times to visit following abundant winter rains.

Saguaro National Park ✳ Formerly Saguaro National Monument, this park is divided into two units separated by 30 miles of metropolitan Tucson. The West Unit in the Tucson Mountains is my favorite for its dense saguaro population and clear western skyline over the sparsely populated Avra Valley. I recommend heading straight to the visitor center on 2700 N. Kinney Road for an entry permit and to pick up information on several great nature trails. My favorite is the Desert Discovery Nature Trail a half-mile south of the visitor center, a short loop through a great stand of giant saguaros. Sunsets can be truly amazing during the monsoon season, and lightning and rainbows often provide spectacular backdrops. Stay in your car when storms loom overhead. My best images were taken when the storms packed the distant horizon during the sunset hours.

Organ Pipe Cactus.

Organ Pipe Cactus National Monument

✳ Organ Pipe is a spectacular favorite in good spring wildflower years. Poppies, brittlebush, and owls clover can create real magic. But it all depends on the preceding winter's rain. Photographers watch the Sonoran Desert's rhythms throughout the cool months, knowing that regular visits of soggy weather from October through February are likely to trigger a spring festival of flowers—if there's no killing freeze as they emerge. If all goes well, there will be plenty of action along the park's Ajo Mountain Drive. This is a 25-mile improved dirt road that winds through some of the park's most amazing scenery with pullouts along the way. The wise photographer will scout this drive in advance and return to the most promising spots when early morning light filters through the valleys. Best time: Early March through mid-March, poppies all day long with owls clover and brittlebush best at early and late light.

Catalina State Park ✳ The "back yard" of the Santa Catalina Mountains accessed from the town of Oro Valley is an amazing opportunity for varied views of the steep palisades soaring out of the Sonoran Desert. When Cumberland Wash is flowing, there's great opportunity for capturing the last light on the Catalinas reflected in the braided streambed. Here, too, water is the key element and localized reports will help plan a trip. The best time for me is either after August monsoons rains or following October's occasional gentle rains.

Aravaipa Canyon ✳ This secluded desert canyon northeast of Tucson is administered as a wilderness area by the Bureau of Land Management, which requires permits for overnight backpack expeditions or daytime visits. The limited permits are available

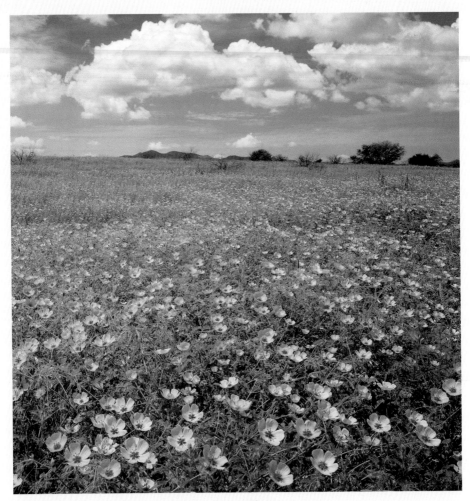

ABOVE: **Field of Arizona Caltrops.** RIGHT: **Saguaro Cactus Blooms.**

online and should be booked well in advance, especially for weekends. This is true wilderness, not suitable for a casual stroll. To enjoy the full Aravaipa experience, you'll have to commit to miles of hiking in a flowing (though shallow) stream. May wildflowers in streamside seeps make this oasis a wonderful diversion. My best images resulted from multi-day backpacking trips.

Superstition Mountains ✹ The jagged peaks of the Superstition Mountains east of Phoenix make an amazing backdrop for carpets of wildflowers in Lost Dutchman State Park.

Given the right combination of gentle winter rains evenly distributed from November to February, the bajadas explode with a wonderful combination of Mexican poppies, lupines, and brittlebush. From early evening on, photographers can witness beautiful sunset-lit mountains and yellow flowers as far as the eye can see. Best time: begin scouting in late February with prime time usually in early March.

Sabino Canyon ✹ Snow and rain falling on the high elevations of the Santa Catalina Mountains next to Tucson ends up in the picturesque stream and riparian forest of this

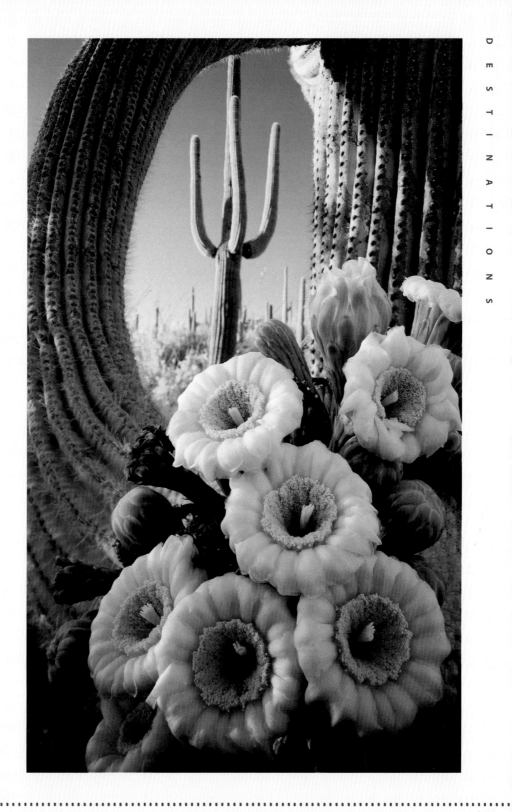

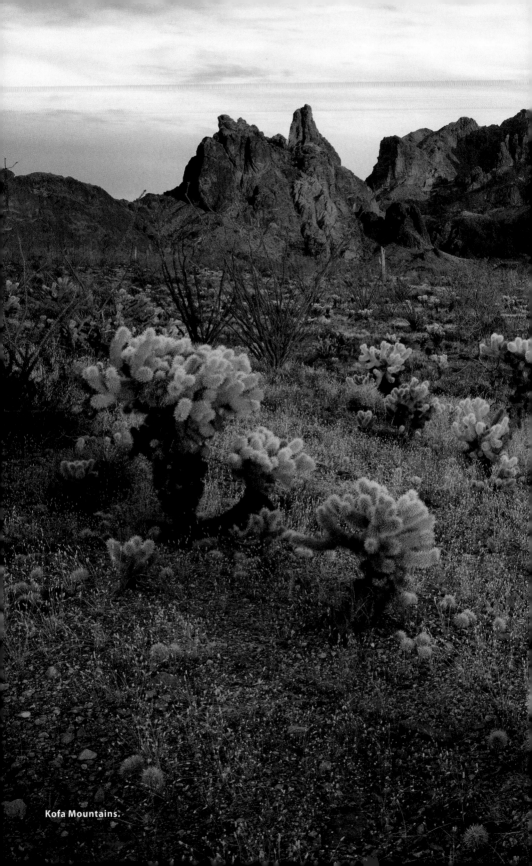

Kofa Mountains.

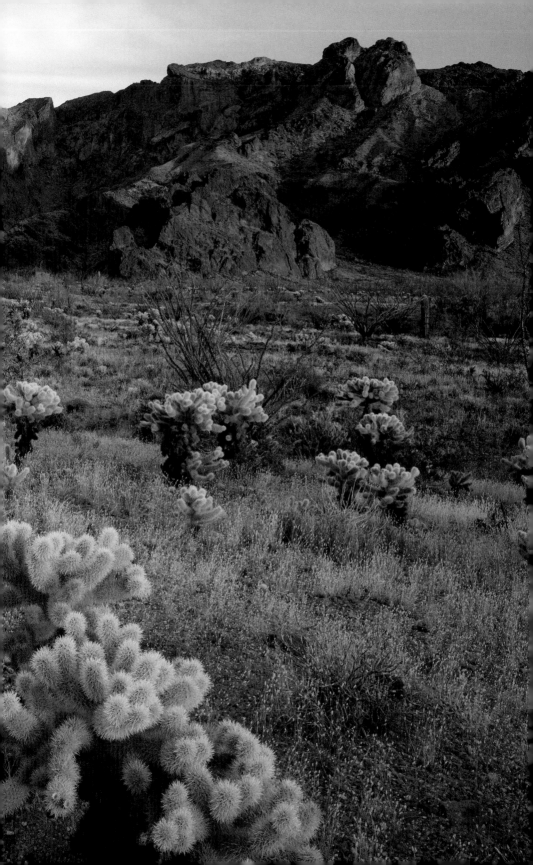

canyon right on the city's northwest fringe. Photographers enjoy excellent access either by a network of hiking trails or the diesel-powered trams chugging up the paved road into the canyon (closed to all other traffic). The great mix of deciduous cottonwood trees and sycamores against a backdrop of saguaro cactus is best in early morning light. Look for reflections of saguaro-studded mountainsides in streamside pools along the tram route. The stream is ephemeral, so check for local conditions. March is usually excellent, thanks to mountain snowmelt.

Buenos Aires National Wildlife Refuge

✴ Grasslands punctuated with yuccas form the scenic attraction in this high Sonoran Desert valley. The sacred Tohono O'odham peak of Baboquivari points skyward like a giant thumb above the amber grass. Early morning light can color the thumb dramatically while the surrounding valley remains in shadow. If winter rains have been relatively generous, flowering yuccas' abundant white blossoms can make the foregrounds very interesting. Begin scouting this opportunity in late May, with best flowers usually in June. Access to the refuge's 200 miles of dirt road is unlimited, but high-clearance vehicles are recommended.

> **PHOTO TIP**
> Prime opportunities happen daily at sunrise and sunset. They occur monthly with the phases of the moon, annually, with the change of seasons and in the winter with the lower angle of the sun.

Kofa Mountains ✴ The west-facing cliffs of this mountain range northeast of Yuma are among Arizona's most impressive, their natural ruddy tint turning red in the late afternoon light. They are also great to photograph alone with the full moon rising or when spring wildflowers adorn the surrounding desert. Palm Canyon Road, accessed from U.S. Route 95, will be rewarding for the photographer with a keen eye. At the end of this dirt

road is the trailhead to a remnant stand of *Washingtonia* palms tucked into a steep canyon hideout. It's worth the time to make the strenuous half mile ascent. The teddy bear cholla cacti here are some of the best I've seen and photograph well in backlit situations. Best time: February through March, with both sunrise and sunset light being very good.

Joshua Tree Forest Near Wickenburg.

PLACES FOR PHOTOGRAPHY

Joshua Forest Scenic Parkway ✷ U.S. Route 93 between Wickenburg and Wikieup winds through a fascinating transition zone between the Sonoran and Mohave deserts. Saguaro cacti give way to stands of Joshua trees, whose twisted, spiny limbs make excellent silhouettes against a monsoon sky. This is an area where fine photographs can be captured right beside the road. Be careful: many motorists are more intent on Las Vegas delights than noticing wandering photographers. Park well off the roadway. Best time: March through July. Sunsets are great in monsoon season, but flowers adorn the Joshua trees in March.

Ridges: Sunset defines the ridge lines of the Chiricahua Mountains in southeastern Arizona. DAVID MUENCH

Sky Islands

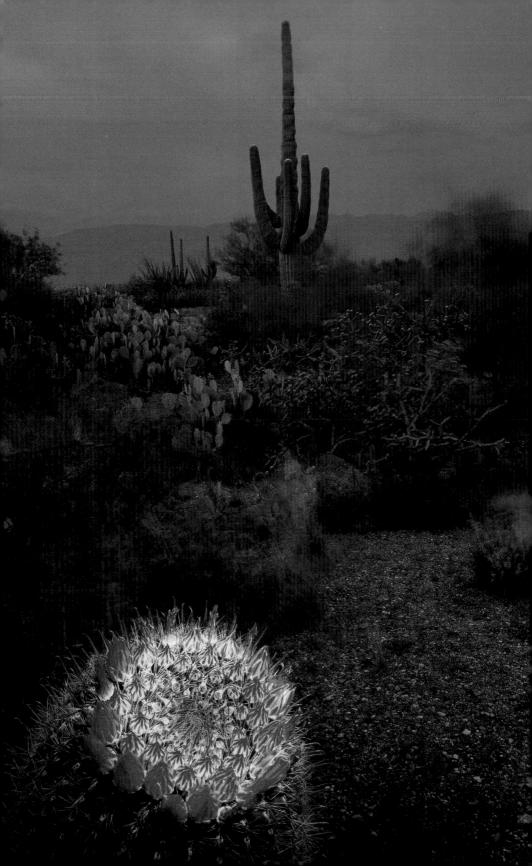

Jutting from a Desert Sea

Text by Ruth Rudner Photographs by David Muench

THE FORESTED MOUNTAINS IN southeastern Arizona are called sky islands because they rise from relatively flat desert and grassland much like islands rise from an ocean. Several peaks top 9,000 feet. The tallest, Mount Graham near Safford, is 10,720 feet. Climbing from the scrubby, hot desert environment of the Lower Sonoran life zone, through oak-pine woodlands and then ponderosa pine and fir forests, into the Hudsonian with its spruce-alpine fir trees, each "island" offers a layering of landscapes and habitats from bottom to top. The desert "ocean," acting as a barrier to the movement of plant and animal species from one mountain to another, in the same way a watery ocean isolates species on islands, renders each mountain island unique.

These sky islands fascinate David Muench. They have since he began wandering in them in the early 1970s to create photographic essays for *Arizona Highways*. Drawn by the drama of their contrasts, he returns continually. Few other places on this continent juxtapose landscapes so antithetical to one another, ecosystems of such magnificent anomaly. In this place—where desert leads to country of northern conifers, grassland, and high peaks and where mountain streams pour from snow-covered summits into forests of cactus, creosote, and yucca—David's passion for Southwestern deserts merges with the excitement he feels in high mountains.

In our seven years of hiking together, I have watched what draws David to a subject, how he sets up a photograph, what he waits for in weather, in light, how he chooses the moment to make an image. Each time he returns to a place, he finds something new. For him, familiarity is an avenue to the new.

Watching him work is as much a revelation of the landscape as it is of the photographic process. With each island, David looks for something unique in the foreground that identifies the country. He composes a scene by using a close-up foreground subject to lead the eye through a middle ground into connection with the distant landscape. This is style he calls a near/far approach.

He works instinctively, with knowledge of the terrain intimate enough to know its vagaries, adapting to them like a wild animal or plant. Because he sees everything with wonder, as if it all were new, each image he makes is fresh, even in a place he has often photographed.

The minute is as alive to him as the monumental. Once, in the Chiricahua

Painting with Light: Taking advantage of low light and a long exposure, the photographer used a small flashlight to "paint" the blooms on this barrel cactus. Moving the beam continually during the exposure created this brilliant effect.

National Monument, at the northern edge of the 9,500-foot–plus Chiricahua Mountains, we walked among gargantuan rock pillars while water from the morning's rain pooled on a small ledge. Although he was surrounded by a world of dramatic rock, David drew the most excitement from a delicate stream of water dropping from the pool to moisten a strip of green and white lichen. The wet lichen shone, standing out sharply against the water-dark rock.

"It's drying fast," David said, as fierce wind swept the rock, understanding that it is sometimes as necessary to work quickly to capture the moment's beauty as it is to wait patiently at others. For the ephemeral, timing is everything.

What matters to him are the conditions at the moment and carefully choosing the moment to capture an image. More interested in the philosophy of making images than in photographic technicalities, he enters into whatever nature presents.

A gathering of clouds

The Apaches call the volcanic-formed Chiricahuas "land of standing-up rocks." David calls them "cloud-gatherers," a name describing the play of storm clouds and lightning in monsoon season, when huge, billowy thunderheads form above the forested peaks. Clouds manifest a huge part of his awareness of weather and of timing. Monsoon season (usually in July and August) offers him interesting midday buildups of cumulus clouds and, later, the drama of a foreboding sky with its galvanic, brooding colors. Rainbows arch over mountains and desert cactus at once. After the rain, wet light takes over with its subtle saturation of colors and tones, especially in the forest.

This, his favorite light, "is the antithesis of the bold, dramatic light to which I naturally respond," he says. "I like working with opposites."

Wet light provides a silence, a sheen, a softness, a sense of the Earth's acceptance of its own life. In offering a neutral gray sky or fog, it creates conditions in which there are no unnecessary forms. In the soft, ambient light provided by cloud cover, detail is pronounced. There is an intimate subtlety, as opposed

Forest Finery: Ladybugs bejewel a swath of lichen, right, on Flys Peak in the Chiricahua Mountains.

Land of Standing Up Rocks: Compressed by a telephoto lens, opposite, a vast array of hoodoos near Cochise Head shows how the Chiricahuas got their Apache name.

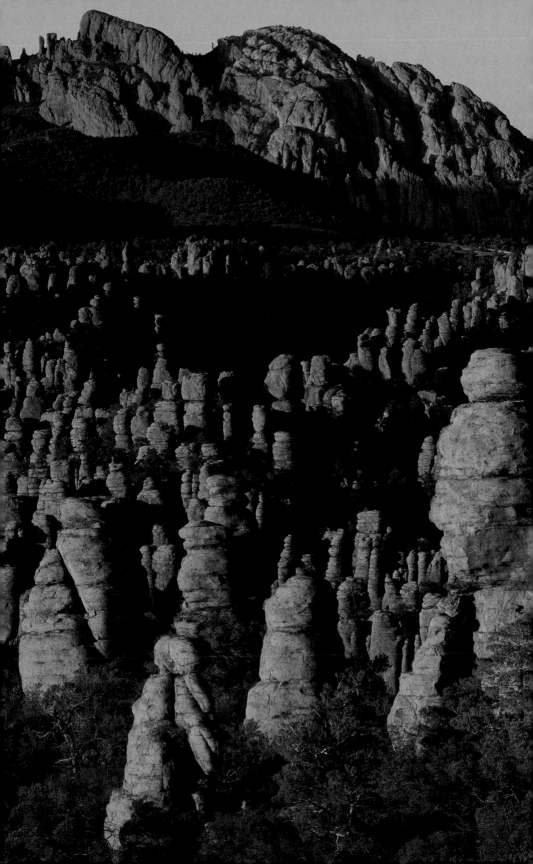

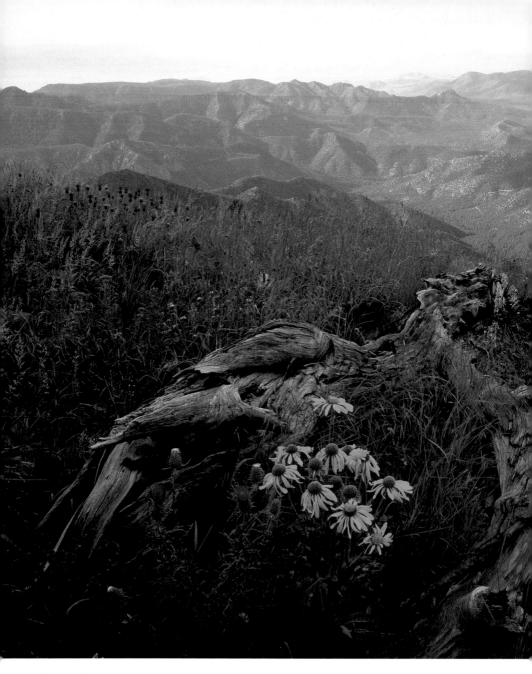

Sky Island Slope:
Wildflowers bloom
in Monte Vista
Park in the
Chiricahua
Wilderness.

to the brilliant highlighting between light and shadow under clear skies.

Missing nothing as he walks through wild country, he hones in on his subject as soon as it appears. Walking beyond the tree (or rock, or mushroom patch, or cactus grove), around it, he carefully explores to discover an angle or view. Very little interferes with his concentration. Occasionally holding an umbrella over the camera in a rainstorm, I have watched him spend hours photograph-

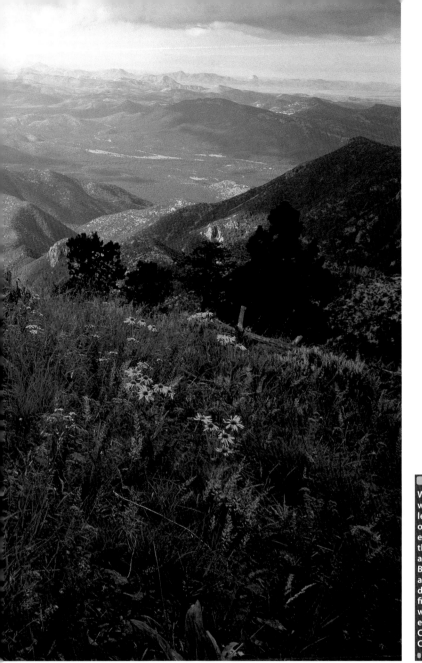

PHOTO TIP

When using wide-angle lenses, be aware of strong design elements in the foreground and use them. By making this a conscious decision, the final image will be greatly enhanced. See Composition Chapter, Page 98.

ing mushrooms, or the multiple trunks and twisting, lace-limbed branches of an old sycamore. An umbrella, incidentally, is a vital tool for David, even if I am not there to hold it. With the camera on a tripod in rain, a large umbrella can keep both photographer and equipment dry.

"It's hard to focus on the richness before you when you are soaking wet," he suggests.

Anything for a photograph

Not much daunts him. He will climb anything for a photograph or scramble through catclaw or other prickly shrubs and cactus to arrive at his goal, a bit bloodied, perhaps, but ready to work. I find interesting the fearlessness the camera imbues in him, although perhaps, for David, fearlessness and concentration are the same word.

Nonetheless, he never allows concentration on one subject to obscure the unexpected. He responds to unusual details that often appear when he is looking for something else.

Once, bound for a shot of claretcup cactus blooms on Fly's Peak near the middle of the Chiricahuas, he found and photographed thousands of ladybugs massed among the patterns of lichen on a fir tree. Nature's abstract designs appeal to his sense of design, his curiosity about nature's repeating patterns.

Another time, in the Huachuca Mountains, David made an afternoon hike up Miller Peak specifically looking for massed ladybugs. On his descent, an opening in the pine forest revealed a spectacular view of sunset over the ridges of Patagonia and the Tohono O'odham's sacred Baboquivari Peak and provided the day's best shot. In the last light, he was given phenomenal color.

"Be aware of what's around you," David says. "The most rewarding shots may be surprises."

Tucson-area islands

The Santa Rita Mountains' 9,357-foot Mount Wrightson is a magnet for David. Hiking to the summit, he stops at Baldy Saddle for well-framed views of the peak. From the peak itself, the mountain offers him a gamut of photographic possibilities—views west, backlit in the late afternoon; expanses of desert far below to the north; leftover snowdrifts accenting the top rock; Mount Lemmon in the Santa Catalina Mountains—another sky island—on the horizon. In Santa Ritas' Madera Canyon, autumn's fallen sycamore leaves provide him abstract designs in motion on the creek.

Mount Lemmon is the defining mountain of the Santa Catalinas, a mountain David often photographs from Saguaro National Park East to capture cactus and mountain together. The range's Sabino and Bear canyons offer myriad possibilities for the reflections he loves. The secret is very still water—and the patience to wait for it. Unlike Narcissus of Greek mythology, David falls in love not with his own face, but with all else reflected in the pool. While Narcissus gradually pined away watching his reflection, David thrives on the reflections given him.

In the Pinalenos

The Pinaleno Mountains are the domain of Mount Graham, highest of the sky islands. Mount Graham has been a source of controversy because of the astronomical observatory placed on the highest point, over objections of the San Carlos Apaches, for whom the mountain is sacred, and wilderness advocates trying to protect the endangered Mount Graham red squirrel.

Cool Reflection:
Water in the Santa
Catalinas' Bear
Canyon mirrors a
saguaro cactus.

Nevertheless, opportunities for photography abound. Circling Riggs Flat Lake in a pre-storm fog, David made deeply mysterious images before a violent monsoon storm sent us scrambling for shelter. Once the storm passed, he walked into the surrounding wet forest to capture remarkable details of flowers and fungi. Starting in the morning dark for a steep, short hike to Ladybug Peak from Ladybug Saddle, David arrives in time for superb sunrise views over the ridges to the northeast. His goal is always to catch a rare moment of predawn light and the spatial mood created by successive ridges of purples and blues topped by the sky's reds, oranges and yellows.

There is no end to views here. David says, "The idea is to explore all the possibilities—the forested ridges extending to the top of Mount Graham to the west; the effects garnered by looking northeast; the drama of the clouds gathering early; the rocks in the foreground; the plentiful sky images; sun emerging over the ridge."

Adding to his "explore all possibilities" mantra, he advises: "Be fluid in approach. Know your equipment. Focus and concentrate with camera and tripod. Know the rocks, the plants, animals and birds particular to each island in the sky. From this, the creative emerges and flows."

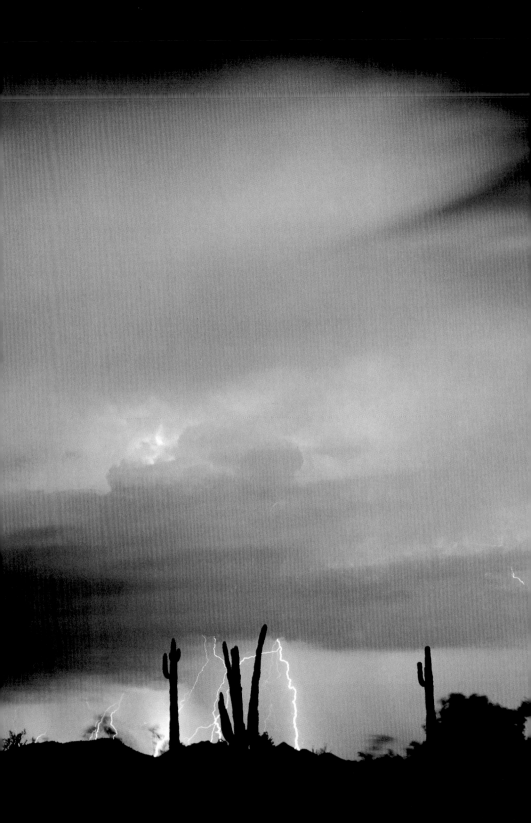

DESTINATIONS where to make great photographs

Chiricahua Mountains ✳ The Chiricahuas—northern extension of Mexico's Sierra Madres—are the largest and best-known of the sky islands. Named for the Chiricahua Apache Indians, the range was a battleground between Apaches and the U.S. Army. Even the leadership of the great warriors Cochise and Geronimo could not permanently ward off the homesteaders and pioneers who followed the army. Fortunately, much of these magnificent mountains garnered protection as national forest and national monument wildernesses. The north-south Crest Trail winding along the range's central ridge offers photographers wildflower-filled alpine meadows in late spring. Side trails east and west of the Crest Trail offer numerous routes to it. The southernmost stand of Engelmann spruce in the U.S. grows on 9,796-foot Chiricahua Peak, accessed via the Crest Trail, the Monte

Vista Peak Trail, the Green House Trail or from Rustler Park. There are campgrounds throughout the range, commercial lodging in Portal or Douglas.

Heart of the Rocks—Chiricahua National Monument ✳ Rhyolitic pinnacles, spires, and balanced rocks create a fantastical world here, with endless possibilities for photography. The 9-mile Heart of Rocks Trail, beginning at either Echo Canyon or Massai Point parking area, takes you into the heart of the rock formations for which this area is famous. Being here for sunset guarantees returning in the dark. Take a flashlight.

Cave Creek—Chiricahuas ✳ Cave Creek Canyon is a prime birding spot where you are likely to see elegant trogans, hummingbirds, hepatic tanagers, and red-faced warblers. As one of the few perennial

LEFT: **Bear Canyon, Santa Catalina Mountains.** BELOW: **Huachuca Mountains.**

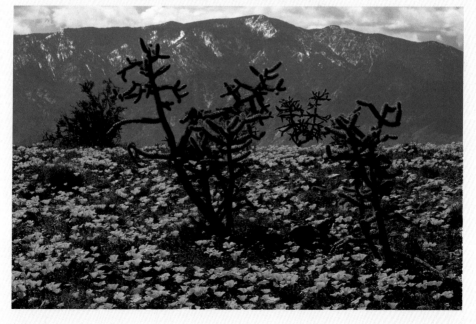

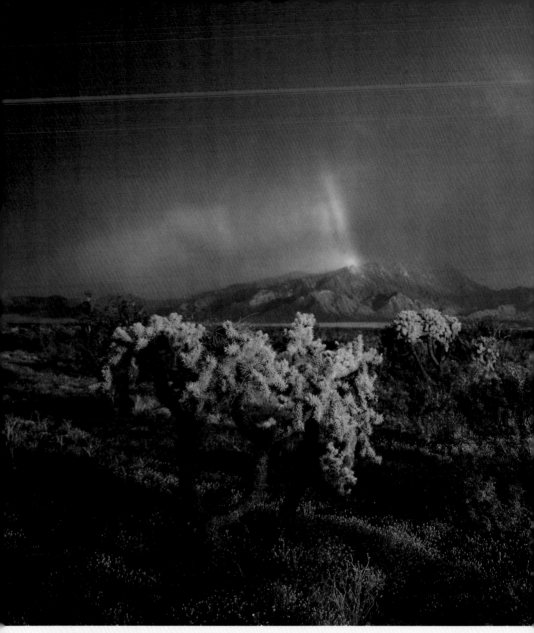

Santa Rita Mountains.

creeks in the Chiricahuas, it attracts a variety of wildlife—black bear, coatimundi, ringtail, javelina, mountain lion, coyote, and others. There are marvelous, sculptural trees along the lower stretches of the creek, a narrow gorge on the upper end with alluring caves, arches, and natural windows. Reaching vantage points from which to photograph these formations, however, requires fortitude and determination.

Huachuca Mountains ✳ Huachuca is a Chiricahua Apache word meaning "thunder." There is no lack of "huachuca" in monsoon season, which usually begins in late June or early July throughout Arizona. Monsoons

hike, is across the road from the parking area at the Coronado National Memorial in Montezuma Pass. As the trail climbs (gaining about 1,500 feet in the first 2.5 miles) it offers views southeast into Montezuma Canyon. About 3 miles farther, a spur trail climbs 0.5 of a mile to the peak with its spectacular views south into Mexico, north to the San Pedro River and several other sky islands. The Miller Peak wilderness is one of southern Arizona's best wildlife areas. On the northeast edge of the Wilderness, the Nature Conservancy's Ramsey Canyon Preserve is a heralded birding area. A perennial spring-fed stream provides dependable year-round habitat for birds, wildlife, and plants. There is lodging in Sierra Vista, rental cabins at the preserve, and a few, mostly small, campgrounds in the area.

Santa Rita Mountains ✳ The easily accessible Santa Ritas offer dramatic views on a variety of trails, all an easy day trip from Tucson. The paved road through Madera Canyon (another birding and wildlife hotspot) ends at the Roundup Picnic Area. From here, two trails enter the Mount Wrightson wilderness, both leading to the summit of 9,453-foot Mount Wrightson. The shorter, steeper Old Baldy Trail climbs 2.5 miles to Josephine Saddle, 2 miles farther to Baldy Saddle, another 0.9 of a mile to the summit. Openings along the way offer views of the Tucson basin and the Santa Catalinas to the north. The 8.1-mile Super Trail is gentler. From the summit you look south to the Sierra San Jose and Sierra Mariquita in Mexico, the Santa Catalinas, Pinalenos, Chiricahuas, and Huachucas in Arizona.

Santa Catalina Mountains ✳ Sabino and Bear canyons, at the northeast edge of Tucson, are easy entries into the Santa Catalina range. You can walk into either canyon from the visitor center at the parking area, or take a motorized tram 1.7 miles to

occur when a change in wind flow brings tropical air up from the south, moderating hot, dry temperatures and producing frequent thunderstorms. A second rainy season arrives in winter. The Huachucas are on the Mexican border, 10 miles south of Sierra Vista. The trailhead for the Crest Trail to 9,462-foot Miller Peak, a 5-mile (one way)

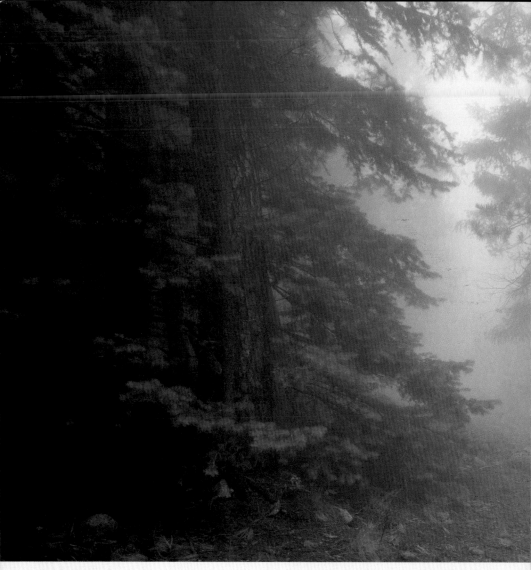

Mount Graham.

the Seven Falls trailhead, or 3.8 miles to the Sabino Canyon Trail. It is a 25-mile, hour-long drive on the Mount Lemmon Highway to the top of the mountain. A toll is collected at about Mile 5. The highway presents many photographic opportunities.

Because each sky island is an isolated geography, there are many distant vantage points from which to photograph them, places to take in the whole of the diversity these islands represent. Outside the Santa Catalinas, Ironwood Forest National

Monument offers superb views of the range, with Mount Lemmon prominent, above the Sonoran Desert's rich botany.

Mount Graham ⊕ Called "Big Seated Mountain" by the San Carlos Apaches, Mount Graham offers myriad photographic moments. This mountain is a showcase of natural history. Besides the preservation of a Pleistocene-relic spruce-fir forest, there are 14 perennial streams, high-elevation wet meadows, and a plethora of plant and

animal species. (Pinaleno is the Spanish version of the Apache "pinal" — meaning deer.) An hour's drive on the Swift Trail (State Route 366) is the equivalent of driving from Mexico to Canada. (The gamut of life zones is present in other sky islands, although there are few roads in which you can travel through them in an hour.) Lower elevation summers are exceedingly hot, while winter produces heavy snow in the heights. Both Riggs Flat Lake and Ladybug Peak (and virtually every other trail on the mountain)

are accessed from the Swift Trail. There are campgrounds on the mountain and lodging available in Safford, 20 miles north.

For maps and other information, contact the Coronado National Forest, 300 W. Congress St., Tucson, AZ 85701; (520) 388-8300. The Safford and Santa Catalina ranger districts cover the Pinaleno and Santa Catalina ranges; Douglas Ranger District covers the Chiricahuas; Sierra Vista and Nogales ranger districts cover the Huachucas and the Santa Ritas.

Directions

Al Fulton Point
This is the easiest-to-reach of all Mogollon Rim points.
✤ From Payson drive State Route 260 northeast until you top out on the Rim at 30.5 miles. Turn right into the Al Fulton Visitor Center. A half-mile south on Forest Service Road 171 (a dirt road suitable for all vehicles) brings you to the point.
www.fs.fed.us/r3/asnf/recreation/black_mesa_trails/trl_chv_gencrook.shtml

Alstrom Point
Located on Lake Powell. From Page, a 40-mile trip.
✤ From Page, take U.S. Route 89 north for about 15 miles to Big Water, Utah. Turn right onto National Recreation Area Road 230, a primitive road. There are many forks in the road from here on, and most of them are unsigned. Take the most-traveled road at forks and turn right onto Road 264. On a good day the drive takes two hours. The end of the road divides into several short spurs, all of which are worth exploring.
www.nps.gov/glca/planyourvisit/mountainbiking.htm

Antelope Canyon
✤ From Page, at Arizona's northern edge, drive 3 miles west on State Route 98; turn left at the signed turnoff and drive a few hundred yards to a parking area. Fee. (928) 645 2741.
www.navajonationparks.org/htm/antelopecanyon.htm

Apache-Sitgreaves National Forests
The Apache and the Sitgreaves are two adjacent national forests in the mountains of eastern Arizona with a common administration. U.S. Route 191 and State Route 260 are the major highways cutting through the forests.
www.fs.fed.us/r3/asnf

Apache Trail
✤ From metro Phoenix, take the Superstition Freeway (U.S. Route 60) east to Exit 196 (Idaho Road); turn left (north) and go about 2.2 miles to State Route 88, the Apache Trail; turn right.
www.arizonascenicroads.com. Click on the Phoenix & Central link atop the page.

Barrio Historico
The barrio (Spanish for neighborhood) is near downtown Tucson.
www.visittucson.org/listings. Click on the Interactive Maps link; enter "barrio historico" in the Points of Interest window.

Betatakin Ruin
See entry for Navajo National Monument. Fee.

Bisbee
✤ From Tucson, take Interstate 10 east to Exit 303 for Benson and State Route 80; go south on State 80 through Tombstone to Bisbee, a total of about 43 miles.
www.discoverbisbee.com

Blue Ridge Reservoir
✤ From Pine drive State Route 87 north 27.6 miles and turn east onto Forest Service Road 751. This graded dirt road (suitable for most passenger vehicles) brings you to this view in 5 miles.

Boyce Thompson Arboretum
✤ From Phoenix, take U.S. Route 60 (Superstition Freeway) east for about 60 miles to a signed turnoff about 3 miles west of Superior; turn right into park.
http://arboretum.ag.arizona.edu
http://www.azstateparks.com/parks/parkhtml/boyce.html

Bright Angel Point
See entry for Grand Canyon, North Rim.
✤ The point is located at the southern end of the entrance road. A paved, half-mile (round-trip) trail leads from the lodge to the point. This trail is steep in places, with drop-offs and stairs, but provides dramatic views into Roaring Springs and Bright Angel canyons.

Buckskin Gulch
This generally is regarded as the world's best slot-canyon hike. It stretches for 13 miles in a canyon as little as 10 or 15 feet wide. Sections of it can be reached by way of the Houserock Valley Road, Wire Pass Trailhead, Paria Canyon, or the Middle Trail.
www.blm.gov/az/st/en/prog/blm_special_areas/wildareas/paria_vermilion.html

Cape Royal
See entry for Grand Canyon, North Rim. Cape Royal is located on the Walhalla Plateau and can be reached on a paved road from the North Rim visitors center. From the southeast side of the Cape Royal parking area a flat, paved trail (0.6 miles roundtrip) leads to excellent views of the Canyon, Angels Window, and the Colorado River.
www.nps.gov/grca/planyourvisit/maps.htm

Canyon de Chelly National Monument
See entry for Chinle.
✤ At the stoplight, turn east for a 2-mile drive to the visitors center.

Chapel of the Holy Cross
See entry for Sedona.
✤ From State Route 179 about 3 miles south of its junction with Alternate State Route 89 (99A), take Chapel Road east to its end in less than a mile.
www.chapeloftheholycross.com

Chinle
This Navajo Nation town is the gateway to Canyon de Chelly.
✤ From Flagstaff, take Interstate 40 east to Exit 333 at Chambers. Go north on U.S. Route 191 for about 80 miles to Chinle. At Ganado, U.S. 191 turns west and coincides for a few miles with State Route 264 before turning northward again.

Chiricahua Mountains
The sky island can be reached several ways.
✤ From Interstate 10 east of Tucson, take Exit 336; follow the service road 3 miles to State Route 186; turn right (south); go about 31 miles to State Route 181;

turn left (east) and in about 4 miles you'll enter the Chiricahua National Monument.
- ✤ Continuing on State 186 past the monument turnoff brings you to Turkey Creek Road in about 12 miles; turn left (east).
- ✤ From Interstate 10 east of Tucson, take Exit 5 in New Mexico for U.S. Route 80; follow 80 south for about 28 miles to Portal Road; turn right (west); you quickly enter Arizona and the community of Portal, which provides access to several areas of the Chiricahuas. Portal Road also can be reached by taking U.S. 80 northward from Douglas.
www.fs.fed.us/r3/coronado/forest/recreation/scenic_drives/scenic.shtml

Chuska Mountains
The Chuskas run along the Arizona-New Mexico border from just north of Window Rock to north of the town of Lukachukai. Navajo permit required for backcountry travel.
www.cpluhna.nau.edu/Places/chuska_mtns.htm

Clifton
The eastern Arizona town is located on U.S. Route 191 north of Interstate 10.
www.co.greenlee.az.us/history/PointsofInterest.aspx

Coal Mine Canyon
- ✤ From Flagstaff, take U.S. Route 89 north for about 70 miles to U.S. Route 160; turn right (east); 10 miles to State Route 264; turn right (south); about 16 miles to the canyon on the left; look for a windmill.
discovernavajo.com/attractions/coal_mine_canyon_20060309_188.html

Cochise
- ✤ From Tucson, take Interstate 10 east to Exit 331; turn right (south) onto U.S. Route 191; drive about 4 miles to signed turnoff on right.
www.ghosttowns.com/states/az/azcochise.html

Colorado Plateau
The region includes about 170,000 square miles in northern Arizona, southern Utah, and western New Mexico.
www.arizona-map.org

Coyote Buttes
Fee and permit required for some activities. The area is encompassed by Vermilion Cliffs National Monument. Permit required.
www.blm.gov/az/asfo/paria/coyote_buttes/permits.htm

Deer Creek Falls
Reachable by boat. See Elves Chasm entry.

Desert Botanical Garden
Located in Papago Park, 1201 N. Galvin Parkway, Phoenix.
www.dbg.org

Desert View
See entry for Grand Canyon, South Rim. From Grand Canyon Village, take Desert View Drive (also called East Rim Drive and State Route 64) for 26 miles to Desert View, the east entrance to Grand Canyon National Park.
www.nps.gov/grca/planyourvisit/placestogo.htm

Dominguez Butte
Reachable by boat. See Lake Powell entry.

Douglas
- ✤ From Tucson, take Interstate 10 east to Exit 331; turn right (south) onto U.S. Route 191, which in about 72

miles leads to Douglas.
www.fws.gov/southwest/refuges/arizona/sanbernardino.html

Dry Creek Basin
See entry for Sedona.
- ✤ From the junction of Alternate State Route 89 (89A) and State Route 179, go west on 89A to Dry Creek Road (Forest Service Road 152C) at the west end of town; turn right (north) on Dry Creek Road; drive 2 miles to Forest Service Road 152; (rough, but can be traveled by passenger vehicles; not recommended during wet weather); about 4.3 miles up 152 you can park at a small, sandy opening; hike out the east end of the opening along a jeep trail that dead-ends at a drainage; continue on the foot path up the canyon.
www.fs.fed.us/r3/coconino/recreation/red_rock/secret-cyn-dry-creek-loop.shtml

Elves Chasm
Grand Canyon. Reachable by boat. For commercial trip information: (800) 959-9164 or (928) 638-7843.
www.nps.gov/grca/planyourvisit/whitewater-rafting.htm

Fossil Springs
- ✤ From Pine, drive State Route 87 north 3 miles to Strawberry; turn left (west) onto paved Fossil Creek Road, which in 2 miles turns to a dirt road suitable for most passenger vehicles; proceed 2.5 more miles, turn right (north) into the Upper Fossil Creek Trailhead, which is less than a half-mile up the road.
www.fs.fed.us/r3/coconino/recreation/red_rock/fossil-spgs-wild.shtml

Grand Canyon, North Rim
- ✤ From Jacob Lake at the intersection of U.S. Alternate Route 89 (89A) and State Route 67, drive 30 miles south on State 67 to the North Rim entrance. The highway from Jacob Lake is closed due to snow from mid-October to mid-May. (928) 638-7864.
www.nps.gov/grca/planyourvisit/directions_n_rim.htm

Grand Canyon, South Rim
Reached from Flagstaff or Williams, both along Interstate 40.
- ✤ From I-40 at about 6 miles east of I-17, take Exit 201 to reach U.S. Route 89 northbound. Drive 52 miles to Cameron; turn left (west) onto State Route 64; drive 57 miles to Desert View, the east entrance to the Canyon, and then 25 miles to Grand Canyon Village.
- ✤ From downtown Flagstaff, take U.S. Route 180 (Humphreys Street) for 51 miles to State Route 64; turn right (north); go 30 miles to the Canyon's South Entrance.
- ✤ From I-40 in Williams, take Exit 164 for northbound State Route 64; drive 58 miles to the Canyon's south entrance. Fee. (928) 638-7888.
www.nps.gov/grca

Grandview Point
See entry for Grand Canyon, South Rim.
- ✤ From Grand Canyon Village, drive east on Desert View Drive (also called East Rim Drive and State Route 64) for 12 miles to the signed turnoff on the left for Grandview.
www.nps.gov/grca/planyourvisit/day-hiking.htm

Greer
- ✤ From Show Low, take State Route 260 east about 40 miles to State Route 373 (signed turnoff is near Milepost 385); turn right (south); about 10 miles to Greer.
www.greerarizona.com

Gunsight Butte
Reachable by boat. See Lake Powell entry.

Havasu Canyon
The canyon is located on the Havasupai Indian Reservation and is reachable only foot, helicopter, or boat. The trailhead is on Hualapai Hilltop.
✸ From Flagstaff, drive west on Interstate 40 for about 70 miles to Exit near Seligman; drive northwest on Historic Route 66 for about 30 miles to Indian Route 18 and turn right; drive 60 miles to the hilltop parking area. Fee and permit required.
www.nps.gov/grca/planyourvisit/havasupai.htm;
www.havasupaitribe.com

Historic Route 66
Several segments of the old road are in Arizona, just off Interstate 40.
www.national66.com
www.www.azrt66.com
www.historic66.com

Holbrook
✸ From Flagstaff, take Interstate 40 about 91 miles east to Exit 285 or 286.
www.ci.holbrook.az.us
www.azrt66.com

Honanki Ruin
See entry for Palatki Ruin.
✸ From Palatki, drive a short distance and turn right onto Forest Service Road 525, then continue about 5 miles on the very rough road (high clearance recommended). The dwelling is in the alcove's shadow all summer, so all day is good for photography. In winter, the low sun lights up the stone masonry. Red Rock Pass required.
www.fs.fed.us/r3/coconino/recreation/red_rock/
honanki-ruins.shtml

Horseshoe Bend
✸ From Page on Arizona's northern border, drive south on U.S. Route 89 for 2 miles; just past Milepost 545, turn right (west) onto a gravel road and drive to the parking area. It's a half-mile hike to the overlook of the Colorado River.

Huachuca Mountains
✸ To reach the summit of the range with sweeping views south into Mexico and north towards the San Pedro River and a succession of other sky island peaks, take Interstate 10 east out of Tucson to Exit 302, which feeds into State Route 90; go south on State 90 about 32 miles into Sierra Vista and State Route 92; turn right (south) onto State 92; continue for 13 miles on 92 to the Coronado Memorial Road (Forest Service Road 61); turn right (south); continue for 8.2 miles through the memorial to the top of Montezuma Pass and parking area. The Crest trailhead is across the road from the parking lot. It's a strenuous hike to 9.466-foot Miller Peak.
www.fs.fed.us/r3/coronado/forest/recreation/
trails/crest.shtml

Hubbell Trading Post
See entry for Chinle. Before reaching Chinle, U.S. 191 passes through Ganado (location of the trading post) about 38 miles north of Interstate 10.
www.nps.gov/hutr

Hunt's Mesa
See entry for Monument Valley.
http://discovernavajo.com/tours/monument_
valley_tours.htm

Iceberg Canyon
Reachable by boat. See Lake Powell entry.

Jerome
✸ From Interstate 17 between Phoenix and Flagstaff, take Exit 286; turn left onto State Route 260, which in about 15 miles leads to Jerome.
www.jeromechamber.com

Jones Crossing
✸ From Pine, drive State Route 87 north 21.6 miles; turn right (east) onto Forest Service Road 141; a 4-mile ride on this graded dirt road (suitable for most passenger vehicles) brings you to Jones Crossing.

Kaibito Plateau
Located on the Navajo Indian Reservation, the plateau is north of Flagstaff and is bordered on the west by U.S. Route 89, on the south by U.S. Route 160, and on the east and north by State Route 98, which links Page to U.S. 160. Navajo permit needed for backcountry driving.
www.lapahie.com/Navajo_Map_Sh.cfm (click on the map to enlarge it)

Kayenta
This Navajo Nation town is the gateway to Monument Valley.
✸ From Flagstaff, take U.S. Route 89 north for 68 miles to its junction with U.S. Route 160; turn right (east); drive east by northeast for 82 miles to U.S. Route 163 and Kayenta. Along the way you'll pass the turnoff for Navajo National Monument.
www.discovernavajo.com; www.explorenavajo.com

Keet Seel
See entry for Navajo National Monument. Fee.

Lake Powell
✸ Page, Arizona, is the gateway to Lake Powell, the centerpiece of the Glen Canyon National Recreation area. Near Page are two marinas: Wahweap, 3 miles north of Page off U.S. Route; and Antelope Point, 3 miles east of Page off State Route 98 (turn north on BIA Route N22B).
www.lakepowell.com; http://www.nps.gov/glca;
www.antelopepointlakepowell.com

Lee's Ferry
✸ From I-40 at about 6 miles east of Interstate 17, take Exit 201 for U.S. Route 89 northbound. Go 111 miles to Bitter Springs (25 miles south of Page); turn left (west) onto Alternate U.S. Route 89 (89A); go 15 miles to Marble Canyon and cross the new Navajo Bridge over the Colorado River; continue 1 mile to a turnoff on the right marked for Lee's Ferry; go 7 miles to Lee's Ferry and the mouth of the Paria River. Park Service maintains a campground (fee, no reservations.)
(928) 608-6200. www.nps.gov/glca/planyourvisit/
lees-ferry.htm

Lukachukai Mountains
The Lukachukais generally are considered the northern part of the Chuska Mountains. One good entry point begins in the town of Lukachukai (see Chinle entry).
✸ From Chinle, drive eastward on paved Indian Route 64, which runs along one rim of Canyon de Chelly, to Tsaile, about a 25-mile drive. Turn left (north) onto Indian Route 12 and drive about 12 miles to Indian Route 13; turn right, drive through the town and continue on 13 into the mountains and over Buffalo Pass. Navajo permit required for backcountry travel.
www.cpluhna.nau.edu/Places/chuska_mtns.htm

Marble Canyon
See entry for Lee's Ferry. The beginning of Marble Canyon can be viewed from the Navajo Bridge.
www.nps.gov/deva/planyourvisit/upload/Cottwood-Marb%20handout.pdf

Mather Point
See entry for Grand Canyon, South Rim. As you come into Grand Canyon National Park from the South Entrance on State Route 64, Mather Point is the first vista on your right after passing Desert View Drive.

Mission San Xavier
1950 W. San Xavier Road, Tucson
www.sanxaviermission.org

Mitten Ridge
See entry for Sedona.
⚜ From the junction of State Route 179 and Alternate State Route 89 (89A)—known as the Y, take 89A up Oak Creek Canyon for about a mile and turn left immediately after crossing the bridge.
www.fs.fed.us/r3/coconino/recreation/red_rock/munds-wagon-tr.shtml

Mogollon Rim
Located at the junction of State Route 87 and State Route 260, Payson generally is considered the gateway to the Mogollon Rim. See entries for Al Fulton Point, Promontory Butte, Tonto Falls, and Woods Canyon Lake
www.fs.fed.us/r3/coconino/recreation/mog_rim/rec_mogollon.shtml

Mohawk Dunes
⚜ From Yuma, take Interstate 8 east for about 42 miles to Exit 42 at Tacna; turn south onto a dirt road that leads to the dunes' northern edge in about 15 miles. Free permit required; contact Marine Corps Air Station, Yuma, (928) 341-4021; or Bureau of Land Management, Yuma Field Office, (928) 317-3200.
www.blm.gov/az/st/en/fo/yuma_field_office.1.html

Monument Valley
See entry for Kayenta.
⚜ From there, go about 45 miles north on U.S. Route 163. Fee.
www.navajonationparks.org/htm/monumentvalley.htm

Montezuma Castle
This 20-room "high-rise apartment" was built by the Sinagua people into a recess of a cliff.
⚜ From Interstate 17 north of Phoenix, take Exit 289; drive east for about 0.5 of a mile to the blinking red light; turn left on Montezuma Castle Road. Fee.
www.nps.gov/moca

Mystery Valley
See entry for Monument Valley.
http://discovernavajo.com/tours/monument_valley_tours.htm

Navajo National Monument
See entry for Kayenta. The monument includes Betatakin and Keet Seel ruins.
⚜ About 62 miles after turning onto U.S. Route 160, turn left (north) onto State Route 564; turn left (north); drive 9 miles to the monument parking area. Fee and reservations.
http://www.nps.gov/nava/

North Kaibab Trail
See entry for Grand Canyon, North Rim.
www.nps.gov/grca/planyourvisit/day-hiking.htm

Oak Creek Canyon
Located in the Sedona area.
⚜ From I-17, take Exit 298 for northbound State Route 179; go 15 miles to a junction in Sedona with Alternate State Route 89 (89A), which goes northward through Oak Creek Canyon and on to Flagstaff.
Day-use fee in places. (928) 282-4119 or (928) 203-7500.
www.redrockcountry.org

Organ Pipe Cactus National Monument
⚜ From Tucson, drive east on State Route 86 for 120 miles to intersection of State Route 85 at Why; turn left (south) onto State 85; about 27 miles to monument's entrance.
⚜ From Phoenix, drive east on Interstate 10 to Exit 112; turn left (south) onto State 85; about 113 miles to monument's entrance.
www.nps.gov/orpi

Padre Bay
Reachable by boat. See Lake Powell entry.

Palatki Ruin
See entry for Sedona. Ruin is about 15 miles northwest of Sedona (part of the way is on dirt roads). The ruin lies in shadow early and late in the day, but the midday sun actually highlights the texture of the stone walls. Red Rock Pass required.
www.fs.fed.us/r3/coconino/recreation/red_rock/rec_redrock.shtml

Paria Canyon
See entry for Lee's Ferry, where the Paria River empties into the Colorado River. Paria is a part of Vermilion Cliffs National Monument. Fee for some activities.
www.blm.gov/az/st/en/prog/blm_special_areas/wildareas/paria_vermilion.2.html

Point Imperial
See entry for Grand Canyon, North Rim. The signed, paved road to Point Imperial leaves State Route 67 just north of Grand Canyon Lodge.
www.nps.gov/archive/grca/grandcanyon/north-rim.

Potato Lake
⚜ From Pine, drive State Route 87 north 13.4 miles; turn right (east) onto the Rim Road (Forest Service Road 300); proceed east 3.7 miles and turn left (north) onto Forest Service Road 147; in 2 miles a sign will point out the Potato Lake turnoff to the west; another half-mile brings you to the lake. These are graded dirt roads, sometimes bumpy, but suitable for most passenger vehicles.

Prescott
⚜ From Interstate 17 between Phoenix and Flagstaff, take Exit 262 at Cordes Junction; turn left onto State Route 69, which leads to Prescott in about 34 miles.
www.prescott.org or www.cityofprescott.net/visitrors

Promontory Butte
See entry for Woods Canyon Lake.
⚜ Rather than drive into the lake area, continue on Forest Service Road 300, which becomes unpaved. At 9.3 miles from State Route 260, turn left (south) onto Forest Service Road 72. This road is shown on some maps as ending in the middle of Promontory Butte, but it actually continues (in worse condition), first due

south, then east, then south again. At around 3.5 miles from the Rim Road, take a faint track due west, which brings you to the viewpoint in another half-mile. You'll need a high-clearance, four-wheel-drive vehicle.

Rainbow Bridge
Reachable by boat or by hiking. See Lake Powell entry.
www.nps.gov/rabr

Red Rock Crossing
✤ Drive west from Sedona on Alternate State Route 89 (89A) to the stoplight near the high school; turn left (south) onto Upper Red Rock Loop Road; drive 1.8 miles to the bottom of a hill and turn left onto Chavez Ranch Road; cross over the small bridge and immediately turn right; go 0.5 of a mile and turn left into Crescent Moon Picnic Area. Fee (not covered by Red Rock Pass). (928) 203-7500 or (928) 282-4119.
www.fs.fed.us/r3/coconino/recreation/red_rock/
crescentmoon-picnic.shtml

Red Rock Pass
See entry for Sedona. Pass is required for many sites in the Sedona-Oak Creek Canyon area.
www.fs.fed.us/r3/coconino/passes/index.shtml

Reflection Canyon
Reachable by boat. See Lake Powell entry.

Riordan Mansion
409 W. Riordan Road, Flagstaff.
www.azstateparks.com/parks/parkhtml/riordan.html

Route 66
See entry for Historic Route 66

Ruby
✤ From Interstate 19 south of Tucson, take Exit 12 for State Route 289; drive 18 miles west.
Ruby is privately owned but open to visitors Thursday through Sunday or by appointment (call 520-744-4471). Entry fee and fee for camping and fishing.

San Francisco Peaks
This loop around the Peaks winds through pine forests, aspen groves, prairies, meadows, and passes. You'll pass through Hart Prairie, Hochderffer Hills, Lockett Meadow, and Schultz Pass. Along the way, there are trails to hike and places to have a picnic.
✤ Begin in Flagstaff at the junction of U.S. Route 180 (Humphreys Street) and Route 66. Drive northwest on U.S. 180 for 10.8 miles to Forest Service Road 151. Turn right.

Head north on FR 151 for 12 miles to FR 418. Turn right (east) and go 16.4 miles to FR 552 and turn right for an optional trip to Lockett Meadow below Sugarloaf Peak.

Return to FR 418, turn right for a 2-mile drive to U.S. Route 89. Turn right (toward Flagstaff).

Drive 1.7 mi. to FR 420, Schultz Pass Road, and go west to U.S. 180. Turn left for a return to Flagstaff.
www.fs.fed.us/r3/coconino/recreation/peaks/
rec_peaks.shtml

Santa Rita Mountains
✤ From Tucson, take Interstate 19 south about 25 miles to Exit 75 (Sahuarita); turn left (east) onto Helmet Peak Road; in a few miles turn right onto Santa Rita Road.
✤ From Tucson, take Interstate 19 south about 37 miles to Exit 63 (Continental); go east on Conti-

nental-White House Canyon Road, which after about 7 miles leads to several Forest Service roads leading into the mountains, including one to Madera Canyon.
www.fs.fed.us/r3/coronado/forest/recreation/scenic_
drives/scenic.shtml

Schnebly Hill Road
See entry for Sedona.
✤ Schnebly Hill Road leaves from State Route 179 less than a mile south of Alternate State Route 89 (89A). Or you can start from the top of the road by taking Exit 320 from Interstate 17 south of Flagstaff.
www.fs.fed.us/r3/coconino/recreation/red_rock/
schnebly-hill-munds-mtn-tr.shtml

Sedona
✤ This scenic community is reached easily from Interstate 17, which stretches between Phoenix and Flagstaff. From I-17, take Exit 298 for State Route 179 and drive 15 miles north.
✤ Option: From Flagstaff, take Alternate State Route 89 (89A) south to Sedona.
(800) 288-7336 or (928) 282-7722.
www.visitsedona.com or www.sedone.net

Soldiers Pass
See entry for Sedona.
✤ From the junction of State Route 179 and Alternate State Route 89 (89A), drive west for 1.2 miles; turn right (north) onto Soldiers Pass Road; after 2.7 miles turn right onto Rim Shadows Drive; go straight a quarter-mile; turn left into the gated parking area.
www.fs.fed.us/r3/coconino/recreation/red_rock/
soldier-pass-tr.shtml

South Kaibab Trail
See entry for Grand Canyon, South Rim. The trail begins near Yaki Point, reachable by shuttle bus. There's water at the trailhead but none on the trail itself, which is steep. A hike to Cedar Ridge, about 3 miles, leads to excellent Canyon views.
www.nps.gov/grca/planyourvisit/upload/
2007Summer_sRimMap_final.pdf

South Mountain Park
There are several routes to this, the world's largest municipal desert park. The main entrance is at 10919 S. Central Ave., about 15 miles south of downtown Phoenix.
phoenix.gov/PARKS/parks.html

Taliesin West
Located in Scottsdale at 12621 N. Frank Lloyd Wright Blvd.
www.franklloydwright.org

Tlaquepaque
See entry for Sedona. The center is on the west side of State Route 179, less than a mile from Alternate State Route 89 (89A).
www.tlaq.com

Tombstone
✤ From Tucson, take Interstate 10 east to Exit 303 for Benson and State Route 80; go south on State 80 for about 23 miles to Tombstone.
www.tombstone.org

Tonto Falls
✤ From Payson, take State Route 260 northeast for 17 miles; turn left (north) on the paved Tonto Creek Fish Hatchery Road; after 1 mile, watch for the falls

on Tonto Creek on the right below.

Tonto National Monument
Overlooking Roosevelt Lake, this pueblo was built by the Salado people.
✤ From Phoenix, take State Route 60 (Superstition Freeway) east to Globe/Miami (75 miles); turn left (northwest) on State Route 188; drive 25 miles to the monument.
✤ Alternate: A shorter (scenic, but more driving time) route from Phoenix is State Route 88, the Apache Trail. The trail is 47 miles long, about half of which is a gravel road. From the Superstition Freeway, take Exit 196 for Idaho Road northbound; go about 2 miles to State 88; turn right (east).
www.nps.gov/tont

Toroweap Point
✤ From Pipe Spring National Monument in the Arizona Strip, turn left (east) onto State Route 389. Drive 5.2 miles (between mileposts 24 and 25) to County Road 109, the Sunshine Route. Turn right (south).

Checkpoint: At 7.2 miles south of State 389, continue past junction on right with BLM 1067.

Checkpoint: At 10.4 miles beyond BLM 1067, County 109 veers right and then left, changing direction from southwest to northwest to south within 0.4 miles. In this stretch, you'll pass two BLM roads on right.

Continue on County 109 for 22.5 miles beyond the second road to County Road 5. At this point you are 40.5 miles from State 389. Turn left (south) onto County 5.

Continue on County 5 for 6.3 miles to County Road 115. Stay left to get onto County 115. A directional sign for Toroweap is at this junction.

Continue on County 115 for 7.6 miles to Tuweep Ranger Station, located less than a mile south of Grand Canyon National Park boundary.

Continue south on 115 for 3.4 miles to a fork. Bear left for Toroweap campground and overlook in 1.2 miles. Camping permit required.
www.blm.gov/az/st/en/fo/arizona_strip_field.html
www.nps.gov/archive/grca/grandcanyon/tuweep
www.nps.gov/grca/planyourvisit/permits.htm

Tuzigoot
This 110-room pueblo was constructed just off the Verde River by the Sinagua people around A.D.1000.
✤ From Interstate 17 at Camp Verde, take Exit 287 for State Route 260 westbound to Clarkdale. From Flagstaff, take Alternate State Route 89 (89A) south for about 55 miles. Fee.
http://www.nps.gov/tuzi/

V-Bar-V Heritage Site
The largest-known petroglyph site in the Verde Valley, it is administered by the Coconino National Forest.
✤ From Interstate 17 about 100 miles north of Phoenix, take Exit 298; turn right (east) onto Forest Service Road 618 at the bottom of the ramp; the site is 2.8 miles from the interstate. Fee.
www.redrockcountry.org/recreation/cultural/
v-bar-v.shtml

Vermilion Cliffs National Monument
This remote 294,000-acre monument contains Paria Plateau, Vermilion Cliffs, Coyote Buttes, and Paria Canyon. Elevations range from 3,100 to 6,500 feet. See entry for Grand Canyon, North Rim. When you cross Navajo Bridge on U.S. Route 89A, the cliffs will be on the right.

www.blm.gov/az/vermilion/vermilion.htm

Vulture City
✤ From Wickenburg, take U.S. 60 west for 3 miles to Vulture Mine Road; turn left; 12 miles to the Vulture Mine site.
www.wickenburgchamber.com/attractions.asp

West Clear Creek
✤ From Pine, take State Route 87 north for 23 miles to Clints Well; turn left (west) onto paved Forest Service Road 3; at 7 miles turn left (west) onto dirt Forest Service Road 81; proceed southwest for 3 miles and then south on Forest Service Road 81E for 6 miles to the Maxwell Trailhead.
www.fs.fed.us/r3/coconino/recreation/mog_rim/
rec_mogollon.shtml
www.fs.fed.us/r3/coconino/recreation/red_rock/
west-clear-creek-wild.shtml

White Water Draw
In southeastern Arizona's Sulphur Springs Valley, this 1,500-acre preserve attracts more than 20,000 sandhill cranes in the winter plus other wildlife from late summer through spring. To locate the main entrance, which includes a restroom, picnic tables, viewing platforms, interpretive signs and trails:
✤ From Tucson, take Interstate 10 east to Exit 331; turn right (south) onto U.S. Route 191; go about 50 miles to McNeal; turn right (west) onto Davis Road; in a few miles turn left onto Coffman Road, which leads to the entrance.
www.sabo.org/birding/wdwamap2.JPG
www.sabo.org/birding/chirsulp.htm#wdwa

Willcox
✤ From Tucson, take Interstate 10 east to Exit 340.
www.willcoxchamber.com
www.azgfd.gov/outdoor_recreation/wildlife_area_
wilcox_playa.shtml

Window Rock
This is the capital of the Navajo Nation. See entry for Chinle.
✤ At Ganado, turn right onto State Route 264 for a 50-mile drive to Window. Or, from Interstate 40 take Exit 357 for paved Indian Route 12 and a 30-mile drive to Window Rock.
www.discovernavajo.com

Woods Canyon Lake
✤ From State Route 260 about 25 miles west of Heber, turn north onto paved Forest Service Road 300 (it's across the highway from the Rim visitors information station); drive about 4 miles to the lake and adjoining campgrounds.
www.fs.fed.us/r3/asnf/recreation/campgrounds/
devcamp/devcamp_aspenrimlakes.shtml

Wupatki National Monument
✤ From Interstate 40 in Flagstaff, take Exit 201 for U.S. Route 89 north; go 12 miles to a road signed for Sunset Crater Volcano-Wupatki National Monuments; turn right (east); the Wupatki visitors center is 21 miles from the junction. Fee.
www.nps.gov/wupa

Index

Back Cover: Clockwise from top left: Misty sunrise by Peter Ensenberger; Bobcat by Tom Vezo; a student practices at a Friends of *Arizona Highways* photo workshop in Monument Valley by J. Peter Mortimer.

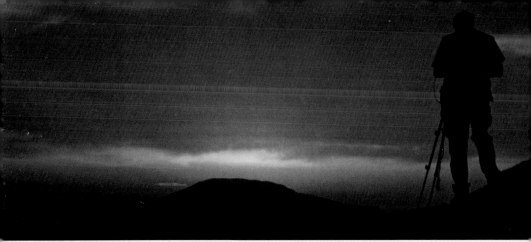

Arizona Highways
Photo Workshops

Visit some of the West's most scenic locations while learning the art of photography.

WHAT TO EXPECT

Workshops are taught by world-class photographers and take place throughout Arizona and the West. Limited group sizes allow you to enjoy education, camaraderie and friendship with others who possess your passion for photography.

To make the most of your workshop experience it helps to:

- be familiar with your equipment
- share your photos, knowledge and questions
- experiment with new techniques
- stay enthusiastic and flexible
- participate to the fullest extent you are able

IT'S JUST BEFORE DAWN and a small group of photographers is waiting with anticipation. A pinprick of light breaks the horizon and a dozen shutters go off in succession, capturing the fleeting moments of golden glory known as "sweet light." So begins a typical workshop day. It's these moments that photographers live for, and the experience is made even more special by our professional instructors, who move among the students demonstrating their secrets for good composition and exposure.

If you'd like to refine your photographic technique, your artistic vision, and go where *Arizona Highways* photographers go, we encourage you to join us for an unforgettable adventure. Most workshops combine instruction both in the field and classroom, creating the perfect atmosphere for you to advance your creative and technical skills, no matter what your current level of expertise. Critiques will show you what the pros look for, and will give you the tools you need to make immediate improvements to your photographs.

For more information, a full Calendar of Events, or to register call (602) 712-2004, toll-free 1 (888) 790-7042, or visit us online at www.PhotographTheWest.com

Workshops are conducted by the Friends of Arizona Highways, a 501(c)(3) organization.
Proceeds from the workshops help support the goals and mission of Arizona Highways magazine.